LIKENESS AND LANDSCAPE

THOMAS M. EASTERLY
AND THE ART OF THE
DAGUERREOTYPE

LIKENESS AND LANDSCAPE

THOMAS M. EASTERLY
AND THE ART OF THE
DAGUERREOTYPE

DOLORES A. KILGO

MISSOURI HISTORICAL SOCIETY PRESS ∞ SAINT LOUIS

Library of Congress Catalog Card Number 94-075212

Likeness and Landscape:
Thomas M. Easterly and the Art of the Daguerreotype
ISBN 1-883982-04-9 soft bound
ISBN 1-883982-03-0 hard bound
First Edition

Printed in Canada by
Friesen Printing Company

Editor: Candace O'Connor
Photo Editor: Duane Sneddeker
Designer: Robyn Morgan
Photography by: Dennis Waters and David Schultz

Distributed by The University of New Mexico Press

Cover illustration: *Chouteau's Pond, View South from Clark and Eighth Streets.* Quarter plate (laterally reversed), 1850. MHS. Plate inscription: T.M. Easterly Daguerrean Chouteau's Pond

Funding for this publication was provided, in part, by the National Endowment for the Arts, a federal agency, and the Missouri Humanities Council.

To my parents
and to the late Margaret Wing Dodge

CONTENTS

ACKNOWLEDGMENTS

esearch for this book began nearly a decade ago. In the interim, many individuals and institutions have assisted me in bringing this work to fruition. My deepest thanks go to Duane Sneddeker, curator of photographs and prints at the Missouri Historical Society in St. Louis, who so generously and patiently shared his time, expertise, cogent advice, and good humor as a valued friend and collaborator. Without his enduring faith in the worth of this project, especially during its difficult moments, this book would not have been possible.

I am also extremely grateful to Alice Dodge Wallace, who contributed significantly with moral and financial support, and to her mother, the late Margaret Wing Dodge. Together they are responsible for preserving vital Easterly works and important materials related to his life and career.

Individuals who gave generously of their time and knowledge with valuable research assistance include: Paul Carnahan and Mary Beth Brigham, Vermont Historical Society; Richard Rudisill, Museum of New Mexico; John Aubrey and the late Michael Kaplin, the Newberry Library, Chicago; Douglas Severson, the Art Institute of Chicago; Stephanie Sigala, St. Louis Art Museum; Michelle Delaney, Division of Photographic History, National Museum of American History, Smithsonian Institution; Jeff Marshall, Special Collections, University of Vermont; Bonnie Wilson, Minnesota Historical Society; William Severin, Niagara Historical Society and Museum,

Niagara-on-the-Lake, Ontario; William Sturtevant, Department of Anthropology, Smithsonian Institution; Joanna Cohan Scherer, *Handbook of North American Indians* Project, Department of Anthropology, Smithsonian Institution; George R. Lindsey, Brooks Memorial Library, Brattleboro, Vermont; Janet Perusse, Brattleboro Retreat; Anne Tabaka, Lundy's Lane Historical Museum, Niagara Falls, Ontario; Regena Jo Schantz, Colonel Davenport Historical Foundation, Davenport, Iowa; Kenneth MacFarland, Albany Institute of History and Art, Albany, New York; John Lawrence, The Historic New Orleans Collection; J. B. Harter, Louisiana State Museum, New Orleans; collector Greg D. Gibbs; and Frank E. Janson, Metropolitan St. Louis Sewer District.

I am particularly indebted to Pauline and Harold Barry of West Brattleboro, Vermont, who provided invaluable help in locating Easterly's early work in that region. Special thanks are also due to John P. Zeller for his assistance in tracking Easterly's movements in Iowa.

John Wood, whose publications on the daguerreotype in America have fostered wider appreciation for this early medium, also contributed significantly to this project by sharing his knowledge of this era and by introducing me to a community of supportive daguerreotype enthusiasts, scholars, dealers, and contemporary practitioners. Many in this circle offered ideas, related images, and helpful information. Those who deserve particular thanks among this group are Robert Shlaer, Peter Palmquist, Martha

Sandweiss, Brooks Johnson, Laurie Baty, Cliff Krainik, Larry Gottheim, Ken Nelson, Brian Wallis, George Whiteley, Joan Schwartz, William B. Becker, David Haynes, and Dennis Waters, who also did much of the photography for the book. A special thanks also to Dr. Carl Walvoord, who encouraged me to pursue this work and generously shared his knowledge on daguerreotype cases. I am also particularly indebted to Matthew Isenburg, who made countless contributions.

It is fitting that the Missouri Historical Society in St. Louis, where Easterly's work was most appreciated during his lifetime, has been an essential partner in this effort, and I am grateful to Society President Robert R. Archibald for his commitment to this publication. The exceptional staff at the Society's Library and Collections Center also provided indispensable research help over the years. I would especially like to thank Peter Michel, Director of Library and Archives, and Archivist Martha Clevenger, who became friends as well as valued advisers during my many research visits. Librarian Carol Verble, who saw the project through from beginning to end, deserves special recognition, as do Kirsten Hammerstrom and David Schultz of the Department of Prints and Photographs. In the early stages of my research and writing, I also received important encouragement and assistance at the Society from Kenneth Winn, Judith Ciampoli, and Glen Holt. Executive Vice-President Karen Goering saw the project through several institutional changes; Vice-President Marsha Bray and Director of Publications Lee Ann Schreiner provided administrative support during the editorial and production phases.

Thanks are gratefully extended to the Smithsonian Institution and to the Newberry Library for fellowship awards to do research on Easterly's works in their collections. Major financial support was also provided by Metropolitan Zoological and Museum District of St. Louis; Emerson Electric Company; Elberth R. and Gladys Flora Grant Charitable Trust; Hunter Engineering Company; Stanley and Lucy Lopata; Mallinckrodt Specialty Chemical Company; Norman J. Stupp Foundation, Commerce Bank, Trustee; and Missouri Historical Society Members, Donors to the Year-End Appeal. Additional thanks to Shaughnessy-Kniep-Hawe Paper Company of St. Louis.

I would also like to acknowledge important institutional assistance that I received from the Graduate School and the University Research Grant Program at Illinois State University. For their advice and patient listening, I am indebted to Rhondal McKinney and to my ISU art history colleagues Bill Archer, Arthur Iorio, and especially Susan Appel for her personal support and insightful observations on Easterly's architectural views. Among the many scholar-consultants in other academic departments on campus who offered advice or assistance, I am grateful to Fine Arts Librarian Steve Meckstroth, to historians L. Moody Simms and Ira Cohen, and to costume specialist Frank Vybiral. ISU staff and friends Betty Kinser, Linda Barnett, Georgia Bennett, and Teri Derango helped in numerous ways on a day-to-day basis throughout the project.

I have also benefited from opportunities to work on collaborative research undertakings with several talented graduate students and Honors Program students. I would especially like to acknowledge Rebecca Henrich Lamb, Barbara Little, Laurie Dahlberg, Brian Simpson, and Jane Rohrschneider, whose industry and enthusiasm for American daguerrean art led us to discoveries that validated or generated some of the ideas explored in this book. During his tenure as ISU Art Department Chairperson, Ed Forde provided much-appreciated early encouragement. Over the past two years, the critical assistance of Art Department Chair Ron Mottram has truly demonstrated the key role that administrators can play in facilitating and encouraging faculty research. I have also been extremely fortunate to work for a dean whose enlightened view of scholarship was critical to making this publication a reality. Indeed, I can never adequately express my appreciation to Dean Alvin Goldfarb for giving me his personal support and for allowing me the flexibility I needed to complete this project.

To Gweneth Schwab, Keith Davis, Alan Trachtenberg, Grant Romer, Duane Sneddeker, Eric Sandweiss, and Paula Fleming, who read various versions or sections of the manuscript, I express my deep appreciation for many helpful observations and comments. A special thanks to Ann Lee Morgan, who introduced me to early photography during a graduate seminar at the University of Illinois and on whom I have depended heavily for criticism, advice, and scholarly insights throughout this work. I am also extremely grateful to Candace O'Connor, who edited the manuscript with skill, precision, and patience, and to Robyn Morgan and her assistant Lorrie Calabrese for their careful design of this volume.

Finally, I could not have endured this long-term commitment without the help and understanding of friends and family. Amy Kilgo, Patty Monoson, and Judy and Lars Hoffman saw me through many wavering moments. To my sons, Rob, Matt, and Alex, who grew up with this project, I express my deepest appreciation for their tolerance and enthusiastic encouragement. My greatest debt is to my husband, Bob, whose unfailing support sustained me throughout this work.

Dolores A. Kilgo

INTRODUCTION

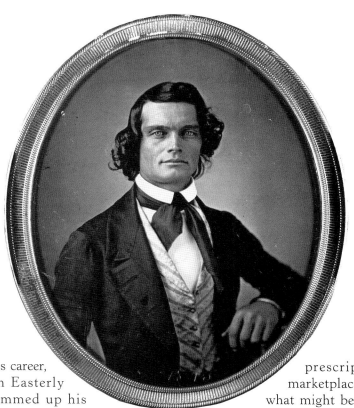

In 1865, late in his career, Thomas Martin Easterly (1809-1882) summed up his loyalty to the daguerreotype process with a warning to a fickle public, which no longer shared his devotion to pictures on silver. "Save your old daguerreotypes," he wrote prophetically, "for you will never see their like again."[1] As striking reminders of the singular beauty of the medium that introduced the world to camera-made pictures in 1839, the surviving works of Daguerre's most dedicated follower still serve to confirm the wisdom of those words. Easterly's likenesses and landscapes recall a time when each photographic image was unique, deliberate, and cherished. This remarkable legacy takes on additional significance when viewed as a mosaic of visual ideas that invite fresh insights into the ways in which the daguerreotype both reflected and defined the culture that produced it. Prompted by artistic and documentary impulses generally credited to later generations of photographers, Easterly ignored the prescriptive demands of the marketplace to pursue his own goals for what might be aspired to and accomplished with the camera. What he produced in this quest represents one of the most important and broad-based achievements in nineteenth-century photography.

Since serious inquiry into the era of the daguerreotype medium began several decades ago, Easterly has remained little more than a footnote in the early history of photography. His only well-known work is the powerful and frequently reproduced portrait of Keokuk (fig. 3-12). In Beaumont Newhall's comprehensive work, *The Daguerreotype in America,* he is remembered as a pioneer photographer who once daguerreotyped a streak of lightning (fig. 1-10). If these isolated incidents from Easterly's

Portrait of Thomas M. Easterly. Sixth-plate daguerreotype, possibly a self-portrait, 1845. Easterly Collection, Missouri Historical Society (MHS). Plate inscription: 1845.

career hint at ambitions that have rescued him from anonymity, his legacy of more than six hundred surviving plates unequivocally confirms the breadth of his skills and intentions.

Named after its artist-inventor, Louis Jacques Daguerre, the process that Easterly refined in his St. Louis studio was not photography as we know it today. The Frenchman's technique produced a one-of-a-kind image secured on a silver-coated copper plate. Before use, the plate was polished to a mirror-like finish and made light-sensitive by exposure to iodine. After exposure in the camera, the silver surface was fumed with mercury vapor to bring out the latent image, which was then washed in a fixing bath to remove any unexposed silver salts. The resulting image was a direct positive; since there was no negative, each plate was unique. The daguerreotype picture, like the reflection in a mirror, is laterally reversed. Because of its highly reflective surface, the image shifts from positive to negative depending upon the viewing angle. Daguerreotype plates were manufactured in several standard sizes. Those most widely used were the half plate, 4 ¼" x 5 ½"; the quarter plate, 3 ¼" x 4 ¼"; and the sixth plate, 2 ¾" x 3 ¼". To protect its extremely delicate surface from tarnish and abrasion, the picture was sealed and protected under glass. In the tradition of miniature paintings, most American daguerreotypes were sold in velvet-lined decorative cases.

Easterly was among hundreds of individuals whose pictures, created by the action of light, signaled a new era in the history of the visual arts. Working diligently to refine Daguerre's original process, ambitious practitioners on this side of the Atlantic quickly demonstrated that Yankee ingenuity was a valuable asset in this new business. By 1845, America's unparalleled enthusiasm for the "exquisite truthfulness" of the daguerreotype's sharp-focus vision had encouraged the proliferation of permanent daguerreotype galleries and itinerant practices all across the United States. Native daguerreans rapidly gained an international reputation for superior accomplishment. The large and impressive display of American plates at the 1851 Crystal Palace exhibition in London confirmed the exceptional quality of their efforts.

The heyday of the "mirror with the memory," as Oliver Wendell Holmes described the glowing miniatures, ended in this country in the late 1850s with the introduction of the collodion or wet plate process, a less expensive technique that overcame the daguerreotype's most prominent deficiencies. Pictures on paper or glass made by the collodion process provided the crisply rendered image so revered by the American public and eliminated the reflective glare created by the daguerreotype's polished metallic surface. Glass-plate negatives coated with light-sensitive collodion emulsion could also provide any number of identical paper prints. Daguerre's technique, which produced only one-of-a-kind positive images, was inherently ill-suited to mass production.

Despite its relatively brief period of dominance, the daguerreotype had a swift, enduring, and irreversible impact on American society. As an art form accessible to nearly all, it secured photography's place in the hierarchy of the visual arts as a pictorial medium that transcended the boundaries of social class structure. Unprecedented in the scope of its influence on the American visual experience, the daguerreotype conditioned public taste to accept the photographic vision as a surrogate fragment of reality. As a consequence, native painters and printmakers began to reassess inherited conventions that had limited the role of observed reality in the picture-making process. By midcentury, American artists reflected their acquiescence to the aesthetic language of their new competition both in less fanciful portraits and in more literal and precisely executed depictions of the national scene.

It was not only in the art community where the daguerrean era forecast the functions that camera-made pictures would serve long after photography had emerged from its infancy. "The new machine for making nature take her own likeness," as the American painter Thomas Cole described the daguerreotype camera, could facilitate other, more practical tasks of society.[2] With a seemingly unbiased eye, the process routinely extolled as "nature's own paintbrush" could record and communicate a microcosm of specific information with a new authority guaranteed by the union of art and science. Faces, events, and sites of historical significance could be preserved with a documentary validity unattainable in any earlier art form. While it is apparent that ambitious daguerreotypists eagerly applied themselves to the task of recording their nation's most celebrated faces, we have less visual evidence to indicate a serious and widespread commitment during this era to documentary work outside the studio.

Easterly left little doubt that from the outset of his career he recognized the potential of Daguerre's process not only to record the present but also to reclaim the past for future generations. During his years in the East and later in St. Louis, he consciously set out to document surviving fragments of the early history of those regions. He was equally astute at observing and preserving contemporary scenes that would one day delineate the history of his own time. Today his many views showing the growth of commerce and industry in St. Louis represent a unique and astonishingly complete photo-

graphic chronicle of urbanization in mid-nineteenth-century America. His early, scenic views are equally important in representing what appears to be the first consistent manifestation of a romantic landscape sensibility in American photography.

In collections here and abroad, this pictorial legacy is unsurpassed as a comprehensive record of individual achievement in exploring the new language of daguerreotypy. Only the Boston team of Albert Southworth and Josiah Hawes, long acknowledged as the American Rembrandts of the daguerreotype medium, left a more abundant record of their efforts to demonstrate the full potential of Daguerre's new "sunbeam art." In their own time, Southworth and Hawes enjoyed a wide reputation for excellence that was enhanced by their association with Boston's preeminent personalities. Indeed, the roster of national heroes who sat before their camera by itself guaranteed the talented partners a prominent place in history.

While Easterly shared Southworth and Hawes' artistic standards and high aspirations for the process extolled as "nature painting itself," he had little else in common with such illustrious colleagues. In a modest St. Louis gallery, he worked without partners or assistants, distant from the major art centers of America, and with no recognition for his accomplishments outside his immediate locale. In these ways his career was far more typical of the average practice of daguerreotypy across America. Rarely did others in this populous but now largely anonymous profession leave more than occasional advertisements or a handful of images to describe their aims or the exigencies of their businesses. In this regard Easterly's many surviving plates offer an exceptional opportunity to examine the activities and accomplishments of a pioneer photographer who worked outside the eastern mainstream establishment.

This corpus of work, like its author's achievements, went essentially unnoticed for more than a century. During the decades following the Civil War, when Easterly was St. Louis' only practitioner of Daguerre's by-then-outmoded process, his gallery display was probably viewed as little more than a curiosity by a new generation of picture consumers. We can be thankful that John Scholten, one of the leading photographers in the city, placed a higher value on Easterly's work.

When Easterly died in March 1882, his wife left St. Louis to live with her sister's family in Columbus, Ohio. At some point before her departure, Scholten purchased her husband's gallery collection, a transaction that generated a brief renewal of interest in the daguerrean's work. Within six weeks of Easterly's death, articles in the *Missouri Republican* brought attention to

Scholten's newly acquired mementos of St. Louis' past. One of these reports, which appeared on April 10, 1882, proposed that Scholten's "rare collection would be of great interest in any history of St. Louis that may hereafter be published." The writer concluded that "The Historical Society should have an eye on a portion of this collection."[3]

In 1896, a decade after Scholten's death, the Missouri Historical Society followed up on that suggestion by purchasing the daguerreotypes that now make up the bulk of its Easterly Collection. When Scholten died in 1886, his son John, Jr., inherited his father's gallery and custody of the Easterly daguerreotypes. We can assume that after the 1896 death of Scholten, Jr., an event that marked the end of the Scholten Gallery, the family sold the Easterly collection to the Society. In a brief notation that provides no details on the transaction, minutes of the Society's February meeting that year record "the purchase of a series of Daguerreotypes representing views in and about St. Louis taken in the 40s, 50s, and 60s by T. M. Easterly."[4] Since the Society also owns the portraits that the *Missouri Republican* listed in its account of Scholten's "rare collection," they were probably a part of the same acquisition. It is also possible that some Easterly plates had been acquired in earlier, unrecorded arrangements with Scholten, Sr., who was an active member of the Society before his death.

When Easterly's work came to the Missouri Historical Society, many of the plates were stored in the wooden boxes that had held unexposed plates when they were purchased decades earlier from the Scovill Manufacturing Company in Waterbury, Connecticut. Several boxes bearing the Scovill Company's label are still in the Society's possession. Additional paper labels affixed to the boxes bear handwritten notations such as "Miscellaneous St. Louis Streets and Citizens," "Vermont, Niagara, St. Louis Views," and "St. Louis Streets." Inscribed below the notations that once classified the original contents of each box is what appears to be the date "Sep _ /94." Presumably, the plates were examined or organized at this time, possibly by John Scholten, Jr. At some later date, many of the plates originally housed in Scovill boxes were randomly paired with mats or cases that now display those images. Relatively few Easterly images among the Society's holdings appear to be housed in their original cases.[5]

As the Missouri Historical Society's photography holdings grew to include thousands of images by the early decades of the twentieth century, Easterly's daguerreotypes essentially fell into archival obscurity while the record noting the acquisition of this "rare collection" was entirely forgotten. For many years, in fact, the Society's daguerreotype views were casually attributed to Easterly's

more widely known competitor, John Fitzgibbon. As early as 1938, Robert Taft's *Photography and the American Scene*, still an indispensable resource for students of the history of photography, perpetuated this misconception by citing "the industry of Fitzgibbon" as the probable explanation for the Missouri Historical Society's extensive holdings of daguerreotype views.[6]

Charles van Ravenswaay, director of the Society from 1946 to 1962, took a serious interest in his institution's early photography collections during the 1950s. In his writings, he acknowledged Easterly's authorship of the views and dismissed the Fitzgibbon "legend" as an "error" that had "originated in some obscure way many years ago." He could only speculate that Fitzgibbon's reputation as "the most colorful and dynamic of the early St. Louis photographers" had encouraged the erroneous assumption.[7]

In 1956, under van Ravenswaay's leadership, the Society reorganized its extensive daguerreotype holdings and established a separate Easterly Collection that included the original Scholten inventory, additional plates acquired through the years from private donations, and twelve views that the Society had purchased directly from the daguerrean in 1867. This latter group, identified at the time of purchase simply as a collection of plates picturing "old landmarks," is generally regarded as the Society's first acquisition after its founding in 1866.[8]

In 1970, the Easterly holdings received a significant addition with the gift of sixteen daguerreotypes that had remained in the possession of Easterly's wife after her husband's death in 1882. These plates, now known as the Easterly-Dodge Collection, were presented to the Society by Margaret Wing Dodge, a descendant of Mrs. Easterly's sister, Margaret Bailey Townshend. The Dodge Collection also includes many personal items originally belonging to the Easterlys. In more recent years, Alice Dodge Wallace, continuing her mother's dedication to the preservation of the daguerrean's work, has added other daguerreotypes and personal memorabilia to the Dodge Collection. Today, more than 450 portraits and 160 views constitute the Society's extensive Easterly holdings. Additional evidence of his work can be found in the Society's general collections in the form of photographs copied from now-lost daguerreotypes.

Fewer than three dozen Easterly plates, most of them held by three institutions, are known to exist in public collections outside St. Louis; they are even less common in private collections. Among fifteen Easterly works in the Newberry Library's Ayer Collection is an extraordinary series of thirteen hand-colored Indian portraits that rank among the gems of the daguerrean era. While a number of these unpublished treasures picture some of the same Sauk, Fox, and Iowa tribesmen recorded in the Missouri Historical Society's Easterly Collection, other images in the group add new subjects to this important subcategory within Easterly's documentary work.

The Smithsonian Institution's Division of Photographic History also owns several daguerreotypes closely related in subject to other known Easterly Indian portraits. In sharp contrast to the pristine condition of most of the Newberry Indian portraits, several of the Smithsonian plates have suffered such extensive damage that the images are now almost indiscernible. Fortunately, the sitters, as they originally appeared in the daguerreotypes, are preserved on glass-plate negatives used to reproduce these portraits later in the nineteenth century.

The discovery of a third body of work in the collections of the Vermont Historical Society revealed other dimensions of Easterly's pioneering efforts to explore less conventional avenues for making pictures with the daguerreotype process. This remarkable group, apparently his earliest located work, comprises scenic and architectural views made in Vermont. Although these plates have no provenance data, there is evidence suggesting that the Vermont Historical Society may have acquired its Easterly daguerreotypes at the same time as or not long after Scholten's collection of Easterly plates was sold to the Missouri Historical Society. When the Easterly views came to the attention of Society personnel in 1977, they were stored in a wooden plate box bearing the Scovill Manufacturing Company label and an additional paper label carrying the handwritten notations "Vermont Scenes" and "Sep _ /94"—in a manner similar to Scholten's Easterly Collection at the Missouri Historical Society. If the Vermont scenes were a part of Scholten's collection, which seems plausible in light of the dates and labels, the Vermont Historical Society may have acquired its views from Scholten's family in a transaction similar to that arranged with the Missouri Historical Society. It is also possible that the Society in St. Louis first obtained the views as part of its Easterly purchase in 1896 and later passed them on to the Society in Vermont.

As this study suggests, the complex story of this pioneer photographer's career and achievements has only begun to unfold. Indeed, any initial effort to define and interpret the significance of a body of work as substantial and richly diverse as Easterly's can provide at best only a partial and invariably subjective reading of his accomplishments. This outcome is even more predictable when these interpretations are set against the background of a photographic era that is in itself not yet clearly defined.

Efforts to look beyond Easterly's work for clues to who he was and what might have shaped his uncommon ambitions have yielded only pieces of his past. He left no personal papers or business accounts; almost nothing is revealed about his St. Louis practice in official city and county records. What little is known about his activities and personal life has been gleaned primarily from newspaper references and fragmentary insights gained from letters written by his brother-in-law, Dr. Norton Townshend. At least for the present, we are left largely with what can be surmised or inferred from the work itself to help us discover the ideas and emotions that lie beneath the surface of these richly evocative images.

As the first extensive study devoted to the career of a frontier daguerrean, this book adds another perspective to our understanding of the ways in which Daguerre's process and its practitioners answered the diverse artistic and cultural needs of antebellum America. More importantly, what is presented here attempts to bring forth and properly acknowledge the extraordinary talent of Thomas Easterly, whose vision for the daguerreotype and unflagging devotion to its special beauty affirm his place among the pioneer masters of American photography.

CHAPTER I
THE LAST OF
"THE OLD-STYLE PICTURE-MEN"

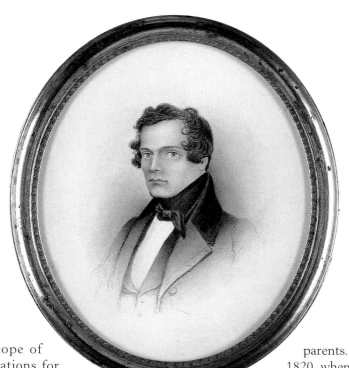

Although the scope of Easterly's aspirations for the daguerreotype would come to distinguish him from the average professional, his early career in many ways paralleled that of hundreds of others whose work introduced Daguerre's invention to the American public. As is often the case with photographers of this period, we have only limited information from which to reconstruct the circumstances of Easterly's early life. He was born on October 3, 1809, in Guilford, Vermont, a small village five miles outside the larger farming community of Brattleboro. Little is known about the background of his parents, Tunis and Philomela Richardson Easterly. The couple married in 1806 and settled on property that Easterly's mother had inherited from her family. According to Guilford census records, Tunis Easterly, a native of New York state, was engaged in the "manufactures and trades." In 1816, during a period when the family apparently experienced severe financial difficulties, Easterly's father was recorded as a "shoomaker."[1]

Thomas Martin was the oldest son and second-born child of the Easterlys' five children.[2] Perhaps because of the family's financial problems, Thomas and his older sister, Maria, did not spend all of their childhood with their parents. Census records show that in 1820, when Easterly was eleven years old, only the three younger children were living in the Guilford household. Possibly the parents placed their oldest son in the care of relatives who lived near the Ontario border in St. Lawrence County, New York; evidence suggests that in 1830, at the age of 21, Easterly was living in that area.[3] From what we know of the daguerrean's studious disposition and later interests, we can assume that he received at least an adequate formal education. During his school years Easterly probably began to develop the expertise that he would later put to use as an itinerant calligrapher and teacher of writing.

In this first profession during the 1830s and early 1840s, Easterly traveled extensively throughout upstate New York and Vermont; on occasion he visited towns in New Hampshire near the Vermont border. In 1837, he was working in Burlington, Vermont, where James H. Hill painted his portrait in miniature (fig. 1-1). Clues to his other

Fig. 1-1. *Thomas M. Easterly.* Ink on paper by James H. Hill, 1837. Easterly-Dodge Collection, MHS. Gift of Mrs. Margaret Wing Dodge.

temporary locations during this period come from a framed collection of calling cards that he displayed to demonstrate his talents. Standard commodities of the calligrapher's trade, the cards are inscribed in Easterly's hand with the names and cities of individuals who engaged his services.[4] In larger cities such as Burlington, Vermont, advertisements for his services as a "Teacher of Writing and Penmanship" ran for two- to three-week periods (fig. 1-2).[5]

In 1839, the calligrapher settled temporarily in Brattleboro, Vermont, where he purchased property that year. Though he continued his itinerant practice during this period, he also left tangible evidence of his professional activities in the Brattleboro community. Receipts issued to local residents in 1840 record charges of three dollars per "term" for "Instructions in Writing" (fig. 1-3). Sometime in the early 1840s, Easterly designed a single-page illustration of the fundamentals of calligraphy, a project intended to supplement his income and assist in the instruction of his students. He traveled to Albany, New York, to have his "Elements of Writing" (fig. 1-4) reproduced by Rawson Packard, an engraver who worked in Albany until 1845.

In shifting his focus from calligraphy to photography, Easterly was following a pattern that was not uncommon. Teaching penmanship was also the first career of such well-known figures in early photography as Marcus Root and A. J. Russell, along with numerous less illustrious practitioners. While the end products of the two professions were quite different, both were practical arts that combined technical skill with a measure of artistic talent. At the popular agricultural and mechanical fairs of the period, "ornamental penmanship" displays often appeared alongside exhibits of daguerrean art. With an ever-increasing market for the products of the camera, compared to a more limited demand for instruction in writing, it is not surprising that calligraphers would adapt their skills to a potentially more profitable calling. Many engravers took up the practice of daguerreotypy for the same reason.

Easterly would continue to employ his calligraphic skills throughout his career as a photographer. With the same dexterity that he demonstrated in his penmanship, he used the engraver's tool to add the personal touch of a signature to the inherently impersonal character of the daguerreotype's pristinely polished surface.

Few of his colleagues showed the same interest in providing such an indelible reminder of their role in the picture-making process. To set their works apart from the anonymous productions of the "cheap operators," most ambitious daguerreans provided cases or mats stamped or embossed with the name of the studio or photographer. As time has shown, this practice did little to insure a

THOS. M. EASTERLY.

TEACHER of Writing and Penmaking wishes respectfully to inform the citizens of Burlington, that he has taken the room over Mr. Lovely's Store, which he formerly occupied as a Writing Academy, where, at such hours as may best suit the convenience of his pupils, he will impart all the instruction which eight years of study and experience as a teacher of writing, have enabled him to acquire.

In short, as a teacher of penmanship, he will faithfully discharge his duty.

N. B. Mr. E. desires immediate application, as he wishes to form classes to attend at stated hours.

Ladies waited upon at their residence, where a class of five or eight will meet at the same hour.

For further information inquire at the Book store, or at the Burlington Hotel.

June 13, 1838.

Fig. 1-2. *Advertisement from the* Burlington *(Vt.)* Free Press, *22 June 1838.* Vermont State Library.

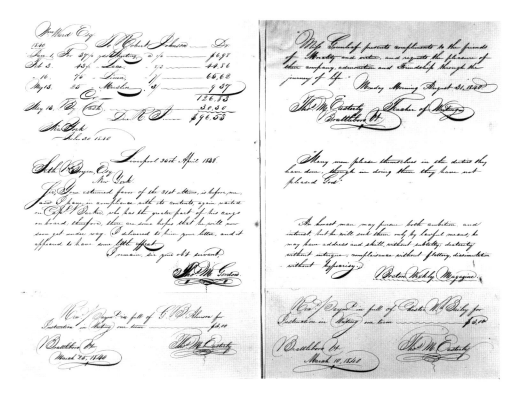

Fig. 1-3. *Calligraphy by Thomas M. Easterly, c. 1840.* Easterly-Dodge Collection, MHS. Gift of Mrs. Margaret Wing Dodge.

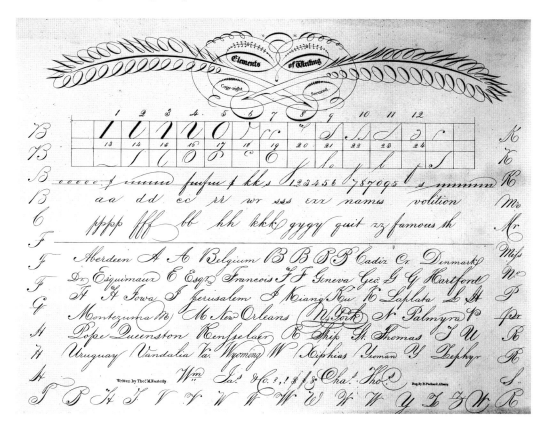

Fig. 1-4. *"Elements of Writing."* Engraving after Thomas M. Easterly, c. 1840. Easterly-Dodge Collection, MHS. Gift of Mrs. Margaret Wing Dodge.

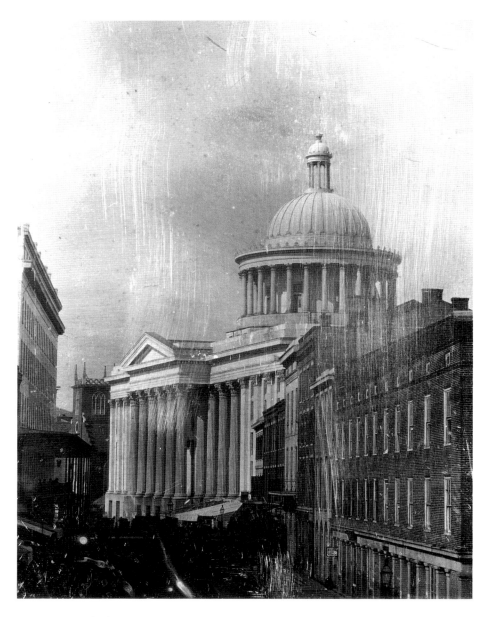

Fig 1-5. *St. Charles Hotel, New Orleans.* Half plate, c. 1845. MHS.

permanent record of authorship, since mats and cases were easily exchanged or discarded. Although Easterly sometimes identified his work with a mat embossed with the words "Easterly" and "Artist," he frequently preferred a more prominent and durable means of documenting his presence behind the camera. By inscribing his signature directly on the surface of the plate, he was guaranteed a lasting record of his accomplishments. Few gestures more vividly reveal his desire to affirm his identity as an artist.

In 1841 Easterly gave up his property near his hometown in Vermont. His activities during the next three years and the events that generated his interest in photography remain largely a mystery. Our only clue to where he might have learned the new art of daguerreotypy appears in an 1846 advertisement which notes an earlier "connection with a large establishment in New York."[6] Based on this reference, we can speculate that Easterly's introduction to Daguerre's process may have taken place in Albany or possibly in New York City.

We do know that Easterly spent time in Albany during the early 1840s while overseeing the printing of his "Elements of Writing." In early 1841 and again in late 1843, the *Daily Albany Argus* noted that the local post office was holding letters for T. M. Easterly.[7] While he was there, residents of that city saw their first daguerreotypes when T. H. Cushman, later joined by E. N. Horseford, opened the earliest "miniature gallery" in the city in January 1841. In April, the partners were offering instructions in "Taking Portraits and Landscapes with the Daguerreotype."[8]

By 1843, the Meade brothers, who would soon rank among America's most prominent daguerreans, were also established in Albany.[9] Like Horseford, Cushman, and most pioneers in the field, the Meades were quite willing—for a price—to share the secrets of their methods. Given the high quality of Easterly's early work, it seems likely that he received his instruction from a relatively accomplished technician and may well have been among the Meades' first pupils. If Albany was not the site of Easterly's initiation into his new profession, it may have been New York City, where any number of able daguerreans could have provided excellent guidance.

While we may never know the source or site of Easterly's tutelage in the new mode of picture-making, we can assume that he was making daguerreotypes by 1844, when, by his own account, he left New York City, traveling to New Orleans aboard the steamer *Mississippi*.[10] Evidence that he worked with the camera during this sojourn appears in an 1846 advertisement that refers to his "specimens" made "two years earlier in a southern climate."[11] Those "specimens" probably included his daguerreotype of the magnificent St. Charles Hotel in New Orleans (fig. 1-5), the only known photographic image that shows the hotel before

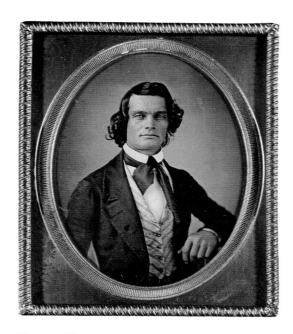

Fig.1-6. *Thomas M. Easterly.* Sixth plate, possibly a self-portrait, 1845. MHS. Plate inscription: 1845

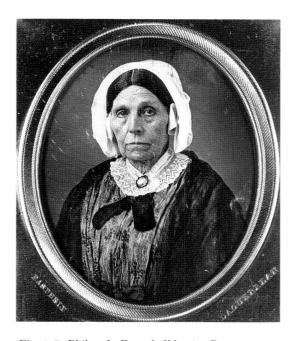

Fig. 1-7. *Philomela Easterly Wearing Daguerreotype Brooch.* Sixth plate, 1854. MHS.

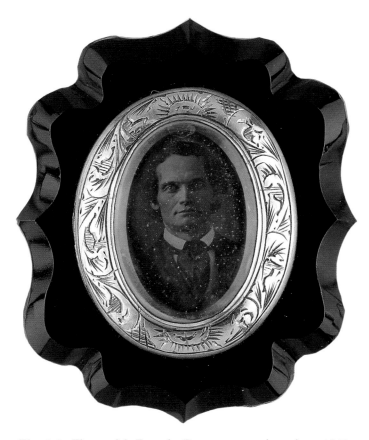

Fig. 1-8. *Thomas M. Easterly.* Daguerreotype brooch, c. 1845. Courtesy of Mrs. Alice Dodge Wallace.

its massive dome was destroyed by fire in 1850. This plate is also the only located evidence of Easterly's activities "in a southern climate." As yet, no advertisements or other records have been found to indicate the length of his stay in New Orleans or the extent of his travels in that area. If we accept his date of 1845 for several extant eastern views, we can conclude that his first journey west was relatively brief. He may have spent the winter months in the South, returning to Vermont in the spring of 1845. It was probably at this time, perhaps during a visit with his family in the Brattleboro area, that he made his romantic scenic views of the Winooski and Connecticut rivers. Judging from Easterly's handsome portrait inscribed "1845" (fig. 1-6), we can imagine that the thirty-five-year-old New Englander presented a dignified and impressive figure to those who watched him set up his camera. His face also appears in a daguerreotype, which he made several years later (fig. 1-7); it pictures his mother wearing a brooch set with another early portrait of her son (fig. 1-8).

Easterly obviously found travel on the frontier appealing, since he soon returned to the West, probably in the summer of 1845. On a much more extensive journey, he traveled up the Mississippi, appearing in Iowa in the fall of 1845. The first written evidence of Easterly's presence in this region appears in the *Davenport Gazette* on October 30, 1845. Easterly and a partner, Frederick F. Webb, advertised their services to local residents as representatives of the Daguerreotype Art Union and Photographic Association. Prior to his appearance in Iowa, Webb had been working in Galena, Illinois, as an agent for the same association.[12] Over the next few weeks, similar advertisements appeared in other Iowa newspapers, indicating that Easterly was once again following the itinerant lifestyle that had characterized his earlier career as a calligrapher.

The advertisements that establish locations for the partners during the fall of 1845 also provide clues to their links with the eastern photographic establishment. While Easterly and Webb were traveling from town to town, like scores of other pioneer photographers who served America's more provincial markets, they were probably more sophisticated in the practice of their profession than the average itinerants of the time. In publicizing their credentials, the partners emphasized their affiliation with the Daguerreotype Art Union, a group that unfortunately left few other records of its existence. These announcements indicate that the Union was "instituted by the most eminent Artists in the United States," with representative galleries in Boston, New York, Philadelphia, and New Orleans.[13] Since Easterly and Webb note their "connection to a New York establishment," it is possible that New York City was the base of operation for the association's enterprise.

While the partners' advertisements were vague about the origins of the Union, they offered more specific information as to its goals, which suggest that a shared concern to develop the artistic potential of photography was operative in America at a very early date. The name of the organization in itself reflected the ambitious aspirations of its founders.

Identification with an art union, a well-known institution in American society by the 1840s, carried with it explicit associations with the older fine arts. The New York-based American Art Union, which spawned a plethora of similar organizations on the regional level, was instituted in 1844 to expand patronage for works of native painters and printmakers and to increase public participation in the arts. It is unlikely that the Daguerreotype Art Union held lotteries to distribute works, a practice basic to the function of the older art unions. However, in its goal to aid in "the diffusion of a

refined taste" among patrons, the Union was in line with its model institutions in the fine arts community. Assuming a function that would later be appropriated by more enduring photographic societies and journals, the Daguerreotype Art Union, through the example of works by daguerreans like Easterly and Webb, was intent on "discountenancing unskilled operators" whose "disreputable influence" countered serious efforts to elevate their medium to a respected art form.[14]

The eastern itinerants may have done much toward accomplishing these goals in frontier communities such as Davenport, Iowa, which had probably hosted few experienced daguerreotypists at this early date. In announcing the various openings of their "Photographic Depot and Daguerrean Miniature Gallery," Easterly and Webb were quick to point out their superior qualifications: "Very few of the operators traveling in this country understand the business in all its branches, but in consequence of our being connected with a large establishment in New York, we are enabled to get all the new improvements as fast as made."[15] Their ability to provide "exquisite colored" pictures in "10 to 25 seconds," two features that the visiting daguerreans claimed to introduce to the more remote frontier patrons, was a demonstrable measure of their knowledge of "new improvements" in the art.[16]

Easterly and Webb were also proficient in the process of gilding the finished picture with a solution of gold chloride, as they indicated in an advertisement placed in the Liberty, Missouri, *Weekly Tribune* in the summer of 1846 (fig. 1-9).[17] While their suggestion that gilding would insure the permanency of the delicate images under any circumstances was a slight exaggeration, the introduction of that procedure in 1840 had constituted a major technical advancement in the art.[18] Carried out after the image had been developed and fixed, the gold chloride bath heightened the contrast of tones in the picture and, to an appreciable degree, did increase the mechanical strength of the image.

In their application of the gilding bath, Easterly and Webb promoted the technique as a new means of stabilizing the image surface to accommodate hand coloring with powdered pigment. They suggested that "by the new process, the face, dress and jewelry can be colored, and by the old they cannot be touched with the finest pencil without injury."[19] While no Easterly plates made during his itinerant period in the West have yet been identified, his later portraits—superlative examples of both gilding and subtle tinting techniques—suggest that his performance justified the claims of sophistication he made in his early advertisements. Webb, unfortunately, left no records to indicate what skills he contributed to the partnership.

DAGUERREOTYPE ART UNION:

FOR mutual protection against the low prices and disreputable influence of inexperienced and unskillful operators; the diffusion of a refined taste for superior daguerreotype pictures, and the taking of daguerreotype miniatures at the LOWEST NEW YORK PRICES, as charged at any respectable gallery in the eastern cities.

Miniatures, copies of engravings, &c., of the most approved styles and greatest excellence, taken in 5 minutes, in all weather from 9 o'clock A. M., to 5 o'clock P. M. The public are invited to call and see the specimens of distinguished statesmen, eminent divines and prominent citizens, which will always be found at their rooms.

A Detachment of the association, under the charge of Messrs. EASTERLY & WEBB, may be found at their room in the Court-House for a short time for taking miniatures of individuals and groups; copies of engravings, family portraits, &c.

An impression seems to have gone abroad that these pictures will fade, which is true in relation to miniatures taken previous to the discovery of gilding with chloride of gold. The discovery was made by Professor Morse, (inventor of the Electro Magnetic Telegraph) who has done more towards bringing out the late improvements in Daguerreotype than the inventor himself. By this new mode of finishing, the picture is wholly excluded from atmospheric action and cannot change, nor can the impression be rubbed off with the finger, while those taken by the old process can, as we will show any person who has doubts on this subject. Furthermore, by the new process the face, dress and jewelry can be colored, and by the old they cannot be touched with the finest pencil without injury. We gild all our pictures and will warrant them to stand in any climate. Many of our specimens have been hanging in the open air exposed to the sun in a Southern climate for the last two years, and no change has taken place, a convincing proof that neither atmosphere, light, nor time can efface them when properly finished. Very few of the operators travelling in this country understand the business in all its branches, but in consequence of our being connected with a large establishment in New York we are enabled to get all the new improvements as fast as made.

The citizens of Liberty and vicinity are invited respectfully to call and examine our numerous specimens of this wonderful and delightful art.

N. B. Thorough Instructions given on the most liberal terms.

Liberty, July 11, '46.

BOONVILLE, May 1st, 1846.

Messrs. BENSON AND GREEN:—Dear Sirs: As Messrs. Easterly and Webb, who have been sojourning in our city, a short time, in the capacity of Daguerrian Artists, are about to visit your place I would recommend them to such of your community as may wish to have likenesses taken by this new and beautiful process. A large number of pictures have been taken here and I have heard no complaint of bad likenesses or defective pictures. I believe these gentlemen understand their business perfectly and are honest enough not to suffer a defective likeness to go from their hands if they can avoid it. As the world is full of humbugs I have thought it but sheer justice to these gentlemen to contribute this testimonial of their superior qualifications. Yours truly, J. L. TRACY.

Fig. 1-9. *Advertisement from* Liberty (Mo.) Weekly Tribune, *11 July 1846.* State Historical Society of Missouri.

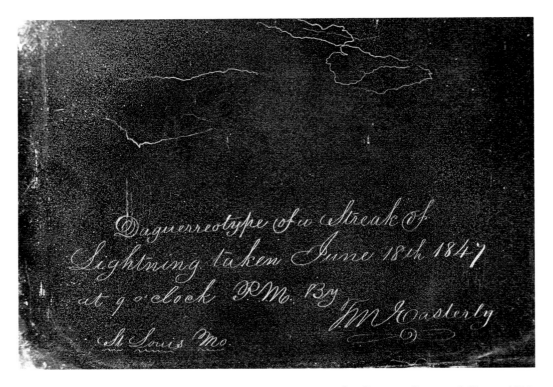

Fig. 1-10. *Streak of Lightning.* Photograph of daguerreotype by Cramer, Gross and Co., c. 1880. MHS. Plate inscription: Daguerreotype of a Streak of Lightning taken June 18th 1847 at 9 o'clock P.M. By T.M. Easterly St. Louis Mo.

Although Easterly and Webb may have viewed their trip to Iowa as an opportunity to introduce high-quality daguerrean art to a relatively uninitiated segment of the frontier population, the timing of their arrival in Davenport in late October 1845 suggests that a newsworthy event inspired their visit to that city. On July 4, 1845, the popular and respected Colonel George Davenport was robbed and murdered on his island farm near the town that he had been instrumental in founding a decade earlier. Several weeks later, Granville Young and two brothers, John and Aaron Long, were apprehended and convicted of the murder. Their execution by hanging, which drew a crowd of more than three thousand spectators, took place on October 29 at Rock Island, Illinois, a city directly across the Mississippi River from Davenport. On October 30, the Rock Island *Mississippian and Republican* reported under the heading "LIKENESSES OF JOHN AND AARON LONG, AND GRANVILLE YOUNG": "We never saw more complete likenesses than those taken of the above named convicts by Messrs Easterly and Webb. They tarry at the LeClair House in Davenport for four days only."[20] Several days later, the *Burlington Hawkeye*, in an article announcing Easterly and Webb's upcoming visit to that city, noted that the partners had recently been "at Rock Island for the purpose of taking the likenesses of the murderers of Col. Davenport."[21] All reports agreed that the partners had "secured splendid likenesses" of the criminals.

If Easterly and Webb recognized a rare opportunity to preserve a moment of history in daguerreotyping Davenport's murderers, they were also fully aware of the commercial potential of such images. The faces of the Iowa fugitives undoubtedly became featured attractions among the portraits of "notorious robbers and murderers" displayed in Easterly's St. Louis gallery. At present, the "splendid likenesses" of Young and the Long brothers have not been located. While it is provocative to imagine that these images are among the unidentified subjects in the Missouri Historical Society's collection of Easterly works, we have no surviving portraits of these individuals to provide a basis for identification.

After their stay in Davenport, Easterly and Webb retraced their earlier route, traveling southward on the Mississippi with a brief stopover in Burlington, Iowa. The *Burlington Hawkeye* reported that the daguerreans' "stay in this Town will be short in consequence of engagements elsewhere."[22] By early May 1846, the photographers had traversed half the state of Missouri to set up temporary quarters in the river town of Boonville.

They moved further west along the Missouri River arriving in mid-July in Liberty, Missouri, where the *Weekly Tribune* carried an advertisement for the opening of their Daguerreotype Art Union Gallery. In a separate article announcing their arrival, the editor of the *Tribune* directed readers' attention to a letter of endorsement that accompanied the daguerreans' advertisement. In the editor's view, it was a worthy commendation coming from a highly respected Missouri citizen who "would scorn to give utterance to any thing but what was true."[23] Commenting on the earlier performance of the "Daguerrian Artists" in his home city of Boonville and the "large number of pictures" they had made there, J. L. Tracey concluded his endorsement:

> I believe these gentlemen understand their business perfectly and are honest enough not to suffer a defective likeness to go from their hands if they can avoid it. As the world is full of humbugs I have thought it but sheer justice to these gentlemen to contribute this testimonial of their superior qualifications.[24]

It is likely that Easterly and Webb remained in the Liberty-Kansas City area over the winter of 1846-47. Probably in early spring, when steamboat operations resumed, they began their journey back down the Missouri River to return to more eastern sectors of the frontier territory. At some point during this period, Easterly and Webb dissolved their partnership. They may have parted company when their steamboat made its stopover at Jefferson City, Missouri, where Webb worked for a time in 1847.[25] Easterly, apparently deciding to try his luck going it alone in a more populous market, traveled on to St. Louis where he opened a gallery at 112 Glasgow Row. The daguerrean's break with Webb also appears to mark the end of his association with the Daguerreotype Art Union, since no reference to this affiliation appears in any of his later advertisements.

While local newspapers did not announce the opening date of Easterly's gallery, he was definitely working in St. Louis by the middle of March when the famous Keokuk and his retinue of Sauk and Fox Indians appeared in the city. Easterly's remarkable series of studio portraits recording the members of Keokuk's entourage was made shortly after the group's arrival on March 23. A plate picturing Appanoose (fig. 3-14), whose presence in the party was noted in the press, bears the engraved inscription "T.M. Easterly Daguerrean, St. Louis Mo. 1847." Easterly's fruitful encounter with Keokuk and his tribesmen, producing some of the earliest known camera-made pictures of Native Americans, represents the

beginning of one of the most fascinating series in the history of daguerrean art.

As a demonstration of his skills and of the unparalleled veracity that marks a well-executed daguerreotype image, Easterly's display of Indian portraits at his Glasgow Row gallery surely provided persuasive evidence that this newcomer was a cut above his local competitors. His technical expertise and his desire to demonstrate the miraculous recording powers of his medium brought him further attention the following July when he succeeded in daguerreotyping a streak of lightning. Under the heading "Astonishing Achievements in Art," the *Iowa Sentinel* reported "the success of Mr. T. M. Easterly of St. Louis" in securing a permanent record of this natural phenomenon.[26] While the original plate—signed and engraved with the June 18, 1847 date—has disappeared, a later cabinet card copy by Cramer, Gross & Co. (fig. 1-10) documents Easterly's exceptional skill in a process generally thought to preclude such instantaneous impressions.

Easterly stayed on in St. Louis for several months. In a notice that appeared in the *Missouri Republican* on August 19, the daguerrean offered his "sincere thanks to the public for the very liberal patronage extended to him in his profession during his residence in this city." That expression of gratitude followed the report that "Easterly being about to leave for the east" had "disposed of his interest" to his former partner, Frederick Webb, and a Mr. Irwing, who would be taking over his establishment at the Glasgow Row location.[27] The Irwing-Webb association was apparently short-lived, since an announcement in late fall 1847 reported that the "newly-widowed" Mrs. Irwing had assumed operation of her late husband's practice.[28] Webb presumably left the area since there is no further mention of his presence in St. Louis.

If Easterly returned east in the fall of 1847, he did not remain there long. In February 1848, John Ostrander, the longest-established daguerrean in St. Louis, announced that T. M. Easterly, "a man well-known as being a skillful and successful operator," would take charge of his Miniature Gallery at the corner of Fourth and Olive streets while Ostrander made an extensive "tour in the south."[29] The temporary arrangement became permanent when Ostrander died in May 1849, shortly before his scheduled return to St. Louis.

Easterly's decision to continue his practice in the gallery at Fourth and Olive streets was not surprising. After more than a year in the thriving river city, he had established a successful business and had also confirmed his position as a leading daguerrean in the community. At the Mechanics Institute exhibit in the spring of 1848, he had received the first premium award for the excellence of his pictures.[30]

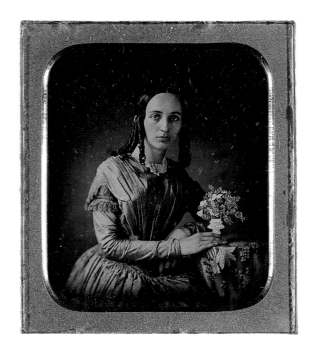

Fig. 1-11. *Anna Miriam Bailey*. Hand-colored sixth plate, c. 1848. Easterly-Dodge Collection, MHS. Gift of Margaret Wing Dodge.

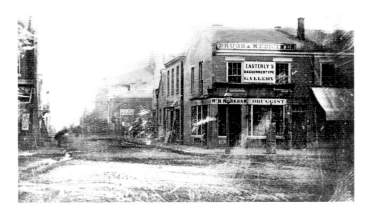

Fig. 1-12. *Easterly's Gallery, Fourth and Olive Streets*, c. 1849. Photograph of daguerreotype, MHS.

We can also guess that Easterly, who was then nearly forty years old, may have gained a new appreciation for a more permanent lifestyle. A young woman who visited his gallery not long after his arrival in the city may have been another important consideration in his decision to settle permanently in the West. The daguerrean would marry Anna Miriam Bailey, pictured in one of his most lovingly embellished portraits (fig. 1-11), in the summer of 1850.

Easterly soon became a familiar face in the prosperous and growing levee town, maintaining his gallery on Fourth Street for nearly two decades. Early in his career at that location and again in 1853, he pictured the facade of his well-known establishment (figs. 1-12, 1-13), which today would be only a stone's throw from the famous St. Louis Arch. Easterly's window offered a bird's-eye view of the heart of the bustling commercial district and he became a keen observer of his adopted city. More than a decade before a developing commercial market for camera-made views sent photographers scouring the American scene, he showed an enduring preoccupation with illustrating the character of his urban environment. While he devoted considerable time and effort to building an extensive collection of outdoor views, he gave equal attention to the more customary activities of his trade. As was the case for all daguerreans, portraiture was the bread and butter of Easterly's practice. We can assess his success in the competitive likeness-making business by the number of civic leaders and visiting luminaries whose faces appear among his surviving works.

St. Louis, with its rapidly growing population and steady stream of travelers arriving daily at the levee, was a haven for a host of pioneer photographers whose ambitions and personalities would set the tone of Easterly's professional milieu. In the early years of his career in St. Louis, before the demands of a more experienced and discriminating clientele brought greater consistency to the practice of daguerreotypy, Easterly contended with this diverse and frequently changing circle of practitioners, whose opportunistic instincts were often better developed than their pictures.

Itinerant operators began making brief stopovers in the city by 1841.[31] Offering no guarantees as to the quality of their work, the visiting "professors" of the new art, as they were often described, generally set up their equipment in the parlor of a local boardinghouse. The Cleveland daguerreotypist James Ryder, who left an interesting and detailed account of his early experiences as an itinerant, provides a vivid picture of the difficulties faced by those hearty souls whose process was still in many ways as much a mystery to them as it was to their public:

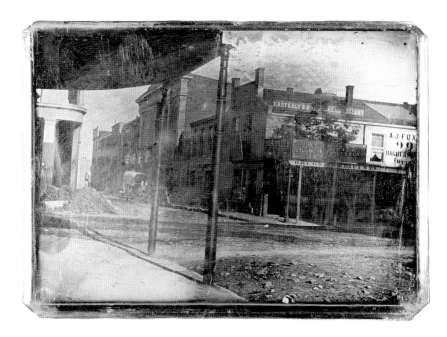

Fig. 1-13. *Easterly's Gallery, Fourth and Olive Streets.* Quarter plate, 1853. MHS.

In the first few years most practitioners were plodding in the dark, something like "the blind leading the blind." There was no literature bearing upon the subject beyond the mere statement of routine description, no sure road yet opened to successful work. "Professors" were more plentiful than intelligent teachers. In our work repeated trial was the rule—we would try and try again without knowing the cause of failure. Many a day did I work blindly and almost hopelessly, pitying my outraged sitters, and pitying myself in my despair and helplessness. The weak excuses and explanations I made to cover my ignorance were many. The lies I told, if recorded, would make a big book which I would dislike to see opened. "*You moved!*" headed the list. "You looked too serious!" "You did not keep still!" "You winked too often!" These and other fabrications to show the necessity for another sitting were made with great efforts at cheerfulness, but the communings with my inner self in the dark room while preparing the next plate would hardly bear the light, and were best left in the dark.[32]

John Ostrander, who was apparently more practiced than Ryder in securing acceptable images on the silver plate, had been among the first daguerreotypists on the frontier to make an enduring commitment to the business. In 1842, he opened the first permanent gallery in St. Louis. Five years later, when Easterly opened his first rooms on Glasgow Row, the daguerreotype process was widely acknowledged as a "marvelous benefit to society," but the role of its practitioners as productive and legitimate professionals was still not firmly established, especially within the more rapidly growing population in the West.

Less numerous than their male counterparts, several females were among his first competitors in St. Louis. Caroline Hospes, who for several years had taught drawing and painting in the city, had already added the new chemical-mechanical process to the list of services available at her Market Street studio in 1846. The following year Mrs. Irwing, who had probably assisted her husband in their business, established her own practice at the same location after his death. Daguerreotypist J. Maria Dinsmore also joined the local competition with a brief effort to capture a portion of the area market for likenesses.[33]

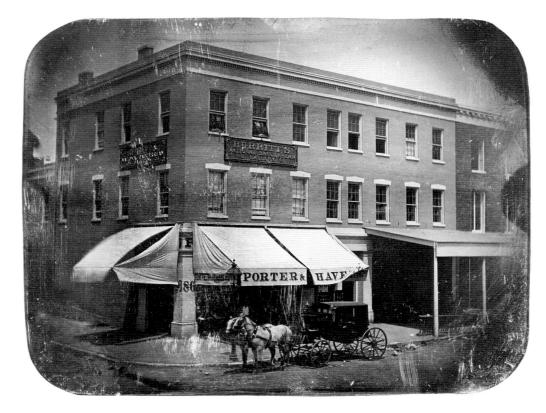

Fig. 1-14. *Burritt's Gallery, Fourth and Olive Streets.* Half plate, c. 1851. MHS.

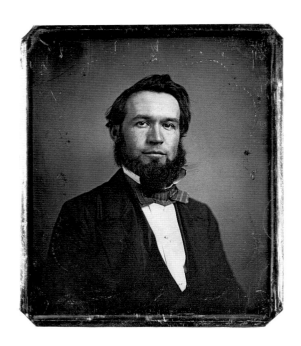

Fig. 1-15. *Enoch Long.* Sixth plate. MHS.

By 1850, when at least a half dozen portrait galleries and several photographic supply dealers had become permanent fixtures in the commercial sector of the growing city, itinerants of the trade increasingly found it more profitable to operate in smaller towns where there were fewer—and generally less competent—competitors. By the same year, the hierarchy within the ranks of local daguerreans was also becoming more firmly established.

In separate and apparently unsolicited reviews published in 1850, a writer for the *Reveille* singled out four local daguerreotypists for special recognition: E. Burritt, Enoch Long, John Fitzgibbon, and Thomas Easterly. Of these leading photographers, only Easterly left a body of work to substantiate the accuracy of the writer's appraisal.

As a reflection of contemporary attitudes toward the prerequisites for success in the business, it is worth noting the attributes deemed worthy of the *Reveille*'s attention. When John Ostrander died in 1849, E. Burritt became St. Louis' senior photographer. Burritt had opened the "New Daguerreian Saloon" on Market Street in 1846. He later set up practice on the northwest corner of Fourth and Olive, where Easterly recorded the new establishment from his gallery window (fig. 1-14). In the *Reveille*'s assessment, it was Burritt's camera—"one of the best in the west"— rather than the quality of his productions that seemed to be

his most important credential.[34] The same writer praised Burritt's competitor, Enoch Long, for the superiority of "his instruments," which in conjunction with "his extended experience," provided pictures to "compare with those of any similar establishment in the west."[35]

Long may have deserved a more enthusiastic endorsement, since he was among the most serious and successful daguerreans in the region. With his older brother Henry, he had learned Daguerre's process in 1842 while working with Robert Cornelius, one of Philadelphia's earliest and most respected pioneer photographers. After a brief tenure making pictures in Augusta, Georgia, the brothers established a St. Louis practice in the fall of 1846. Enoch Long, pictured in Easterly's portrait of about 1850 (fig. 1-15), continued the business after his brother's death in 1851, and during a lengthy career he remained one of the most progressive photographers in the West. He was the first in the region to employ a steam engine to polish daguerreotype plates, and in 1858 he introduced St. Louisans to photographic enlargements made with a solar camera.[36]

Long was also eager to gain respect both for the quality of his own work and for the artistic potential of his medium. He advertised that his pictures would "bear the strictest criticism, both as a likeness and a work of art."[37] In 1853, along with John Fitzgibbon, Long represented St. Louis at the Crystal Palace display of daguerreotypes in New York, where his portrait entries earned an honorable mention. Three years earlier and again in the company of Fitzgibbon, Long was named in one of the early issues of the *Daguerreian Journal*, America's first publication devoted to the new graphic medium, as an important figure in one of the "distant branches" of the "Daguerreian Beehive."[38]

Long's efforts to achieve recognition outside his own community were modest compared to those of John Fitzgibbon, who opened his St. Louis "Gallery of Daguerreotype Miniatures" in 1846. In his ongoing advertising campaigns, Fitzgibbon vowed to "let no establishment in the West surpass him."[39] His diligence in living up to that claim brought him considerable notice from the eastern photographic establishment. Like many

Fig. 1-16. *Bryan and Helen Clemens.* Hand-colored quarter plate, John Fitzgibbon Gallery, c. 1855. MHS.

significant figures from the daguerrean era, Fitzgibbon was an energetic, gregarious, and highly proficient entrepreneur. In eastern circles, he ranked as the profession's most visible and accomplished representative in the West. H. H. Snelling, who as editor of the *Photographic Art Journal* contributed significantly to Fitzgibbon's high profile in the national photographic community, described him as "the prince of good fellowship," a commendation that played more than a minimal role in securing his wide reputation.[40] Fitzgibbon frequently corresponded both with Snelling and S. D. Humphrey, editor of the *Daguerreian Journal*. In his informal role as western correspondent for these publications, he reported on daguerrean activities in his region. Because of his amicable relationship with some of the most important professionals of his time, which he maintained through frequent trips East, Fitzgibbon, along with such notables as Humphrey, Albert Southworth, and Marcus D. Root, was elected in 1851 as a vice-president of the newly organized American Daguerre Association. Fitzgibbon also promoted his reputation through a series of articles on "Daguerreotyping Simplified" that appeared in the *Western Journal and Civilian* in 1851. With such impressive credentials, it is not surprising that the St. Louis *Reveille* referred to its hometown talent as the "far-famed Fitz."[41]

The versatile Fitzgibbon also gave his community more tangible proof of his success in the business of picture-making. In 1851, his eight-room establishment, "fitted up in a princely style," matched the similarly ambitious tone of his advertisements. With the aid of six assistants he proposed to deliver "the fastest pictures in the city" and, for more affluent patrons, "the largest size pictures taken in the United States."[42] A boldly colored but otherwise lackluster double portrait (fig. 1-16), bearing a Fitzgibbon Gallery imprint, may have been made by one of the many "operators" who appear to have been actively involved in all aspects of the daguerrean's business.

In all departments, Fitzgibbon epitomized the enthusiastic and aggressive impresarios who quickly assumed leadership in one of America's most competitive vocations. While Fitzgibbon's ambitious activities and professional involvements provide a distinct profile of his personality and entrepreneurial talents, we have a remarkably sparse record of his skills in the practice of his craft. Although contemporary accounts emphasize his prodigious production during the early 1850s, fewer than a dozen plates in the Missouri Historical Society's extensive daguerreotype collection are housed in Fitzgibbon Gallery cases.

Along with his own work, Fitzgibbon regularly duplicated and exhibited plates made by other daguerreotypists. In one of his most substantial attempts to remain "unsurpassed" by his competitors, Fitzgibbon acquired a collection of three hundred California views by the San Francisco daguerrean Robert Vance. The Vance plates had attracted considerable attention when they were exhibited in New York in 1851. At the close of the exhibit, the collection was purchased by Jeremiah Gurney, a leading New York daguerreotypist, who later sold it to Fitzgibbon. In January 1854, the *Missouri Republican* reported that Fitzgibbon's gallery featured a display of "Vance's Panoramic Views of California."[43] By April he began a series of "Gas-Light Exhibitions" with his rooms "lit up at night to show his collection of Pictures and California Views."[44] With the purchase of the California views, Fitzgibbon declared that his gallery display, "the finest in the U.S.," was valued at ten thousand dollars.[45] The fate of the Vance collection, which could be seen in 1856 alongside mummies and other curiosities at the St. Louis Museum, remains unknown.[46]

In Fitzgibbon's home territory, only Easterly's Fourth Street establishment displayed a similarly diverse and ambitious—if more modestly scaled—exhibit. Since Easterly and Fitzgibbon shared a range of aspirations and skills that set them apart from their local competitors, the rivalry between them may have exceeded even the standard spirit of lively competition that characterized their occupation as a whole.

Surprisingly, Easterly showed no interest in vying with Fitzgibbon for national recognition. Indeed, given his confidence in the superior quality of his work and the pride that he took in his professional stature in St. Louis, the limited scope of his reputation during the daguerrean era is one of the most puzzling aspects of his career. Only once during this period is he mentioned by the editors of a major photographic journal. In January 1853, *Humphrey's Journal* (previously the *Daguerreian Journal*) reported without elaboration: "T. M. Easterly, of St. Louis, is the gentleman who Daguerreotyped a streak of lightning. We saw that impression during our visit to that city last summer."[47]

Perhaps Easterly's personality, as well as his competitive relationship with Fitzgibbon, contributed to his failure to gain wider recognition. Numerous clues in Easterly's personal and professional life indicate that he was a quiet-mannered, introspective man who had greater insight into the aesthetic possibilities of picture-making than into the exigencies of a commercially successful enterprise. His creative temperament and sensitivity to his subjects confront us most prominently in the pictorial strength and expressive character of his portraits. The poetic side of Easterly's disposition is also reflected in several early New England views that give visible form to

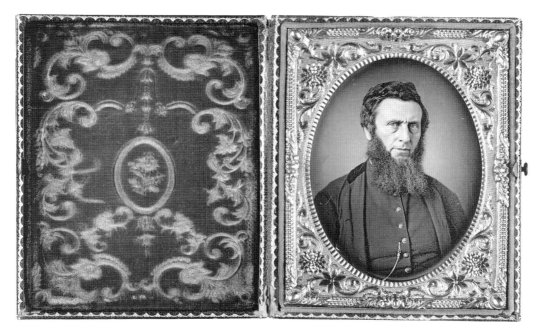

Fig. 1-17. *Dr. Norton Strange Townshend.* Quarter plate, c. 1865. Courtesy of Alice Dodge Wallace.

his romantic attachment to nature and in his candid expression of those emotions in verses engraved on views of Niagara Falls and the Connecticut River. On a more private occasion, when Easterly announced his feelings to the young woman who would later become his wife, he fully disclosed the depth of his romantic temperament. Written in 1849 or 1850, Easterly's note to Anna Miriam Bailey accompanied a small pear-shaped natural crystal that he had found some years earlier while visiting Trenton Falls, a popular tourist site near Utica, New York. His creative proposal was expressed in characteristically tender Victorian prose:

> Seven long years have elapsed since I first saw (at Trenton Falls,) this beautiful crystal. It lay half concealed in earth, as one alone. Its beauty and purity attracted my attention. A smaller one of equal worth adheres to the larger one. I called it an emblem of kindred spirits mingling together, and vow'd to present it to the first lady I fondly loved, if such an [*sic*] one I should ever chance to meet. It falls to you—If the feeling be reciprocal, keep the gem as emblematic of the purity of our affection. If not, separate the smaller from the larger, and return the broken fragments as a token of my last fond hope crushed forever—
>
> Ever Yours[48]

Easterly's close personal relationships and lifestyle indicate that he was a reflective and essentially private person, whose interests focused on artistic and intellectual pursuits. His circle of friends and supporters in St. Louis included Edward Wyman, principal of the English and Classical High School, and the painters A. J. Conant, Ferdinand Boyle, and Manuel De Franca. His tender relationship with his handsome, well-educated wife is reflected time and again in his many portraits capturing her dark exotic beauty and dignified demeanor.[49] Like her husband, Anna Miriam Easterly, known as Miriam to her friends and family, appears to have preferred the company of a small group of close friends and family members or the companionship of a book to a wider and more active social circle. The couple apparently had no connections to civic or social organizations. Since they had no children, Miriam's daily life revolved around her husband and caring for his needs. She spent her free time reading within a remarkable range of subjects from philosophy to exotic travel accounts.[50] Her brother-in-law, Dr. Norton Townshend (fig. 1-17), who found Miriam's passionate "taste for reading" quite admirable and in keeping with her shy personality, once said of her that he had "seldom found a person so thoroughly enquiring."[51] Although Townshend was less specific about his brother-in-law, his respect for Easterly suggests that the daguerrean shared his wife's studious "enquiring" nature and diverse intellectual interests.

ROOMS, 103 FOURTH STREET,

(Corner of Olive,)

SAINT LOUIS, MO.

AMONG HIS SPECIMENS MAY BE SEEN LIKENESSES OF

Distinguished Statesmen, Eminent Divines, Prominent Citizens, Indian Chiefs, and Notorious Robbers and Murderers.

—ALSO—

Beautiful Landscapes, Perfect Clouds, and

A BONA FIDE STREAK OF LIGHTNING,

Taken on the night of June 18th, 1847.

To the subscriber, for this rich and rare collection, the *first premium* was awarded by the St. Louis Mechanics' Institute, at the last annual Fair.

Every description of Daguerreotype work done at this establishment on short notice. and in the best possible manner. All whom interest or curiosity may prompt, are respectfully invited to call and examine his work, which will speak for itself.

Fig. 1-18. *Advertisement from* Green's St. Louis Business Directory, 1851, *p. 405.* MHS.

Townshend, who married Miriam Easterly's older sister Margaret in 1851, developed a close friendship with his brother-in-law when he was stationed in St. Louis during the Civil War while serving as medical inspector of the Union Army. The lieutenant colonel's diary and letters to his family in Ohio recounted his daily activities on the frontier. During the periods between tours to military hospitals in adjoining states, Townshend spent much of his leisure time with the Easterlys. His frequent references to the couple are a valuable source of information on the daguerrean's personal life and the circumstances of his career during this period.

The fact that the two men appear to have had much in common in itself says something about Easterly's character. Townshend, who had earlier served in the Ohio state legislature for several years, was not only a sophisticated and compassionate person but also a dedicated scholar, who read daily on a multitude of subjects related to science, philosophy, agriculture, and religion. His comment that he found Easterly to be "a very intelligent" man suggests that his brother-in-law shared at least some of these interests.[52] We can be certain that in the area of scientific matters the two men found common ground for conversation, since Easterly often expressed an interest in science that extended beyond the technical requirements of his vocation. He attended lectures on physiology and other scientific topics, and in the late 1860s, when a large Indian burial mound was excavated in St. Louis, Easterly was among the few residents who recognized the anthropological significance of the event. In at least one instance he actually assumed the role of the amateur scientist. Undoubtedly inspired by the ongoing debate over the reportedly "healthful" effects of drinking the muddy water of the Mississippi River, Easterly carried out his own inquiry on the subject. Shortly after he settled in St. Louis, he began collecting samples of river water to make his own tests of its purity. Years later he reported that his original samples still remained "clear, pure and sweet."[53]

If Easterly's avocational interests imply that he and Townshend shared an intellectual interest in science, the two men may also have had an even more specific connection in regard to Easterly's work with the camera. A Townshend family history relates that in 1840, while spending a year in Paris studying medicine, the young doctor became interested in the newly introduced technique for making daguerreotype pictures. Pursuing that interest, he arranged for an introduction to the inventor, Louis Jacques Daguerre, with whom he reportedly developed a friendship.[54] This interesting coincidence, which gave Townshend firsthand knowledge of the technique as it was originally practiced by its inventor, surely heightened his appreciation of his brother-in-law's accomplishments.

From what we can surmise of Easterly's character, his professional profile in St. Louis seems consistent with his personal values and reserved disposition. In an era and a profession that encouraged bombastic rhetoric and one-upmanship as the advertising standards, Easterly's address to the public was explicit and to the point. Since he firmly believed that a signed work was a gesture of the maker's artistic intentions, it was appropriate that his familiar, eye-catching logo incorporated the signature that identified his plates. Written in his distinctive hand, and displayed boldly against a large black rectangle, the heading "T. M. Easterly, Daguerrean Artist" (fig. 1-18) distinguished his advertisements and his aspirations. Without making extravagant claims, his announcements focused on the skills displayed in his "rich and rare collection" as evidence of what could be expected by those who patronized his studio. He appealed to the popular taste only in the list of subjects he presented to arouse the "interest or curiosity" of the public. Among

the "specimens" on view were likenesses of "Distinguished Statesmen, Eminent Divines, Prominent Citizens, Indian Chiefs, and Notorious Robbers and Murderers." Larger type placed greater emphasis on his "Beautiful Landscapes, Perfect Clouds, and A Bona Fide Streak of Lightning," the inventory of images that most explicitly announced the primacy of his aesthetic interests.

Easterly further implied the high priority that he placed on artistic standards by what he did not include in his advertisements. Seemingly indifferent to the standard promotional tactics of his peers, he made no mention of price or the superior quality or variety of his equipment. If he offered such popular novelties as "mammoth size" pictures or jewelry set with daguerreotype portraits, he made no reference to providing those commodities. Nor did he offer instruction in his craft, an activity that supplemented the income of most proficient daguerreotypists.

Other omissions from Easterly's public announcements are equally revealing. Apparently preferring to reserve his talents for more mature and cooperative sitters, he made no appeal to parents for the opportunity to daguerreotype their children, one of the most profitable and eagerly sought-after markets in his business. At the height of his practice, he also opted to exclude the post-mortem portrait from his advertised repertoire of services. In Easterly's day, making pictures of the deceased was a routine function of the business, and few in the vocation neglected to publicize their willingness to undertake this morbid task. Although he did announce that he provided "every description of Daguerreotype work," which could imply that he accommodated the requests of a bereaved family on occasion, there are no portraits of the deceased among his surviving work, which further suggests that he avoided that activity. Easterly probably concluded that his aesthetic aims required the participation of a more animated and cooperative subject.

During the 1850s, when Daguerre's process dominated the practice of photography in America, Easterly could afford to be less aggressive than some in promoting his business. At the height of his career, an adequate income apparently allowed him to focus his efforts on work that suited his interests and promoted his reputation for excellence. Although it is doubtful that his daily receipts ever rivaled those of Fitzgibbon, Long, or others who operated larger establishments in his city, financial gain was never Easterly's principal motivation, as the difficulties of his later years so dramatically demonstrate. To a man who emphatically announced his ambitions as an artist with the camera, personal satisfaction in his work and the recognition that he received for his efforts were less tangible—but apparently far more meaningful—forms of compensation.

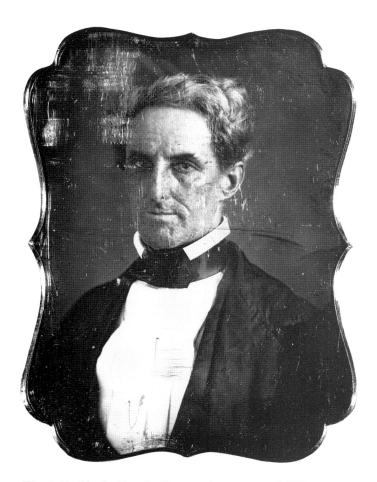

Fig. 1-19. *Charles Keemle.* Quarter plate, c. 1847. MHS.

In the arena of local critical favor, Easterly's rewards were abundant. His record of claiming prizes for daguerrean art at the St. Louis Agricultural and Mechanical Fair went unchallenged well beyond the heyday of his medium. The local press was equally approving of his talents. Charles Keemle (fig. 1-19), the respected editor of the *Reveille*, took a particularly active role in supporting the daguerrean's work. In 1847, when Keemle praised a now-lost engraving that was based on Easterly's striking portrait of James Kirker (Plate 17), he gave considerable attention to the talents of the original author. In Keemle's opinion, Easterly was "the unrivalled daguerreotypist," a view that his newspaper maintained when it published the series of articles on local galleries in the summer of 1850.[55] The *Reveille*'s review of Easterly's establishment concluded: "The enviable reputation of Mr. T. M. Easterly as a Daguerrrean artist, is the best evidence that can be adduced of the perfection of his likenesses. His gallery on Fourth and Olive Streets, is filled with the finest specimens in the west."[56]

Although newspapers are not always reliable sources of information on the merits of early photographers, Keemle and his staff were more discriminating than most in their praise of local talent. There is no evidence that the *Reveille*, widely respected for its combination of news and literary fare, followed one of the common practices of the time, which today often confounds an accurate assessment of our first photographers. Unlike the *Missouri Republican* and other local papers, the *Reveille* did not publish laudatory articles, unsigned and written in the third person, which were actually thinly disguised paid advertisements, authored by the photographers themselves. For these reasons, its 1850 reviews can be regarded as relatively unbiased reports, especially since these commentaries addressed the merits of establishments that did not advertise in the journal.

The *Reveille* was not the only publication in the region to note Easterly's achievements at the height of his career. In 1852 the *Western Journal and Civilian* promoted his talents to frontier readers when it published an engraving (fig. 1-20), copied from his daguerreotype of the Missouri State Capitol building at Jefferson City (fig. 1-21). The caption credited Easterly as the original author of the view and praised him as "a highly accomplished artist who stands in the front ranks of his profession."[57]

If the high quality of Easterly's work brought him the respect of local critics and the patronage of prominent citizens, it was not so appealing to his competitors. Although he did not mention names, one St. Louis daguerrean may have been expressing his resentment toward Easterly in a comment that appeared in his 1852 city directory advertisement. With the obvious intention of casting doubt on his unnamed rival's integrity, John Outley asserted that his own "specimens," which were as "Good and Perfect" as any in St. Louis, truly displayed his talents since "they are all taken by myself in this city, and NOT BROUGHT FROM THE EAST."[58]

Several years earlier the Mauzy brothers, proprietors of two short-lived miniature galleries in the city, had been much more direct in their efforts to compete with Easterly's talents. When Easterly left St. Louis briefly in 1847, he sold a number of views to Mr. Irwing, the daguerreotypist who, in partnership with Frederick Webb, had taken over his Glasgow Row gallery. When Irwing died later that fall, the Mauzy brothers bought the Easterly images and proceeded to exhibit them as examples of their own work. Although the pirating and copying of plates was not uncommon during the early years of photography, Easterly did not take kindly to the use of his plates to promote the business of another establishment. Some months after his return to St. Louis in early 1848, he addressed the issue publicly by appending the following message to an advertisement:

Fig. 1-20. *Missouri State Capitol, Jefferson City.* Engraving from the *Western Journal and Civilian,* March 1852, p. 435. MHS.

There is no telling what such bright and rising geniuses as the Mauzys may accomplish, claiming, as they do, to be the "oldest artists in Daguerreotype" in the country. One thing, however, is certain, that with all the pictures they have taken and bought, they have not been able to produce any equal to those of my taking, which they purchased from the estate of the late Mr. Irwing, and now hang at their door as specimens of their own work.[59]

Easterly's pointed reference to the Mauzys' inferior talents was an understandable but unusual departure from his generally more impersonal approach to his competitors. Indeed, he seems to have made a concerted effort to remain aloof from the advertising and price wars that regularly enlivened rivalries among local daguerreotype establishments. That inclination is understandable, especially if comments that appeared in 1856 in the *Photographic and Fine Art Journal* accurately reflected the intensity of those rivalries: "We have just received a batch of delectable advertisements, which have passed between Messrs. Fox and Moore, of St. Louis, but we must be excused from copying them into our columns, as they are of too vulgar and disgraceful a nature to be admitted. The names of those who would write such stuff for the public eye should be held up to scorn by every respected artist."[60]

A view that Easterly made from his gallery window (fig. 1-22) offers additional evidence of the increasingly

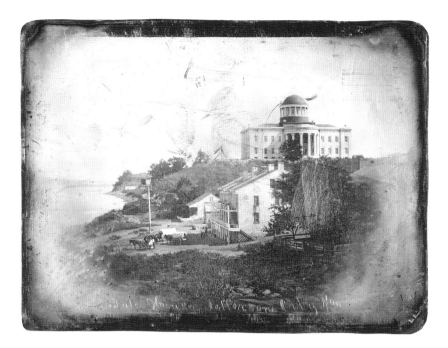

Fig. 1-21. *Missouri State Capitol, Jefferson City.* Oversized quarter plate (laterally reversed), 1852. MHS. Plate inscription: State House, Jefferson City Mo.

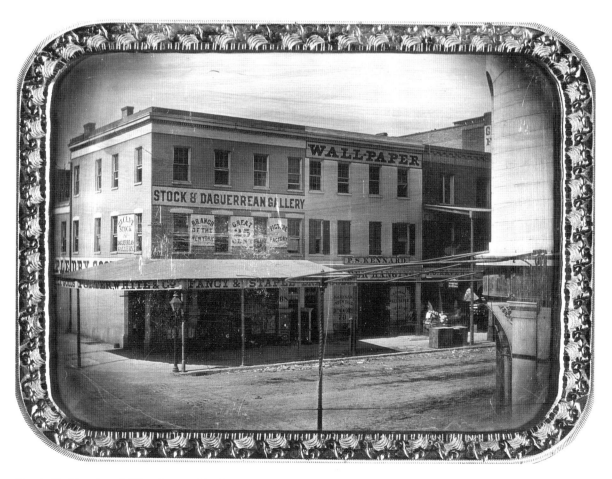

Fig. 1-22. *Fourth and Olive Streets, Northwest Corner, Stock and Daguerrean Gallery.* Half plate, c. 1855. MHS.

aggressive commercialism of the profession. After E. Burritt left St. Louis in 1851, his former rooms above Porter and White's Dry Goods housed several short-lived galleries. By the mid-1850s, when Easterly daguerreotyped the site, the space was occupied by the "New York Great 25-cent Picture Factory." In St. Louis and other major cities, the increasing number of "cheap-john operators," as they were scornfully described by more discriminating practitioners, fostered the public perception that the making of a likeness on silver was not art but industry. City boosters reinforced this notion with enthusiastic reports about the flourishing "daguerreotype line" in St. Louis. In 1854, the *Daily Missouri Democrat* reported that sixteen galleries in the city were generating an annual income of more than seventy-five thousand dollars.[61]

By refusing to adopt the questionable standards of his competitors, Easterly may have contributed to what seems to be his relatively independent position within the local community of pioneer photographers. By nature he was probably not inclined to engage in the kinds of activities that generated personal and professional camaraderie among his peers. The most prominent signal of what may have been construed by his colleagues as an elitist attitude was Easterly's absence from the membership of the St. Louis Daguerrean Association, an organization formed primarily for the purpose of establishing price controls. Although he signed the group's 1858 proposal to raise prices for portraits of children, his name does not appear in other records related to the membership.[62]

Among the contingent of local photographers, Enoch Long, who was both vocal in his commitment to aesthetic concerns and notably professional in his advertisements, was probably closest to Easterly in philosophy. Easterly's sensitive portrait of Long is some indication that the two men may have enjoyed a friendly association. What may have been a less amicable relationship with John Fitzgibbon, the organizer and first chairman of the St. Louis Daguerrean Association, could have been a factor in Easterly's aloofness from the organization. In local competitions, where a panel of judges so often conferred the highest honors on Easterly, Fitzgibbon was far from secure as the West's authority on daguerrean art. At the St. Louis fairs, his daguerreotype displays generally received the second-place awards. Although the fair competitions may be the most obvious measure of their rivalry, other factors may also have put the two men at odds.

In background and disposition, Fitzgibbon and Easterly had little in common. Early in his life Fitzgibbon had learned the rudiments of gregarious salesmanship from his father, Michael Fitzgibbon, a Dublin native who had transported his family from London to New York City in the early 1820s. On his arrival in America, the elder

Fitzgibbon had established a business selling equipment and goods related to the maritime industry. As a teen-ager, the younger Fitzgibbon was out on his own, trying his hand at a variety of trades before daguerreotypy presented itself as a potential source of income. Just before he took up the daguerrean profession, Fitzgibbon was an innkeeper in Lynchburg, Virginia, an occupation well-suited to his outgoing personality.[63]

By comparison, Easterly's vocational experiences were limited and less oriented to the requisites of public relations. First as a calligrapher and teacher of penmanship and then as an itinerant photographer, Easterly had always depended primarily on craftsmanship to promote and sustain his business. Moreover, unlike Fitzgibbon, who at the height of his success in the business of making daguerreotypes continued to look for other ways to supplement his income, Easterly was singularly committed to photography for reasons that extended beyond his desire to make a living with the camera. Fitzgibbon's announcement in 1849 that he had caught "the yellow fever" and would be leaving St. Louis on the first of May to look for gold in California, reflected not only his restless, venturesome spirit but also the high priority that he placed on making a dollar. Although Fitzgibbon was undoubtedly a highly proficient daguerreotypist, during his regular absences from the city he left his practice in the hands of a changing retinue of assistants. By contrast, Easterly never relinquished his camera to stand-ins, and he may have felt little respect for a man who demonstrated such casual concern for quality control while claiming to operate the finest gallery in the West.

Easterly may well have paid a price for being Fitzgibbon's most able and confident competitor. If he chose not to participate in the local association of daguerreans because Fitzgibbon controlled that organization, his independence probably had no real effect on his success in St. Louis. On the national scene, however, where Fitzgibbon exerted considerable influence, rivalry between the two men may have had more far-reaching and lasting consequences for Easterly's career.

In Fitzgibbon's reports to eastern photographic journals on daguerrean activities in St. Louis, he makes no mention of Easterly. It is understandable that the ambitious correspondent, at risk of losing his acknowledged position as the frontier's leading daguerreotypist, may not have wished to promote his principal rival's reputation outside the region. Even on the occasion of H. H. Long's death in 1851, when Fitzgibbon wrote a poem for the *Daguerreian Journal* paying tribute to his deceased colleague in St. Louis, Easterly's name was omitted from the list of local daguerreans who joined the author in his public gesture of respect.[64] Although Easterly may have chosen

not to endorse the eulogy for Long, it is more likely that Fitzgibbon never solicited his participation. By deliberately excluding Easterly from his accounts of frontier activities, Fitzgibbon may have played a role in limiting Easterly's reputation during the period of the daguerreotype's dominance.

Fitzgibbon's selective reporting may also have had another long-term impact. Modern scholars who have shaped our historical perspective of the daguerrean era have depended on the *Daguerreian Journal* and the *Photographic Art Journal* to reconstruct the pantheon of early masters of American photography. Easterly's talent and his remarkable collection might have been rediscovered years ago had Fitzgibbon been more candid when he reported to those journals on the development of photography in the West.

Regardless of the part that Fitzgibbon may have played in limiting his competitor's reputation, we are still left to wonder why Easterly himself, a man who so consistently demonstrated his desire for recognition in his immediate locale, showed so little initiative in expanding his own professional horizons. It is particularly surprising that he did not submit plates to the Crystal Palace exhibition in New York in 1853. His absence there is especially puzzling since both Fitzgibbon and Long, in the company of other western daguerreotypists, took part in that competition. Easterly also ignored opportunities to display work at the Illinois State Fair and other regional competitions where the St. Louis daguerrean community was frequently represented. Perhaps he was sufficiently gratified by the respect of those in his own city whose liberal patronage during the 1850s provided more immediate and tangible confirmation of his exceptional talents. Possibly he simply chose to avoid the politics involved in aggressively promoting his work to a wider audience.

Easterly's curiously indifferent attitude toward gaining national recognition becomes somewhat less puzzling in light of later events which clearly reveal the streak of "Yankee stubbornness" that sometimes conditioned his actions. By the late 1850s, when the refinement of the wet collodion process made diversity and novelties the keys to success in the picture-making business, Easterly's independent disregard for the norms and general practices of his profession earned him an even more distinctive place in his community. With an unflagging devotion to pictures rendered on the polished metal plate, and perhaps a naive belief that the vogue for newer techniques was only temporary, he refused to join his colleagues in their eager crusade to introduce the numerous by-products of the more versatile collodion technique.

The use of collodion to hold imaging materials on a glass plate was introduced in England in 1851 by Frederick Scott Archer. The term "wet collodion" was applied to Archer's method because exposure and development of the plate had to be carried out before the collodion emulsion dried. Quickly adopted in Europe, the new negative-positive process was not widely used in America until the later 1850s. A myriad of new, creatively titled photographic "styles" or techniques became available as a result of Archer's process.

On this side of the Atlantic it was the relatively short-lived ambrotype that became the first commercially successful alternative to the daguerreotype portrait. The ambrotype picture was a slightly underexposed glass-plate negative that assumed the appearance of a positive image when mounted in front of a dark surface. Sometimes called a wet collodion positive on glass, the ambrotype enjoyed considerable popularity in the late 1850s and early 1860s even though the process precluded the production of duplicate images. While the one-of-a-kind ambrotypes—preserved under glass as small, cased portraits—retained familiar characteristics of daguerreotype likenesses, their cheaper materials and glare-free surface were considered significant advancements.

Although few were as immediately appealing as the ambrotype, other challenges to the supremacy of the daguerreotype also appeared on the St. Louis scene in the late 1850s. The advertisements of the photographer W. L. Troxel, Easterly's neighbor on Fourth Street, vividly illustrate the rapid proliferation of novelties spawned by the introduction of the collodion process. Troxel's roster of services, publicized in the St. Louis city directory of 1857, also denotes the confusing state of affairs occasioned by a lack of standardization in terms or practices during this transitional period. At 213 North Fourth Street, patrons could have portraits taken for "ONE DOLLAR TO ONE HUNDRED" at "TROXEL'S Ambrotype, Sphereotype, Melenaiotype, Collodiotype, Ambrograph, Mezzograph, Photograph and HELIOGRAPHIC Gallery." Demonstrating his commitment to only the latest developments in his profession, Troxel's advertisement mentioned daguerreotypes only as a commodity that he was willing to copy "to the size of life."[65]

Most of Troxel's competitors in St. Louis, like many of his counterparts elsewhere, were more cautious in completely eliminating the patron's option for a daguerreotype portrait. As late as 1866, two local "heliograph" galleries still offered pictures on the silvered copper plates. Unlike Easterly's work in this medium, theirs was merely a minor adjunct to a successful practice in more fashionable modes. By this date, a universal enthusiasm for duplicate images provided by the positive-negative collodion process had clearly announced the final demise of the daguerreotype. Along with larger photographs on

Fig. 1-23. *Advertisement from the* St. Louis Daily Morning Herald, *28 February 1858.* MHS.

DAGUERREOTYPES.

THE prevailing opinion that Daguerreotypes will *fade* is an error. Like silver or gold they will tarnish, but not fade, and such pictures can be restored to their original brilliancy and beauty, which is *proof* that they have *not* faded.

Twenty years experience in this branch of business, has enabled the subscriber to arrive at facts, and he is willing to risk his reputation on the above assertion. Old Daguerreotypes entrusted to his care, supposed to be faded, will be cleaned and returned in as good order as on the day of their creation, provided they have not been defaced by handling, which is frequently done by attempting to wipe the dust from the plate, after the glass has been removed.

Save your old Daguerreotypes, for you may never see their like again. They last longer and copy better than any other picture known. In short, by no other process can so perfect and durable a likeness be produced, and every unprejudiced artist will bear testimony to what we assert.

A brief outline of the process by which the Daguerreotype is made thus durable, may not be uninteresting to the public.

In the first place, a perfectly polished surface of pure silver is coated with Iodine and Bromine in the proper proportions, which forms a bromo-iodide of silver, and by the action of light through the Camera and an exposure to hot mercury, as perfect an etching of the object before the instrument is produced, as if done on steel, with acid, though not so intense. In the next place, the picture is subjected to the gilding process, and a coating of pure gold covers the entire surface of the plate, and although Nitric Acid will act on and dissolve silver, it will not act on gold, and a well gilded Daguerreotype is as imperishable as gold itself. The subscriber has often subjected his pictures to the test of Nitric Acid, and knows of what he speaks. Furthermore, he has exposed Daguerreotypes to the weather and hot sun for fifteen years, without their undergoing the slightest change. Try the experiment on a Photograph for as many weeks, and mark the difference. We do not wish to say anything derogatory to the character and nature of the Photograph. It has *its* advantages and we contend only for facts in relation to the perfection and durability of the two pictures.

Be not alarmed then for the safety of a good Daguerreotype. It will doubtless out live you, your children, your grand-children, and your great-grand-children.

If you desire them or any other pictures cleaned, copied, enlarged or changed into any other style, such as plain Photographs, or finished in Crayon, India Ink, Oil or Water Colors, the subscriber is prepared to take the order.

He is also prepared to take likenesses of deceased persons, which can be copied into any other size or style of picture desired.

T. M. EASTERLY,

Entrance to Office between 63 and 65 North Fourth Street, east side, South of Olive,

Room No. 7, Third Floor. Office hours from 10 to 12 A. M.

N. B.—As regards old friends and customers, Mr. E. has no need of credentials, but for the benefit of strangers, he offers the following references :

Mr. T. M. EASTERLY has been known to us for many years as a most accomplished Daguerrean Artist, and has always executed his work in the most durable and satisfactory manner. Beside his claims in his profession, he is regarded as a most estimable and reliable gentlemen, deserving the full confidence of his fellow citizens.

EDWARD WYMAN,	FELIX COSTE,
JAS. E. YEATMAN,	ROBERT BARTH,
M. J. DEFRANCA,	J. F. WILKINS,
F. T. L. BOYLE,	N. S. TOWNSHEND,
A. J. CONANT,	C. W. SPALDING, D. D. S.

ST. LOUIS, January 1st, 1865.

Fig. 1-25. *"Daguerreotypes."* Broadside, 1865. Easterly-Dodge Collection, MHS. Gift of Margaret Wing Dodge.

Agricultural Implements.

Easterly's Reaper & Mower

MANY VALUABLE IMPROVE-ments have recently been made in this Machine, all of which have been thoroughly tested, and it now stands higher in the estimation of farmers, where known, than any other in the country. It has no superior, and in point of fact it has no equal, as we are fully prepared to show, not only by the testimony of practical farmers who have used it for the last two years but by actual demonstration.

Two great advantages which this Machine has over all others are its entire *freedom* from side draft, and the small amount of power requisite to work it—as shown by the dyamometer.

It runs on four wheels, the driving wheel being four feet in diameter and the grain wheel two feet. The draft frame is attached to the forward truck-wheels by means of a bolster and king-bolt, which gives the tongue light and easy play, and it can be turned on as short a curve as a hack. Another important feature is the perfect control which the driver has over it while in motion. The leverage is so perfect that the cutter-bar can be raised and lowered by the foot at pleasure, and retained at any desired height.

It is more simple in construction than any other, there being but two cog-wheels in the whole machine, and nothing to get out of repair. Two light horses can work it all day with ease, and a boy fifteen years of age can manage it as well as a man. It is a self-sharpener, and cuts in grass five feet two inches, and in grain five feet six.

The improved machine for 1858 has an entire new arrangement for the sickle sill, fingers, guards and divider, whereby it works well in wet grass or lodged clover. Five minutes are amply sufficient to change it from a Reaper to a Mower, and it has been done in one minute.

An acre of grass has been cut with this Machine in twenty-two minutes, and sixteen acres and a half of heavy wheat in one half day. In doing this unprecedented amount of work, the Machine was drawn by two medium sized horses, and managed by two boys, fifteen years of age; and we have the affidavits of nineteen as reliable men as can be found in Wisconsin, to prove the above statement.

Every farmer would find it to his interest to examine Easterly's combined Reaper and Mower, before making a purchase elsewhere. We will guarantee it to do all that is claimed for it, and to do as good work, and *more of it*, in a given time, than any other *can do* with the same team, either in grain or grass, and we wish it distinctly understood that we do not except *first premium* machines nor any other.

One of the above named machines, set up and in running order, can be seen at No. 47 Olive street between Third and Fourth, near the New Custom House, St. Louis, Mo. To any address sent by mail, we will forward, free of postage, a pamphlet, containing cuts, a full description of machine, recommendations, &c., together with directions for putting up and running it.

Price of machine, delivered on steamboat or at any railroad depot in St. Louis, $150 cash.

All orders promptly attended to. Good, responsible farmers wanted to act as agents in the several counties where they reside.

T. M. EASTERLY, (Daguerrean,) No. 71 South-east corner of Fourth and Olive streets, St. Louis, Agent for Missouri, Southern Illinois, Kansas and Nebraska. may13dltw&w

Fig. 1-24. *Advertisement from the* Alton Weekly Courier, *3 June 1858.* Illinois State Library.

albumen paper, the small carte-de-visite portrait—a 2 ½" x 4" picture mounted on cardboard—was well on its way to becoming a national passion. With the beginning of the Civil War, the bargain-priced tintype or ferrotype would also become immensely popular.

By refusing to capitulate to progress, Easterly quickly became an anachronism in his profession. From 1867 on, until he stopped working in the 1870s, he was the city's only practitioner of Daguerre's outmoded technique.[66] During these years he was known in St. Louis as "The Daguerrean," a nickname that acknowledged his tenacious belief in the superiority of his one-of-a-kind pictures. Although Easterly's stubborn resistance to adopting other "styles" set him apart from his more progressive colleagues, he was not alone in the enduring respect that he felt for the antiquated process. Other photographers of his generation shared his conviction that technological advances had not improved upon the veracity and beauty of America's first camera-made pictures. Looking back on his own career, Abraham Bogardus, one of the most respected senior members of America's photography community by the 1880s, voiced the sentiments of many veterans in his circle. Writing for the *Photographic Times and American Photographer* in 1884, Bogardus reminisced:

I shall always remember with pleasure the good old daguerreotype.

No glass to clean and albumenize; no black fingers; few or no re-sittings; no retouching; no proofs to show for the grandmother and the aunts to find fault with; no waiting for sunshine to print with; no paper to blister; and no promising of the pictures next week if the weather was good.

The picture was gilded, finished, and cased while the lady was putting on her bonnet, delivered, put in her hand and you had the money in your pocket.

I have yet to see the picture made with a camera equal to the daguerreotype.[67]

Easterly demonstrated even higher regard for daguerreotypy by suffering the practical consequences of his steadfast loyalty. From the late 1850s on, his dwindling income and downscaled advertisements (fig. 1-23) reflected the public's growing enchantment with an ever-increasing number of innovations in the photographic industry. Adding to his financial burden, he also took over the care of his aging mother, who moved from Vermont to St. Louis in 1864.

Over the years Easterly did take sporadic measures to improve his financial situation with sideline businesses. In 1858, he became the regional agent for what his advertisements called "Easterly's combined Reaper and Mower (fig. 1-24).[68] He also sold farm implements in 1860, in partnership with Thomas Brown.[69] Several years later he became a local sales representative for a new line of washtubs. In reading Norton Townshend's letters and diaries, which confirm the dismal state of the daguerrean's finances by 1864, one can only wonder how Easterly could persist in his resistance to the obvious and expedient solution of adding the collodion process to his practice.

Townshend's letters to his wife during his stay in St. Louis often express his concern for "Sister Easterly" and her husband's difficulties. In December 1864, shortly after his arrival on the frontier, the doctor reported to his wife that "Mrs. Easterly appears very well, the mother more feeble, and Mr. Easterly without steady employment."[70] Townshend also indicated at that time that he hoped to use his connections with the Quartermaster's Department to secure a position for his brother-in-law. When those efforts proved unsuccessful, Townshend explored investment opportunities in the area that could possibly provide additional income for the couple. Several times during his sixteen-month tenure in St. Louis, he made tactfully offered loans to "Mr. Easterly." The physician's careful bookkeeping indicates that the money was repaid on each occasion.

Despite Townshend's anxieties over the couple's financial situation, his letters never once mentioned or questioned his brother-in-law's continuing allegiance to a process that was clearly out of step with the taste of his time. Nor did the doctor point out Easterly's obvious deficiencies as a businessman. Perhaps because of his respect for the daguerrean's talents, Townshend seemed sympathetic to his brother-in-law's independent attitude toward photography and hopeful that his professional difficulties were only temporary. Writing to his wife in December 1864, Townshend optimistically suggested, "I think Mr. E. is likely to do well at his Daguerrean _____ this winter though as yet he has hardly made a beginning."[71] Townshend's hopeful forecast was prompted by Easterly's newly devised plan to promote a business in cleaning and restoring daguerreotype pictures. A broadside (fig. 1-25), printed in early January of 1865, was aimed at advertising his competency in this delicate and often precarious task.[72] In the additional hope of inspiring patrons to reconsider the unique merits of the daguerreotype, Easterly's circular also reminded the public that while "the new styles have their advantages," no other process could produce "so perfect and durable a likeness." Although the broadside may have eventually improved

Easterly's business, a new set of unfortunate circumstances precluded any immediate results.

On the evening of January 19, only days after the preparation of the circular, a fire swept through the building that housed Easterly's studio.[73] Only a portion of his daguerreotype collection survived the disaster. In Townshend's account of the event, Easterly's considerable losses included his "machines" and "a great many pictures." Townshend lamented to his wife that the sum of five hundred dollars, which Easterly would be receiving in insurance money, would not only be inadequate to cover the damages but would also be much too slow in arriving.[74] Several times in the following weeks, Townshend indicated that both Easterly and his wife were in a state of despair over the disaster. Their depression over the loss of many of the daguerrean's pictures was compounded by the problem of meeting even the most basic living expenses. Fortunately, Townshend came to the couple's aid by loaning them money for rent and fuel. A double portrait of the Easterlys from the mid-1860s (fig. 1-26) may have been taken with one of the daguerrean's new replacement "machines."

Presumably as a result of the fire, Easterly had no business address listed in the 1865 St. Louis city directory. From 1866 on, when Townshend's letters to his wife ceased with his return to Ohio, city directories and a few sporadic advertisements are our only source of information on the conditions of the daguerrean's career and his efforts to maintain his practice. With a move that took place by 1866, Easterly set up a smaller gallery at 65 North Fourth Street, a location just south of the building that he had earlier occupied for nearly two decades. Within a year he relocated again, maintaining his last gallery at 218 ½ North Fourth Street until he gave up the practice of photography. In 1867, after seventeen years in their rooms at 60 Jefferson Street, the Easterlys also moved to a smaller apartment at 906 Jefferson.

At this time Easterly was still caring for his mother, who died in 1871 at age ninety-one.[75] Less than a year before her death, he made a half-plate portrait of Philomela Easterly on the occasion of her ninetieth birthday (fig. 1-27), an image that is as much a revelation of the daguerrean's enduring poetic sensibility as it is a touching gesture of devotion to his mother. This curious, almost surreal scene shows the aged matron seated beneath the branches of a large, dead tree. The towering architectural backdrop both dwarfs her doll-like figure and underscores her fragility. With the tree symbolizing the old woman's impending death, this methodically constructed narrative reiterates the message of the verse engraved on the plate: "The Day still smiles upon me,/And beside the ancient gate,/In this soft evening sunlight/I calmly sit and wait."

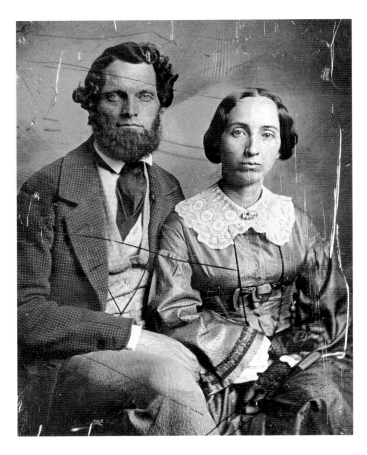

Fig. 1-26. *Mr. and Mrs. Thomas Easterly*. Quarter plate, c. 1865. MHS.

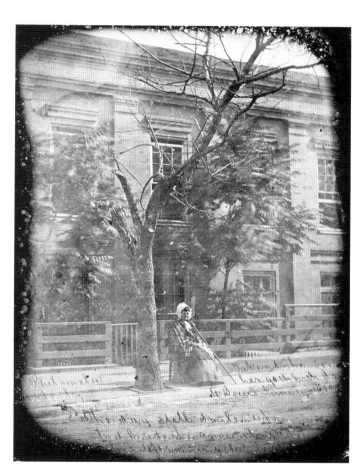

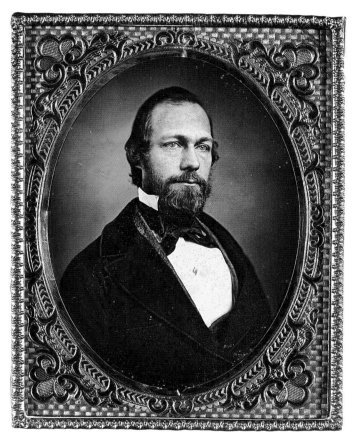

Fig. 1-27. *Philomela Easterly at 90.* Half plate, 1870. Easterly-Dodge Collection, MHS. Gift of Margaret Wing Dodge. Plate inscription:

> Mrs. Philomena Easterly Taken by her son on
> her 90th. birthday
> St. Louis June 17, 1870
> "The Day still smiles upon me,
> And beside the ancient gate,
> In this soft evening sunlight
> I calmly sit and wait."

Fig. 1-28. *Dr. C. W. Spalding, Dentist, St. Louis.* Quarter plate, c. 1865. MHS.

Despite what must have been a nearly non-existent market for daguerreotypes during the years following the Civil War, Easterly somehow managed to maintain his position as St. Louis' last representative of what had essentially become an extinct professional breed. With the exception of two years when his establishment was advertised, probably inadvertently, under the more generic category of "Photograph Galleries," city directories listed Easterly as a "Daguerrean Artist" until 1880. During this final chapter of his career he was forced to explore numerous avenues to supplement his income.

As one particular enterprise suggests, Easterly's financial needs occasionally took him far afield from his artistic aspirations. Sometime around 1865, he became involved in the business of marketing Wisner's Patent Washtubs, a venture that he may have continued for a number of years. In a broadside advertising the new product, Easterly and a partner named Spalding, probably the dentist C. W. Spalding (fig. 1-28), are noted as the company's "Proprietors For the State of Missouri." According to the circular, several business establishments in St. Louis would be selling the new products. We can assume that Easterly and Spalding expected to share in the profits, although we have no way of determining the success of the project. During these difficult years the daguerrean may also have come to depend on his wife's talents as a seamstress to add to the family income. On several occasions Norton Townshend's letters referred to Miriam's work and skill in this activity.

If Easterly was forced to devote greater energy to more purely commercial activities during the declining decades of his career, he was also eventually forced to compromise some of the principles that had earlier governed his practice of photography. By 1865 his broadside announced that he was "prepared to take likenesses of deceased persons." Providing additional clues to the character of his practice at this time, the brochure also suggested that the post-mortem daguerreotypes could "be copied into any other size or style of picture desired." In an advertisement that appeared in the Rolla, Missouri, *Weekly Herald* in 1869, Easterly indicated that he made "a specialty of taking likenesses of deceased persons from which any style of picture can be copied."[76]

Such proposals, along with other new services listed in his advertisements of this period, would seem to imply that Easterly was willing and equipped to reproduce daguerreotype images in "any other size or style of picture." Although these references suggest that he had finally succumbed to adopting the new techniques of his trade, there is sufficient evidence to indicate that this was not the case. During Townshend's frontier assignment, he availed himself of his brother-in-law's talents on several occasions; however, he patronized other local galleries for ambrotype and carte-de-visite portraits.[77] Since Townshend so openly admired his brother-in-law's skills, it seems highly unlikely that he would have taken his business elsewhere had Easterly practiced more fashionable modes. A later comment, made on the occasion of the daguerrean's death, would seem to confirm that Easterly's later advertisements are misleading. According to the *Practical Photographer*'s posthumous account of his career, Easterly "never would embark in the photographing business, but stuck to Daguerreotyping until the last."[78]

From this evidence it seems likely that Easterly enlisted the services of more progressive-minded colleagues to make copies of his daguerreotype plates when duplicate prints in "other styles" were preferred by his patrons. Indeed, he may have operated during the last two decades of his career in unofficial partnerships with photographers who were equipped to carry out various duplicating and enlarging processes. Such partnerships could explain the fact that Easterly shared his business address in 1867 with George P. Hall who was listed in the city directory that year as the proprietor of a "Photograph Gallery." Since Easterly sat for a carte-de-visite portrait in 1871 at the Cramer and Gross gallery (fig. 1-29), it is possible that he also worked cooperatively with that establishment.

We can assume that it was with the assistance of Hall or others that Easterly was able to offer the wide variety of services that he began to promote with his broadside of 1865. While a testimony to his talents as "a most accomplished Daguerrean Artist" appears at the bottom of his circular, Easterly stated the expanded extent of his practice: "If you desire them [daguerreotypes] or any other pictures cleaned, copied, enlarged or changed into any other style, such as plain Photographs, or finished in Crayon, India Ink, Oil or Water Colors, the subscriber is prepared to take the order."

If it is certain that Easterly himself filled the orders for cleaning daguerreotypes, the extent of his hands-on participation in some of the other services offered is more problematic. Presumably he subcontracted work for "plain Photographs" or other kinds of pictures that involved the wet collodion process; he may have played a more active role when filling orders for pictures "finished" with ink or colored pigment. If his beautifully tinted Indian portraits are an indication of his potential as a competent photo-colorist, Easterly could well have capitalized on this skill when his talents with the daguerreotype camera became less interesting to the public.

Easterly's 1865 broadside is more than an interesting record of the aging daguerrean's plan for surviving the demise of his specialty. It is also a public justification of his abiding attachment to Daguerre's obsolete technique.

Easterly presented a convincing case for his views. His broadside asserted that for image quality and durability, daguerreotype pictures would never be outmoded. "They last longer and copy better than any other picture known," he maintained. Following his description of "the process by which the Daguerreotype is made thus durable," Easterly proposed that through years of experimenting he had proved that "... the well gilded Daguerreotype is as imperishable as gold itself. The subscriber has often subjected his pictures to the test of Nitric Acid, and knows of what he speaks. Furthermore, he has exposed Daguerreotypes to the weather and hot sun for fifteen years, without their undergoing the slightest change. Try the experiment on a Photograph for as many weeks, and mark the difference." In a tactfully phrased conclusion on the shortcomings of paper prints made by the wet collodion process, Easterly stated: "We do not wish to say anything derogatory to the character and nature of the photograph. It has its advantages and we contend only for facts in relation to the perfection and durability of the two pictures."[79]

In the years that followed, Easterly intensified his crusade on behalf of the daguerreotype using circulars, newspaper advertisements, and exhibitions to further his campaign against progress. Even during the 1860s and early 1870s, when there was little or no commercial market for his specialty, Easterly continued to enter his daguerreotype displays in the annual art competitions at the St. Louis fairs. The circumstances surrounding the "premium" awards at the 1866 fair provide a clear picture of the lengths to which he was willing to go to defend the merits of his medium.

The honors conferred by the judges for the 1866 fair ran the gamut of photographic techniques currently being practiced in area galleries. Interspersed among the awards listed for watercolor paintings, engravings, and architectural drawings were premiums for photographs on paper, ivory, and porcelain. "Stereoscopic pictures" had also gained a place in the Fine Art Hall. John A. Scholten, who had emerged as a leading photographer in St. Louis by the mid-1860s and would later acquire Easterly's daguerreotype collection, took the first award in nearly every category. Easterly's one-time rival, John Fitzgibbon, earned a second-place premium for "Photographs Painted on Porcelain."[80] Always attuned to progress, Fitzgibbon no longer had to be concerned about the challenge of his once-formidable competitor, who was the only exhibitor in the daguerreotype category. Easterly's display included new works along with a selection of "specimens" made many years earlier.

The judges acknowledged Easterly's efforts with "a favorable mention," an assessment that did not sit well with a man who saw little aesthetic merit in the techniques that

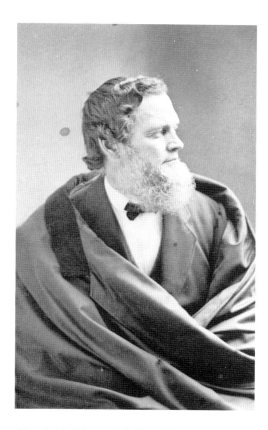

Fig. 1-29. *Thomas M. Easterly.* Carte de visite by Cramer, Gross and Co., 1871. Courtesy of the author.

LIKENESS AND LANDSCAPE

Fig. 1-30. *Fourth Street North from Olive, Bell's Gallery.* Half plate, 1870. MHS.

had outranked his own. The straightforward and unconventional manner in which he expressed his feelings on the matter caused a considerable stir in the community. One writer's account of Easterly's reaction to the situation appeared in the *Missouri Republican* shortly after the awards were made public. On the topic of premiums the writer suggested that "in such matters, where personal pride is involved, it is hard to make people, particularly artists, reason wisely." The report went on to comment that certain exhibitors who "consider themselves especially aggrieved" chose to "express their dissatisfaction in no measured terms." Easterly's response, singled out as "an instance of this kind," was described in some detail:

> In the west end of the hall there is to be seen a very fine collection of daguerreotypes sent in by Mr. T. M. Easterly of this city, but which for some reason or other did not receive the first premium, and in the morning there appeared the following card conspicuously posted on one of the pictures:
>
> "This collection of daguerreotypes took the first premium at the three preceding Fairs held in St. Louis, to competition with the best talent of the city. Such men as De Franca, Boyle, and other distinguished artists were the judges. The present committee, however, seem to be men of better judgement, hence the decision."

This ironical notice seems to me altogether uncalled for. The attempt to cast ridicule on men who endeavored to discharge a disagreeable and delicate duty with fairness and impartiality is certainly in bad taste and calculated to mar by unpleasant memories an annual event that should be connected with nothing but pleasing associations and general harmony.[81]

Easterly was apparently forgiven for his display of "bad taste" by later panels of judges who determined that his fair exhibits were worthy of higher "premium" awards. In 1871, at least one local critic writing on the artwork at the fair that year expressed the same convictions that Easterly himself had so audaciously defended five years earlier: "Easterly has a varied lot of his daguerreotypes on exhibition. They are remarkable fine specimens of this art, which photographs can never wholly supersede, for after all, such pictures have a nearness to nature that photographs generally lack."[82]

In the previous year, Easterly's fair exhibit had received even wider attention when a representative of the National Photographic Association reported on the event for the *Philadelphia Photographer*. The lengthy commentary on the various gallery exhibits, written two days after Easterly's sixty-first birthday, appeared in the November 1870 issue of that journal. To this viewer, who was more closely allied to the profession, the daguerrean's retrospective inventory was impressive not only as a measure of the maker's exceptional talents but also as an unexpected reminder of the unique beauty of an antiquated process. The writer summed up his critique with a nostalgic and respectful tribute to Easterly's talents and his tenacity:

> One other I must not omit to mention, and that is Easterly, the Daguerreian, as he is called; although not properly a photographer, he has forgot more about pictures than many of them will ever know. One of the old-style picture-men; never would change, but expecting Daguerreotypy to come back again, he will die with his harness on, rather, he will never quit his first love—the Daguerreotype. He had a fine collection of pictures, some of them over twenty years old, as good as the day they were taken, and would put to shame many of the so-called fine pictures of the present day.[83]

After a quarter century of single-minded devotion to the daguerreotype, Easterly's accomplishments had finally come to the attention of the eastern photographic establishment. The daguerrean surely reacted to the long-overdue praise with mixed emotions. He undoubtedly felt gratified to see his works exalted as evidence of the deficiencies of the so-called advancements in photography. At the same time, however, he must have been painfully aware that the writer's insightful observations would be lost on a public that valued novelty over "perfection" and price over permanence.

Ironically, the man who earlier may have contributed to Easterly's anonymity among America's pioneer photographers was acknowledged in the same review. In a brief report on the work of "the old veteran of the art in St. Louis," the correspondent reaffirmed John Fitzgibbon's ongoing and ever-ingenious appropriations of progress. Fitzgibbon's exhibit was described as "a very fine display of all styles, among which were some beautiful mezzotints, phunnygraphs, and night pictures, specialties by this artist alone." One of his most creative inventions, which was described in greater detail, illustrates the contemporary taste for manipulated or fabricated pictures that frequently took the "novelty"

Fig. 1-31. *Still Life with Flag, Lamp and Daguerreotype Materials.* Quarter plate, n.d. MHS. Inscribed on verso: *Trompe l'oeil*

photograph into the realm of the bizarre. Fitzgibbon's quintessential contribution to this category, a work "much admired" by viewers at the fair, was "a dress photograph of a lady, some three feet in length; the head, arms, and hands of a cabinet picture being used, and the balance in dry goods very neatly and handsomely dressed...."[84] A public enamored with such large-scale curiosities might well find Easterly's small and seemingly unimaginative transcriptions of nature antiquated and uninteresting.

It is also not surprising that the *Philadelphia Photographer*'s correspondent so frankly appreciated the qualities that set Easterly's daguerreotypes apart from "many of the so-called fine pictures" of his time. The reviewer was consistently open in expressing his distaste for excessive retouching and other widely practiced techniques that in his mind obscured the "clear, distinct pictures" characteristic of "the work of a good photographer." He was particularly distressed by the role that "paid artistical work," presumably a reference to the contributions of hired colorists, had come to play in the productions of many photography galleries. From this purist point of view, the crystalline clarity and sharp, rich detail of a superior daguerreotype were poignant reminders of the days when the camera-made image had been assessed solely on the unique beauty of its own distinctive pictorial language.

Easterly may have been nostalgically acknowledging the passing of that era when he made one of his last views of the changing St. Louis scene (fig. 1-30). This fitting epilogue to his long career frames a sweeping expanse of Fourth Street that is intentionally obstructed by a large sign marking the location of Bell's photographic gallery. It is a visually engaging composition accentuated by a top-hatted figure that may be Bell, or perhaps even Easterly himself, posed on a rooftop beneath an eye-catching banner. The banner's boldly displayed message—"PICTURES OF EVERY STYLE"—announced the credo that had transformed the practice of photography from a one-person endeavor into an industry devoted to the rapid turnout of mass-produced images.

In 1882, more than a decade after the *Philadelphia Photographer* noted Easterly's achievements, another widely read journal again drew attention to the daguerrean's singular position as an "old-style picture-man." In April of that year, the *Practical Photographer* offered Easterly his last accolade in an article reporting his death to the photography community. This final tribute to America's last "faithful follower of Daguerre" described the sacrifices that Easterly had endured to maintain that loyalty:

Death of T. M. Easterly

One of the oldest Daguerreotypers of the country, at the age of seventy-three years. Mr. Easterly, strange to say, never was a photographer; believing in letting well enough alone, he never would embark in the photographing business, but stuck to Daguerreotyping until the last. In fact, we may say he was starved out of the business, for it left him in poor health and pocket. Some years ago he became paralyzed, and of late suffered a great deal. He was truly a faithful follower of Daguerre, and one of its most competent and worthy artists.[85]

The local press had briefly noted the daguerrean's death on March 12: "Easterly—March 11, 1882 at 9:45—Thomas M. Easterly in his 73rd year, after a very long and painful illness. Funeral Sunday, March 12 at 3:00 p.m. at 1916 N. 9th Street. Brattleboro, Vt. papers please copy."[86] Easterly was buried next to his mother in an unmarked grave in Bellefontaine Cemetery. A medical report listed "congestion of the brain" as cause of death.

There may have been considerable truth in the *Practical Photographer*'s suggestion that Easterly's long practice had affected his health as well as his income. The health hazards of working with a process that used mercury vapor to develop the latent image had been a widely discussed concern since the introduction of daguerreotypy. The toxic vapor, which had no warning properties, contaminated the space of the daguerrean's developing room, as well as the surface of his clothing, leading to the risk of acute or chronic mercury poisoning from inhalation and skin absorption. Along with side effects such as liver and kidney malfunction, prolonged exposure to mercury fumes generally causes most damage to the nervous system; muscle tremors and psychic disturbances are common symptoms of this condition.[87] Neurological damage resulting from working with this substance was recognized in France as early as the seventeenth century when the term "Mad Hatters' Disease" described the maladies of hatmakers who used mercuric nitrate to soften animal hides. Mid-nineteenth-century medical handbooks focused on "the mercurial trembles," a condition which impaired, and in severe cases precluded, "normal locomotion," as the most dangerous result of inhaling the poisonous fumes. Bromine, which was commonly used in processing daguerreotype plates, could have similar effects on the nervous system.[88] After more than thirty years of exposure to these chemicals, Easterly may have been affected. Indeed, it is possible that what the *Practical Photographer* described as the "paralysis" of his last years

was actually a condition of debilitation associated with severe "mercurial trembles."

Since Easterly certainly knew of the widely discussed dangers involved in developing daguerreotype plates, he was apparently willing to risk the physical consequences of his attachment to that process. After demonstrating the strength of his convictions by living his last years in near poverty, his slow and painful death may have been the final testament to his single-minded allegiance to the perfection and magical simplicity of the miniatures that had once been the passion of the American public. He left a more tangible reminder of that allegiance in a remarkable still-life composition that poignantly symbolizes both his ideals as an artist and his unflagging devotion to Daguerre's process (fig. 1-31). Prominent among the objects in this artfully arranged study are the tools and materials of the process that he refused to abandon.

As the tragic circumstances of his last years clearly indicate, Easterly's commitment to promoting and confirming the superior attributes of his "first Love" had little impact on his contemporaries. More than a century later, conditioned by historical hindsight and more keenly appreciative of the supremely purist nature of the daguerreotype medium, we can be properly grateful for his efforts and sympathetic to the principles that inspired his campaign against progress. Most importantly, we can be thankful for the care with which Easterly and his family preserved one of the world's most remarkable legacies to the history of photography.

THE "FAITHFUL AND NATURAL" LIKENESS

*D*uring the early decades of the nineteenth century, art in America was a commodity largely reserved for the wealthy and the elite. By the 1840s, however, the democratic ideals of Jacksonian society had generated a new spirit of egalitarianism in the appreciation of the arts. The daguerreotype played a singular role in making art more relevant and accessible to the general public. As a writer for *Godey's Lady's Book* observed in 1849, it was unquestionably in the arena of portraiture that the new "sunbeam art" had most dramatically affected the American visual experience: "If our children and children's children to the third and fourth generation are not in possession of portraits of their ancestors, it will be no fault of the Daguerreotypists of the present day; for verily, they are limning faces at a rate that promises soon to make every man's house a Daguerrean gallery."[1]

By this time, the portrait had become standard fare in the daguerrean's studio, though a decade earlier few had envisioned this development. When Daguerre initially introduced his technique in 1839, those who attempted to apply the new procedure to portraiture found their process and equipment sorely inadequate.

Primitive lenses and relatively insensitive plates forced subjects to endure sittings of fifteen minutes or longer in strong outdoor sunlight. The results of this painful exercise were more startling than satisfactory.

Recognizing the enormous commercial potential of camera-made portraits, experimenters quickly made numerous improvements on Daguerre's original process. By 1841, chemical accelerants, smaller plate sizes, and improved lenses had reduced exposure times from minutes to seconds and the portrait had become the principal product of the daguerreotypist's practice.

Despite the resolution of technical problems, some observers continued to question the commercial potential of faces secured on a metal plate. Human vanity, they proposed, would play a significant role in determining the success of portraits produced by a union of art and science. The painter and inventor Samuel F. B. Morse was among those who predicted a limited market for "daguerreotyped faces" that could not be improved or

Fig 2-1. *Unidentified Older Woman with Glasses.* Ninth plate. MHS.

perfected by the artist's touch. Morse's comments, however, were primarily intended to assuage the anxieties of the many painters who were fearfully contemplating the potential obsolescence of the hand-wrought likeness. Shortly after Daguerre's invention was introduced in America, Morse assured his colleagues: "Be not alarmed. Nature's pencil is too true to be popular, she does not flatter. Who wishes to hear or see the truth of themselves...."[2]

Even at the height of the daguerreotype's popularity, others close to the art community continued to echo Morse's views on the shortcomings of daguerreotype portraits. A writer for *The Crayon*, America's first journal devoted exclusively to the visual arts, assured readers in 1855 that a discriminating patron could never be satisfied with a mechanical reproduction: "The camera, it is true, is a most accurate copyist, but it is no substitute for original thought or invention. Nor can it supply that refined feeling and sentiment which animate the productions of a man of genius...."[3] An article in the more widely read *Ballou's Pictorial Drawing Room Companion* agreed that in a daguerreotype portrait "the face comes before us without passing through the human mind and brain to our apprehension." As a result, the author concluded, "it always leaves something for the sympathies to desire."[4]

If some in elite circles continued to promote the sentient transformations of the portrait painter, their disdain for the camera's objective eye had little influence on the vast majority of Americans. Indeed, Morse and others who predicted a limited market for daguerreotype portraits had considerably underestimated the power of familiarity in the life of pictorial forms. As the scrupulous fidelity of these likenesses became a commonplace experience in American life, their straightforward realism became increasingly appealing to patrons. In 1851, the *Photographic Art Journal* assessed the situation: "It seems already that the public, more allured by the truth, becomes less difficult to please in the style of the face and the acknowledged beauties, and to turn with curiosity to the adoration of the real."[5] A decade later Marcus Root, prominent American daguerrean and historian of the medium, would summarize the outcome of this shift for the community of painters: "The time was when portraitists were frequently well paid, and with thanks also, for an indifferent painting resembling the original but slightly. Thanks, however, to heliography, its productions have taught the public to see and judge for themselves."[6]

As the new mechanical medium exposed the conspicuous gap between physical fact and artistic paraphrase, patrons from all classes affirmed their preference for the more impartial language of photography. Abraham Bogardus, looking back on the successful early years of his career as a photographer, recalled that "to have

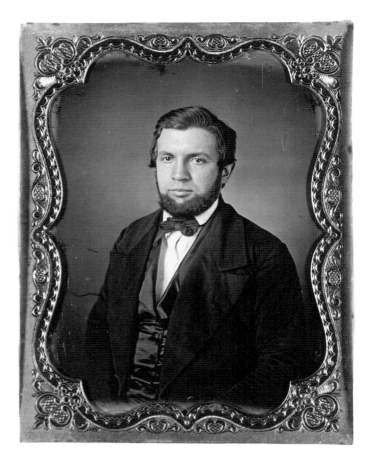

Fig 2-2. *Daniel Allmon, Boot Maker.* Quarter plate, c. 1858. MHS.

a daguerreotype taken was the ambition of every aspiring man."[7] With the proliferation of itinerant and established practitioners, the products of Daguerre's invention became accessible to the ordinary citizen. For nearly two centuries, the inexpensive and crudely fashioned silhouette image, which provided little more than a ghostly emblem of individual character, had been the workingman's principal means of preserving his presence for later generations. For this segment of society, which could never have afforded the skilled painter's services, the daguerreotype was tangible evidence that advanced technology had helped to usher in a more democratic era.

Thomas Easterly provided many citizens on the western frontier with their first opportunity to see themselves immortalized through the powers of the new invention. Today, through a confluence of fortunate circumstances, we have the privilege of sharing the results of many of those early encounters with the camera. The preservation of such an exceptionally large number of portraits from a single, identified gallery can be attributed principally to the standards that Easterly maintained and to

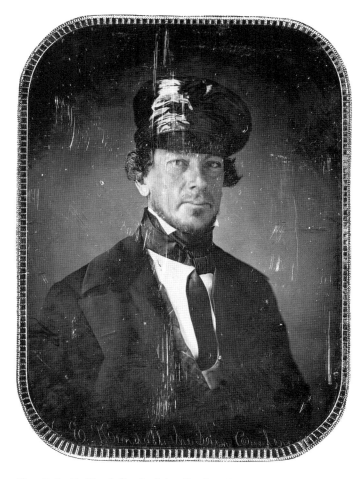

Fig. 2-3. *E. Kendall, the Lion Bugler.* Quarter plate, c. 1848. MHS. Plate inscription: E. Kendall, the Lion Bugler

1845 plate believed to be a self-portrait and possibly one ninth-plate portrait (fig. 2-1)—all of these appear to have been made during Easterly's career in St. Louis.

Although many previously unknown subjects were identified during the course of this research, others remain anonymous. Easterly himself provided some information on the identities of his patrons. In the case of more eminent or interesting personalities, he frequently engraved the subject's name on the front of the plate beneath the image, using the same distinctive script that identified the sites pictured in many of his outdoor views. When he documented the identity of less prominent patrons, the names appear on the verso of the plate incised in a simple and consistent block printing style.[9]

Easterly's patrons included such average citizens as bootmaker Daniel Allmon (fig. 2-2) and the bugler of the Lion's band (fig. 2-3), but he earned his reputation during the decade of the daguerreotype's dominance through the support of a more elite clientele. As his early advertisements reported, "Distinguished Statesmen, Eminent Divines and Prominent Citizens" were among the many "specimens" on view in his gallery. Today his portraits of social and civic leaders such as Abby Churchill Clark (figs. 2-4, 2-5), Rev. William Potts (fig. 2-6), and pioneer industrialist Samuel Gaty (fig. 2-7) make up a uniquely authentic pictorial index to who's who in St. Louis society in the mid-nineteenth century. With commendations from this sector, it is not surprising that such well-known and diverse personalities as Jenny Lind (Plate 19), Lola Montez (Plate 21), and Alexander Campbell (Plate 7) found their way to Easterly's gallery during their visits to this cosmopolitan city.

While a number of celebrity portraits are among Easterly's most striking artistic achievements, several of these plates are treasures on other levels as well. For example, Easterly's perceptive portrayal of Father Theobold Mathew (Plate 20) may be our only surviving photographic record of the Irish priest's impressive appearance. Although the enormously popular temperance leader was undoubtedly daguerreotyped many times during his two-year tour of America in 1851, none of these plates has yet been located.[10] Unlike his contemporaries working in other pictorial media, Easterly had neither the inclination nor the technical means to idealize the physical features of his famous subjects in compliance with popular expectations or artistic conventions. In this regard, his portraits of Dan Rice (Plate 22), George H. "Yankee" Hill (Plate 15), and the youthful Julia Dean (Plate 10), whose faces were regularly improved beyond recognition on the lithographer's stone, are exceptional as factual records of the true physical appearance of these popular entertainers.

the uncommonly prominent role that personal gratification played in the practice of his craft. The same kind of pride that helped to ensure the survival of hundreds of plates from the Southworth and Hawes studio prompted Easterly to keep an inventory of his portraits.[8] Like Southworth and Hawes, he also maintained his reputation for superior work by making several exposures during a sitting, with one or more of those images becoming a part of his gallery reserve. While it is hard to imagine that some of Easterly's striking images may once have been classified as rejects, many of his best productions undoubtedly left the gallery in the hands of his customers.

That Easterly practiced for many years in the same community was an additional blessing because a significant number of Easterly portraits, protected as cherished mementos, remained in the hands of St. Louis families. Through the years, gifts from these donors and from Miriam Easterly's family have added important works to the Missouri Historical Society's current holdings of more than 450 Easterly portraits. With the exception of two—the

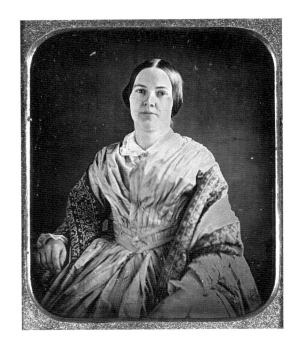

Fig. 2-4. *Abby Churchill Clark.* Sixth plate, c. 1850. MHS.

Fig. 2-5. *Abby Churchill Clark.* Copy of painting by Manuel De Franca. Half plate, 1853. MHS. Gift of Mrs. Harry N. Seeley.

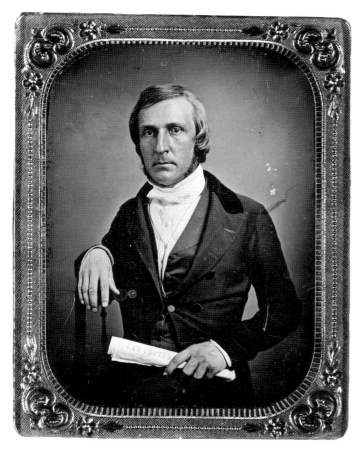

Fig. 2-6. *Rev. William S. Potts.* Quarter plate. MHS.

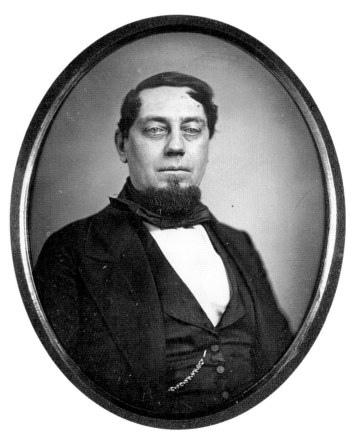

Fig. 2-7. *Samuel Gaty.* Oversized quarter plate. MHS.

Fig. 2-8. *Zachary Taylor* (copy plate). Sixth plate. MHS. Plate inscription: Gen. Taylor.

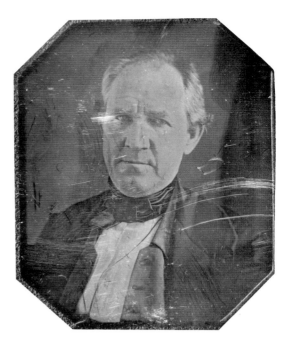

Fig. 2-10. *Sam Houston* (copy plate). Sixth plate. MHS.

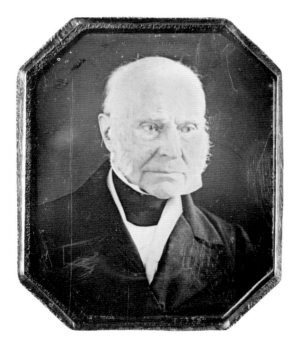

Fig. 2-9. *John Quincy Adams* (copy plate). Sixth plate. MHS.

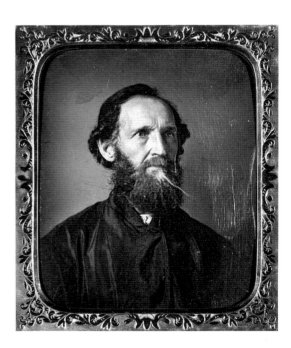

Fig. 2-11. *Thomas (Stonewall) Jackson* [?] (copy plate). Sixth plate. MHS.

During a period when hero-worship was a national pastime, portraits of illustrious personalities, especially political and military figures, were coveted commodities. Daguerreans quickly tapped this market, responding in an important new way to a need previously answered by written biographies and engravings or lithographs. Mathew Brady launched one of the most ambitious projects along these lines in 1850 when he published the "Gallery of Illustrious Americans," a series of lithographs based on his daguerreotype portraits of prominent political figures. John Plumbe in Philadelphia and Edward Anthony in New York had earlier undertaken similar projects. Because the daguerreotype's delicate surface did not lend itself to a process for making multiple prints directly from the plate, artists transferred the images secured with the camera onto traditional printmaking surfaces. Despite certain artistic transformations that could occur in the process of copying, a portrait based on a daguerreotype had substantial appeal because of what was perceived to be its closer proximity "to nature."

The practice of re-daguerreotyping original and copy plates provided a steady source of income for the fortunate photographer who had firsthand access to the celebrated faces of his time. As other daguerreans eagerly purchased copy plates, usually making their own set of saleable duplicate images, the likenesses of midcentury heroes made their way into gallery displays across America. In this process of distribution, the original creator by default lost his claim to authorship. This circumstance has resulted in a preponderance of historically significant portraits which today bear the caption "daguerrean unknown."

Perhaps because of the pride that he took in his own work, Easterly's stock of distinguished notables included very few images appropriated from other daguerrean studios. Among the hundreds of plates in the Missouri Historical Society's collection, fewer than a half-dozen portraits appear to be copy plates. It is certain that his portraits of Zachary Taylor (fig. 2-8), John Quincy Adams (fig. 2-9), and Sam Houston (fig. 2-10) are re-daguerreotyped images, as the top edges of the original plates are clearly visible in Easterly's reproductions. It is also highly unlikely that Easterly was the original author of the image that bears the questionable "Thomas 'Stonewall' Jackson" inscription on the verso of the plate (fig. 2-11).

If the average citizen found Easterly's exhibit of daguerreotyped luminaries a reassuring endorsement of his talents, the firsthand experience of a sitting in his gallery left little doubt that he applied the same high standards to every portrait that left his establishment. He was frequently praised in the local press as an artist whose likenesses produced "faithful and natural representations of the originals." While these superlatives quickly became clichés in the promotional literature of his trade, in Easterly's case they were well-deserved commendations.

By simply relying on the mechanical facility of the camera, most daguerreans could guarantee customers a certain degree of faithfulness in their productions. The "natural presentation" associated with a relaxed posture and responsive expression was far more difficult to deliver. Understandably, few individuals felt at ease facing the mysterious mechanical apparatus in the unfamiliar setting of the daguerrean's gallery. Metal head braces designed to secure a stabilized posture added to their discomfort. Under these trying circumstances, many early patrons responded to the camera with vapid, mask-like expressions which communicated little more than the sitter's steadfast resolve to endure the trying experience at hand.

Easterly's proficiency at capturing more animated and apparently fleeting expressions was in part a result of his ability to facilitate a minimal period of exposure. From the outset of his career, he had emphasized the importance of reducing exposure times. One of his earliest advertisements warned against the dismal result when sitters were "required to keep a steady look and fixed expressions for one, two, and three minutes." The advertisement went on to suggest that the accomplished daguerreotypist consciously worked to avoid "the frowning brow, intense stare, and rigid outline" which were the inevitable outcomes of such lengthy exposures.[11] While exposure times varied depending upon weather, time of day, and sensitivity of the plate, three to forty seconds would have been a typical exposure for such an experienced and competent practitioner as Easterly.

In contrast to many of his competitors, Easterly was clearly adept at easing the anxieties of his patrons. Only an easy rapport with the photographer could have elicited the spirited expression that strikes us in his remarkably fitting portrayal of Dan Rice (Plate 22), the famous clown whose riverboat circus delighted American audiences for decades. The unidentified man with the shock of tousled hair (fig. 2-12), whose dandyish attire so well suited his impish expression, and a young woman posed with a basket (fig. 2-13) appear equally at ease and responsive in the daguerrean's presence.

While such easy displays of cheerfulness were distinctive achievements during the daguerrean era, Easterly was equally skillful in capturing the personalities of his more serious-minded patrons. His characterization of the indomitable Rev. Artemus Bullard (Plate 6) substantiates accounts of the minister's awesome presence at the pulpit. In the same forthright manner, Ernst Angelrodt (Plate 1), with his unflinching gaze and posture of rigid authority, communicates a persona well suited to one of St. Louis' first self-made millionaires. Angelrodt's staunch demeanor

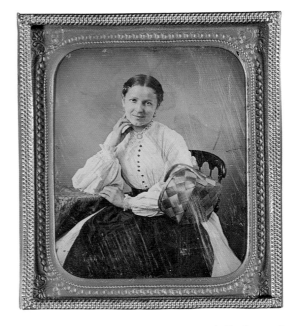

Fig. 2-12. *Unidentified Man.* Quarter plate, c. 1847. MHS.

presents an interesting contrast to the gentle and sensitive temperament revealed in Easterly's portrait of Rev. William Greenleaf Eliot, St. Louis' eminent Unitarian clergyman, educator, and social reformer (Plate 11). Eliot's wistful look and weary eyes project the deep compassion that inspired his long career as a reformer and humanitarian.

As these works suggest, Easterly's "likenesses" presented more than a minutely rendered transcript of face and physique. With a combination of skills and sensitivity rarely displayed in this early process, he was able to evoke and preserve that elucidating moment when expression and demeanor reveal the sitter's view of himself and the world around him. Such men as Dan Rice, Ernst Angelrodt, and the intimidating James Kirker (Plate 17) assert their self-confidence and aggressive personalities with a startling, lifelike intensity. Indeed, by 1847, as his works of that year indicate, Easterly was consciously engaged in "making" rather than "taking" a portrait. In his early efforts to extend the daguerreotype likeness beyond a literal transcription of corporeal fact, he was among the first of his profession to demonstrate that the sensibility of the individual behind the camera could bring an expressive dimension to the products of a chemical-mechanical process. Among numerous Easterly plates that qualify as early masterpieces of expressive portraiture are

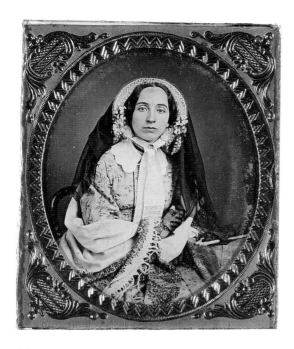

Fig. 2-14. *Anna Miriam Bailey Easterly.* Sixth plate, c. 1850. MHS.

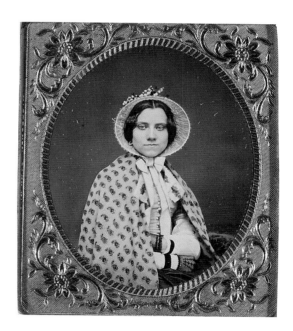

Fig. 2-16. *Unidentified Woman with Printed Shawl and Bonnet.* Sixth plate. MHS.

those of Colonel John Lehmanowsky (Plate 18) and "Mountain Spy and Guide" Thomas Forsyth (Plate 12).

Easterly's ability to abstract the distinctive personalities of his subjects did not go unnoticed by local observers. Writing in the summer of 1847, the editor of the *Reveille* declared Easterly "the unrivalled daguerreotypist."[12] Such unrestrained enthusiasm was well deserved, coming as it did in response to a portrait of the legendary Indian fighter, James Kirker, one of the most colorful and controversial frontier heroes of the period. In striking contrast to the many vacuous daguerreotyped faces produced by less talented daguerreans, Kirker's wary expression betrays the surly temperament beneath his weathered countenance. Even today, we can marvel at Easterly's ability to capture a momentary response that so vividly conveyed the aggressive disposition of the mountain man who came to be called "The King of New Mexico" for his daring exploits against the Apaches.

Easterly's portraits of women avoid such forceful and vigorous expressions, displaying instead a consciously underscored mood of tenderness consonant with period standards. As ambitious daguerreans sought a pictorial equivalent for Victorian ideals of femininity, the qualities of grace, elegance, and passive acquiescence became the agreed-upon attributes in portraying the fairer sex.

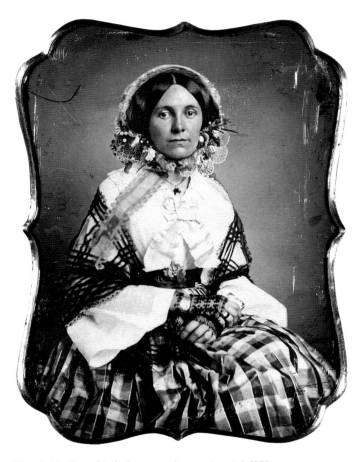

Fig. 2-15. *Cora Vail.* Quarter plate, c. 1854. MHS.

The photographer's wife epitomized these qualities. At twenty-four years old, Anna Miriam Bailey had given up a teaching career to marry the daguerrean, who was nearly twenty years her senior. In many charming portraits he revealed his pride in her striking appearance and graceful manner. One of his earliest records of his wife (fig. 2-14), made not long after their marriage in 1850, presents her looking directly at the camera in the three-quarter-length pose that he favored for youthful and attractive female subjects. As Miriam's carefully coordinated costume suggests, clothes were an important ingredient in Easterly's vision of feminine elegance. Meticulously arranged walking veils, ribboned bonnets, and fancy shawls enhanced the stately yet feminine presence of his patrons. If Cora Vail, pictured by Easterly in a portrait of about 1854 (fig. 2-15), was not naturally endowed with these qualities, she became the picture of midcentury gentility with her delicate features framed by an ornamented gossamer bonnet. Such elaborate ensembles of promenade attire served other purposes as well. As suggested in his charming presentation of a young woman wrapped in a printed shawl (fig. 2-16), Easterly delighted in the daguerreotype's ability to delineate the smallest details with microscopic precision. His eye for the intricate patterns and rich textures that so beautifully demonstrated this highly regarded property of his medium is equally apparent in his portrait of a man wearing a lamb's wool coat (fig. 2-17).

On the rare occasion when a female patron's natural beauty left little room for improvement, Easterly eliminated more lavish ornamentation. Indeed, the striking appearance of the unidentified woman with the beaded coiffure (fig. 2-18) needed no extraneous enhancement. In one of the most exquisite images in nineteenth-century portraiture, Easterly created a work that finds its closest parallel not in photography but in the painting of J. A. D. Ingres, the master of French neoclassical portraiture. Ingres, the consummate draftsman, executed his distinctive portraits of cool, aristocratic beauties with a meticulous "photographic" technique that erased all traces of brushwork. Like Easterly, the painter often dramatized the elegance of his female sitters by setting gracefully curving contours against an unobtrusive neutral background. Easterly's portrayal is in one regard even more arresting than the creations of his French contemporary. While the daguerrean's presentation was carefully fashioned to accentuate his patron's attractive appearance, his medium could not polish and perfect nature's handiwork. Numerous strikingly handsome females among Easterly's work (figs. 2-19, 2-20), all presented with the same elegant simplicity, could easily take a place alongside Ingres' repertory of European sophisticates.

When individual character rather than physical appearance captured Easterly's interest, he took a less conventional approach to picturing his female subjects. A particularly sensitive portrayal of his wife (fig. 2-21), made during the early years of their marriage, seems to imply such an intention. Compared to the portrait which presented Miriam Easterly as a fashionably attired symbol of Victorian elegance, this second work pictures his wife bareheaded and simply dressed. It is a far more discerning characterization of the introspective and intelligent woman who shared the daguerrean's life for more than thirty years. To emphasize her high forehead and aquiline nose, features particularly appealing to Victorian observers, he directed her gaze away from the camera in a pose that also communicated her shy and gentle nature.

Late in his career, in a discussion with his brother-in-law, Dr. Norton S. Townshend, Easterly shared the convictions that produced his striking character studies. Townshend's recollections of that exchange, recorded in a diary entry of June 11, 1865, provide an insightful summary of the principles that guided the daguerrean's studio practice:

> Evening at Mr. Easterly's
> His system the best [I] ever saw
> 1st fundamental notion
> Not follow _____ artificial style alike for all but
> improve all without destroy[ing] individuality
> 2. Look before instead of after.[13]

Easterly's ambition to "improve all" may account for the relatively few young children that appear among his many surviving portraits. During a technological era when the only practical method of photography discouraged the participation of amateurs, parents who wished to record the faces of their children were solely dependent on the professional gallery. Daguerreans eagerly competed for this profitable market. The more confident cameramen emphasized their exceptional skills in this category of portraiture, and some of the most prosperous establishments even featured specially equipped "Children's Daguerreotype Rooms." Gallery advertisements routinely informed the public of the special midday hours when light conditions were most favorable for securing likenesses of youngsters.

Easterly's attitude toward this line of work was probably consistent with sentiments expressed in Marcus Root's advice to early photographers. Root noted that a "considerable sacrifice" was called for in making portraits of children. The solution he proposed was a relaxation of the standards that ideally guided the aspiring photographer: "Such pictures, though not very creditable to the heliographer [if] regarded solely as specimens of art, are, if perfectly truthful, highly acceptable to parents."[14]

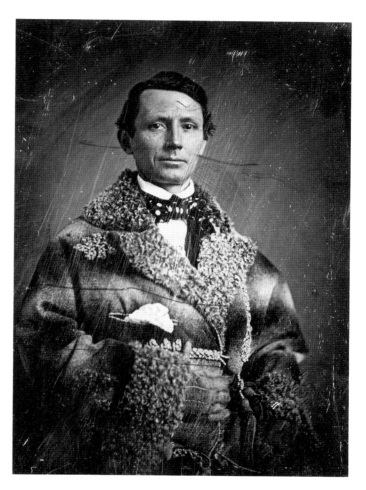

Fig. 2-17. *Unidentified Man in Lamb's Wool Coat.* Quarter plate. MHS.

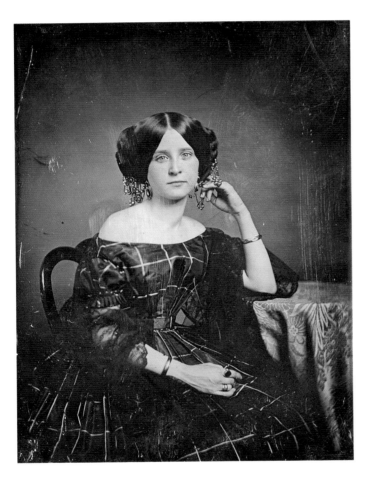

Fig. 2-18. *Unidentified Woman with Beaded Coiffure.* Quarter plate. MHS.

Fig. 2-19. *Unidentified Woman in Black.* Sixth plate. MHS.

Fig. 2-20. *Unidentified Woman with Velvet Drape.*
Sixth plate. MHS.

Fig. 2-21. *Anna Miriam Bailey Easterly.* Oversized quarter plate,
c. 1854. MHS.

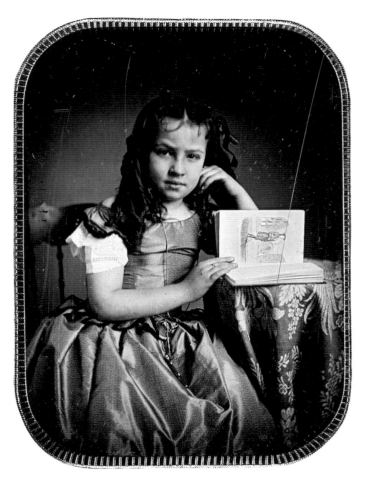

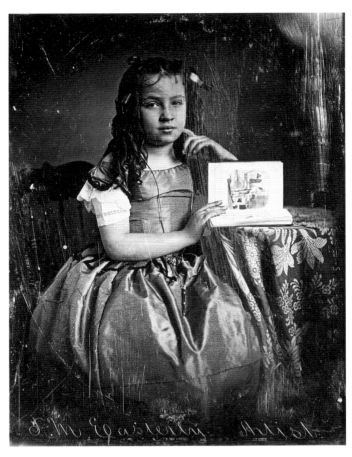

Fig. 2-22. *Unidentified Girl with Open Book.* Quarter plate. MHS.

Fig. 2-23. *Unidentified Girl with Open Book.* Quarter plate. MHS. Plate inscription: T.M. Easterly Artist

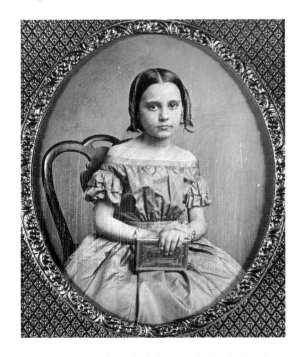

Fig. 2-24. *Unidentified Girl with Curls Holding Book.* Sixth plate, c. 1855. MHS.

Easterly's skillfully crafted portraits of the unidentified young girl with the book (figs. 2-22, 2-23) may well have been demonstration pieces conceived to challenge the notion that youthful subjects were anathema to artistic aims. Making the most of the child's remarkable patience during what must have been quite a lengthy sitting, he exposed several plates, showing her seated and standing, while altering the lighting for each presentation. His methodical decisions, addressed at more than the rendering of a "perfectly truthful" likeness, produced a "specimen of art" that the daguerrean considered worthy of the signature "T. M. Easterly, Artist." He achieved equally pleasing and occasionally quite striking results with similarly cooperative youngsters (figs. 2-24, 2-25).

When other children sat for Easterly's camera, he apparently deemed the results less worthy of his signature. We can agree that the grim expression of the infant (fig. 2-26) who sits squeezed into submission by his visibly tense mother hardly reflects the daguerrean's usual standards. Such portraits indicate that at times Easterly, like the rest of his profession, found it necessary to make the "considerable sacrifice" that Root equated with the experience of photographing children.

While publicly asserting their eagerness to accommodate the demands of parental devotion, Easterly's colleagues in St. Louis apparently shared his aversion (if not his degree of resistance) to what they described as the "uncertainties" involved in recording the likenesses of children. In an interesting collective measure, taken in March 1858, local daguerreans adopted a citywide policy raising their prices for portraits of children. Reporting on the "Daguerreans Strike," the *Missouri Republican* published the newly adopted policies: "Resolved. That we the undersigned artists of St. Louis deem it but just (owing to the many difficulties, uncertainties, and perplexities of making pictures of young children) that we should have a fair and reasonable compensation for our time, labor and patience, mutually agree on and after April 1, 1858, to take no pictures of children three years of age, and under, for less than $4."[15] A dozen daguerreans, including Easterly, were among the "undersigned artists" who proposed to adopt the four-dollar minimum fee. A second, more forbearing group in the same article informed the public that a three-dollar minimum for children's likenesses would be the rule at their establishments.

Although most of Easterly's portrait work fell within the norms of his profession, he occasionally set out to accomplish objectives that were considerably less conventional. What we now view as some of his most compelling images, such as the Kirker and Forsyth images, were by-products of his goal to expand the standard iconography of the daguerrean's gallery practice.

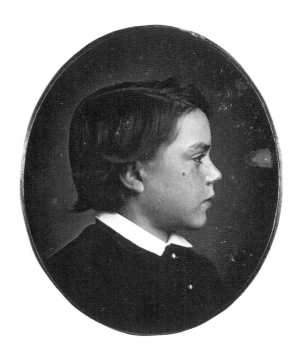

Fig. 2-25. *John O'Fallon Clark.* Sixth plate, 1855. MHS.

Fig. 2-26. *Unidentified Woman and Frowning Baby.* Sixth plate. MHS.

Fig. 2-28. *Unidentified Black Man.* Sixth plate. MHS.

Fig. 2-27. *Unidentified Black Man with Goatee.* Quarter plate. MHS.

We can assume that his portraits of two anonymous black men may have been inspired by that same ambition.

These unusual works (figs. 2-27, 2-28), presumably made at the daguerrean's request, are interesting both as arresting images in themselves and as striking departures from popular artistic norms of the time. It seems highly unlikely that these sitters, who were probably among the many free blacks earning pennies a day as laborers on the levee, could have afforded the luxury of a three- or four-dollar daguerreotype portrait. During the 1850s, when Easterly probably recorded these subjects, blacks had become standard subjects in the repertoire of picturesque and rustic themes popularized by American genre painters. The strong nationalistic impulse operative in America during this period had given rise to a healthy market both in literature and art for subjects that had come to be associated with the distinctive character of American life. Building on the comic stereotype created by the popular and ubiquitous black-faced minstrel, artists such as William Sidney Mount and James Clonney often depicted blacks as jovial jesters or colorful entertainers content with their lot in society. If Easterly's portraits were an attempt to explore that genre, the outcomes represent a dramatic contradiction of that romantic conception. Giving full play to the objective eye of the camera, he made no effort to temper the stern expressions that nullify all associations with the rustic or picturesque. Together the men's solemn stares and shabby clothing communicate the grim reality of their status in antebellum America. In graphically

conveying his subjects' dehumanized existence, these images rank among the first starkly realistic portrayals of the black man in nineteenth-century American art.

By contrast, the more conventionally genteel portraits among Easterly's work recall the comfortable lifestyle of St. Louis blacks such as Robert Wilkinson (Plate 25), whose economic prosperity certified their membership in the elite group of free blacks known as "the Negro Aristocracy of St. Louis."[16] During the heyday of Easterly's process, when the phrase "as ugly as a daguerreotype" was frequently a well-founded adage, Wilkinson's pleasant, dignified expression exemplified the quality of work that brought a steady stream of patrons to Easterly's gallery.

Few among his clientele may have fully appreciated the role that artistic judgment played in the daguerrean's success. His *modus operandi*, so succinctly summarized in the prescript "look before instead of after," involved far more than simply perusing the image registered on the ground glass of his camera. Fully aware that the nature of his medium rarely accommodated the fortuitous accident, Easterly was methodical, uncompromising, and sure of his means in the studio setting. At its best, his portraiture is distinguished by a sophisticated and studied simplicity that accentuates the unique graphic powers of the daguerreotype medium. The decisions he made when composing the portrait were calculated to achieve those effects.

The scrupulous attention that Easterly gave to positioning the figure on the ground glass could be expected. Professional advice on the artistry of daguerrean portraiture focused on the sitter's "attitude" or "arrangement." A popular handbook on daguerreotyping summed up the importance of this feature: "It is acknowledged that ease and grace in the position adds one-half to a fine picture. No matter how successful the chemical effect may have been, should the image appear stiff and monument-like in position, all is lost."[17] The same expert warned professionals to ignore patrons who expressed a personal preference for how their portraits should be taken.

Like other discerning daguerreans, Easterly frequently positioned his subject with one shoulder at a slight angle away from the camera to enhance the illusion of depth in the picture (fig. 2-29). For the same effect, he rarely aligned the head and body. When he did arrange the sitter with both body and face squarely facing the lens, Easterly made the individual's natural demeanor his overriding consideration. As he rightly determined, the commanding presence of Ernst Angelrodt (Plate 1) was dramatically conveyed by a forceful, straightforward encounter with the camera. Similarly, a less imposing portrayal of Luther Shreve (fig. 2-30), well known for his intimidating tactics in St. Louis courtrooms, might have diminished the attorney's natural assertiveness. Ignoring standard advice to

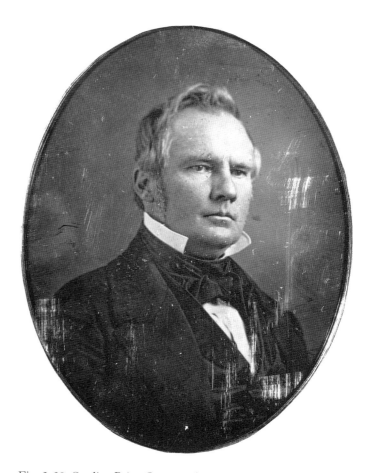

Fig. 2-29. *Sterling Price.* Quarter plate, c. 1850. MHS.

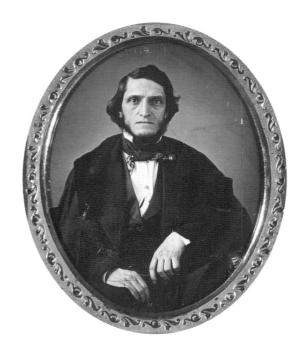

Fig. 2-30. *Luther Shreve.* Sixth plate. MHS.

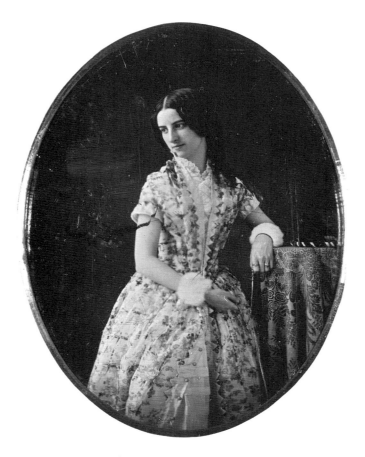

Fig. 2-31. *Unidentified Woman with Fur Cuffs.* Oversized quarter plate. MHS.

daguerreotypists, Easterly instructed his subjects to look squarely at the camera, their penetrating gazes contributing to the impact of their confrontational postures. Marcus Root, like most recognized authorities, warned that "eyes directed to the lens produced lifeless states" or, at best, "dissatisfied or dolorous expressions."[18] With quite the opposite results, Easterly repeatedly used eye-to-eye contact to reinforce a lifelike intensity in his subjects. Only occasionally, as seen in one of his few portraits that picture a single, standing figure (fig. 2-31), did he use an averted gaze to create a more pensive moment.

For the less confident practitioner, how-to manuals offered numerous guidelines for composing the figure on the sensitized metal plate. For example, the waist-length view was considered suitable for gentlemen "only sometimes," but superior for ladies "almost always."[19] In Easterly's practice, such prescribed conventions played a minimal role. Fully aware that the hands and posture of the upper body could provide valuable clues to the personality of his sitter, he frequently elected the waist-length view for male and female patrons alike. When a three-quarter-length or bust portrait seemed more suitable, he was equally at ease working with those formats.

Only the full-length composition is notably absent from Easterly's otherwise versatile approach to picturing his subjects. His decision to avoid recording the complete figure is not surprising, since he generally executed his studio work in the standard "miniature" sizes, with a notable preference for quarter-plate (4 $\frac{1}{4}$" x 3 $\frac{1}{4}$") portraits. He also used the smaller and much more widely employed sixth-plate (3 $\frac{1}{4}$" x 2 $\frac{3}{4}$") size. While his competitors in St. Louis willingly produced full-length portraits in these miniature formats, Easterly probably determined that such images offered little beyond a diminutive display of posture and props. He likely had little interest in making distant and inherently decorous compositions that diminished individuality or expressive content.

In every aspect of "arranging" the portrait, Easterly's taste for a minimum of artifice consistently emerges as a determining factor. He favored simple, unconstrained poses that sustained a potent sense of reality and human presence. In much of his work, arms fall naturally at the subject's side with hands resting in the lap, unobtrusively conveying the inner grace or natural composure of the sitter (fig. 2-32). When making double or group portraits, categories that appear relatively infrequently in his work, he showed the same skill in directing seemingly unaffected gestures intended to convey a psychological as well as a physical relationship between or among the sitters (figs. 2-33, 2-34, 2-35). The infrequency of his digressions toward less passive postures suggests how thoroughly he understood and employed the expressive potential of the most subtle physical gesture.

Fig. 2-32. *Mr. and Mrs. Charles Humes.* Quarter plate. MHS.

Only five plates among Easterly's known works picture the subject with one arm raised to rest on the chair back. His portrayals of George H. "Yankee" Hill (Plate 15), Leon Giavelli (Plate 14), and Noah Ludlow (fig. 2-36) share this distinction. They also shared the honor of being popular theatrical figures. The informality suggested by their slightly leaning postures clearly signaled the debonair and easy manner of individuals accustomed to the limelight. The same quietly cavalier gesture suited Easterly's expressive intentions in his portrait of J. M. White (Plate 24), another subject who falls outside the category of the average St. Louis citizen. Although White sits more rigidly upright than Hill and Giavelli, he displays the same imperturbable aplomb as he rests his arm on the chair back. Coupled with the sitter's forceful gaze, such a seemingly minor directive as the position of an arm masterfully communicated the intrepid character of the New Mexico trader. White's regular treks across the perilous western plains would have been unthinkable to less self-assured or adventurous individuals.

Fig. 2-33. *William Wiesenfels and His Son.* Quarter plate. MHS.

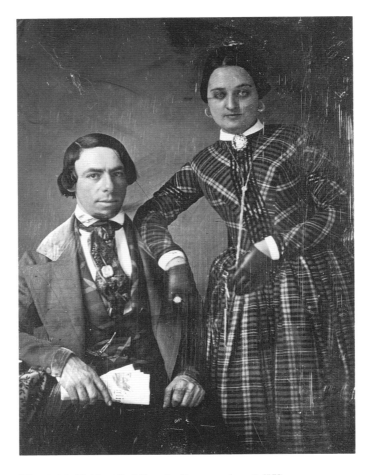

Fig. 2-34. *Unidentified Couple.* Quarter plate. MHS.

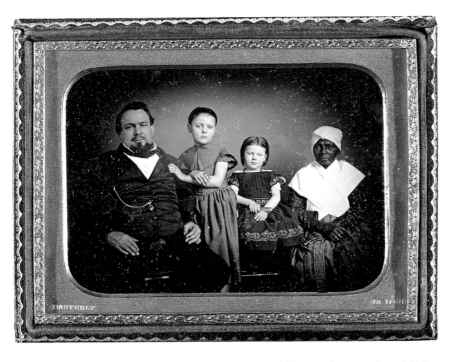

Fig. 2-35. *Southern Man, His Two Daughters, and Nanny.* Quarter plate, 1848. Collection of the J. Paul Getty Museum, Malibu, California.

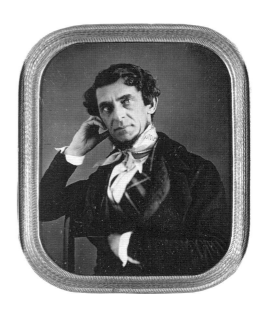

Fig. 2-36. *Noah Miller Ludlow.* Sixth plate, c. 1848. MHS.

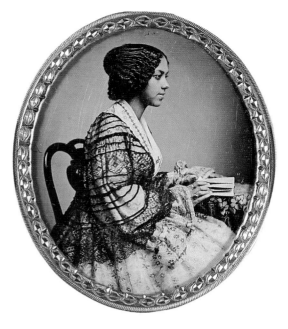

Fig. 2-37. *Unidentified Young Black Woman* (profile). Sixth plate. MHS.

Fig. 2-38. *Unidentified Young Black Woman* (frontal view). Sixth plate. MHS.

Fig. 2-39. *Mary Lang Bailey.* Sixth plate, c. 1852. MHS.

Fig. 2-40. *Sara Malinda Bailey.* Sixth plate, c. 1852. MHS.

When daguerreotyping female patrons, Easterly's experiments with more unusual "arrangements" were largely confined to the profile portrait—an uncommon feature in Easterly's work and in daguerreotype portraiture generally. Since most early photographers relied on a head brace, they opted for a side view of their sitter only when it served to conceal such physical defects as crossed eyes or other obvious discrepancies in the two sides of the face. For Easterly and a few other talented daguerreans, this approach to picturing his subject could accommodate other, more ambitious goals as well.

With carefully selected sitters, the profile pose allowed Easterly the opportunity to explore more purely artistic motives, as he did in two stunning works, the portraits of Lola Montez (Plate 21) and an unidentified young black woman (fig. 2-37). Both are subjective interpretations, consciously romantic in mood. The ethereal quality implicit in the profile pose sets the emotional tone in both pictures. Easterly's portrayal of the young black woman, with her delicate beauty accentuated by the flawless contours of her features, evokes a methodically constructed mood of tenderness and reverie. A soft, uniform light crystallizes his subject's profile to create a paradigm of innocence and beauty. The outcome was no less arresting when he made a second exposure picturing her in a more conventional frontal pose (fig. 2-38).

To capture the sultry beauty of the actress Lola Montez, Easterly created a more dramatic and mysterious ambience, again using the ethereal effect of the profile pose. There is surely no hint of wistful innocence in this portrayal of a woman whose notorious love affairs and unconventional lifestyle frequently received more attention than her famous Spider Dance. The personality of the audacious performer was never more aptly recorded. Other early photographic portraits of Montez, such as the well-known daguerreotypes by Southworth and Hawes, present a sophisticated but notably demure lady whose stormy disposition and flair for the histrionic are obscured by genteel, decorous poses. Only the cigarette that Montez held for one of the Southworth and Hawes portraits signaled her indifference to conventional midcentury modes of female behavior.

Easterly's efforts to avoid the distractions of pretentious or theatrical poses were consistent with his preference for simple, unadorned backgrounds. In line with the purist sensibility that prevailed in his portraiture, he did little to dispel the impression of the setting as a empty enclosure dominated by the presence of the subject. Even those who shared his ambitions for daguerrean art did not always share his taste for such starkly neutral settings.

By the early 1850s, the commercial manufacture of studio columns and pedestals signaled the popularity of such background accessories in the aspiring daguerrean's gallery. These classical accoutrements, often accompanied by cascading drapery in the background, had long served painters both as compositional elements and as symbolic references to antiquity thought to enhance the dignity and status of the subject. By appropriating these conventions, Easterly's better-remembered contemporaries, such as Gabriel Harrison, Alexander Hesler, and Southworth and Hawes, hoped to strengthen associations between photography and the art of painting.

Easterly appears to have made few experiments along these lines. Only twice among his hundreds of surviving portraits do we see an overt attempt to borrow from those inherited traditions. In a pair of portraits picturing his wife's younger sisters, Mary Lang Bailey and Sarah Malinda Bailey (figs. 2-39, 2-40), he used a background that incorporated a classical column. Why he made the effort to secure a painted backdrop, only to discard it after recording the Bailey sisters' portraits, remains a mystery. Quite possibly he found such an artificial embellishment inconsistent with the inherently factual nature of the photographic process.

If Easterly showed little interest in relieving the austerity of an unadorned background plane, he skillfully but sparingly made use of props in composing half-length or three-quarter-length portraits. Most often, a conspicuously empty tabletop and a portion of a chair back were his only visual embellishments. The small table covered with a patterned cloth, serving both as a decorative element and as a brace for the sitter's arm or elbow, is the hallmark of daguerreotype portraiture. For Easterly, the vertical and horizontal configurations of the cloth-covered table also stabilized the composition by locking the figure into an ordered arrangement of forms. When he incorporated an additional object into his portraits, a small, unobtrusive book was his favorite accessory. As daguerreans in all classes of the trade seemed to agree, the book provided a pleasing visual accent (fig. 2-41) and a simple solution to the problem of fidgeting fingers.

Looking to long-established practices in portrait painting, critics promoting the artistic potential of daguerreotype portraiture frequently suggested that books and similar props could convey such attributes as superior intelligence or scholarly interests; accessories could also denote the social status or occupational skills of the subject. Rarely do the objects included in Easterly's portraits appear to carry such symbolic connotations. Most often they function simply as visual elements intended to add interest to the overall design.

When Easterly did give a more prominent role to accessories, his experiments had mixed results. The curious but interesting double portrait of Ann Rigdon

Fig. 2-41. *Unidentified Black Woman with Book.*
Sixth plate. MHS.

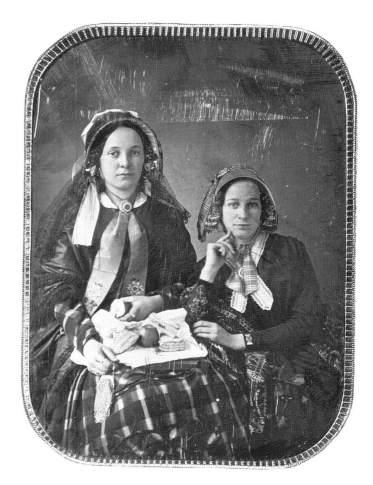

Fig. 2-42. *Ann Rigdon and Elizabeth Altemus.* Quarter plate,
c. 1850. MHS.

and Elizabeth Altemus (fig. 2-42) represents his most ambitious effort to use props to alter the reality of the studio setting. Mrs. Rigdon is shown with an array of sandwiches and an apple carefully poised on the linen napkin that covers her lap. While her attractive companion seems somewhat more comfortable with the notion of a cozy picnic arranged for the camera, Mrs. Rigdon's role as an active participant in the event is less convincing. Indeed, she seems almost as inanimate as the objects she displays. If Easterly was aiming at a "fancy piece" rather than a conventional portrait in this work, it was an isolated episode in his lengthy career.

In contrast to this uneasy association of actors and props, Easterly's use of an extraneous object in his portrayal of an unidentified man (fig. 2-43) effectively conveys the impression of a casual activity. In this engaging work, the intent sitter is absorbed in the act of reading a letter or document. Without the usual pretensions of a directed production, Easterly has created a contemplative mood, a seemingly private moment that dispels the sense of a subject self-consciously performing for the camera.

When Easterly daguerreotyped Eliza Angelrodt (Plate 2), his masterful use of props achieved the same kind of unaffected presentation. Needles and a half-finished stocking in hand, Mrs. Angelrodt appears to pause in the act of knitting. A decorative basket holding a ball of yarn rests on the table beside her. As an integral element in a carefully ordered pyramidal structure, the basket's curved handle echoes the contours of the bonnet and chair back

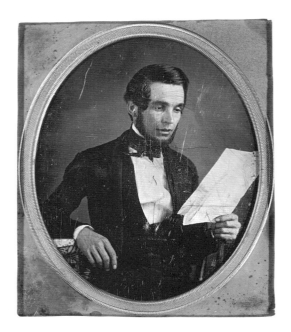

Fig. 2-43. *Unidentified Man Reading Letter.*
Oversized quarter plate. MHS.

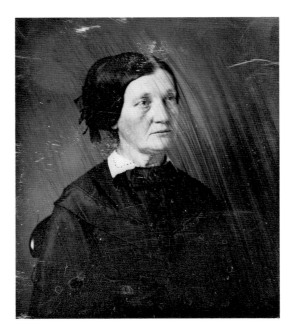

Fig. 2-45. *Margaret Bailey Townshend.* Sixth plate,
1865. MHS.

Fig. 2-44. *Margaret Bailey Townshend.* Sixth plate,
1865. MHS.

while the pale stocking punctuates the broad, dark form of the skirt. These objects, combined with Mrs. Angelrodt's kindly, responsive expression, also contribute to the striking naturalism of the work. The gentle-natured German immigrant, one of St. Louis' most gracious hostesses, seems so remarkably at ease that we might believe she was knitting in her own parlor when this exceptional portrait was recorded.

Easterly's controlling presence behind the camera, so strongly felt in his meticulously ordered compositions, is equally apparent in his skillful handling of light. While there are no accounts to provide specific details on the lighting conditions in his gallery, we can assume that the circumstances under which he worked were much like those in other first-class establishments.

When Easterly returned to settle permanently in St. Louis in 1848, the *Reveille* reported that he had taken over John Ostrander's rooms located upstairs in a two-story building at 104 Olive Street. As was customary in his profession, his gallery was on the top floor of the building where he had access to a skylight. Although Easterly did not mention this feature in his advertisements, his colleagues in the local daguerrean community placed considerable emphasis on this asset in the names of such establishments as "West's Skylight Gallery" and "Fitzgibbon's Great Sky Light Daguerreotype Rooms."

Since sunlight provided the pioneer photographer's only source of illumination, weather and atmospheric conditions significantly affected his business. Skylights, ideally with a northern exposure, increased the amount of light available and prolonged the daguerrean's working hours. The diffused light from this overhead source combined with more direct rays entering the gallery through one or more windows. For more subtle adjustments in lighting the sitter, accomplished practitioners used mirrors or screens covered with white muslin to direct reflected light into darker portions of the image.

Despite the numerous devices designed to control and manipulate the character of existing light, it was no simple matter to achieve the "well-toned masses of light and dark" that characterized the superior daguerreotype portrait in critical circles. Like his counterparts now considered the virtuosos of the daguerrean era, Easterly fully understood the premise underlying that phrase of approbation. "Painting with light," as London's respected daguerrean Antoine Claudet described his process, only fully displayed its special beauty when the medium's most unique properties—microscopic detail and infinitely delicate gradations of halftones—were explicitly realized.

Easterly demonstrated those properties with the acumen and simplicity that denote the master photographer's eye for effective lighting. Fully aware that overtly dramatic lighting could undermine the revered descriptive character of the portrait, he rarely deviated from a system of lighting designed to achieve readily visible detail in both the shadow and highlight areas of the picture and a convincing illusion of plasticity in the forms and features of his subject. When atmospheric conditions permitted, he accomplished these goals by daguerreotyping his subjects illuminated by a diffuse, even light that eliminated sharp tonal contrasts and areas of ambiguity. The all-revealing character of such effects, which allow for a wide range of tones consistent with accustomed ways of seeing, undoubtedly played a significant role in his reputation for securing "the natural likeness."

Only two portraits among Easterly's surviving plates deviate from the relatively unobtrusive mode of lighting that generally characterizes his portrait style. The hazy ambience that merged figure with ground in his profile portrait of Lola Montez appears to be his earliest experiment with the expressive potential of more dramatic chiaroscuro effects. Twelve years later, in 1865, he was even more audacious when he obscured the features of his sister-in-law, Margaret Bailey Townshend, in a uniform veil of semi-darkness (fig. 2-44). The shadowy result—a primitive precursor of turn-of-the-century pictorialist work—could easily be mistaken for a daguerreotyped copy of a charcoal drawing. A more conventional portrait of

Fig. 2-46. *Unidentified Woman and Son in Blue Velvet Jacket.* Hand-colored sixth plate. MHS.

Mrs. Townshend taken at the same sitting (fig. 2-45) suggests the systematic nature of Easterly's experiments on this occasion. While today we can appreciate the artistic thinking that produced the dramatic presentations of Lola Montez and Margaret Townshend, few of Easterly's patrons would probably have applauded such blatant digressions from expected practices.

From all indications, Easterly's usual predilection for simplicity in lighting mirrored the taste of his public. Indeed, some critics lamented that American patrons were completely unsophisticated in the matter of lighting in daguerreotype portraiture. S. D. Humphrey, for example, instructed daguerreotypists on how to obtain the "clear white but flat impression, which unfortunately is too often called for."[20]

One might expect that early photographers serving more cosmopolitan eastern cities could exercise greater latitude in experimenting with more artistic lighting systems. The experiences of Southworth and Hawes, who took pride in their ability to create "Rembrandt style" portraits distinguished by dramatic chiaroscuro lighting, suggests that that was not the case. As a letter from one of their students indicated, the partners' aspirations along this line were not universally appreciated. On the advice of Albert Southworth, daguerrean L. C. Champney had experimented with more dramatic effects when illuminating

his subjects. He reported on the outcome: "I have tride [*sic*] the light as you proposed, but they do not like the dark on one side of the face, and I can't sell a picture that where one side of the face is darker than the other, although it seems to stand out better and look richer."[21]

If the general public concluded that chiaroscuro lighting diminished the descriptive credibility of the daguerreotype portrait, the same audience was curiously inconsistent in approving hand-applied color as a significant enhancement to the "natural likeness." The practice of hand-tinting camera-made portraits had been introduced in America as early as 1842 when two Massachusetts daguerreotypists filed the first patent related to coloring techniques.[22] Over the next decade, numerous patented methods, nearly all variations on the same basic procedure, confirmed the public's enthusiastic response to colored portraits. Indeed, as one observer of the time suggested, daguerreans' efforts to modify the inherently monochromatic character of their productions "created more popular clamor than all the other improvements combined."[23] While several procedures and many variants were introduced, the standard and most widely used technique was relatively simple for those with a degree of artistic skill, including Easterly who adopted this method. Using a fine camel's-hair brush, the daguerrean added powdered pigments, mixed with a small amount of gum arabic, in the desired areas of the picture.[24] More elaborate variations on this technique made use of stencils to control the application of the pigment. Like Easterly, many daguerreans relied on their own talents in the addition of color; others hired artists to accomplish the task.

Although hand-tinted likenesses quickly became standard in the daguerrean's business, there was still considerable disagreement among professionals as to the aesthetic merits of the practice, especially when less discriminating practitioners eagerly took up the paintbrush. In an 1854 commentary on works by the Meade brothers, the *Photographic and Fine Art Journal* voiced an opinion shared by more than a few serious photographers of the time: "Although some of our first artists use the style of coloring, they must in their own minds condemn it, as they know they are working to please the bad taste of the community...."[25] In his *American Hand Book of the Daguerreotype*, S. D. Humphrey was more explicit in stating his reservations: "Of all the so-called improvements in the Daguerreotype, the coloring is the least worthy of notice. Yet the operator is often, in fact most generally, called upon to hide an excellent specimen under *paint*. I can conceive of nothing more perfect in a Daguerreotype than a finely-developed image, with clearness of lights and shadows, possessing the lively tone resulting from good gilding."[26]

Like numerous others dedicated to promoting the aesthetic virtues of Daguerre's invention, Humphrey asserted that the unique beauty of a well-made daguerreotype needed no extraneous enhancement. From a more practical perspective, though, he went on to acknowledge that "Such pictures, however, are not always had, and then color may perform the part of hiding the imperfection."[27] Many of Easterly's colleagues in St. Louis, like less technically proficient daguerreans elsewhere, followed that suggestion, often with predictably curious and synthetic results.

In the very early years of his career, Easterly may have been quite willing to accommodate the popular notion that hand-colored likenesses were more appealing and saleable commodities. In 1846, when he was traveling in western Missouri with Frederick Webb, their advertisements highlighted their proficiency in the technique of gilding the finished picture, with the added comment that "by the new process the face, dress and jewelry can be colored...."[28] At that early date, tinted portraits, particularly those that were skillfully executed, would have been a novelty on the frontier and a considerable asset to the itinerant daguerrean's business.

At the height of his St. Louis practice, the security of an established clientele allowed Easterly to define and exercise his own ideas as to what constituted a superior daguerreotype portrait. From the relatively small number of tinted plates among his surviving works, it appears that he was in sympathy with those purists who equated boldly colored portraits with inferior talent. With rare exceptions, Easterly's use of pigment was confined to a subtle, almost indiscernible flesh tint applied to the cheeks and forehead. In those few instances when color played a more prominent role in his presentation of a subject, pale glazes of blue or red gave a subtle hint of color to shawls or other articles of clothing. On at least one occasion, as suggested by his double portrait of a young boy and his mother (fig. 2-46), Easterly may have been tempted to test Humphrey's theory that a less-than-satisfactory work might be improved by the application of pigment. The obtrusive blue accent of the boy's jacket, an unusually bold handling of color for Easterly, may have been a conscious attempt to compensate for the child's scowling expression.

If Easterly was not often inclined to engage in the popular practice of coloring garments or tablecloths, he more frequently obliged the public's taste for articles of jewelry accentuated by the daguerrean's artistic touch. A number of portrait subjects among the Easterly inventory display brooches or pendants that have been meticulously outlined or accented with gold paint. The physical surface of the daguerreotype also lent itself to the practice of scratching or drilling into the plate to add an authentic

metallic character to brooches, chains, or stickpins. Experts agreed that "a small drill with a diamond-shaped point is excellent for representing brilliants in jewelry by boring slightly into the silver of the plate."[29] These tiny decorative touches were seen as elegant additions, especially to portraits of handsomely attired females. Just as they were indifferent to the often blatantly artificial character of hand-coloring, patrons appear to have been equally oblivious to the curious visual results when the conspicuous "brilliants" pulled away from the sculptural forms of the figure to sit isolated on the image surface. Easterly's portrait of the young boy and his mother illustrates the delicacy of his touch when he chose to expose the surface of the plate to give a sparkling, metallic appearance to the woman's jewelry and buttons. Among Easterly's surviving works, his Indian portraits in the Newberry Library's Ayer Collection represent his most liberal use both of color and the ornamental drilling or scribing technique.

In demonstrating what our most gifted pioneer photographers could achieve with a relatively primitive process, Easterly's studio work provides convincing evidence of the singular position that daguerreotype portraiture holds in the history of nineteenth-century photography. Technical advancements introduced in later decades did not increase the camera's potential to transcend the superficial rendering of the human physiognomy. Indeed, the techniques that displaced Daguerre's process collectively diminished the expressive power of the camera-made portrait. While a common language of postures and props imposed a degree of stylistic uniformity on daguerrean portraiture, technical progress increasingly imposed an even greater conventionality on the products of the photographer's gallery. As candid and literal reflections of the spirit of an era, the faces preserved by Daguerre's technique express the cultural climate of their time far more vividly than the standard studio portraits that have come to define later generations of nineteenth-century Americans. In his straightforward and explicit portrayals of the civic leaders and ordinary citizens of St. Louis, Easterly preserved the individuality and assertive spirit that distinguished his frontier society.

With the introduction of alternatives to the one-of-a-kind picture on silver, the insistent and penetrating realism of the daguerreotype portrait gave way to a more impersonal and congenial aesthetic. The small, fashionable carte-de-visite portraits, which popularized the distant and miniaturized full-figure presentation, subsumed the individuality of the subject in a decorous display of props and elegant apparel. The glass-plate photographer's ability to conceal physical imperfections by retouching the negative further neutralized the camera's inherent facility for scrutinous specificity.

During the decades after the daguerreotype's demise, the public made its own contribution to the increasingly lackluster character of portrait photography. What had been considered a miracle of science in the daguerrean era had become a commonplace amenity of technology. Later nineteenth-century patrons, with less veneration for the mysterious powers of the photographer, could confront the camera with a more casual and practiced air. Their faces no longer convey the intensity of expression that signals the sitter's self-conscious awareness of the camera. It was in part that apprehensive edge and its consequence of compelling immediacy that gave presence and unique pictorial vigor to the faces and figures recorded by the daguerreotype process. Easterly's striking portraits will continue to remind us of the powerful magic that was lost when new photographic technology redefined the original meaning of "the faithful and natural" likeness.

PORTRAIT PORTFOLIO

Plate 1

Ernst Carl Angelrodt

1799-1868

Quarter Plate

c. 1850

MHS

Gottfried Duden's *Letters from the Western States*, first published in Germany in 1829, described Missouri as an arcadian paradise, inspiring a large influx of Germans to come to the region. Three decades after the book appeared, forty thousand of Duden's compatriots made up one-third of the St. Louis population. Easterly recorded many of these prominent immigrants, whose mercantile activities contributed so substantially to the growth and prosperity of his city.

Few in this industrious group were as successful as Ernst Angelrodt, who came to St. Louis in the 1830s in the earliest wave of cultured, well-educated Germans. Like many of his fellow immigrants during this decade, Angelrodt had left a successful business in his homeland when his political views came into conflict with those of the reigning powers in Germany.

The Angelrodt family first settled near Wild Horse Creek in St. Louis County on a tract of more than three thousand acres. Working the land with slaves, Angelrodt raised tobacco for export to Europe. In 1832 he moved to St. Louis, where he and a partner opened a wholesale house on Main Street as "Importers of Groceries, Liquors, Wines and Segars"; their business soon prospered and expanded.

While amassing a fortune that placed him among the city's first millionaires, Angelrodt also pursued his hobby as collector of exotic American animals. On Sundays the public was invited to view his sizeable menagerie, displayed on the grounds of the mansion that he built in north St. Louis. During the winter, Angelrodt's reindeer pulled a sleigh that carried him through the streets of the city.

Along with his curious role as amateur zookeeper, Angelrodt assumed many civic responsibilities. He served as one of the early directors of the Bank of the State of Missouri, and in 1835 he became the first appointed German consul to St. Louis. A patriotic American, he served as an officer in the Mexican War, but he also maintained strong ties to his homeland. For a time in 1849 he went back to "devote himself to the achievement of Republican liberty," as the *Missouri Republican* reported.[1] After the 1853 revolution, he returned with his family to live permanently in Germany. His animal menagerie was transported to Berlin, where it made up the "Angelrodt section" of the city zoo.

Easterly's crisply textural transcription seems to validate Angelrodt's reputation as a man of energy, intelligence, and ardent convictions. His penetrating gaze, framed and accentuated by prominent spectacles, suggests that he was at ease with his powerful position in the community. Angelrodt's squarely frontal pose is equally effective in communicating the assertive character that contributed to his success.

Plate 2

Eliza Westhoff Angelrodt

1800-1872

Quarter Plate

c. 1850

MHS

Both in mood and presentation, Easterly's portrayal of Eliza Angelrodt recalls several masterful depictions of middle-aged matrons painted nearly a century earlier by the celebrated American artist John Singleton Copley. During Mrs. Angelrodt's sitting, Easterly exposed several plates, each one slightly different in lighting or pose. The work shown here, an artfully crafted impression of femininity and grace, stands in sharp contrast to Easterly's record of her husband. While he sits rigidly upright, challenging the viewer with his authoritative demeanor, his wife appears relaxed and cordial. Her slightly tilted head is a small but carefully considered adjustment in Easterly's attempt to present his subject in a dignified yet informal manner.

The daguerrean's eye for effective composition is apparent throughout this charming work. A series of curving contours, forming a graceful silhouette against the neutral background, moves the eye smoothly upward from the outer edges of the plate to the face of the primly dressed matron. The basket, which appears as a prop in a later portrait of the daguerrean's mother, is an essential element in the pictorial structure. The curve of its handle echoes the form of the chair back to provide a harmony of rhythms and a means of unifying the figure with the lateral space of the picture. In the striking naturalism of the portrait, we could easily believe that Mrs. Angelrodt, distracted momentarily from her knitting, sits presiding over the parlor of her stately mansion.

Plate 3

Theron Barnum

1803-1878

Quarter Plate

c. 1850

MHS

*S*t. Louis was noted for its first-class hotels, and Theron Barnum, proprietor of the well-known Barnum Hotel on Second Street, was among the city's most popular hosts. His impressive establishment, the first six-story building in St. Louis, symbolized progress when it was built in 1854.

Although he assumed a reserved demeanor for Easterly's portrait, Barnum apparently revealed a more congenial side to the public. One biographer suggested that he filled his role as the city's "veteran caterer for public taste" with the same "pertinacity and energy"

shown by other members of his family, including his distant cousin, the well-known showman P. T. Barnum.[2] Theron Barnum, a one-time schoolteacher, had learned innkeeping from another relative, an uncle who owned the famous Barnum's City Hotel in Baltimore.

Along with its proprietor's reputation, the Barnum Hotel offered another attraction to visitors as well. Dred Scott, the St. Louis slave who achieved national renown in his lengthy legal battle to gain his freedom, worked as a porter at the Barnum Hotel after his case was decided by the U. S. Supreme Court in 1857.

Plate 4

James Harvey Blood

1833-1885

Sixth Plate

1866

MHS

When James Blood appeared in Easterly's studio, the daguerrean could not have foreseen the eventful future that lay ahead for his sitter. As the common-law husband of Victoria Woodhull, Blood participated in a liaison that launched one of the nineteenth century's most notorious campaigns against the strictures of Victorian society.

In Easterly's portrait, the features of the thirty-three-year-old Blood are explicitly transcribed in a clean, crisp style that matches the sitter's dispassionate expression. There is no outward sign of the impetuous nature that made Blood the kindred spirit and lover of one of the period's most audacious and flamboyant personalities. The measured reserve of his expression reflects instead the seriousness of purpose with which he promoted both his own unorthodox ideas and the multifaceted career of his mistress.

Victoria Woodhull arrived in St. Louis in 1866 as part of a Spiritualist caravan that included her earthy sister, her two children, and an intemperate husband twice her age. The sisters' colorful past included a chaotic tangle of medicine shows, psychic performances, and scrapes with the law. Blood's early history is equally complicated. It has been suggested that he once operated as Dr. J. H. Harvey, "king of the medicine showmen."[3] He also claimed to have served as commander of the Sixth Missouri Regiment during the Civil War and city auditor of St. Louis. Though Blood was a veteran of the war, he apparently awarded himself the title of colonel and based his professional activities on those of distant relatives named Blood. At the time of his fateful meeting with Woodhull, he described himself as "broadminded—a Free Lover, A Spiritualist, a Communist, an Internationalist, and Cosmopolitical, the latter being a radical of extreme radicalism."[4]

An officer of the St. Louis Spiritualist Association, Blood called on Woodhull at her hotel to consult her as a "fellow physician," according to an account of the couple's initial encounter later recorded by one of Woodhull's

followers. During their meeting, Woodhull passed into a trance from which she announced that the destiny of her handsome visitor would be linked with hers. To their "mutual amazement," they were betrothed at that instant "by the powers of the air." The partners quickly became lovers, eventually divorcing their respective mates. However, Woodhull's ex-husband remained part of the touring entourage, a circumstance that added to her notoriety as "the Priestess of Free Love."[5]

Blood played a crucial role in Woodhull's life, channeling her uninhibited spirit into strident crusades for causes consistent with their shared ideal of a mystic socialist society. Her public promotion of free love and women's rights, which she advocated in lectures and writings, branded her as an immoral eccentric. Critics were also incensed by her campaigns for legalized prostitution, short skirts, and a one-world government. At Blood's encouragement, Woodhull ran for president in 1872 on the Equal Rights Party ticket.

Throughout the turbulent decade of Woodhull's prominence, Blood provided the impetus and ideology for her attacks on acceptable behavior. It has even been suggested that he authored the books and pamphlets that articulated Woodhull's positions.[6] When asked why her manuscripts arrived at the printer in his handwriting, Blood explained that Woodhull's writings were transcriptions of messages she received from Demosthenes, her "guiding spirit." Since she recounted these messages while in a trance, Blood maintained that he simply recorded her words as she repeated the spiritual communications.

Later denouncing the controversial crusades that had brought her national attention, Woodhull abandoned Blood in 1876 in an attempt to gain respectability. "The grandest woman in the world went back on me" was Blood's only response.[7] Still chasing rainbows, the man who had so ardently championed Woodhull's causes died in 1885 while on a gold-hunting expedition in Africa.

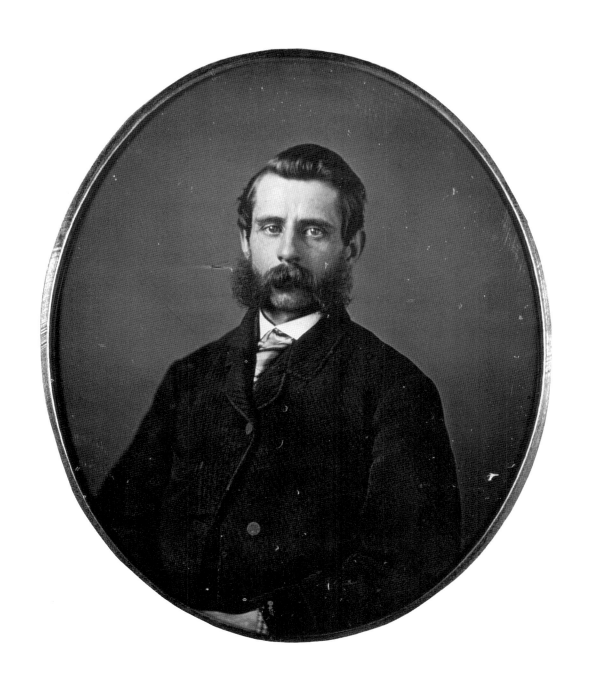

Plate 5

Thomas Booth

?-1855

Plate Inscription: T. G. Booth the Comedian. T. M. Easterly Daguerrean

Quarter Plate

1851

MHS

*I*n this image, Thomas Booth appears curiously priggish for a man who launched his theatrical career during the 1840s as a black-faced minstrel doing the "cotton plantation jig." He was one of many now-forgotten performers who practiced this popular form of entertainment, often called "Ethiopian opera," in mid-nineteenth-century America. Programs of dances, songs, and skits, performed by actors and musicians with blackened faces, exploited the fad for caricaturing American blacks.

As Booth's diffident mien in Easterly's portrait seems to imply, by 1851 he was aspiring to more exalted theatrical pursuits. That fall he made what was apparently his dramatic debut at the Bates Theatre in St. Louis with a role in *Macbeth* and a monologue comedy "afterpiece" following the performance. Although frontier critics were often more kind than discriminating, the *Missouri Republican* described the comedian as "an actor of decided merit, and deservedly a favorite in St. Louis."[8] Booth may well have been basking in the glow of such accolades when he assumed his confident expression before Easterly's camera.

Plate 6

Artemus Bullard

1802-1855

Quarter Plate

c. 1850

MHS

When Artemus Bullard, one of the most influential religious leaders on the western frontier, lectured to an appreciative audience at the World Peace Convention in London in 1850, the press was struck by his lean, angular appearance and by his good humor.[9] If Easterly's portrait of the prominent clergyman does not convey the lighter side of his personality, it surely captures the intensity of the man whose spirited sermons and lectures moved St. Louisans to take up his many causes. A tireless proponent of temperance and improved education, Bullard worked to strengthen the moral rectitude of frontier society and to expand the Presbyterian ministry to the hinterlands of the West. He was the first prominent figure in St. Louis to denounce publicly the practice of dueling, which had given the city a reputation for violence.

In 1855, Bullard joined other local dignitaries for the first train trip to Jefferson City, the state capital, on the newly opened Pacific Railroad line. But the day of celebration ended in disaster when the bridge over the Gasconade River collapsed under the weight of the train. Along with many other passengers, Bullard plunged to his death in the tragic accident. When his dynamic personality had become only a memory to his many followers, Easterly's portrait remained as a vivid and lasting testament to the preacher's commanding presence.

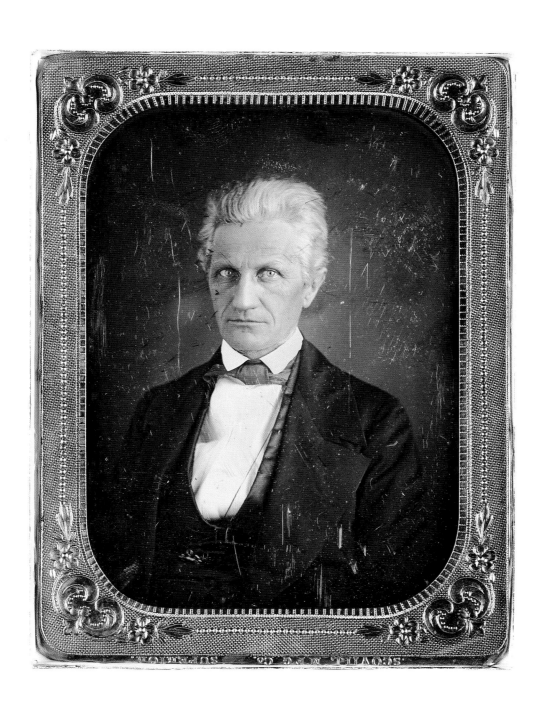

LIKENESS AND LANDSCAPE

79

Plate 7

Alexander Campbell

1788-1866

Quarter Plate

1852

MHS

Alexander Campbell, one of America's most charismatic ministers, came to St. Louis in 1852 to deliver a series of lectures to his many followers in the region. During his stay, Easterly made what is now a rare photographic portrait of Campbell, whose rustic, backwoods appearance enhanced his public appeal. He had founded the Disciples of Christ in 1827 with his father, a disenchanted Presbyterian minister; the Pennsylvania-based sect became widely known as the Campbellites. Through aggressive proselytizing, Campbell won a following estimated in 1862 at more than three hundred thousand people. Most believers lived in West Virginia, Kentucky, and Tennessee, though others were scattered throughout the West and even in England and Canada. A small group of St. Louis Disciples formed in 1837; just months before Campbell's 1852 visit to that city, this growing congregation had dedicated its impressive new St. Louis Christian Church on Fifth Street.

Campbell traveled widely throughout frontier areas, promoting ideas that challenged established Protestant doctrine. He wanted to restore apostolic simplicity to religious practice by eliminating elaborate creeds or man-made doctrine and returning to the Bible as the only guiding law. During a period in which revivals, camp meetings, and millenialism stirred the emotions of America, Campbell's evangelistic tone fueled the fires of religious fervor and rampant denominationalism. In 1845, one member of the large audience that gathered in the Kentucky countryside to hear Campbell preach recalled his first impression of the articulate Scotsman:

> We behold the great man himself seated in the first carriage. He was leaning back in his seat with an air of a magnate and a ruler of Israel. It was evident that he was a man of no common mould, his very air and bearing showed that he thought himself so, for he bowed to us with a most patronizing grace, as we passed.[10]

In Easterly's sober depiction, the aging preacher exudes that air of authority. The daguerrean also captured the rugged appearance that made the lean Scotsman a picturesque and impressive figure in the pulpit. His weathered face and shock of unruly white hair were the hallmarks of his distinctive public image.

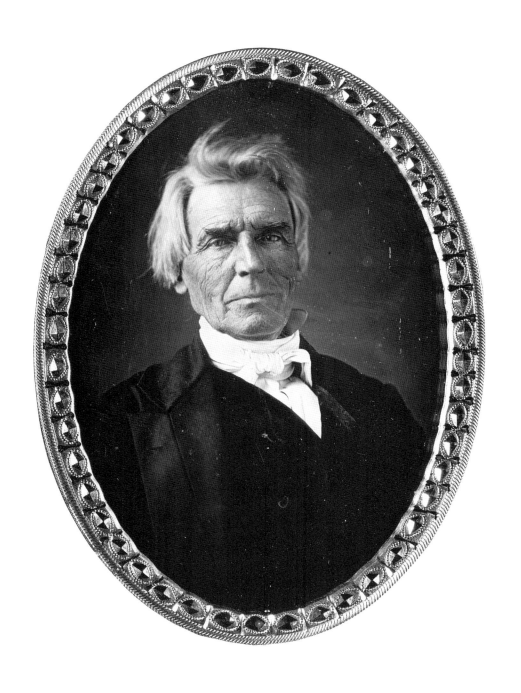

Plate 8

Meriwether Lewis Clark

1809-1881

Quarter Plate

c. 1850

MHS

Easterly's portraits of Meriwether Lewis Clark undoubtedly hung in his advertised display of "prominent citizens." Years before, Clark's father, William, had played an important role in American history. In 1804, along with Meriwether Lewis, the elder Clark had led the Lewis and Clark expedition west to seek a route to the Pacific Ocean. By 1807, William Clark was serving as superintendent of Indian affairs in St. Louis and in 1813 was appointed governor of the Missouri Territory.

Meriwether Lewis Clark followed in William Clark's footsteps with a military career that began with his graduation from West Point. After serving in the Black Hawk War in 1831, he resigned from the army two years later. During his civilian life, which was interrupted by service in the Mexican War, Clark pursued various professions. He held numerous city posts, including engineer of the city of St. Louis; he also served for a time in the state legislature. He designed the grand St. Louis Theatre, which opened in 1837 at the corner of Third and Olive streets.

This project was particularly satisfying to Clark, who may have made his most lasting contribution to St. Louis through his active support of the arts. As a student, Clark himself had shown artistic talent. His interest in drawing alarmed his superiors at West Point, who wrote his father that young Meriwether's devotion to drawing was sure to damage his eyesight.[11] In response, William Clark told his son to stop drawing, as it was "too great a risque" to his health.[12]

Despite his many interests, Clark faced personal and financial difficulties as he grew older. With the early death of his wife, Abby Churchill Clark, in 1852, the couple's seven young children were dispersed among various relatives. Clark lived in rented rooms near the St. Louis Courthouse, but his professional activities were neither stable nor regularly profitable. He spent much of his time at Minoma, the spacious country villa built by his half-brother, Jefferson Kearny Clark, who was also the guardian of Meriwether's two youngest children. After serving as a major in the Confederate army during the Civil War, he spent his last years as commandant of cadets and professor of mathematics at the Kentucky Military Institute.

Easterly daguerreotyped Clark on at least two occasions. At what appears to be the earlier sitting—which probably occurred before the death of his wife—the camera is placed closer to the subject, showing the elegantly dressed sitter in a waist-length view. While Clark looks appropriately dignified and sanguine, in keeping with his social position, there is an animated quality in his expression that hints at a naturally gregarious disposition. The slightly oblique angle of his body, together with the easy manner suggested by his folded arms, neutralizes the formality of his rigidly upright posture. Reflecting Easterly's informed sensitivity to figure-ground relationships, Clark's presence is magnified by the perfectly measured, luminous space that surrounds him.

A second sitting captured Clark's public persona. In this nearly full-length pose, Clark projects much more gravity, with a sedate expression that seems suited to his formal outdoor attire. Compared to the more intimate glimpse offered by the half-length portrait, this presentation is the record of an elegant, aristocratic gentleman, accompanied by props that signal the sitter's professional status. Easterly's original daguerreotype, now in poor condition, was copied by St. Louis photographer George Stark sometime after 1895.

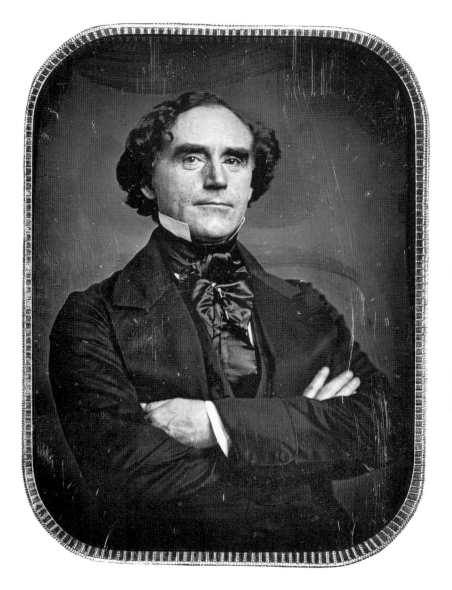

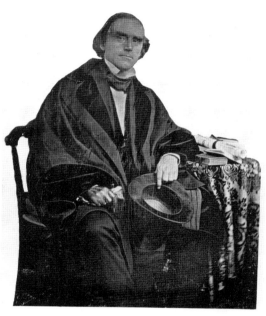

Meriwether Lewis Clark. Photograph by George Stark, c. 1900, of daguerreotype by Thomas M. Easterly. MHS.

Plate 9

Madame Josephine Clofullia

1831- ?

Quarter Plate

1853

MHS

Easterly's portrait of Josephine Clofullia is a rare precedent for Mathew Brady's later photographic inventory of P. T. Barnum's human curiosities. The "Bearded Lady of Geneva," as she was billed in America, had been a popular personality in London and Paris before she joined Barnum's Menagerie for an 1853 tour of the United States. The attraction of a well-bred lady with whiskers also proved irresistible to throngs of curious Americans.

The facial hair of Josephine Boisdechene, the daughter of a prosperous Swiss farmer, had begun to grow during infancy, but she nevertheless received the proper boarding-school education for an upper-class female of her time. Her marriage to the landscape painter Fortune Clofullia produced two children: a daughter born without her mother's abnormality, who died in infancy; and a son Albert, whose body was covered with hair at birth. During her tour in America, Madame Clofullia frequently appeared with the "Infant Esau," a biblical name assigned by Barnum, who hoped that the presence of little Albert would help confirm Madame Clofullia's feminine gender.

Despite signed affadavits from the medical community, disbelievers frèquently charged that the bearded "lady" was actually a man, coiffed and attired as a woman. To the delight of the public, this question was examined in a New York courtroom in July 1853. A visitor to Barnum's Museum, rumored to be a paid accomplice in the showman's advertising campaign, charged that he had been defrauded of his twenty-five-cent admission by Barnum and a "male humbug" dressed as a woman.[13] The much-publicized trial established Clofullia's female gender and generated considerable interest in Barnum's newest attraction.

In the fall of 1853, Barnum and his troupe of assorted curiosities arrived in St. Louis, where Easterly took his portrait of the twenty-two-year-old bearded lady. During his long career, Easterly would have few more remarkable subjects. Yet in a setting far removed from the carnival atmosphere of a sideshow, the young woman revealed a gentleness of spirit and a quiet dignity that most likely eluded the staring spectators who passed through Barnum's display. It is a sympathetic portrayal that speaks of the human spirit beneath the startling physical facade. Working with a broad, luminous light, Easterly secured a meticulously itemized composite of Madame Clofullia's strikingly incongruous features. The decidedly masculine beard, the emblem of her abnormality, seems especially incredible set against pale, gracefully curving shoulders, bared in the fashionable style of the day. Expressive, almond-shaped eyes, looking serenely away from the camera, conflict with the otherwise manly visage. Amid the elaborate jewelry that she always wore is the daguerreotype brooch that displayed her husband's portrait.

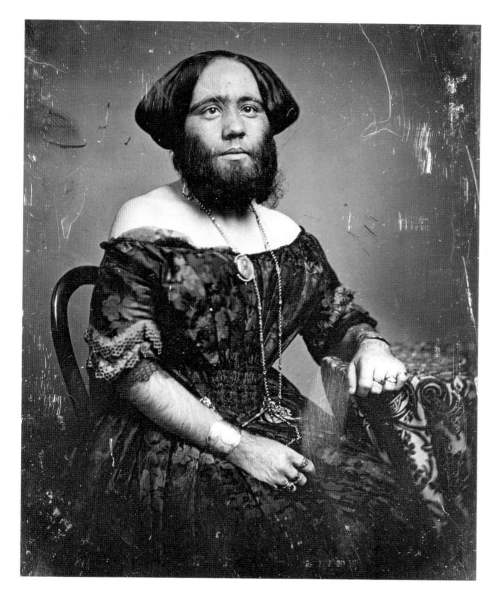

The Swiss Bearded Lady. Lithograph by Currier and Ives, c. 1854. The Theater Collection, Museum of the City of New York.

Plate 10

Julia Dean

1830-1868

Half Plate

c. 1847

MHS

The tender mood that prevails in Easterly's portrait of the famous Julia Dean reflects the qualities that audiences found so appealing in the young actress. Dean, who spent part of her childhood in St. Louis, was one of the most adored performers of her generation. Her parents, Edwin Dean and Julia Drake, were pioneers in the western theater; her grandfather, "old Sam" Drake, was an early theater manager in Kentucky. At sixteen, Dean first took her place on the New York stage in a part that would make her famous: the tragic role of Julia in *The Hunchback*. Her enormous success, based as much on her gentle personality as on the quality of her performances, reflected the same Victorian values that conditioned America's response to Jenny Lind.

Performing in *The Hunchback*, Dean first appeared in St. Louis during the summer of 1847. Three years later, when local audiences were held in suspense by her performance in *Avadne*, competition for boxes at the Bates Theater was so intense that an auction for premium seats brought bids as high as nine dollars. When the actress was away from the frontier city, the familiar packet boat *Julia Dean* reminded St. Louisans of their favorite hometown celebrity.

Easterly's portrait of "the Julia of Julias," probably made in 1847 when she was seventeen, confirms the truth of the axiom that "beauty is in the eye of the beholder." Critics of the time raptly described the striking beauty of the actress' delicate features, while painters, in their many Madonna-like idealizations, transferred those sentiments to canvas. The daguerreotype's literal transcription, which came to revolutionize the role of "truth" in the pictorial arts, provided a more faithful account. Although Easterly's depiction fails to vindicate the many romanticized accounts of Dean's beauty, it captures the wholesome innocence and tender sensibility that assured her success on the American stage.

Plate 11

William Greenleaf Eliot

1811-1887

Sixth Plate

c. 1850

MHS

Easterly's gallery was known for its impressive display of "eminent divines," a particularly fitting description for William Greenleaf Eliot. Both locally and nationally, few St. Louisans commanded more respect than this Massachusetts-born clergyman, who came to St. Louis in 1835. Eliot, a Unitarian, was pastor of the Church of the Messiah, one of the city's most impressive structures when it was built in 1851. A Harvard Divinity School graduate, Eliot was a political and philosophical liberal, whose projects and humanistic concerns extended far beyond his pastoral responsibilities in St. Louis. In 1861 he was instrumental in organizing the Western Sanitary Commission, which provided medical care and facilities for Union troops serving west of the Alleghenies. While devoting his energy to a range of philanthropic projects, Eliot worked tirelessly to improve education in St. Louis. Notable among his contributions in this area was the founding of Washington University in 1853.

Gazing directly at the camera in Easterly's portrait, Eliot seems both forthright and unassuming. His large, deep-set eyes reflect his sensitive, compassionate nature. While Eliot is pictured here in middle age, his small face and delicate features present an almost childlike appearance. Observers frequently noted the disparity between Eliot's small, frail stature and the grand scale of his undertakings.

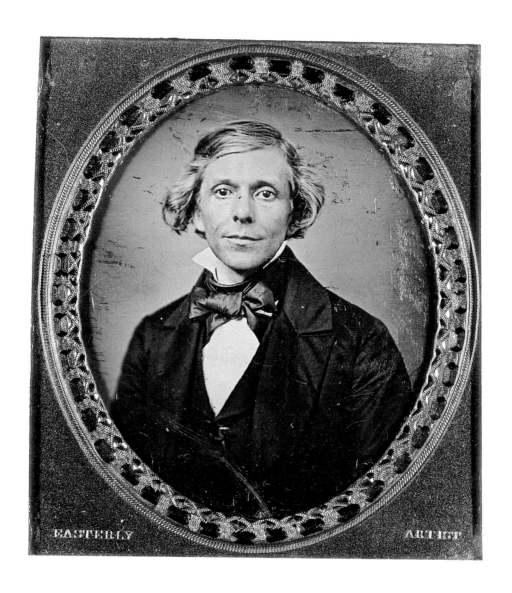

Plate 12

Thomas Forsyth, Jr.

1807-?

Plate Inscription: Thos. Forsyth, the Mountain Spy and Guide

Quarter Plate

1847

MHS

Exceptional in its candid disclosure of the subject's brooding temperament, Easterly's portrait of Thomas Forsyth is a rare, unidealized record of an indigenous breed of men who appeared on the American scene during the 1830s. Forsyth was one of hundreds of mountain men who preferred the silent forests of the Rockies to the parlors of polite society. The eager market for furs provided a means of subsistence and an excuse for their wandering existences. Many mountaineers were outcasts, who crossed the Mississippi with the law at their heels. Others, like Forsyth, were educated individuals who were simply attracted to the adventure of wilderness life.

Forsyth's father, Thomas, Sr., had been a prominent figure in the early history of Illinois and Missouri and had served for many years as agent to the Sauk and Fox Indians. In its description of his four children, one account devoted only a single line to his oldest son: "Thomas [Jr.] was a rover who died away from home."[14] Easterly provided more specific information on the rugged frontiersman, who put aside his fringed jacket and buckskin leggings for a sitting at the daguerrean's studio. In the engraved caption on the plate, Forsyth is described as a "Mountain Spy and Guide."

During a period devoted to its mythologizing of such folk heroes as Mike Fink, Daniel Boone, and Kit Carson, Easterly's reference to Forsyth's wilderness exploits was sure to enhance the romantic appeal of the portrait. Like many other mountaineers, Forsyth joined with American forces in the fight against Mexico, serving with the Missouri Volunteers under Colonel Alexander Doniphan as a scout and buffalo hunter. After mustering out of the army in New Orleans, he probably traveled through St. Louis on his return trip to the West in 1847, possibly in the company of James Kirker, who had also served under Doniphan in the war and whose connections to the Forsyth family went back to his early days in St. Louis in the 1820s. Whatever brought Forsyth to Easterly's gallery, his sitting occasioned one of the daguerrean era's most memorable images.

Plate 13

Margaret and Kate Fox

1833-1893, 1836-1892

Plate Inscription: Kate and Maggie Fox, Rochester Mediums T. M. Easterly Daguerrean.

Quarter Plate

1852

MHS

The belief that the living could communicate with the spirits of the dead was the basis of the Spiritualist movement that peaked in America during the 1850s. The two young women pictured in Easterly's portrait were credited with initiating this national phenomenon.

In 1848, several mysterious incidents brought Kate and Margaret Fox considerable attention in their upstate New York home. Strange knocking sounds began to occur in their presence. Local residents concluded that the spirit of a recently murdered peddler was transmitting messages to the girls, who were endowed with special powers to generate such experiences. An older sister, Leah Fish, moved the children to her Rochester home, where she coordinated a lucrative application of their unusual talents. As interpreted through a system of communication based on the alphabet, the "rappings" served as a telegraph code for messages from the spirits. In 1850, "the Rochester Rappers" became an overnight sensation in New York City, with séances that brought in a hundred dollars or more per evening. The teen-aged mediums captured the imagination of such notables as Horace Greeley, who offered to pay for Kate's education.

The spirit mediums' tour of the United States included stopovers in St. Louis in January and July 1852. During one of these visits, Easterly recorded the youthful innocence that gave credibility to the sisters' popular performances at the Planters' House Hotel. For practical as well as pictorial purposes, Easterly directed a physical connection between the two subjects, a practice that he commonly followed for double portraits. The younger Kate rests her forearm against Margaret's back, further stabilizing her posture with a hand placed gracefully but firmly on her older sister's shoulder. Anchored by this connection, the girls could maintain their assigned positions with a seemingly relaxed composure. On the left, nineteen-year-old Margaret appears sophisticated yet withdrawn. She was considered less attractive but more vivacious than her sister. Fifteen-year-old Kate, whose disposition was described as "diffident," presents a straightforward gaze that is haunting in its intensity.[15] With the addition of long flowing tresses, the younger medium could easily assume a place among the staring, melancholy women who distinguished the Pre-Raphaelite canvases of Easterly's English contemporary, Dante Gabriel Rossetti.

The Fox sisters' appealing appearances did not guarantee them a unanimously enthusiastic reception in St. Louis. As in other cities, a committee of local examiners was formed to investigate the legitimacy of "the Spiritual Knockers." A spokesman, Dr. A. J. Coons, reported the verdict in the *Missouri Republican*. Although Coons did not discuss the basis for their findings, he announced that "the imposition of the 'Rochester Knockings' was triumphantly exposed by his committee of three physicians." Nevertheless, lamented Coons, many local citizens were following in the footsteps of "Believers" across the country. "The Spirits," he wrote, "have made their appearance in St. Louis and are leading captive the ignorant and credulous."[16] Only many years later did Margaret confess that double-jointed toes, cracked surreptitiously, had been the secret of their convincing performances.

Plate 14

Leon Giavelli

1821-1854

Plate Inscription: Leon Giavelli

Quarter Plate

1853

MHS

*L*eon Giavelli undoubtedly attracted considerable attention as he made his way through the streets of St. Louis to Easterly's gallery. As this portrait clearly shows, Giavelli bore the distinctive marks of the theatrical personality, both in appearance and demeanor. He cut a dashing figure with his elegant, dandyish attire and his natural good looks, accentuated by his prominent black moustache. In even more exotic costume, Giavelli performed on the tightrope with the popular European Ravel Troupe, which thrilled American audiences in the mid-nineteenth century with lofty displays of "rope-dancing, herculean feats, and pantomimic ballets."[17] To St. Louis crowds, Giavelli was the star of the show. After his performance at the Bates Theatre in May 1853, the local press declared him "the most daring tightrope performer not merely in the U.S. but perhaps in the whole world."[18] Giavelli's career ended the following year when he died at the age of 33. While the cause of his death is unknown, the boldness that ensured his success on the tightrope may well have led to his early demise.

In its visual drama, Easterly's portrait of Giavelli is in perfect accord with the entertainer's personality. This deceptively simple pose combines his casually extended hand with the more formal, elegant gesture of his other hand, placed inside the waistcoat. Subtly but effectively, these elements signal the man's easy nonchalance—an attitude born of his sense of self-importance.

LIKENESS AND LANDSCAPE

95

Plate 15

George H. "Yankee" Hill

1809-1849

Plate Inscription: Yankee Hill

Quarter Plate

c. 1847

MHS

*S*uch down-home phrases as "so thin you could pitch him through a flute" flavored George Handel Hill's comic stage portrayals of the American Yankee. He began appearing as the shrewd, whittling Yankee as early as the 1820s, and by the following decade he had become so thoroughly associated with the role that "Yankee" Hill had become his permanent stage name. To his audiences, the characters he portrayed represented more than the emblematic New England peddler or backwoodsman. In their ingenuity and individuality, they became generic portraits of the independent spirit of American society. Hill, immensely popular in all parts of America, inspired a host of writers and actors to create their own interpretations of the Yankee character.

Easterly's portrait of the prominent entertainer is a subtle and telling visual document. We might expect a more dynamic expression and less mundane face from one of the period's most successful comedians. Yet by all accounts Hill was very much at home in the Yankee characters he created. A Massachusetts native, he was himself simple-mannered and uneducated; while he embellished the native lingo, his colorful dialect was a part of his own provincial New England heritage. The special brand of humor that came naturally to Hill was apparently as modest as the image that preserves his likeness.

Easterly's seemingly austere presentation of his subject seems perfectly in keeping with Hill's character on stage. Each of Hill's Yankees, as a writer on American humor observed, was "quiet and low-voiced, wearing his own mild countenance, whittled a great deal, talked quite as much, but never very loud."[19] The shrewd, knowing gaze that animates Hill's otherwise impassive expression in this portrait may well have been similar to the look that punctuated the measured pauses in his famous Yankee monologues.

Plate 16

General Ethan Allen Hitchcock

1798-1870

Quarter Plate

1851

MHS

Easterly left two nearly identical portraits of General Ethan Allen Hitchcock. One of these images, a signed and dated plate (not shown here), is engraved: "General Ethan Allen Hitchcock, Grandson of Ethan Allen, Hero of Ticonderoga." Easterly's firsthand knowledge of historic sites in his native New England may have prompted this inscription. A West Point graduate, Hitchcock was a recognized Mexican War hero, especially in St. Louis, where he had been stationed some years earlier. Easterly's inscription recalled the general's illustrious heritage, noting that his grandfather had led the Revolutionary War battle that defeated the English at Fort Ticonderoga. During the early years of his career, Easterly had recorded the remains of that historic fort.

The daguerrean's portrait forcefully portrayed the uncompromising character that often put Hitchcock at odds with his superiors. In 1855, after a conflict with Secretary of War Jefferson Davis, he resigned from the army and moved to St. Louis, where his brother's widow and her family resided. He returned to military service in 1861, serving as an adviser to Lincoln's cabinet during the Civil War.

Known as a man of uncommon intelligence and integrity, Hitchcock was called "the pen of the Army" for his literary pursuits, which ranged to philosophy, science, and religion, especially Swedenborgianism. A writer, noting Hitchcock's retirement from the military in 1867, reported that the general is "now immersed in the dark mysteries of alchemy," a subject that had absorbed him for more than a decade.[20]

As Easterly's depiction suggests, the aging soldier maintained a distinguished appearance throughout his life. In his later years, he was described as "an old man but of superb figure as erect and fine looking a man as one could care to see."[21] Martha Nichols of Washington, D.C., apparently agreed. In 1868 she married Hitchcock, who had spent seventy years as a bachelor.

Plate 17

James Kirker

1793-1853

Plate Inscription: Don Santiago Kirker, "King of New Mexico"

Quarter Plate (laterally reversed copy plate)

1847

MHS

On July 5, 1847, an article in the St. Louis *Reveille* announcing the arrival in the city of well-known frontiersman James Kirker was accompanied by his engraved portrait, based on Easterly's daguerreotype. More than two decades earlier, as the proprietor of a general store on North Water Street, Kirker had been a familiar face on the St. Louis wharves. An Irish immigrant, seasoned by the rugged life of a privateer during the War of 1812, Kirker felt a kinship with the keelboatmen and frontier traders who frequented his establishment.

After nine years in St. Louis, Kirker headed to New Mexico territory in 1826, hoping to make his fortune trapping and trading with the Indians. In the years that followed, the man known to the Spanish as "Don Santiago Querque" became legendary as the most formidable foe of the Apaches in the West. Some contemporary accounts state that he contracted with the Mexican government, for the sum of one hundred thousand dollars, to rid New Mexico of all Apaches.[22]

After the Mexican War began, Kirker joined Colonel Alexander Doniphan's Missouri Volunteers as a scout and interpreter. When the Indian fighter arrived in St. Louis, he had just mustered out of the army and was preparing to go back to the West.

Easterly's portrait does nothing to obscure the surly disposition of the bounty hunter, whose city attire is his only concession to the conventions of polite society. With a countenance that surely petrified timid souls, Kirker stares boldly at the camera, his steely eyes set deep in a weathered face. The formidable presence of the mountain man seems to confirm widespread rumors that Kirker and his band of questionable characters added Mexican scalps to their bounty when Apaches were in short supply. Easterly's portrayal corroborates an impression of Kirker set down by a St. Louis reporter: "He is as dark as the night and upon occasion can look quite threatening."[23] As a penetrating character study, Easterly's portrait was a rare achievement in its time.

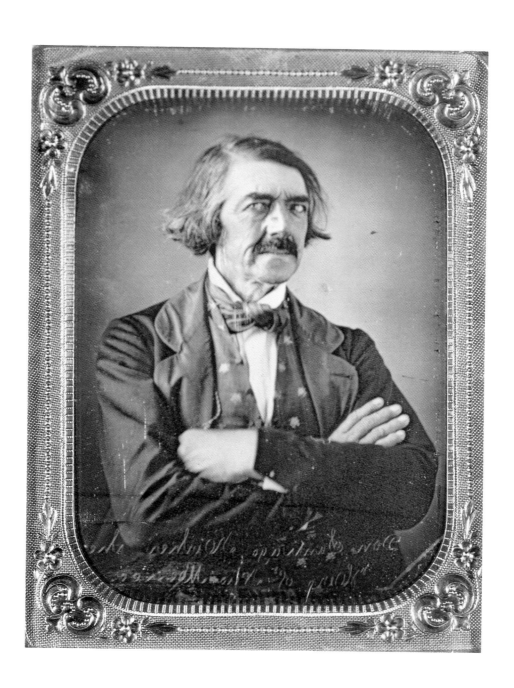

Plate 18

Colonel John Jacob Lehmanowsky

1773-?

Quarter Plate

1849

MHS

*E*asterly's characterization of Colonel John J. Lemanowsky conveys an intimacy rarely encountered in photography of this early period. Lehmanowsky meets us eye to eye, not as a subject self-consciously braced to endure a lengthy exposure, but as an attentive, responsive individual seemingly immune to the intimidating experience of being photographed. As in any portrait that goes beyond the replication of physical features, Lehmanowsky's personality and his rapport with the photographer were essential ingredients in this striking impression of naturalism.

Easterly's eye for effective lighting also contributes to the energy implied in Lehmanowsky's expression. A diffuse light and less insistent image sharpness enhance our perception of the subject as a living, breathing being whose expression is only a fleeting sign of a complex personality. Lehmanowsky is not frozen in place as a scrupulous inventory of details, nor does his figure emerge from the background as a sharply defined silhouette immobilized by the precision of its contours.

A series of articles in the *Missouri Republican* indicate that Lehmanowsky, "a citizen of the U. S. for 32 years," was in St. Louis as a visiting lecturer and "Preacher of the Gospel" during the first two weeks of January in 1849.[24] His service under Napoleon from 1792 through the Battle of Waterloo, including his command of a regiment of Polish Lancers in Napoleon's bodyguard, generated far more interest than his sermons. This military experience provided the material for Lehmanowsky's seven illustrated lectures on Napoleon's life and military career, beginning with one on "The Manners and Disposition of Napoleon." The attention that the press gave these programs suggests that they sparked a great deal of interest in St. Louis. If Lehmanowsky's lectures were delivered with the energy or erudition conveyed in Easterly's portrait, we can imagine that they were well worth the twenty-five-cent admission fee.

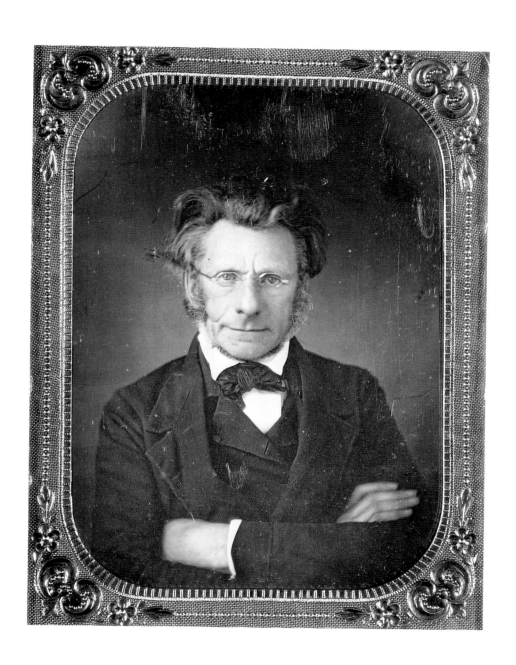

Plate 19

Jenny Lind

1820-1887

Quarter Plate

1851

MHS

*I*n 1849, at the height of Jenny Lind's fame in Europe, the young soprano was essentially unknown in America. By September 1850, when the steamer *Atlantic* arrived in New York harbor with Lind aboard, thirty thousand people were waiting for a glimpse of the "Swedish Nightingale." P. T. Barnum, who brought Lind to America and skillfully prepared the public for her arrival, had earned his reputation as the world's greatest showman. He would continue to display his public relations skills throughout her thirty-seven-city tour of the United States.

More than a series of concerts, Lind's tour was a national sensation. As a writer for the *New York Herald* put it, "All feel her power, all go mad who see her, and they cannot explain the secret of her influence."[25] What came to be known as the "Jenny Lind crush" disheveled thousands in theatre lobbies where the singer was performing, while Lindomania invaded American culture with Jenny Lind beds, Jenny Lind teakettles, Jenny Lind soup, and a host of other products. The daguerrean profession was not immune to the fever. In 1851, the latest appliance for an enterprising daguerrean was the newly introduced "Jenny Lind Headrest," a more decorative version of the standard cast-iron head brace.

The craze for the singer coincided with the heyday of the daguerreotype, and camera operators too reaped benefits from the performer's American tour. For the fortunate few daguerreans who recorded Lind, the brisk sale of copy plates was a lucrative outcome of the experience. Frederick DeBourg Richards, in an advertisement in the *Daguerreian Journal*, indicated the availability of such images:

> Thinking that perhaps Daguerreotypists in the country would like to have a copy of Jenny Lind and as it is allowed by all that my picture is the best in America, I will sell copies at the following prices: one-sixth, $2; one-fourth, $4; one-half, $6.[26]

St. Louis daguerreans may have taken advantage of DeBourg's offer, since it appears that only Easterly and John Fitzgibbon were honored with a sitting from Lind during her five-day engagement in that city in March 1851. Fitzgibbon, maintaining his usual high profile, took full advantage of the opportunity. Although his portrait of Lind has not been located, it was undoubtedly a large-scale picture, since mammoth plates were his specialty. He sent a copy of the portrait to the editor of the *Daguerreian Journal*, who published an acknowledgment thanking his "esteemed friend" for the "superior likeness."[27] Fitzgibbon also exhibited the Lind Portrait at the 1853 Crystal Palace exhibition in New York, where it was part of the "large and passable collection" for which he received an honorable mention.[28]

Although Fitzgibbon gained wider attention with his portrait of the celebrated singer, it was not because Easterly's work was less successful. Of the many photographic images of Lind, few surpass Easterly's portrait in conveying an impression that was perfectly consistent with America's image of the singer as the very picture of Victorian purity. Attractive, even flattering, Easterly's image also captures the aloofness that Lind defenders attributed—probably accurately—to her natural shyness. The few courageous souls who ventured to criticize her performances suggested that the power of the soprano's singing was neutralized by her reserved demeanor. Easterly's Madonna-like conception of the young woman seems to reflect her natural restraint.

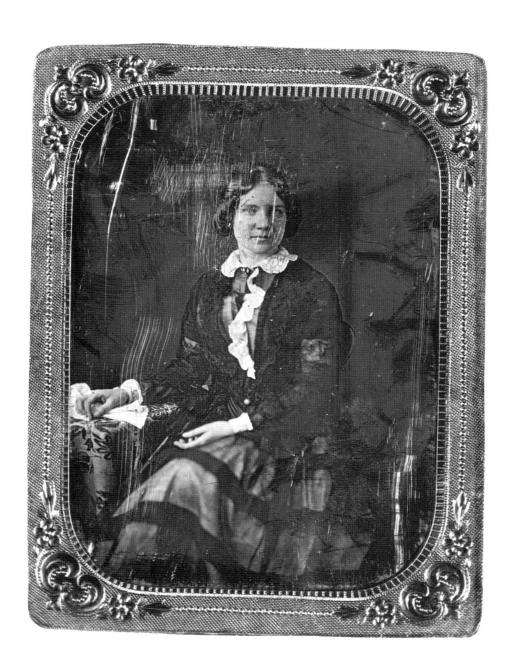

Plate 20

Father Theobald Mathew

1790-1856

Plate Inscription: Father Mathew

Quarter Plate

1850

Easterly-Dodge Collection, MHS. Gift of Margaret Wing Dodge.

*D*uring an interview late in life, the celebrated Civil War photographer Mathew Brady recalled highlights of his early career as a daguerreotypist and some of his most illustrious subjects. First on Brady's impressive list, which also included such distinguished figures as Andrew Kossuth, Daniel Webster, and Edgar Allan Poe, was the name Father Theobald Mathew. Like Brady, many daguerreans must have recorded the famous Irish priest during his extensive travels throughout America, but Easterly's work may be the only attributed daguerreotype that survives to commemorate Father Mathew's influential presence on this side of the Atlantic.

During his two-year tour of the United States, which began in 1850, the "Apostle of Temperance" visited more than three hundred cities and towns in the United States and pledged more than six hundred thousand Americans to abstinence. So great was America's esteem for the Irish visitor that during his stay in Washington Father Mathew was made an honorary member of both the Senate and the House of Representatives—a significant gesture given the strong nativist movement of the day.

Father Mathew arrived in St. Louis in July 1850, following a two-month steamboat journey up the Mississippi from New Orleans. An exhausting schedule of lectures along the route took its toll; the priest became seriously ill in St. Louis and was forced to delay his return to New Orleans.

Despite his weakened condition, Easterly's subject communicates the magisterial demeanor that had such a strong influence on American society. As the press frequently noted, the dignified bearing of the reformer was enhanced by the elegance of his attire. A temperance medal, our only clue to the mission that brought him to St. Louis, hangs around his neck. Easterly's portrait corroborates the observations of the English novelist William Thackeray, who wrote that the famous priest's "noble expression" conveyed an "indomitable firmness." The writer was especially impressed that Father Mathew did "not wear the downcast, demure look" so common "to many gentlemen of his profession."[29] Few pictorial records of the temperance leader convey the strength of character that impressed Thackeray. Indeed, compared to Easterly's penetrating daguerreotype portrait, the likenesses of Theobald Mathew produced by the painters and the printmakers of his time appear to be lifeless, fanciful facsimiles that bear little resemblance to the original.

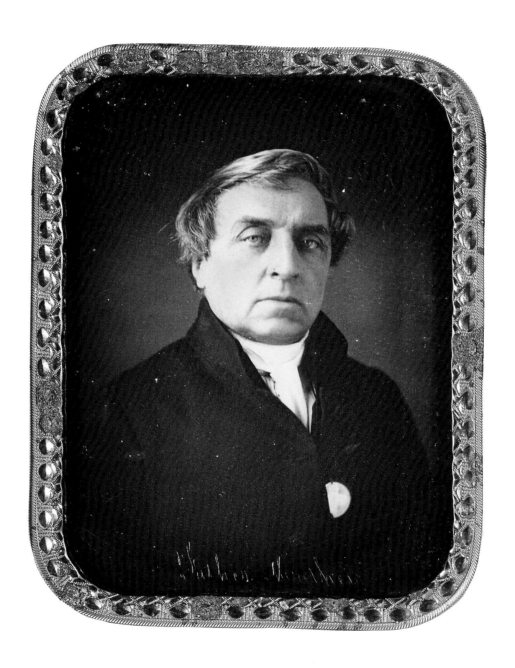

Plate 21

Lola Montez

1818-1861

Quarter Plate

1853

MHS

asterly's uncommon interest in expressive portraiture was never more apparent than in his portrayal of the infamous Lola Montez. Abandoning the straightforward poses that served him so well with the conventional beauties of his city, he sought a more theatrical presentation of this woman, known both for her dark, sultry beauty and her unorthodox behavior. An affair with the King of Bavaria was only one of her many widely publicized escapades.

Easterly's choice of the ethereal profile pose, which he reserved for very few patrons, effectively accented the dancer's striking eyes and distinctive browline. In diminishing the contrast between figure and background, he created a mysterious ambiance, perfectly suited to the performer's exotic character. Easterly's portrayal is especially interesting when it is compared to others by such well-known figures as Southworth and Hawes of Boston or Frederick DeBourg Richards of Philadelphia. In both those studios, the famous "woman in black" was pictured with her head and shoulders draped in a white mantilla, a curiously virginal touch, given her reputation for promiscuous behavior.

Early in 1852, Montez had begun her tour of the United States in New York City, where critics both adored her beauty and condemned her tempestuous outbursts. Her blatant disregard for convention was always newsworthy, even on the distant frontier. A year before her debut in St. Louis, the *Missouri Republican* reported: "Lola Montez wrote from Albany to a friend in New York …'I will never stop at a temperance house again. It contains nothing but bedbugs and bibles.'"[30]

During her short St. Louis stay in March 1853, Montez packed St. Louis' Varieties Theatre where, at least for some observers, she lived up to her wide reputation for "un-Christian-like behavior" by raising her skirts far too high in performing her famous Spider Dance.[31] Not long after the actress' departure, the *Missouri Republican* welcomed a new Spanish ballet troupe to St. Louis, reporting that the Spider Dance, "which became known to us through Lola Montez," would be a part of the upcoming program. In a less-than-subtle allusion to Montez' rendition of that dance, the writer added, "we shall now see what a … modest woman will make of it."[32]

The actress' risqué antics on stage were only part of what made Montez a long-remembered name in St. Louis. Her assaults on theatre managers were also prominent in the legend of her audacity. During her St. Louis stay, she added Joseph M. Field, owner of the Varieties Theatre, to her list of casualties. In a dispute following her engagement, Montez thrashed Field with her riding crop. Ending their fracas with her final blow, she broke his nose with a candlestick.[33]

Plate 22

Dan Rice

1823-1900

Quarter Plate

c. 1848

MHS

The gregarious personality of Dan Rice was his principal stock in trade. For more than four decades his comic antics as a circus clown and showman made him a national celebrity. Although numerous artists and writers attempted to convey his free-spirited charm, Easterly's portrait presents a uniquely authentic record of the performer's special appeal.

Rice's successful encounter with Easterly probably occurred in 1848, although his "Great and Only Show" also appeared in St. Louis on several later occasions. Rice's troupe, deemed unsurpassed for its assortment of "conspicuous attractions," traveled by steamboat, making frequent stops in cities along the Mississippi and Ohio rivers.[34] Rice dominated the show with his remarkably diverse talents as a comedian, songster, equestrian, acrobat, and strong man. Years earlier, Rice had launched his theatrical career with P. T. Barnum, who billed him "The Young American Hercules."

No circus was complete without a menagerie of animals, and Rice's lineup of four-legged performers delighted his audiences. Empress, the largest elephant in the United States before the debut of Barnum's Jumbo, was prominent among the stars who shared the spotlight with Rice. His first animal partner, the scrubbed and bespectacled "Lord Byron the Learned Pig," could "foretell the future, play an invincible game of cards, and read the Book of Fate."[35] This flair for showmanship earned Rice three different fortunes, which he quickly lost through his passion for carefree living and charitable giving.

Plate 23

Marie Elise Provenchere Saugrain

1806-1868

Quarter Plate

c. 1850

MHS

Marie Elise Provenchere grew up in an elite circle of cultivated French families who had settled St. Louis before the Louisiana Purchase. "Lise," as she was known to her family, married Frederick Saugrain in 1835. During the early years of their marriage, the couple lived at the Saugrain mansion, an impressive structure built by Dr. Antoine Saugrain, who had established the first medical practice in St. Louis in 1800. Eventually, Frederick established his own home and livelihood on a large farm outside the city, where he became a close friend of his neighbor, Ulysses Grant.

While Easterly's portrait records his subject as a middle-aged matron, a suggestion of her nature as a child and young woman is also apparent. In the years before her marriage, she displayed unusual artistic talent and sensitivity to the world around her. Working in an art form uncommon in the Midwest, she made intricately detailed paper silhouettes of interior and landscape scenes, cut with remarkable delicacy and skill. At the time of her sitting for Easterly, Mrs. Saugrain had long since given up such fanciful activities. Nevertheless, there is something intensely personal in Easterly's portrayal that hints at an unusually tender nature. Her face, bathed in light and surrounded by the white lace of her cap and collar, is dramatically isolated in a dark, undefined space. The strangely solitary mood that pervades the work is amplified by the scale of the figure in relation to its setting.

Plate 24

J. M. White

?-1849

Plate Inscription: J. M. White— who was murdered on the Plains by the Appachee Indians

Hand-colored Quarter Plate

1849

Edward E. Ayer Collection, Newberry Library

In 1850 the Commissioner of Indian Affairs reported on the "extraordinary" and "ruinous" state of conditions existing in the New Mexico Territory. "There are over thirty thousand Indians within its limits, the greatest portion of which, having never been subjected to any salutory restraint, are extremely wild and intractable."[36] The Commissioner's document implored Congress to protect United States citizens against the plundering and murdering that was taking place in that region. To reinforce the urgency of the message, the report described the massacre of the J. M. White family by the Apaches, an incident that had received national attention in the press. When the St. Louis *Reveille* carried news of the event in early December 1849, Easterly probably added the engraved inscription to his portrait of the trader.

Near the end of October 1849, White was traveling with his family from St. Louis to Santa Fe, where he was engaged as a trader and merchant. After they reached New Mexico Territory, their wagon train was attacked by a band of Apaches, who killed White and his companions, then fled with his wife and ten-year-old daughter. Mrs. White's body was later discovered by a military search party led by Kit Carson.[37] The child was eventually presumed dead when the Apaches did not respond to the government's offer of a fifteen-hundred-dollar reward for her return.

Easterly's glowing image of the trader has the mesmerizing effect that distinguishes daguerrean art at its finest. The handsome, bearded White, dressed in the costume of the *caballero*, was a picturesque addition to the daguerrean's stock of distinctive frontier characters.

When the trader's fate was reported in the press, White's portrait took on still greater significance for Easterly's public. Since the early 1820s, Mexico's independence from Spain had generated a flourishing exchange of goods between Missouri and Santa Fe. For St. Louisans who watched these trading caravans depart, the motley assortment of backwoodsmen, wagoners, muleskinners, and traders made a colorful sight. Imagining the perils that lay ahead for these travelers on their nine-hundred-mile trek across plains, deserts, and mountains added to the romance of the scene. For such onlookers, Easterly's ghostly record of White, a man whose fate came to symbolize the legend of Apache brutality, served as a tangible and striking reminder of the real dangers faced by these adventurers.

Plate 25

Robert J. Wilkinson

?-1880

Quarter Plate

c. 1860

MHS

In an 1858 pamphlet, *The Colored Aristocracy of St. Louis*, Cyprian Clamorgan described the lives and accomplishments of forty-three free blacks in St. Louis. The author defined the group as "those who move in a certain circle; who by means of wealth, education, or natural ability, form a peculiar class—the *elite* of the colored people."[38] Robert Wilkinson, owner and operator of the popular barbershop at the Planters' House Hotel, was on Clamorgan's select list. The conditions that had contributed to Wilkinson's financial success were typical of those that brought a measure of prosperity to a limited number of blacks in antebellum America.

In the early 1840s, Wilkinson had migrated to St. Louis, a growing urban center where he could capitalize on his skills as a barber. Of Missouri's estimated population of twenty-one hundred free blacks in 1850, nearly fourteen hundred lived in St. Louis; some of those who shared Wilkinson's status as free blacks were mulattoes whose ancestors had been freed by the early Creole settlers of St. Louis. Many in this group had made their fortunes from inherited real estate, while others had grown wealthy by working as steamboatmen, nurses, hairdressers, barbers, seamstresses, or boardinghouse proprietors.

Although Wilkinson and other free blacks ran businesses that were eagerly patronized by white St. Louisans, their contributions did nothing to change the racial prejudices of the community. Indeed, as the tension increased between abolitionist and pro-slavery factions, so did public concern over the growing number of free blacks in the city. An 1840 police report expressed a sentiment that was repeated with growing frequency over the following two decades: "the saucy and indolent air of the free Negroes ... is most dangerous to the slave population."[39] By 1847, one law was enacted to keep free blacks from entering Missouri, while others prohibited the education of blacks in St. Louis and denied their right to gather for religious assemblies. Though a few in Wilkinson's circle educated their children in the East or in Europe, their status as property owners in St. Louis earned them only the privilege of paying taxes for the education of white children.

Easterly's portrait reflects none of the frustration that must surely have plagued an ambitious black man in a city that barely tolerated his presence or his prosperity. In striking contrast to the sober and shabbily dressed black sitters pictured in other Easterly portraits, the well-groomed Wilkinson appears pleasant and at ease in the daguerrean's gallery. We can suspect that by nature he was a gregarious man, whose personality had much to do with the success of his business.

The barber's spirited disposition interested Clamorgan when he described Wilkinson's life in *The Colored Aristocracy of St. Louis*. Clamorgan referred both to "youthful indiscretions" that had forced Wilkinson's migration from Cincinnati to St. Louis and to the financial gain that the barber had enjoyed through his marriage to a St. Louis woman. The author concluded that Wilkinson's character should not "be recommended to the young as a model of excellence."[40] Since Clamorgan was also in the barbering business, professional rivalry may have played a part in his unkind assessment. If Wilkinson was a man of questionable principles, Easterly's genteel portrait offers no clues to that side of his character.

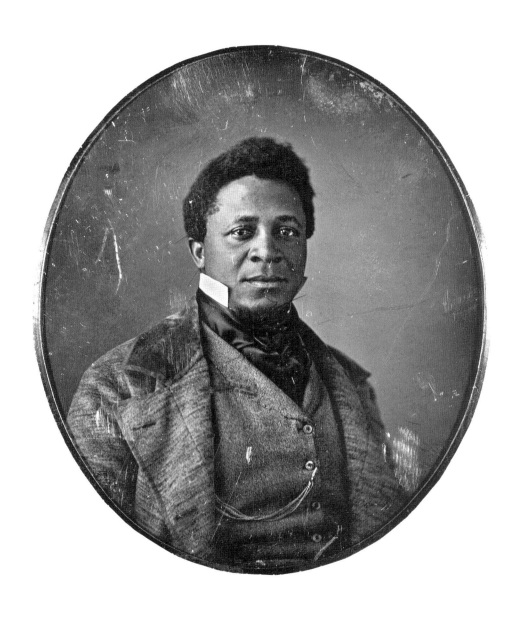

CHAPTER III
THE WATCHFUL FOX AND OTHER "DISTINGUISHED VISITORS"

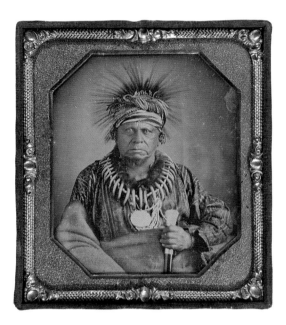

asterly had scarcely arrived in St. Louis in the spring of 1847 when he arranged a studio sitting with a group of Sauk and Fox Indians. This session produced the daguerrean's best-known portrait: his image of Keokuk or the Watchful Fox (fig. 3-1). During the decade of the 1840s, Easterly's encounters with at least two other tribes added to his remarkable collection of Indian portraits. Their extraordinary resonance, both as objects of great formal beauty and as treasured records of western history, resides in Easterly's calculated response to the challenge of preserving accurate ethnographic detail in images that would also appeal to a midcentury public fascinated by the exotic appearance of such subjects. His success in achieving this combination of visual allure and precise documentary record produced some of the most impressive works of the daguerrean era.

Including duplicate images, more than forty Easterly Indian portraits are preserved in public collections.[1] Generally regarded as the earliest known dated daguerreotype records of Native Americans, the Sauk and Fox series marks one of photography's first and most unique contributions to a visual tradition dating back to the sixteenth century when European artist-

explorers documented their impressions of the exotic New World.[2]

Artists who adopted Indians and their culture as a focused specialty made their first collective appearance in America during the early decades of the nineteenth century. A widening audience for pictorial work devoted to these subjects coincided with the growing recognition of the West as an integral part of America's national cultural identity. The romantic appeal of this art was further enhanced by the widely held and enduring belief that the Indian was destined to extinction by the onslaught of civilization.

Motivated by these impulses and a personal fascination with the exotic cultures of the West, some artists left the safety of the East to travel in wilderness regions where they recorded the Indian in his own environment. During the three decades preceding the Civil War, a number of native artists and illustrators—among them George Catlin, Gustavus Sohon, Seth Eastman, John Mix Stanley, and Carl Wimar—produced significant bodies

Fig. 3-1. *Keokuk.* Hand-colored sixth plate, 1847. Edward E. Ayer Collection, Newberry Library. Plate inscription: Ke-o-kuk.

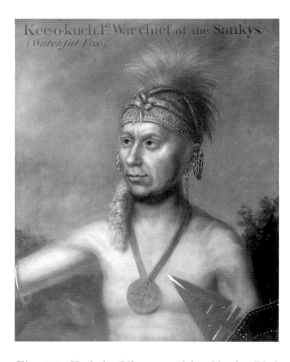

Kee-o-kuek. I.^t War chief of the Saukys.
(Watchful Fox.)

Fig. 3-2. *Keokuk.* Oil on panel by Charles Bird King, 1827. From the Collection of Gilcrease Museum, Tulsa, Oklahoma.

of work as a result of their contact with Indians beyond the frontier. Two Europeans, Karl Bodmer and Rudolph Kurz, rank among the most competent and productive of the variously talented Indian chroniclers who ventured hundreds of miles into Indian country. Most of these artists combined occasional attempts at direct portraiture with drawings and paintings aimed at providing a more comprehensive record of Indian cultures.

During the same period, painters such as Charles Bird King remained in more comfortable and secure settings to execute some of the earliest studio portraits of Native Americans. Working in his Washington, D.C., studio, King produced a large body of officially commissioned paintings that pictured the most important members of delegations visiting the nation's capital during the 1820s and 1830s.[3] King's paintings served as prototypes for many of the hand-colored lithograph portraits that illustrated Thomas L. McKenney and James Hall's three-volume classic *History of the Indian Tribes of North America* (1837-1844). McKenney, who was superintendent of Indian Trade and later commissioner of the Bureau of Indian Affairs, was the first to propose and implement the creation of an official collection of Indian portraits.

Among the painters who made Indians their specialty, the Philadelphia-born George Catlin was unsurpassed in the degree and duration of his commitment to producing a pictorial inventory of America's various tribal cultures. Between 1830 and 1836, his extensive travels west of the Mississippi gave him firsthand experience with Indians of many important tribes.[4] In contrast to the broader documentary interests of most of his counterparts, Catlin made portraiture the principal theme in his remarkably comprehensive record of the many tribes that he encountered. Working in styles that ranged from sketchy approximations to carefully finished studies, he created hundreds of portraits of men, women, and children in his mission to preserve visual records of "native customs and character" before they were lost in "the march of civilization."[5]

Scholars continue to debate the ethnographic accuracy of the images left by Catlin and his artist-contemporaries. Most agree that only occasionally, and primarily among the works of Catlin, Bodmer, and Kurz, do we find portraits or studies of individual heads that appear to be closely observed visual equivalents of the subject's distinctive physical features.[6] Far more prevalent was the practice of generalizing the physiognomy of the Indian sitter to comply with artistic conventions and with the popular romantic notion of the dignified, stoic countenance of the "noble savage." Many of Charles Bird King's paintings exemplify this idealizing tendency. As seen in his portraits of Keokuk (fig. 3-2) and Notchimine

(No Heart) (fig. 3-3), whose faces were later recorded with greater precision by Easterly's camera, his Indians are often linked by a generic idealized resemblance and discernible Caucasoid features.

While King's works were disseminated as lithographs, Catlin's portraits, shown throughout the East when the artist toured his immensely popular "Indian Gallery" in the late 1830s, had a much more pervasive influence in offering an enduring pictorial model for the grand, inviting myth of the exotic, regally attired "warrior." Largely indifferent to discrepancies between physical fact and romantic interpretation in this work, most critics of the time praised these images as models of the "truthfully portrayed" Indian. King's portraits received the same commendations.[7] In a critique of Catlin's work, the artist-naturalist James Audubon was one of the few observers of the period to acknowledge the role that the artist's vision played in homogenizing the physical features of his Indian sitters. Alluding to his own firsthand encounters with several of Catlin's Indian subjects, Audubon offered the conclusion that "different travelers have different eyes."[8]

What one historian has described as the facility to record the Indian "eye to eye" does not appear with regularity until the medium of photography—which would soon lend its own pictorial stereotypes to this tradition—set down new expectations for the "truthfully portrayed" Indian portrait.[9] Joseph Henry, first secretary of the Smithsonian Institution, officially endorsed the camera's ability to preserve more accurate ethnographic data when he recommended the initiation of a government collection of photographs picturing American Indians and their cultures. Following the 1865 fire at the Smithsonian that had destroyed the government's collection of Indian paintings, Henry urged that photography should be used "to begin anew ... a far more authentic and trustworthy collection of the principal tribes of the United States.... The Indians are passing away so rapidly that but few years remain, within which this can be done and the loss will be irretrievable and so felt when they are gone."[10] Although his plan came to fruition through the efforts of glass-plate photographers, the potential of the new medium was earlier demonstrated by daguerreotypists working in frontier galleries or on survey expeditions in Indian Territory.

Nearly every modern history of photography relates the adventures of Solomon N. Carvalho, the Baltimore artist who daguerreotyped Indian settlements while traveling with Colonel John C. Frémont's 1853-54 expedition to explore a transcontinental railroad route through the Rocky Mountains.[11] A government-financed expedition led by Governor Isaac I. Stevens of Washington Territory also set out earlier in 1853 to survey a northern

Fig. 3-3. *Notchimine (No Heart)*. Oil on panel by Charles Bird King, 1837. National Museum of American Art, Smithsonian Institution.

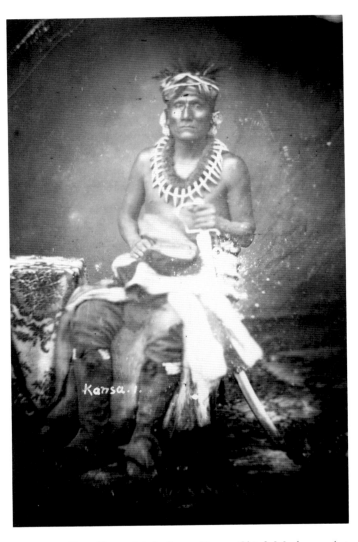

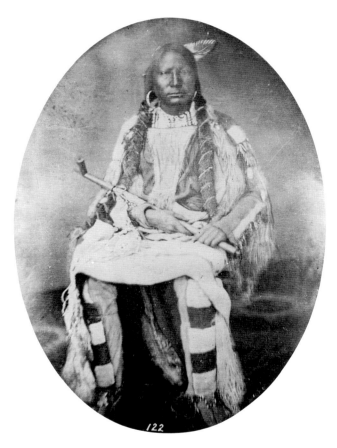

Fig. 3-4. *Kno-Shr or Little Bear, Kansa Chief*. Modern print from glass copy negative by A. Zeno Shindler, 1869, from daguerreotype by John Fitzgibbon, 1851-52. National Anthropological Archives, Smithsonian Institution.

Fig. 3-5. *Alights on the Cloud, Cheyenne*. Modern print from glass copy negative by A. Zeno Shindler, 1869, from daguerreotype by John Fitzgibbon, 1851-52. National Anthropological Archives, Smithsonian Institution.

route for a railroad to the Pacific. Stevens employed John Mix Stanley to document their journey with paintings and a daguerreotype apparatus. Stevens' survey report notes that Stanley's daguerreotypes evoked the "delight and astonishment" of his Indian subjects.[12] Only one view, thought to be the work of Carvalho, has survived from these expeditions.[13] There are no known extant plates to recall the efforts of west-coast daguerreans Robert Vance, William Shew, or John Wesley Jones, who also recorded Indians during this same period.[14]

Although Easterly's work documents the earliest known encounters between Indians and a daguerrean in a gallery setting, many frontier practitioners were seeking similar opportunities by the early 1850s. In part because of the greater difficulty of working in the field in this medium, the scant archive that now represents the daguerreotype's contribution to this genre consists almost exclusively of studio portraits. In most instances, neither the Indian subject nor the author of the image is known. Only in rare cases, as with a group of eight daguerreotypes in the Smithsonian's Division of Photographic History that can now be firmly attributed to John Fitzgibbon, can we reconstruct the circumstances that led to these sittings. At least six of those images were made sometime over the fall and winter of 1851-1852, when his subjects traveled through St. Louis as part of a large delegation making its way to and from Washington, D.C.[15] These images undoubtedly formed the core of the "collection of Indian Warriors" listed among the work in Fitzgibbon's extensive display at the New York Crystal Palace in 1853.[16] By this time, he was borrowing Easterly's practice of identifying his Indian sitters with engraved inscriptions.

If the Smithsonian plates are representative of Fitzgibbon's work in this category, he clearly made no effort to emulate Easterly's more abbreviated and bluntly documentary style. As illustrated in the works seen here (figs. 3-4, 3-5), Fitzgibbon's Indians are shown in full-length poses that capture the full effect of their costumes at the expense of a more revealing visual account of the individual. In contrast to Easterly's Indians, who dominate their decisively measured spaces to confront us at a distance that provides a detailed map of their faces and costumes, Little Bear sits lost in an expansive, artificial setting that both diminishes his presence and underscores his role as a exotic object of curiosity.

Since no one outranked "the far-famed Fitz" in his ability to meet the needs and interests of the buying public, his efforts in this line are a sure indication that there was a promising commercial market for Indian portraits secured with the camera. Existing duplicates of portraits picturing the three "Chiefs" among Easterly's cast of Indian sitters may have been part of a reserve of copy plates that he hoped to sell to the public. In his characteristic fashion, Fitzgibbon devised a much more ingenious plan for making a profit on his Indian images. When the *New York Tribune* reported on daguerreotypes displayed at the New York Crystal Palace in 1853, it commented on the "fine collection of Indian Warriors" by Fitzgibbon, which the writer had been told were "to be forwarded to the Ethnological Society of London, to have copies and busts made from them."[17]

Like Fitzgibbon, Joel E. Whitney, who operated a gallery in St. Paul, Minnesota, was also known for his daguerreotypes of Indians. Although no firmly attributed examples of this work have surfaced, by 1853 he was advertising "pictures of Hole-in-the-Day, Red Iron, and other noted Indians" among his collection of "fine likenesses."[18] Unlike Whitney and other daguerreans who worked closer to the frontier, photographers located farther from the region did not gain regular access to Indian subjects until the later 1850s, when increasing contact between whites and Indians significantly increased the number of delegations traveling to the capital and touring eastern cities.

When we consider the difficulties faced by daguerreans such as Carvalho and Stanley, who worked with the camera on the plains and prairies, Easterly's earlier efforts to record Indian subjects seem nominal by comparison. Indeed, it is possible that his most extensive series in this category was made in a single day, when Keokuk's group added his gallery to their agenda of experiences in St. Louis. If so, it was a brief but remarkably productive encounter. Including duplicate plates of Keokuk and Appanoose, Easterly's most prominent Sauk and Fox sitters, approximately twenty portraits related to this series exist in the collections of the Missouri Historical Society, the Newberry Library, and the Smithsonian's Division of Photographic History.

Easterly's fortuitous meeting with his Sauk and Fox visitors occurred in the spring of 1847, when they left their reservation in present-day Kansas to journey by steamboat to St. Louis. On March 24, under the heading "Distinguished Visitors," a local newspaper reported: "Keokuk, the well known Sac and Fox Chief, arrived last evening from the Missouri river, on board the *Amelia*—He is accompanied by ten of his people. The location of the tribe at present is south of the Missouri river, near the mouth of the Little Nemaha."[19] Keokuk was principal leader of what the government officially recognized as the "Sac and Fox band of the Mississippi," a designation that differentiated this tribal division from a much smaller and politically distinct group known as the "Sac and Fox of the Missouri."

With the removal of the Mississippi group from Iowa to the Nemaha Reservation, which had occurred only

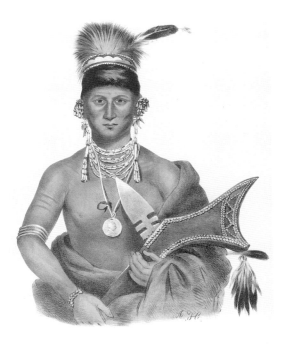

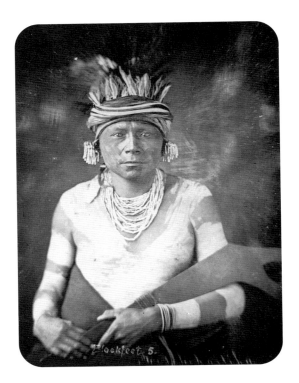

Fig. 3-6. *Appanoose, Saukie Chief.* Lithograph after a painting by George Cooke. From Thomas McKenney and James Hall, *History of the Indian Tribes of North America.* Philadelphia: D. Rice and Co., 1872. MHS.

Fig. 3-7. *Long Horn, Sauk.* Modern print from glass copy negative by A. Zeno Shindler, 1869, from daguerreotype by Thomas M. Easterly, 1847. National Anthropological Archives, Smithsonian Institution.

Fig. 3-8. *Keutchekaitika, Sauk or Fox.* Modern print from glass copy negative by A. Zeno Shindler, 1869, from daguerreotype by Thomas M. Easterly, 1847. National Anthropological Archives, Smithsonian Institution.

Fig. 3-9. *Keokuk's Wife (Nah-wee-re-coo) and Grandson.* Quarter plate, 1847. MHS.

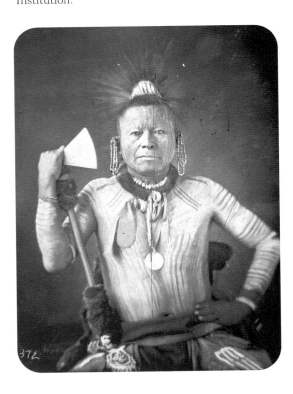

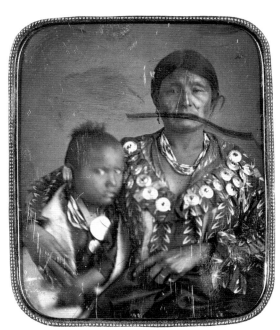

months before Keokuk visited Easterly's gallery, the government concluded its efforts to move all tribes that had originally inhabited the Mississippi and lower Missouri valleys to Indian Territory west of the Iowa-Missouri-Arkansas border. Along with the Iowa and other eastern and central Plains Indians, the Missouri Sauk and Fox had been resettled on the Nemaha Reservation more than a decade earlier.

As he had done on many earlier occasions, Keokuk may have conducted official tribal business on his spring excursion to the city, which was headquarters for the superintendency that managed the affairs of Nemaha Agency tribes. On this particular visit, he and his companions also fulfilled another obligation. On March 25, as the St. Louis *Daily Union* noted: "To-night we are informed that the celebrated Indian Chief Keokuk, with ten of his warriors, will appear at the Circus." After what may have been several "war dance" performances at the Grand Olympia Circus, the St. Louis *Reveille* reported on March 28 that "the celebrated chiefs Keokuk and Apponoose-o-keemar" and their companions had departed the city to return to their reservation. Apponoose-o-keemar, recorded by the government as "a secondary chief" of the Sauk and Fox, was best known as Appanoose, the name that appeared in McKenney and Hall's book (fig. 3-6). As in Easterly's inscriptions, English spellings of Indian names were phonetic translations, a practice that resulted in a wide variety of recorded names for the same individual. It was also not uncommon for Indians to take new names on important occasions.

Given the striking appearances of Long Horn (fig. 3-7), Keutchekaitika (fig. 3-8), and other of Keokuk's "warriors," we can expect that the *Daily Union* was accurate in predicting that his party—"superbly decorated in genuine Indian style"—was sure to draw "good houses" for their performances at the circus. These colorful figures, with their painted bodies and dyed, animal-hair headdresses, would have epitomized the public's romantic notion of the "picturesque" Indian. In Easterly's day and throughout the century, thanks in large part to conceptions impressed upon the popular imagination by writers and by painters such as Catlin, whites persistently clung to the romantic image of the "real" Indian as the exotic "primitive" who looked as he had before contact with white society had altered his traditional customs and costume.[20] The commercial success of later studio photographers would depend upon their ability to recreate that aura of exoticism in their Indian subjects with props and artistic affectations.

Evidence that Keokuk and his group visited Easterly's gallery during their spring 1847 trip to St. Louis appears on one of several located portraits of Appanoose. The Newberry Library plate picturing this Indian (fig. 3-14)

bears the engraved inscription: "Op-po-noos or the Children's Chief. T. M. Easterly, Daguerrean St. Louis Mo. 1847." We can assume that Easterly arranged the event with Keokuk, who was known by his earlier artist-recorders as an eager and cooperative sitter. Like King and other painters who had prepared small-scale facsimiles of their portraits for their most important Indian sitters, Easterly may have provided Keokuk with daguerreotypes of himself and members of his family in exchange for the opportunity to make portraits for his gallery collection.

Among the surviving images that would have had personal meaning for the chief is a double portrait of his wife and grandson (fig. 3-9). Nah-wee-re-coo, pictured with her grandson in Easterly's double portrait, was earlier recorded in a painting made by George Catlin when he visited Keokuk's camp on the Des Moines River in 1835 (fig. 3-10). The artist described his subject as the favorite of the chief's several wives, despite the fact that she was the "oldest of the lot" and the only wife that Keokuk deemed worthy of "the distinguished honor of being painted and hung up with the chiefs." Catlin's notes on Nah-wee-re-coo's costume aptly describe the clothing she wears in

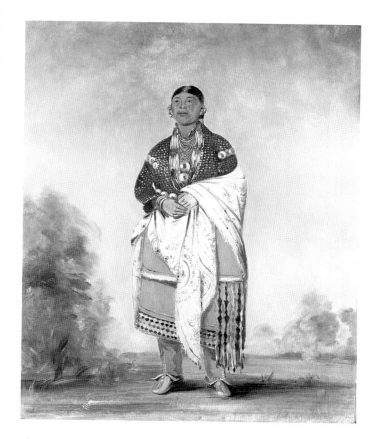

Fig. 3-10. *Nah-wee-re-coo, Wife of Keokuk.* Oil on canvas by George Catlin, 1835. National Museum of American Art, Smithsonian Institution. Gift of Mrs. Joseph Harrison.

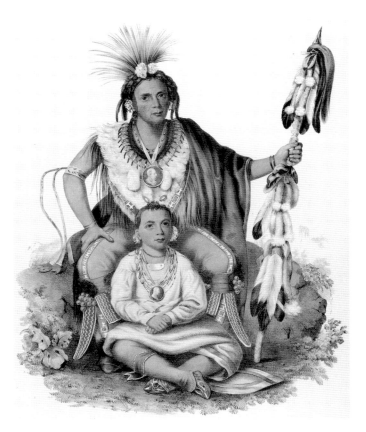

Fig. 3-11. *Keokuk, Chief of the Sacs and Foxes*. Lithograph after the painting by Charles Bird King. From Thomas McKenney and James Hall, *History of the Indian Tribes of North America*. Philadelphia: D. Rice and Co., 1872. MHS.

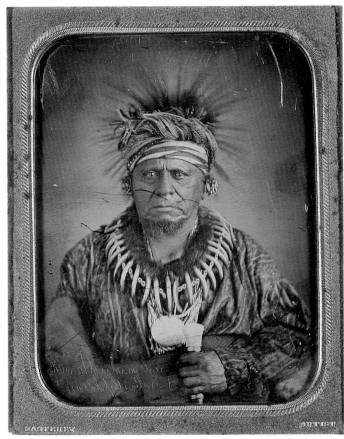

Fig. 3-12. *Keokuk or the Watchful Fox*. Hand-colored quarter plate, 1847. MHS. Plate inscription: Ke-o-kuk or the Watchful Fox.

Easterly's daguerreotype: "Her dress, which was of civilized stuffs, was fashioned and ornamented by herself, and was truly a most splendid affair, the upper part of it being almost literally covered with silver brooches."[21] Her grandson, whose blurred face and figure lend a haunting air to this portrait, has a wary expression that betrays his suspicion of Easterly's mysterious apparatus. Like many elder male members of his tribe, the child has closely shaved hair, with only the traditional scalp lock at the crown. In later years, when his father had become the principal leader of the Mississippi Sauk and Fox, he was known by the Christian name Charles.

If Keokuk shared his grandson's seeming distrust of the camera, he showed no visible signs of those feelings when Easterly recorded him in at least three closely related portraits. As one of the most controversial and widely known Indians in America, Keokuk was already well accustomed to the attention of such artists as James Otto Lewis, Charles Bird King, Peter Rindisbacher, and George Catlin.[22]

Catlin's splendidly regal equestrian portrait of Keokuk, the Watchful Fox, is considered one of the most elaborate and ambitious works of the artist's career. Like Catlin's lavishly decorative portrayal, Charles Bird King's portrait of Keokuk and his son (fig. 3-11) best succeeds as a symbolic representation aimed at conveying the colorful persona and political power of a historically significant figure.

In contrast to these fanciful depictions, Easterly's tightly framed portraits of Keokuk (figs. 3-1, 3-12) provide a meticulous inventory of the Indian's aging face and portly figure. Despite the austerity and simplicity of these portrayals, they in no way diminish the legend of the chief's natural demeanor of commanding authority. On the contrary, they convincingly validate repeated reports of his disarming, "prepossessing countenance."[23] Like his renowned talent for debate, Keokuk's riveting gaze and imperturbable reserve were admiringly viewed by government officials as attributes natural to a born leader of his people.

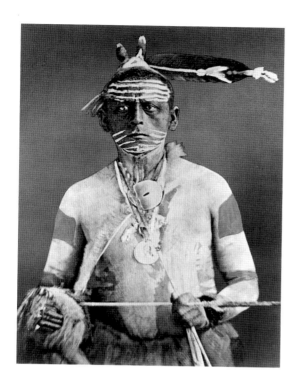

Fig. 3-13. *Young Keokuk or Keokuk, Jr., Sauk.*
Modern print from retouched glass copy negative
by A. Zeno Shindler, 1868, from daguerreotype
by Thomas M. Easterly, 1847. National
Anthropological Archives, Smithsonian Institution.

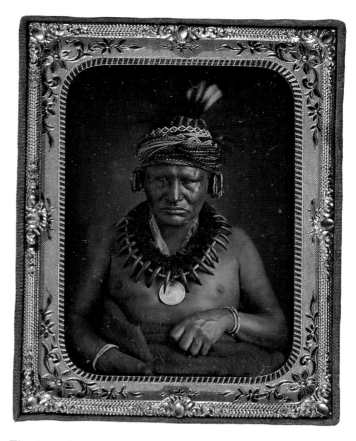

Fig. 3-14. *Op-po-noos, Sauk Chief.* Hand-colored quarter plate,
1847. Edward E. Ayer Collection, Newberry Library. Plate
inscription: Op-po-noos or the Children's Chief. T.M. Easterly
Daguerrean, St. Louis Mo. 1847.

Among enemies within his own people, he had
frequent occasions to test the effectiveness of his steely,
authoritarian demeanor. Originally a tribal councilman,
Keokuk had risen to prominence in 1831 and 1832
through events surrounding the so-called Black Hawk
War, a series of skirmishes that occurred when the Sauk
leader who gave his name to this conflict led the only
organized militant attempt among tribes of this region to
resist government removal from their lands. Following his
defeat, Black Hawk was stripped of power by Indian
Affairs officials and the more cooperative Keokuk was
anointed by the government as the primary leader of the
Mississippi Sauk and Fox. This action created a
permanent breach between factions within both tribes
who supported or opposed his leadership. Many Fox
resented the control of a Sauk leader. Although these
tribes were closely connected by a common Algonquin
language, similar cultural traits, and frequent military
alliances, they had never willingly formed or

acknowledged an official confederation. Ignoring this
circumstance, the government persisted in treating the
Sauk and Fox tribes as a single entity. Keokuk's control
over government land payments, which he used to reward
his friends and punish his enemies, ensured continued
dissension.[24]

Tribal relations between the Sauk and Fox did not
improve with Keokuk's death, which occurred barely a
year after Easterly recorded his portraits. As expected,
government agents transferred Keokuk's power to his son
Waw-naw-ke-saw. The same factions that had contested
his father's position were equally resistant to the authority
of the newly appointed leader.

Keokuk's son, who appeared in Easterly's gallery
along with other members of Keokuk's traveling party,
was twenty-three years old when the daguerrean recorded
his portrait (fig. 3-13). He assumed leadership of the
Mississippi Sauk and Fox in June 1848 upon the death of
his father. His position as second-ranking signatory of the

Sauk's 1842 treaty with the government had forecast this transfer of authority. In this document, he is designated as "Wa-some-e-saw," one of several recorded variants of his Indian name. After his father's death, he was best known as Young Keokuk or Keokuk, Jr., as Easterly's engraved inscription identifies him. In his later years on the reservation in Indian Territory, where many Sauk and Fox were resettled in the late 1860s, he ardently embraced Christianity. When he became a Baptist minister, a position that he held until his death in 1903, he was known as Rev. Moses Keokuk.

In Easterly's portrait, young Keokuk is dramatically portrayed with the paraphernalia and body decoration typical of a young Sauk tribesman. A prominently displayed eagle feather crowns the closely cropped head common to Sauk and Fox tribesmen. A shell gorget, like those that traditionally adorned the chests of Sauk men, hangs around his neck above a silver peace medal. The government had been presenting Indians with these medals, worn by several of Easterly's sitters, since the days of Thomas Jefferson; they displayed the profiles of incumbent presidents. Easterly's daguerreotype of young Keokuk, which is now in poor condition, was copied in 1868 by photographer A. Zeno Shindler of Washington, D.C. At some later point, following a practice that had become common in the production of Indian portraits, Shindler's glass copy negative was generously retouched to emphasize the decorative character of the subject's body painting.[25] These features were visible but more subtle in Easterly's original image.

Although Keokuk and his son played much more prominent roles in the history of the Sauk and Fox, Appanoose (fig. 3-14) was also widely known in 1847 both as a principal tribal leader and as one of Keokuk's strongest and most faithful allies. When the Black Hawk War created a permanent split between the more resistant followers of Black Hawk and the so-called "peace" faction led by Keokuk, Appanoose, a Sauk village leader, aligned his people with Keokuk. While Easterly's plate inscription identifies "Op-po-noos" as "the Children's Chief," his full name, Appan-oze-o-ke-mar, is translated in early treaty records as "The Hereditary Chief, or "He Who Was A Chief When A Child."

Although he ranks among the most formidable-looking figures in the daguerrean's Sauk and Fox series, Appanoose appears in early accounts of his tribe as a mild-tempered "peace chief" remembered for his 1837 address to the governor of Massachusetts on behalf of his Sauk and Fox delegation: "As far as I can understand the language of the white people, it appears that the Americans have attained a very high rank among white people. It is the same with us.... Where we live beyond

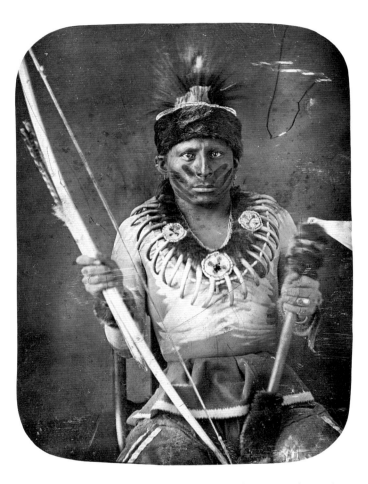

Fig. 3-15. *Bum-bemsue, Sauk or Fox.* Modern print from glass copy negative by A. Zeno Shinder, 1869, from daguerreotype by Thomas M. Easterly, 1847. National Anthropological Archives, Smithsonian Institution.

the Mississippi, I am respected by all people, and they consider me the tallest among them."[26] Earlier that year, during a visit to Washington, D.C., the government confirmed Appanoose's stature among his people by arranging his sitting for the painting that was later reproduced as a lithograph in McKenney and Hall (fig. 3-6). If this highly stylized likeness and the biographical sketch that accompanied this portrait guaranteed Appanoose a place in the historical record of his tribe, Easterly's arresting portrayals of the chief offer far more memorable impressions. The daguerrean's annotations on the frame that holds the Newberry Library's portrait describe Appanoose's neckwear: "The ornaments around the neck are Grisley [sic] Bear claws. The medals were presented at Washington, I think under Tyler's administration."[27]

In later decades, photographers preserved the faces of a new generation of tribal leaders when Sauk and Fox delegations visited the nation's capital. The glass-plate era also left numerous records of tribal culture on the Sauk and Fox reservation in Indian Territory. Compared to many images that document the history of these tribes in the later nineteenth century, Easterly's daguerreotypes are uniquely compelling and instructive. Only in his startling portraits of such tribesmen as Bum-bemsue (fig. 3-15) and Quah-qua-hose the Howling Wolf (fig. 3-16) do we have lasting and impressive records of the independent spirit and tenacious attachment to traditional customs that earned these Indians a distinctive place among the many displaced tribes. For more than a decade after their resettlement on the Nemaha Reserve, the Mississippi Sauk and Fox tenaciously resisted government efforts to convert them to a "civilized" Christian-agrarian lifestyle. Even the unusually amenable Keokuk strongly resisted these overtures. "As to the proposal to build school houses," he once told Indian agents, "we have always been opposed to them and will never consent to have them introduced into our nation."[28] For refusing to adopt readily "the habits and usages of the whites," the government singled out these tribes as the most independent and culturally conservative of "almost all others of the removed Indians on our borders."[29] If the intense, challenging gazes that Cuch-che-wah-pello (fig. 3-17) and Wah-wa-ah-ton (fig. 3-18) directed at Easterly's camera reflect that staunch independence, we can believe an 1852 report lamenting that many Sauk and Fox who "insist on retaining their savage manners" continued to "yearn to go further West, that they may be still more distant from civilization."[30]

In a series made two years after his Sauk and Fox sittings, Easterly also documented a group of Iowa, a much smaller tribe that had frequently been the target of Sauk and Fox aggression during its pre-reservation days.

He made at least five exposures to record Nacheninga, also known as Notchimine or No Heart, who was recognized by government agents as the "second chief" of the Iowa. One of two portraits of Nacheninga in the Newberry Library's Ayer Collection is engraved "1849" (fig. 3-19). On the back of this image is a notation that reads: "Every Indian name has a meaning. Na-che-ninga means no heart of fear or a heart that fears nothing."

Presumably, Easterly's portrait of the Iowa woman Kun-zan-ya (fig. 3-20) was secured at the same sitting. Her husband Mahee, who was recorded on this same occasion (fig. 3-23), would have been thirty years old at this date, an age that seems consistent with his appearance in Easterly's daguerreotypes.[31] A portrait attributed to Easterly, which pictures an unidentified Plains Indian, possibly an Iowa, may have been part of the same series (fig. 3-21).

Nacheninga, who would become the principal leader of his tribe in 1850, was the acknowledged business head of the Iowa, a responsibility that may account for his trip to St. Louis in 1849. As was customary, he and his group were escorted on their journey by a Nemaha Reservation agent, Colonel Alfred J. Vaughn, who held this position for the Iowa tribe in 1848 and 1849.[32] From notes that Easterly penciled on the verso of the frame that holds one of the Newberry Library's Nacheninga portraits, it appears that the agent was more than a silent observer on the occasion of the Indians' sittings. Explaining his subject's intense grimace, Easterly wrote: "The expression of Nacheninga's mouth is unnatural. It was put on to represent their look of wisdom in Council, at the request of the Agent."[33]

In a second portrait of Nacheninga (fig. 3-22), Easterly left even more telling evidence of the value that he placed on his images as informative historical documents. The extensive engraving that covers the background of this image is a fascinating response to that documentary impulse. During his sittings with this Iowa group, Easterly apparently heard the story of the rifle that Nacheninga held in several exposures. His engraved inscription records that account, presumably as it was related by Agent Vaughn: "The Rifle was presented to the Chief of the Chippeway's by King William the fourth of England during his sojourn in America. The barrel is made of Gold, Silver and Platina and carries an ounce ball with accuracy a distance of one mile." Easterly wrote much the same information on back of a related image. In this instance, however, he substantiated the claim of the gun's extraordinary power. After noting its ability to carry "an ounce ball ... a distance of one mile," he added, "So says Col. Vaughn the Indian Agent who saw it tested."[34]

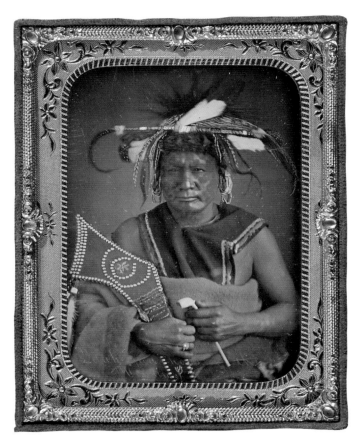

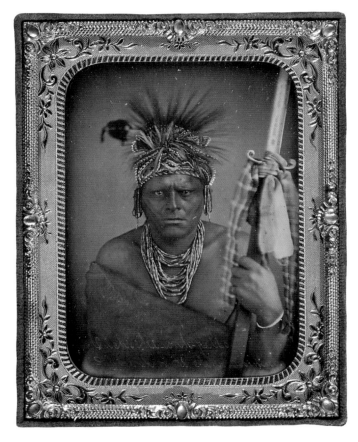

Fig. 3-16. *Quahquahose, Sauk or Fox.* Hand-colored quarter plate, 1847. Edward E. Ayer Collection, Newberry Library. Plate inscription: Quah-qua-hose, or the Howling Wolf.

Fig. 3-17. *Cuch-Che-Wah-Pello, Fox.* Hand-colored quarter plate, 1847. Edward E. Ayer Collection, Newberry Library. Plate inscription: Chu-Che-Wah-Pello, Daybreak or the Clear Morning.

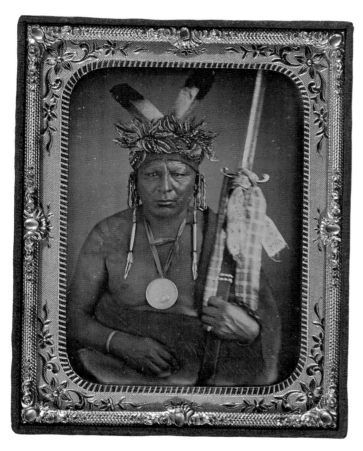

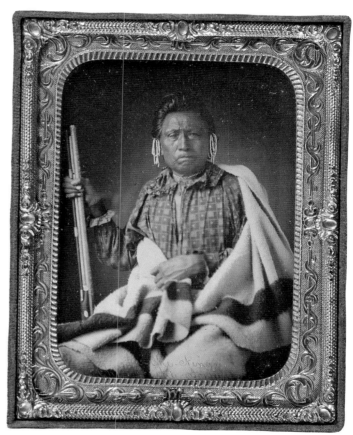

Fig. 3-18. *Wah-wa-ah-ton, Sauk.* Hand-colored quarter plate, 1847. Edward E. Ayer Collection, Newberry Library. Plate inscription: Wah-wa-ah-ton, The Whirlpool.

Fig. 3-19. *Nacheninga or No-Heart of Fear.* Hand-colored quarter plate, 1849. Edward E. Ayer Collection, Newberry Library. Plate inscription: Na-che-ninga, Chief of the Iowas, 1849.

Primarily because of their garments, Nacheninga and his Iowa companions seem less exotic—but no less impressive—than the Sauk and Fox subjects who had earlier sat for Easterly's camera. Unlike Keokuk's followers, Nacheninga's people had adapted to life on a reservation by the late 1840s. More than a decade before they had ceded the last of their lands in western Missouri to settle permanently on their government-assigned tract on the Nemaha Reservation.

Early in their recorded history, a French trader had described the ancestors of Nacheninga as "industrious and accustomed to cultivate the earth."[35] Like the Missouri and the Oto who spoke a similar Siouan dialect, the Iowa plainsmen were horticulturists, whose annual harvests were supplemented with food supplied by winter buffalo hunts. This traditional pattern of subsistence reinforced their ability to conform to the agrarian lifestyle that the government promoted as a means of "civilizing" reservation inhabitants.

In later years, when acculturation had diminished more notable traces of his tribe's traditional culture, the young Iowa brave who sat for Easterly's portrait would be remembered for his contribution to that assimilation process (fig. 3-23). In 1877, William Henry Jackson described "Mah-hee, The Knife" as "a hard-working man" and "among the first to take the lead in settling down to an agricultural life."[36] Noted as "A Brave" in Easterly's 1849 inscription, Mahee is listed as "the third chief" of the Iowas in Jackson's later record.[37] Squarely facing the camera in a closely cropped, three-quarter-length view, the handsome young Indian dominates the space of the picture to convey a strong physical presence and commanding bearing. Those qualities are notably absent in a portrait made during his delegation visit to Washington two decades later (fig. 3-24). This full-figure presentation, a format that diminishes the individuality of the sitter, is typical of most commercial studio portraiture of Indians made after the daguerrean era. The detached, lethargic mood conveyed by Mahee's distant gaze and casual posture is equally prevalent during this later period.[38] While Easterly's portrayal is conspicuously structured by comparison, the outcome creates a sense of immediacy and a charged proximity between the Indian subject and the viewer that is only rarely encountered in later decades.

Easterly's equally forceful portraits of Nacheninga picture an older Iowa leader who had an even greater role in encouraging acculturation among his people. In 1850, Presbyterian missionaries working among the Iowas reported that Nacheninga was "a friend to the Whites and anxious to have his people adopt their customs.... The School and missionaries owe much to him for his friendship and influence."[39] In front of the camera, No-Heart-of-Fear showed little visible evidence of the amenable side of his character.

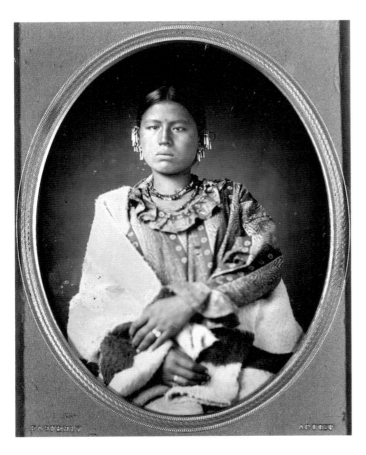

Fig. 3-20. *Kun-zan-ya, Wife of Mahee, Iowa.* Hand-colored quarter plate, 1849. MHS.

If Easterly's camera did not convey Nacheninga's conciliatory attitude toward whites, it did transcribe more discernible signs of external intrusion upon the Iowas' native culture. No-Heart and his tribal companions display the creative admixture of native and European dress that first announced the ubiquitous inroads of foreign influence on Native Americans. Manufactured material goods increasingly made their way into the Plains regions after the Louisiana Purchase in 1803. Well before midcentury, skin garments decorated with beading or quill work were replaced with calico shirts, woolen leggings, or multilayered skirts. During the same period, trade blankets such as those worn by Easterly's Iowa subjects quickly supplanted the Indian's traditional buffalo robes. Although tribes farther west were slower to modify their native costume, reservation Indians—out of necessity if not inclination—were quick to adopt the basics of the European apparel.

Because of the rapid assimilation of foreign material goods, the camera rarely preserved purely traditional Native American dress. By the time the daguerreotype was introduced, all eastern tribes and many of their midwestern counterparts were already living on reservations. Later in the century, when reservation Indians were generally viewed by whites as wards of "civilized" society, most tribes dressed in government-issued clothing. As the wet-plate era progressed, photographers took whatever liberties necessary to accommodate the steady market for images picturing appropriately exotic or "primitive"-looking Indians. By the later 1860s, many commercial galleries owned their own collections of "native" props, including full Indian costumes, which they routinely used without regard to tribal distinctions or ethnological accuracy.[40] Easterly's portraits, which ethnologist John C. Ewers has described as "graphic historical documents" on the basis of the authenticity of dress and accessories, show no evidence of those practices.[41]

His portrait of Mahee and his wife and baby (fig. 3-25) is a particularly interesting illustration of the typically innovative blending of traditional Indian clothing and such European accoutrements as boldly printed calico and ruffled trimmings. As a substitute for the traditional feather fan, Mahee may have been holding a European feather duster, a utilitarian commodity available at any general store. Armed with this purely decorative prop, Mahee seems to embody the gentle spirit that would later lead government observers to conclude that "next to the Cherokee," the Iowa are "the most civilized of the tribes on the Nemaha Reservation."[42] It is unlikely that Easterly's more culturally conservative Sauk and Fox subjects, most of whom prominently display weapons such as war clubs and axes, would have been inclined to pose with this innocuous symbol of white society.

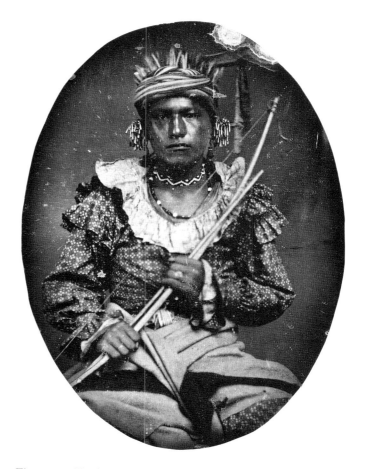

Fig. 3-21. *Unidentified Plains Indian.* Quarter plate, attributed to Thomas M. Easterly, 1849. Amon Carter Museum.

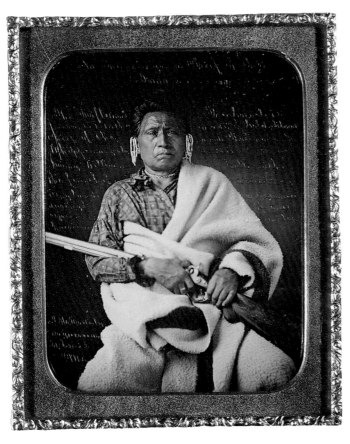

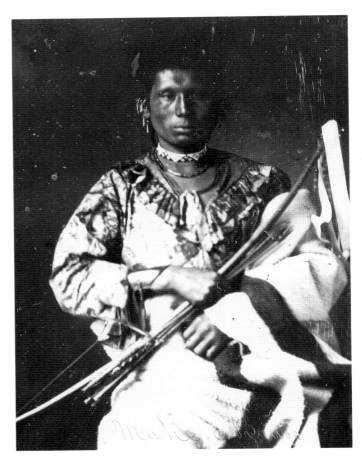

Fig. 3-22. *Nacheninga, Iowa Chief.* Quarter plate, 1849. MHS. Plate inscription: Na-che-ninga, A Chief of the Iowa's. The Rifle was presented to the Chief of the Chippeway's by King William the fourth of England during his sojourn in America. The barrel is made of Gold, Silver and Platina and carries an ounce ball with accuracy a distance of one mile. T.M. Easterly Daguerrean, St. Louis Mo.

Fig. 3-23. *Mahee, The Knife, Iowa.* Quarter plate, 1849. Division of Photographic History, National Museum of American History, Smithsonian Institution. Plate inscription: Ma-he, A Brave.

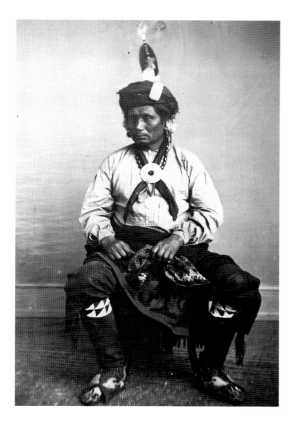

Fig. 3-24. *Mahee, The Knife as Third Chief of the Iowa*. Photograph by A. Zeno Shindler, 1869. National Anthropological Archives, Smithsonian Institution.

Fig. 3-25. *Mahee and Kun-zan-ya, Iowa*. Hand-colored sixth plate, 1849. Edward E. Ayer Collection, Newberry Library. Plate inscription: Ma-he, A Brave - Kun-zan-ya.

Fig. 3-26. *William Blackmore and Red Cloud, Chief of the Ogala Dakota*. Photograph by Alexander Gardner, 1872. National Anthropological Archives, Smithsonian Institution.

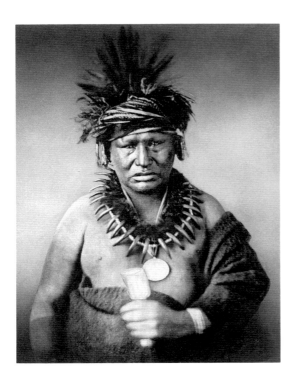

Fig. 3-27. *Appanoose, Sauk.* Modern print from retouched glass copy negative by A. Zeno Shindler, 1869, from daguerreotype by Thomas M. Easterly, 1847. National Anthropological Archives, Smithsonian Institution.

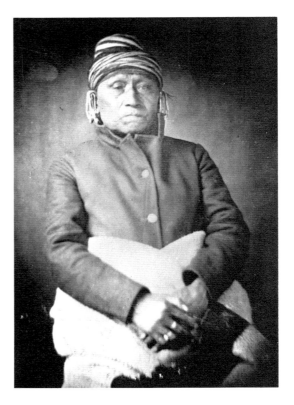

Fig. 3-28. *Nacheninga, Iowa.* Modern print from glass copy negative by A. Zeno Shindler, 1869, from daguerreotype by Thomas M. Easterly, 1847. National Anthropological Archives, Smithsonian Institution.

At the height of his career in the early 1850s, Easterly's advertisements reminded the public that "Indian Chiefs" were among the novel "specimens" on view at his establishment. The opportunity to see likenesses of the well-known Keokuk and his picturesque "warriors" undoubtedly brought visitors to his gallery, and he may have sold an occasional copy plate of his more prominent Indian sitters. When a significant number of works from Easterly's repertory of Indian images did eventually reach a wider audience, it was through the efforts of a patron whose interest in Native Americans extended beyond the appeal of their exotic and picturesque appearance.

More than twenty years after Easterly daguerreotyped his Sauk and Fox sitters, William Blackmore (fig. 3-26), a wealthy English businessman and collector, spent several days in St. Louis. During his stay there in October 1868, he invested more than $350 in the work of local photographers.[43] This information appears in what is generally referred to as the Blackmore "diaries," a series of notebooks used primarily to list his itinerary, personal

contacts, and expenditures during several trips to America. As a record of the photographic materials that he acquired, his sketchy and sometimes illegible notations are disappointingly vague. St. Louis-related entries, which suggest that John Fitzgibbon acted as an agent or middleman for Blackmore's transactions with local photographers, list "Daguerreotypes," "cartes-de-visite," "stereoscopes," and "large" pictures totaling more than 150 images. With the exception of Fitzgibbon, Blackmore makes no mention of the photographers who contributed to his collection.[44] Despite this omission, there is little question that the Easterly Indian portraits now in the Smithsonian's Division of Photographic History were among the works that Blackmore purchased in St. Louis in the fall of 1868.

When we consider this collector's unique legacy to early documentary photography in America, his role in preserving these important images is not surprising. Blackmore had made his first voyage to America in 1863.[45] During this trip, as on several subsequent visits to America,

Fig. 3-29. *Indian on a Rock,* painted by Charles Deas in 1847. Quarter plate, 1847. Division of Photographic History, National Museum of American History, Smithsonian Institution.

Fig. 3-30. *Indian Burial,* painted by Seth Eastman in 1847. Modern print from glass copy negative by A. Zeno Shindler, 1869, from a now-lost daguerreotype by Thomas M. Easterly, 1847. National Anthropological Archives, Smithsonian Institution.

he combined business activities with his passionate interest in the ethnology of the American Indian. Trained as an attorney, Blackmore had channeled his energies into the lucrative business of promoting foreign investment in land, mining, and railroad opportunities. While he hoped to finalize plans for a government loan venture during his trip to America in late 1863, he also used the opportunity to negotiate the purchase of a large body of artifacts retrieved from the Ohio Indian Mounds during their excavation in the 1840s. To display this collection, Blackmore built an ethnological museum in Salisbury, England, that eventually housed what has been described as "the largest Victorian collection of data on North American Indians and the buffalo ever brought together by a single individual."[46]

In the fall of 1868, Blackmore made a second journey to America. During this much more extensive visit, he spent months in the far West exploring regions that bordered the route of the Union Pacific Railroad. He also took part in a buffalo hunt organized by his friend, General William T. Sherman. Plans for this expedition were initiated

in St. Louis, where he had spent ten days on his return trip to the East.

When Blackmore arrived in St. Louis on October 21, he had already embarked on an ambitious project aimed at preserving a comprehensive visual record of America's Indian cultures. During his 1868 trip and on later journeys to America over the next few years, he purchased and commissioned more than two thousand photographs with the ultimate goal of obtaining representative pictures of "all tribes inhabiting the North American continent."[47] Eventually he hoped to publish a series of albums illustrated with reproductions of his photographs.[48] That aspect of his plan did not materialize. Barely a decade after opening his museum, a series of unsuccessful investments forced Blackmore into bankruptcy. Following his death in 1878, this remarkable man, who invested years of effort and much of his personal fortune in preserving records related to the American West, was largely forgotten. Only recently have scholars begun to examine the scope and importance of Blackmore's contributions to western studies.[49]

Many of the most valuable additions to Blackmore's diverse collections, including several hundred pictures that would form the core of his photographic archive, were acquired during his 1868 tour of the West. More than three hundred of those photographs, including at least eleven Easterly plates, were left in the care of Washington photographer A. Zeno Shindler, who was hired to make copies of Blackmore's collection for the Smithsonian Institution. Blackmore's interest in duplicating his collection for the benefit of American ethnologists and historians, and his willingness to bear the financial burden of that project, were in keeping with his serious dedication to furthering the study of the American Indian. In addition, he had developed a close association with Joseph Henry, the first secretary of the Smithsonian, who had originally promoted the idea that his institution should look to photography as an invaluable means of preserving information on Native Americans. Blackmore also had connections to circles close to the Smithsonian through his friendship with Ferdinand V. Hayden of the U.S. Geological Survey of the Territories, with whom he had traveled during a portion of his 1868 sojourn in the West. It was Hayden who arranged for Shindler to make glass-negative copies of Blackmore's collection.

Prints made from many of these negatives were displayed in the Smithsonian's first exhibition of photographs, which probably occurred in 1869. A visitor's leaflet entitled "Photographic Portraits of North American Indians in the Gallery of the Smithsonian Institution" listed the images exhibited.[50] This inventory, now commonly referred to as the *Shindler Catalogue,* identified the Indian subjects pictured by name and tribe, but (as in the case of Easterly's contributions to the exhibit) generally did not credit the original photographers. The many unattributed portraits copied from Blackmore's photographs carried the additional caption: "Copied by Shindler, Washington" in "1868" or "1869." Eleven Easterly works—nine portraits and two reproductions of paintings depicting Indian themes—appeared in this inventory. Shindler's titles for the portraits, such as "Keokuk, Jr." and "Op-po-noos,

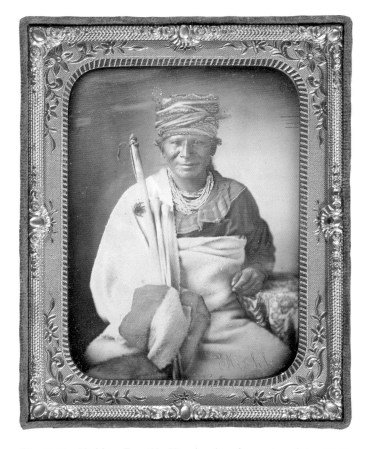

Fig. 3-31. *Kishko, Fox* [?]. Hand-colored quarter plate, 1847. Edward E. Ayer Collection, Newberry Library. Plate inscription: Kishko.

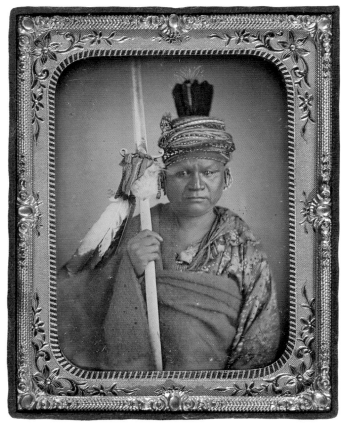

Fig. 3-32. *Tanpushepammehat, Fox* [?]. Hand-colored quarter plate, 1847. Edward E. Ayer Collection, Newberry Library. Plate inscription: Tan-push-e-pammehat or the Thunderstorm.

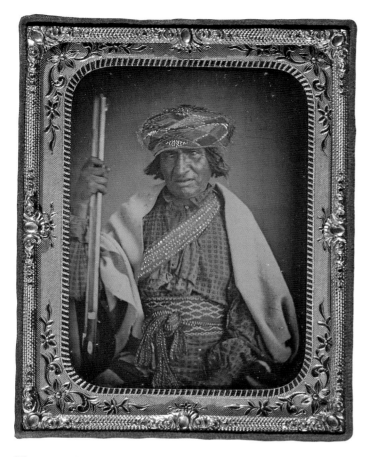

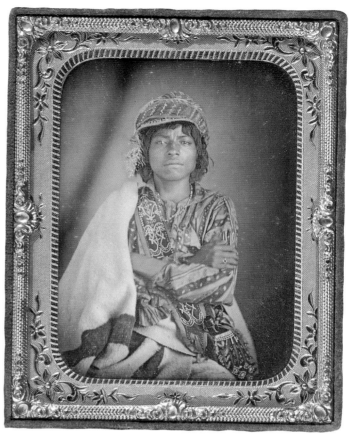

Fig. 3-33. *Muxta, Seminole* [?]. Hand-colored quarter plate, 1845-47. Edward E. Ayer Collection, Newberry Library. Plate inscription: Muxta.

Fig. 3-34. *Baquasha.* Hand-colored quarter plate. Edward E. Ayer Collection, Newberry Library. Plate inscription: Baquasha.

Children's Chief," were taken directly from inscriptions engraved on the original Easterly plates.

Ten of those plates are now housed in the Smithsonian's Division of Photographic History. The fate of Easterly's copy of a Seth Eastman painting is not known. Shindler's glass negatives are now part of the Smithsonian's National Anthropological Archives. The Easterly daguerreotypes that eventually came into the Smithsonian's care as a result of the Blackmore-Shindler collaboration all display the daguerrean's familiar, hand-engraved inscriptions. Although the likenesses of Keokuk, Appanoose (fig. 3-27), Nacheninga, and Mahee seen in this group clearly derive from the same sittings that produced his other known portraits of Sauk, Fox, and Iowa Indians, only the portrait showing Nacheninga posed with a rifle appears to be an exact duplicate of Easterly plates located in other institutional collections. The Smithsonian series includes his only known portrait of this Iowa chief wearing a military jacket (fig. 3-28). Mahee, seen in other collections with his wife and baby, appears alone in the

Smithsonian's daguerreotype record (fig. 3-23). Images of Keutchekaitika (fig. 3-8), Keokuk, Jr. (fig. 3-13), Bumbemsue (fig. 3-15), and Long Horn (fig. 3-7), which complete the Smithsonian portrait series, are unique among the daguerrean's located work and are also the only known half plates among his Indian portraits. Shindler's copy negatives now provide the only records of the original appearance of a number of these portraits. Due to the sadly deteriorated condition of the plates, some of these images are now barely discernible.

Two other Easterly works that Blackmore turned over to Shindler for copying reflect the breadth of the collector's efforts to acquire pictorial work depicting the customs and character of Native Americans. These images, which reproduce paintings by frontier artists well known as specialists in Indian themes, also signal Easterly's early interest in expanding his own repertory of "specimens" illustrating Indian cultures. Both paintings were displayed in St. Louis and praised in the local press during the early months of Easterly's career in that city.[51]

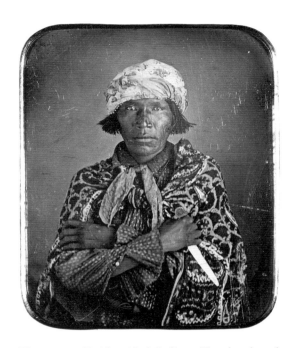

Fig. 3-35. *Unidentified Indian.* Hand-colored quarter plate. MHS.

One of these plates recorded Charles Deas' romanticized portrayal of an anonymous tribesman seated on a rocky promontory (fig. 3-29), an image that was the antithesis of the daguerrean's more objective interpretations of Indian subjects. Inspired by the popularity of George Catlin's Indian Gallery, Deas had left his native Philadelphia in 1840 to explore the dramatic potential of western genre painting. He spent the next seven years working in a St. Louis studio while traveling the Platte, Missouri, and upper Mississippi rivers gathering subjects for his imaginative, melodramatic portrayals of Indian and frontier life. Although he was one of the most widely recognized western artists of his time, fewer than a dozen of his works survive.[52]

His now-lost *Indian on a Rock* painting, shown here in Easterly's daguerreotype copy, has previously been known only through a contemporary description that appeared in the St. Louis *Reveille* in 1847: "The subject is a solitary Indian, seated on the edge of a bold precipice. The form is naked, with exception of a blanket thrown loosely around his middle, and a moccasin on one foot. A cataract is rushing by his perilous perch, and beneath him rise the points of a wild and craggy mountain scene…. The figure is finished in the artist's fine, bold style."[53] Deas exhibited his work in a frame shop on Glasgow Row, which was also the location of Easterly's gallery during his six-month stay in St. Louis in 1847. Easterly must have daguerreotyped the painting sometime before leaving the city in late summer, since Deas had moved to New York before the daguerrean returned to St. Louis in February 1848. Shindler's copy of the daguerreotype was listed in the *Shindler Catalogue* as "An Indian looking down from a Rock," with no credit to either Deas or Easterly.

A copy of a Seth Eastman painting was also among the Easterly plates that Blackmore left in Washington to be duplicated. The original oil on canvas, titled *Indian Burial*, is now in the collections of the Gilcrease Institute of American Art and History. Although Easterly's copy was lost sometime after Shindler reproduced it in 1869, the image was listed in the *Shindler Catalogue* as "Sioux Indians Burying Their Dead" (fig. 3-30). The title that Easterly assigned to the work in his engraved inscription—now just barely visible on the glass copy negative—is illegible.

The daguerrean would have had access to Eastman's painting when it was on view in the studio of St. Louis landscape painter Henry Lewis over the winter and spring of 1847-48. Lewis had acquired the work when he visited the artist while on a trip up the Missouri River to the headwaters. Eastman, then a captain in the U.S. Army, was stationed at Fort Snelling in Minnesota Territory, where he produced a large body of work based on his contact with Indians in the region.

The *Indian Burial* was instrumental in establishing Eastman's reputation. On November 29, 1847, the *Missouri Republican* offered a glowing assessment of the captain's abilities as a recorder of "real Indian life" and a description of the scene that Easterly daguerreotyped: "The painting … represents a Sioux funeral. They bury their dead upon a rude platform or elevation supported by the branches of trees, forks, etc.; the platform is covered with buffalo robes, and surrounded by the weapons and many of the effects of the deceased." Sent on to New York in 1848, the *Indian Burial* was shown in the National Academy of Design's exhibition where it was purchased by the American Art Union. Easterly probably displayed his daguerreotype copy of the painting until it was sold to William Blackmore in 1868.

There is also evidence that Blackmore was once the original owner of a second series of fifteen Easterly plates now in the Edward E. Ayer Collection at the Newberry Library.[54] Since the images pictured in this group do not appear among Shindler's copy negatives of Blackmore's collection, we can assume that the Englishman transported these daguerreotypes directly to his museum in England, presumably at the end of his 1868 trip to America. In addition to a stunning assortment of Indian portraits, this distinctive body of work includes reversed duplicates of portraits of James Kirker, the notorious "King of New Mexico," and the Santa Fe trader, J. M. White, that are in the Missouri Historical Society's collection.[55] Provenance

data on the Kirker portrait indicates that it was purchased for the Ayer Collection in 1951 from an unidentified book dealer who had originally acquired it from the Blackmore Museum.[56] That institution began to disperse its holdings in the 1930s. The British Museum acquired a significant portion of Blackmore's collection, while other groups of artifacts and photographs were sold at auction to private collectors and dealers. Since the mat and elaborate thermoplastic frame that hold the Kirker portrait are identical to those of other portraits in this group (and since all of the images are housed in their original mounts), it seems safe to assume that the entire series was acquired as a single purchase.

The Ayer series includes portraits of Keokuk (fig. 3-1), Appanoose (fig. 3-14), Nacheninga (fig. 3-19), and Mahee with his wife and baby (fig. 3-25). Duplicates or reversed duplicates of these images appear in the Missouri Historical Society's Easterly Collection. Several Indian portraits unique to the Newberry's collection (figs. 3-31, 3-32) represent some of the daguerrean's most striking work in this documentary genre. Nor can the equally impressive figures of Muxta (fig. 3-33) and Baquasha (fig. 3-34), whose tribal affiliations are less certain, be seen among Easterly's work in other collections. The documentation that accompanies several of these images is also a distinguishing feature of the Newberry series. Written in pencil in Easterly's hand, these annotations—possibly made for Blackmore's benefit—appear on the back of the thermoplastic frames.

Easterly's documentation on the frame of the Muxta portrait notes the subject as "a Seminole, 78 years of age." Although no tribal affiliation is given for Baquasha, certain similarities in costume suggest a tribal association between the older Muxta and the handsome young Indian who may have been his traveling companion. Correspondences in the character of headgear and other decorative accessories also suggest possible—if more tentative—tribal connections between these Indians and the subjects of two undocumented portraits attributed to Easterly in the Missouri Historical Society's collection (figs. 3-35, 3-36). All four sitters share some characteristics typically associated with the Seminole and related southeastern tribes. For example, three of the sitters appear to be wearing woven sashes common to the costumes of Seminole, Creek, and Cherokee men at midcentury. Beyond these speculations, nothing is known about these Indians or the circumstances that occasioned their sittings with Easterly.

While Easterly Indian portraits housed elsewhere sometimes show subtle touches of color, the Ayer Collection plates are lavishly tinted and embellished with intricate patterns of gold and silver. The notably consistent

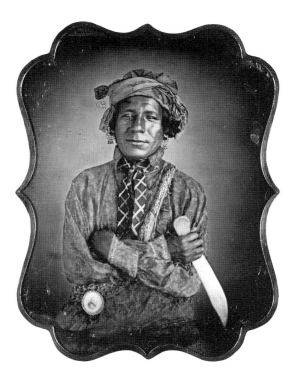

Fig. 3-36. *Unidentified Indian.* Hand-colored quarter plate. MHS.

handling of this decorative detail suggests that he may have prepared these works as a set made to order for Blackmore, who acquired many of his photographs through similar arrangements. Such pronounced digressions from Easterly's usual taste for unadorned plates may have occurred at Blackmore's request. At the same time, we can be certain the daguerrean recognized that the inherently and strikingly picturesque character of these subjects provided a particularly appropriate occasion for such departures. By the late 1860s, when Easterly's business was faltering, he was also publicizing his willingness to color "all styles" of pictures as a means of supplementing his income. The Ayer portraits surely attest to his talents in this sideline. They are unquestionably among the most exquisite hand-colored daguerreotypes ever produced in an American gallery.

Like the best work in this genre by other talented daguerreans, Easterly's Native American subjects meet us eye to eye, not as mannequins arranged or idealized to reflect the painter or photographer's vision but as sitters who present themselves as they wish to be seen. Bringing to bear his respect for historical record and for the classical simplicity that best suited his medium, Easterly admiringly captured the sense of formality and ceremony that was only appropriate for these "Distinguished Visitors."

"BEAUTIFUL LANDSCAPES, PERFECT CLOUDS, AND A BONA FIDE STREAK OF LIGHTNING"

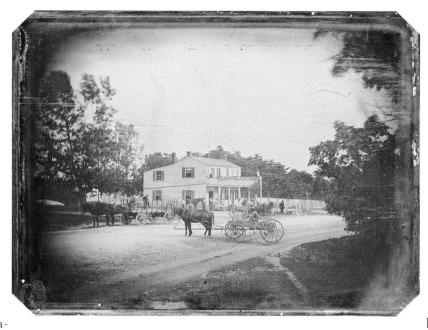

*I*f Easterly's "Distinguished Visitors" attracted potential customers during the period of the daguerreotype's popularity, his less conventional work as a landscape specialist brought an even greater measure of distinction to his St. Louis gallery. In this early era of photography, the term "landscape" was frequently used synonymously with "view" to describe any scene recorded outside the gallery. Through Easterly's many surviving views—a singularly rich and abundant collection—we have access for the first time to a body of outdoor daguerrean art large enough to allow a comprehensive study of the intentions and individual style of its maker. No other aspect of this photographer's practice speaks so eloquently of the breadth of his vision for the daguerreotype medium. Within a program of systematically developed themes, he created images ranging from art-fully constructed pictorialist scenes to bluntly descriptive views that demonstrate what the camera alone could effectively accomplish in transforming the fleeting moment into a permanent historical record. These shifting and overlapping styles reflect both the pioneering nature of his on-site efforts and the wide range of his ambitions for the camera-made view. Indeed, it is in his varied roles as artist-interpreter, reporter, and conservator of the past that we can most fully appreciate his diverse and extraordinary achievements.

In the mid-1840s, when Easterly's advertisements were promoting "views of all kinds,"[1] the vast majority of his daguerrean colleagues were still working to perfect their techniques as likeness-makers. Few American practitioners had reason to explore more fully the potential of the new medium. By its very nature, the small, hand-held daguerreotype was most appealing as a private memento, a precious icon for family or friends; views were less likely to foster the same kind of sentimental

Fig. 4-1. *St. Louis Beer Garden.* Half plate, c. 1860. MHS.

attachment—or generate the same kind of steady demand. And while these minutely detailed miniatures were unsurpassed as precise, graphic equivalents of a scene or monument, they could not be readily or cheaply duplicated for wide distribution. Working outside the more easily controlled conditions of the gallery also required considerably more time and effort.

As suggested by the rarity of surviving daguerreotype views—a long-cherished commodity among collectors—and by contemporary reports on the progress of photography in America, relatively few pioneers in this highly competitive business seemed inclined to focus on a "line" for which there was no established commercial market. In 1856 a visiting British photographer wrote to the *Liverpool Photographic Journal* to remark that in America "We are not troubled with any other branch of the art than face-mapping." He attributed this preoccupation with portraiture to a general reluctance among his American colleagues "to have to learn how to do anything requiring a different routine to what they are accustomed to by having everything at hand in their rooms."[2] Discussing "the great number of establishments on wheels" in America, he added: "From such perambulating establishments many fine views might be procured, were they only to turn their attention to the subject; but the prospect of being paid for their trouble being so remote, and withal rather uncertain, they prefer the usual walk of face mapping...."[3]

It was not until the widespread adoption of glass-plate technology here in the later 1850s, when American photographic journals were reluctantly acknowledging that America lagged behind Europe in the practice of outdoor photography, that cautious predictions began to emerge regarding a potential market for images other than portraits. One of the first such pronouncements appeared in the *American Journal of Photography and the Allied Arts and Sciences* in 1858: "We believe American views will soon be in demand, and that people will be convinced that every branch of photography is as thoroughly understood here as abroad."[4]

During the 1840s, Easterly's intention to explore the varied possibilities of on-site photography aligned him more closely with pioneer photographers in Europe, where outdoor scenes played an earlier and more prominent role in introducing the public to the wonders of the camera. In France, Daguerre's homeland, daguerreotyped records of architectural monuments and scenic sites were quickly recognized as modern extensions of the well-established traditions of travel and topographical views. Many of the earliest daguerreotype views produced abroad were intended for publication.

One of the first and best-known commercial ventures of this kind produced *Excursions daguerriennes: Vues et monuments les plus remarquables du globe* (Daguerrian Excursions: The World's Most Remarkable Scenes and Monuments). Published in several editions from 1840 to 1844 by Parisian lensmaker and daguerrean L. M. P. Lerebours, this pictorial travelogue was illustrated with more than one hundred copperplate engravings based on tracings made from daguerreotype views. *Excursions daguerriennes* inspired other Europeans to produce similar albums composed of lithographed or engraved views derived from daguerreotype models.[5]

For the development of photography in Europe, such projects fostered both an early appreciation for "facsimiles of nature" recorded in the camera and a continuing interest in exploring the possibilities of outdoor photography in a wider variety of early processes. By the later 1840s, serious amateurs who appropriated the new medium as a leisure-class avocation akin to sketching or watercolor favored the more flexible and easily manipulated paper-negative processes for recording scenic or architectural views.[6] Not only did this devoted contingent contribute to the greater popularity of paper photography abroad, but it also moved the accepted functions of the camera beyond the "mapping of faces."

In part because of America's greater and more enduring attachment to the daguerreotype, a process much less congenial to the aims of the nonprofessional, photography developed here without the broadening influence of a community of serious amateurs who worked outside the constraints of market incentives. In addition, unlike their counterparts abroad, American publishers appear to have remained largely indifferent to the commercial potential of large-scale collaborations between daguerrean viewmakers and printmakers.[7] Not surprisingly, on this side of the Atlantic the daguerreotype portrait became a far more popular resource for the productions of artist-printmakers.

If Easterly was aware of Lerebours' publication or comparable projects being undertaken in Europe, there is no evidence that he made a concerted effort to market his views for similar purposes. What he shared most with the gentleman-amateurs and artists-turned-daguerreans who contributed to such projects abroad was a belief that views of the external world, seen and recorded through the lens, might stand as artistically legitimate substitutes for sites and scenes traditionally rendered by the hand of the artist. To a greater extent than many of his American colleagues, he also recognized the power of Daguerre's process to imbue factual, topographical records with an immediacy and reality that no painter could match. His finest views offer a seamless blend of documentary and artistic intentions.

Fig. 4-2. *Brattleboro, Vt. from Chesterfield Mountain.* Half plate, c. 1845. Vermont Historical Society. Plate inscription: Brattleboro Vt. from Chesterfield Mountain, N.H. T.M. Easterly Daguerrean.

Those who joined Easterly in pioneering the development of outdoor photography in America were rarely inspired by such high-minded motives. Most often it was the average or even the itinerant practitioner who introduced the American public to scenes of the external world captured on the silvered plate. Today the vast majority of these photographers remain anonymous; while their scattered works are a treasured heritage illustrating the diversity of American life during the daguerrean era, relatively few extant views provide sufficient information to identify the site or scene recorded. In urban areas, homes or businesses became the most common subjects for those who made occasional attempts to apply their talents to the difficult task of obtaining successful outdoor exposures. Like Easterly's record of the St. Louis Beer Garden (fig. 4-1), these straightforward, reportorial scenes frequently provided a backdrop for contextual portraits of residents or business proprietors. Pride in ownership also benefited traveling daguerreans, whose commissioned views supplied America's rural patrons with permanent records of country homes, farm architecture, or prized livestock. Easterly undoubtedly offered the same service during his early itinerant practice, but only a few of his later St. Louis views suggest that they may have been made at the request of a patron.

As the daguerrean era progressed, some individuals such as Robert Vance, John Wesley Jones, and Alexander Hesler made sustained efforts to expand the iconography of the camera-made landscape. Vance's inventory of three hundred California scenes, the collection purchased by John Fitzgibbon in 1853, has long since vanished. In one of the most ambitious undertakings recorded during the daguerrean era, Jones reportedly made more than fifteen hundred views during an overland trek from California to Kansas in 1851. Those plates, made to serve as visual models for a massive painted panorama, have also disappeared. In Hesler's case, we have firsthand evidence of his accomplishments outside the gallery in several extant views picturing the harbor and steamboats at Galena, Illinois, where he operated his first permanent daguerrean gallery in the early 1850s.[8] Based on the sheer volume of his surviving work, Platt D. Babbitt, America's first tourist photographer, also holds a special place in the history of scenic photography. Many of Babbitt's Niagara Falls views exist in private and public collections. The consummate entrepreneur as well as an accomplished technician, Babbitt was granted the monopoly to daguerreotype the American side of the Falls from Prospect Point in 1853.

Fig. 4-3. *Fort Ticonderoga Barracks.* Half plate, c. 1845. MHS. Plate inscription: Ruins of Fort Ticonderoga, built by the French in the Year 1756 and Surprised and Taken by Col. Ethan Allen on the 10th of May 1775.

To demonstrate the range of their skills, other aspiring daguerreans occasionally turned to outdoor scenes when preparing works for exhibition. In this public arena, the multi-plate view became the *tour de force* of the day. These long, narrow panoramas were created by exposing a series of plates from one position, changing the angle of the camera between exposures. The edges of the pictures were joined together and the finished ensemble mounted in a single frame. The Langenheim Brothers of Philadelphia introduced the multi-plate view and its promotional potential in 1845 with a sequence of plates picturing Niagara Falls. By midcentury, this format was being used almost exclusively for picturing urban vistas. Although many American cities may have been recorded in this manner, only a few of these early photographic panoramas are known today. There is no evidence that Easterly or any other daguerrean recorded St. Louis in a multi-plate image.

For the average practitioner, the successful recording of even a single-plate view was no simple procedure. Changing light conditions and atmospheric effects outside the gallery multiplied the uncertainties of determining appropriate lengths of exposure. Well-executed views also required better lenses or cameras designed or equipped especially for that purpose. The daguerreotype's laterally reversed image, a feature of little concern to the portrait patron, was a more important consideration in the production of views. To secure a "right reading" image where signs and buildings were accurately rendered, mirrors or prisms were employed to reflect the view onto the sensitized plate. The use of such reflective devices extended the length of exposure. When recording the more congested urban scene, only those who worked during the early hours of daylight, when city thoroughfares were deserted, could avoid the blurred trails left by moving objects or pedestrians.

Easterly clearly took pride in his ability to meet these challenges. Although we will never know how many views he produced during his long career, statements made by George Rockwood at an 1885 meeting of the Society of Amateur Photographers of New York indicate Easterly's level of productivity outside his gallery. Rockwood, a prominent New York professional who had begun his career in St. Louis, spoke of his visit twenty-seven years earlier to the daguerrean gallery of "Mr. Eastman in St. Louis."[9] If Rockwood did not

accurately recall Easterly's name, he vividly remembered the daguerrean's many "beautiful, artistic pictures of outdoor scenes" and proposed that "thousands" of Easterly views were "still in existence."[10] At least some of those plates were undoubtedly among "the great many pictures" lost in the fire that destroyed the daguerrean's gallery in 1865.

Easterly's earliest known views, made in the 1840s, picture sites in and around Burlington, Rutland, and his hometown of Brattleboro, Vermont. Among this group is a signed and engraved half plate recording a panoramic view of "Brattleboro, Vt. from Chesterfield Mountain, N.H." (fig. 4-2). The Vermont scenes, which remained in his gallery throughout his career, were among a collection of views that Easterly brought with him when he settled permanently in St. Louis in 1848. In later years, when he campaigned to promote the merits of daguerreotypes over photographs on paper, he frequently referred to the "still bright and beautiful condition" of this early work as evidence of the greater permanence of pictures made by Daguerre's process.[11] In 1873, he stated that these scenes had been recorded "28 years earlier."[12]

Among this body of early work are several images generated by the same impulses that later produced Easterly's extensive survey of St. Louis landmarks. For example, his view of the ruins of the Fort Ticonderoga barracks (fig. 4-3), believed to predate his move to the frontier, signals his early recognition of the potential of the camera not only to record the present but also to preserve the past for future generations. With the intention of daguerreotyping the most distinctive features of the region, he also made straightforward documentary records of the University of Vermont at Burlington (fig. 4-4) and the Asylum for the Insane at Brattleboro (fig. 4-5), two of the state's most impressive architectural structures at that time. The University's first building, then popularly known as the "Old Mill" because its design emulated the building style of New England textile mills, was a model of New England Federal-style architecture when it was constructed in the late 1820s. Its tin-roofed dome was proudly described as a "beacon for the whole Lake Champlain valley above where it stood."[13] In the middle distance of Easterly's view—the only known daguerreotype of the University's original building—is the arched gate and turnstile given to the institution by its graduating class of 1837.

Period guidebooks also recommended the stately architecture and picturesque setting of the Brattleboro asylum as worthy of travelers' attention. Later called the Brattleboro Retreat, the asylum was incorporated in 1834 as America's first privately run mental hospital. Easterly's distant presentation shows the impressive structure,

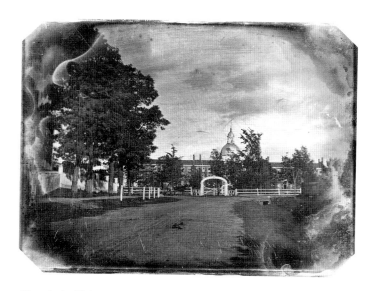

Fig. 4-4. *University of Vermont.* Half plate, c. 1845. Vermont Historical Society. Plate inscription: University of Vermont. Burlington Vermont.

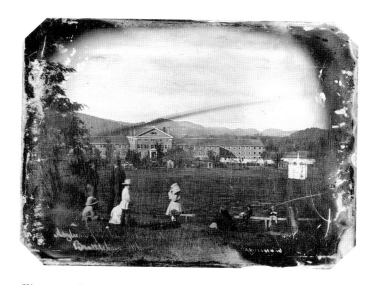

Fig. 4-5. *Brattleboro Retreat.* Half plate, c. 1845. Vermont Historical Society. Plate inscription: Asylum for the Insane at Brattleboro Vt. T.M. Easterly Daguerrean.

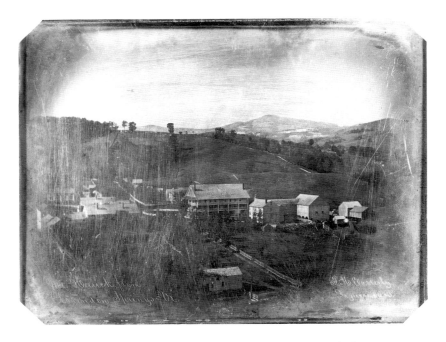

Fig. 4-6. *Mt. Herrick from Clarendon Springs, Vt.* Half plate, c. 1845. Vermont Historical Society. Plate inscription: Mt. Herrick from Clarendon Springs Vt. T. M. Easterly Daguerrean.

Fig. 4-7. *Clarendon Springs, Vermont.* Oil on canvas by James Hope, c. 1853. Shelburne Museum, Shelburne, VT. Photograph by Kenneth Burris.

which was equipped with a gymnasium, a swimming pool, and a bowling alley, in its much-admired park-like surroundings.[14] Animating the picture is a staged tableau of youngsters, an early example of Easterly's career-long penchant for scenes enlivened by the presence of children. His careful placement of the figures in calculated increments across the foreground of the picture imbues this scene with a charming simplicity reminiscent of the imposed abstract patterns of primitive painting. Also consistent with this tradition is his practice of organizing space through a series of horizontal planes parallel to the two-dimensional surface of the plate. The same strongly conceptual taste for symmetry, frontality, and clearly defined spaces links much daguerrean art to the vernacular or folk-art tradition.

During this same early period, Easterly took his camera to the Rutland area to document other attractions that drew hundreds of visitors to the Green Mountain region each summer. By the mid-1840s numerous well-known resorts accommodated thousands of travelers seeking the reputed benefits of mineral spring spas scattered throughout Vermont. Just southwest of Rutland, the rural community of Clarendon Springs was one of the most popular "watering holes" in the region.[15] Easterly recorded this village and its famous Clarendon House

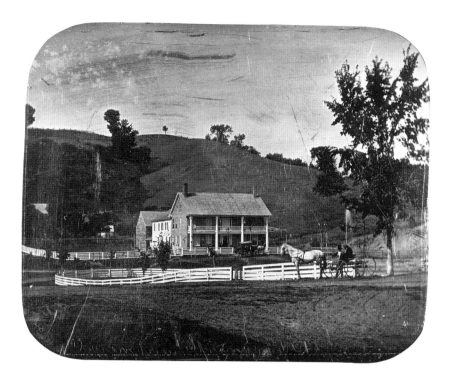

Fig. 4-8. *Clarendon Springs, Vermont.* Oversized quarter plate, c. 1845. MHS. Plate inscription: Clarendon Springs Vt.

hotel as the centerpiece of a sweeping panorama that he identified as "Mt. Herrick from Clarendon Springs Vt." (fig. 4-6). At least one view that he made from this lofty perspective may have served as the prototype for James Hope's painted re-creation of the same prospect (fig. 4-7).

On the same excursion, Easterly set up his camera to make other views that focused more directly on the architecture of the spa community. His plate bearing the inscription "Clarendon Springs Vt." pictures Seamon's country store and hotel located opposite the Clarendon House (fig. 4-8). On the right in this scene, a high-spouting fountain projects a plume of the famous water reputed to promote digestion, cure "the itch," and reverse the effects of baldness. Twenty glasses per day was the recommended prescription. Easterly may also be the maker of a recently discovered plate that pictures the massive facade of the Clarendon House, with guests spread across its wide verandas (fig. 4-9).

Purely personal motives may explain other early views that convey the rustic, rural character of Easterly's New England landscape. Although these exceptional images may have been created as records of ownership, their carefully considered compositions have little in common with the typically graceless portraits of farm architecture generally associated with the daguerrean era.[16]

In a signed half plate inscribed "My Native Hills" (fig. 4-10), a secluded homestead is a decisive marker separating the foreground pasture from the ascending hills in the distance. Forming a prominent and carefully placed border across the base of the plate is a rustic rail fence aligned to lead the viewer into the picture. The fact that Miriam Easterly kept this image after her husband's death suggests that the scene may have recorded his family home near Guilford.

A second "View in Vermont" (fig. 4-11), picturing a distant cluster of houses set against a mountainous backdrop, is even more closely related in structure to the conventional formulas of traditional landscape painting. To enhance the pastoral mood of the scene and punctuate an otherwise empty foreground, Easterly solicited the assistance of a small girl and a woman with a parasol, who occupy assigned positions perfectly equidistant from the outer framing edges of the picture. In later years, when these rustic scenes were displayed in Easterly's St. Louis gallery, frontier observers could appreciate such sights as authentic records of America's picturesque Green Mountain region. To their author, situated in the congested urban milieu of St. Louis, these once-familiar sights undoubtedly served as poignant mementos of his distant homeland and his early life in the East.

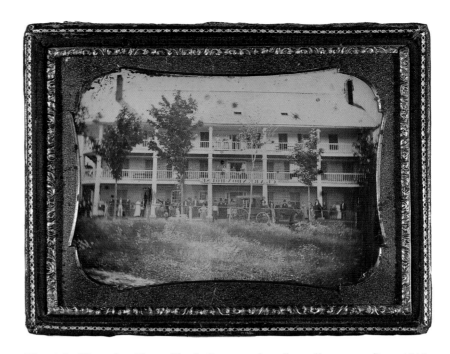

Fig. 4-9. *Clarendon House Hotel.* Quarter plate (laterally reversed), c. 1845. Greg D. Gibbs Collection.

Fig. 4-10. *My Native Hills.* Half plate, c. 1845. Easterly-Dodge Collection, MHS. Gift of Alice Dodge Wallace. Plate inscription: My Native Hills Vt. T. M. Easterly Daguerrean.

"BEAUTIFUL LANDSCAPES, PERFECT CLOUDS, AND A BONA FIDE STREAK OF LIGHTNING"

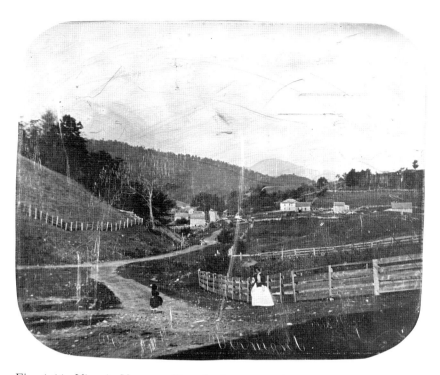

Fig. 4-11. *View in Vermont.* Oversized quarter plate, c. 1845. MHS. Plate inscription: "View in Vermont"

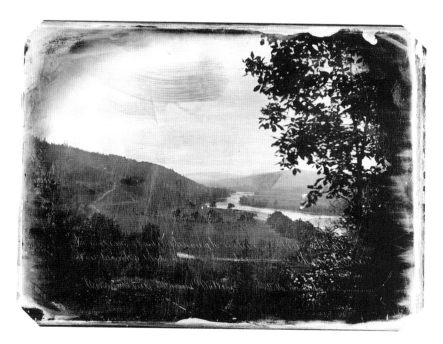

Fig. 4-12. *Connecticut River Valley.* Half plate, c. 1845. Vermont Historical Society. Plate inscription:

 "No watery glades through richer valleys shine,
 Nor drinks the sea a lovelier wave than thine."
 Connecticut River Valley.
 T.M. Easterly Daguerrean.

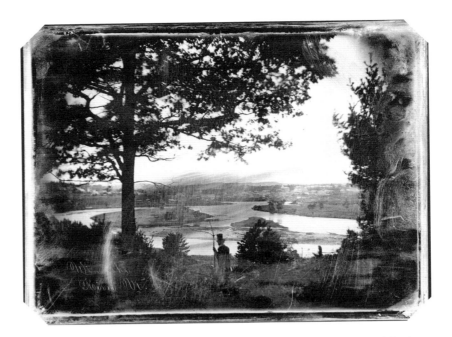

Fig. 4-14. *Winooski River*. Half plate, c. 1845. Vermont Historical Society.
Plate inscription: Winooski River Vt.

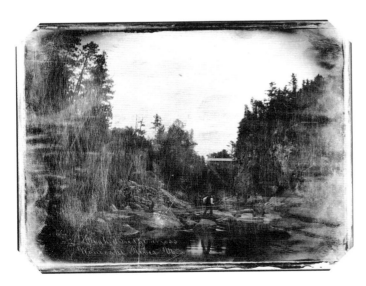

Fig. 4-13. *High Bridge across Winooski River*. Half plate, c. 1845. Vermont Historical Society. Plate inscription: High Bridge across Winooski River Vt.

Fig. 4-15. *The Oxbow*. Oil on canvas by Thomas Cole. Metropolitan Museum of Art, Gift of Mrs. Russell Sage, 1908. (08.228).

Easterly stepped even farther outside the norms of his profession in 1845 when he turned his attention to overtly romantic interpretations of the scenic beauty of New England. As striking counterparts to the popular midcentury landscape paintings of the Hudson River School artists, his views of the Connecticut and Winooski rivers bring a previously unacknowledged dimension to the early history of American landscape photography. In 1864 Marcus Root, America's first theorist on the aesthetic potential of photography, would suggest the appropriateness of that medium as a means "to represent, in their just proportions, the beautiful and the sublime in natural scenery."[17] Easterly anticipated Root by putting this theory into practice two decades earlier. In his elegiac river views, his documentary intentions—in the sense of conveying information that would identify and distinguish a specific site or subjects—were clearly secondary to more romantic impulses. Like Asher B. Durand and other native painters who introduced the public to the wonders of the American landscape in the 1840s, Easterly was responding to a desire to re-create the beauty of the scene before him. The verse inscribed on his Connecticut River view (fig. 4-12) affirms the romantic, pantheistic attitude that inspired these lyrical and picturesque images: "No watery glades through richer valleys shine, / Nor drinks the sea a lovelier wave than thine."

The same poetic sensibility is projected in images inscribed "High Bridge across Winooski River Vt." (fig. 4-13) and "Winooski River Vt." (fig. 4-14). The latter view, which captures a spectacular prospect seen from high above the meandering curves of the Winooski River, bears a striking and possibly intended resemblance to Thomas Cole's 1836 painting commonly known as *The Oxbow* (fig. 4-15). In both images, the viewer vicariously surveys the scenic vista along with a lone figure positioned in the foreground. By endowing his New England wilderness scenes with moral and religious significance, Cole was the first American painter to suggest the emotive potential and distinctive beauty of native scenery as artistically worthy pursuits for the painter. For scores of native painters who were following Cole's example by the 1840s, the mountains and backwoods of New England and New York became favored haunts for discovering the grandeur and tranquillity of America's unspoiled nature. Easterly undoubtedly crossed paths with these artists, whose reverence for nature may well have inspired his ambitions to explore the same pantheistic emotions through the medium of photography.

With little evidence to suggest otherwise, such a consciously artistic approach to outdoor photography during the 1840s has long been viewed as the exclusive preserve of Easterly's pioneering counterparts abroad who explored refined versions of Henry Fox Talbot's calotype process, a technique with inherently "painterly" properties that were particularly well suited to picturesque landscape effects. If other American viewmakers working in the daguerreotype medium sought to explore similarly romantic themes at this early date, they left no evidence of such efforts. Indeed, on the basis of these scenic river views and the intentions they announce, Easterly may well rank as America's first legitimate landscape photographer.

The daguerrean imposed a similar emotional dimension on a better-known natural wonder when he recorded Niagara Falls (fig. 4-16) as seen from the American bank near Prospect Point. His presentation of the Falls is not unusual; Platt Babbitt and other daguerreans who recorded this popular tourist attraction routinely focused their cameras on the same familiar perspective. What sets this work—and its maker's sensibility—apart from the more prosaic reproductions of his colleagues is the romantic ode, "To Niagara," engraved on the base of the plate. Easterly's poetic tribute to the sublime beauty of the scene was a stanza borrowed from James Silk Buckingham's "Hymn to Niagara," a poem inspired by the English writer's "first sight of the magnificent Falls" in 1838.[18]

Two exceptional views taken above the Falls convey a very different perspective on the experience of midcentury America's most celebrated wonder (figs. 4-17, 4-18). Both images offer a lingering glimpse of the bank of the Niagara River seen through the eyes of solitary figures standing on the deserted shore of Goat Island. A favorite vantage point for painters recording the Falls, Goat Island offered a variety of spectacularly scenic prospects. Easterly rejected these familiar perspectives to disclose his interest in the blight of industry and commerce adjacent to the Falls.

While poignantly expressed through an overlay of romantic associations, the message of these dream-like scenes is the impact of tourism and the industrial exploitation of the river, a theme ignored by Niagara's early artist-recorders, but one which figured prominently in travelers' accounts of the Falls. As early as 1838, Caroline Gilman wrote from her room in the massive hotel that dominates the skyline in Easterly's views from Goat Island: "We are at the Cataract House, and as agreeably accommodated as persons can be who see the beautiful and sublime giving place to the useful and the low. This site is a ruin."[19] The same lament was echoed in the writings of another English traveler whose more explicit complaints focused on the very shoreline recorded in Easterly's daguerreotypes: "The Americans have disfigured their share of the rapids with mills and manufactories ... and other unacceptable, unseasonable sights and signs of sordid industry."[20] In later images that echo the elegiac mood and pictorialist approach seen in the Goat Island views, Easterly would continue to explore the conflict between nature and the manmade environment.

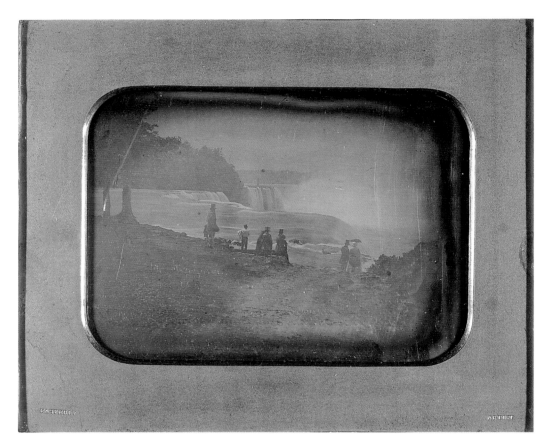

Fig. 4-16. *Niagara Falls from the American Side.* Half plate, 1853[?]. Easterly-Dodge Collection, MHS. Gift of Margaret Wing Dodge. Plate inscription:

To Niagara.

"Thy Diadem is an emerald green, of the clearest purest hue,

Set round with waves of snow-white foam, and spray of feathery dew;

While tresses of the brightest pearls float o'er thy ample sheet,

And the Rainbow lays its georgeous [sic] gems, in tribute at thy feet."

T.M. Easterly Daguerrean.

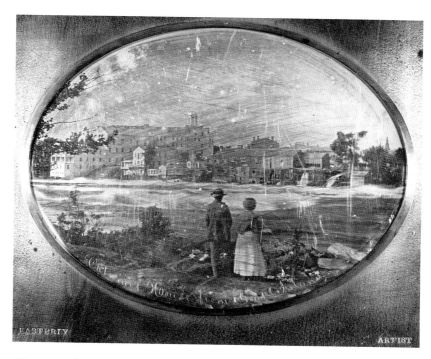

Fig. 4-17. *Cataract House from Goat Island.* Oversized quarter plate, 1853 [?]. MHS. Plate inscription: Cataract House from Goat Island.

Fig. 4-18. *View from Goat Island.* Half plate, 1853 [?]. MHS. Plate inscription: View from Goat Island.

Fig. 4-20. *Lundy's Lane Battle Field.* Half plate, 1853. MHS. Plate inscription: Lundy's Lane Battle Field.

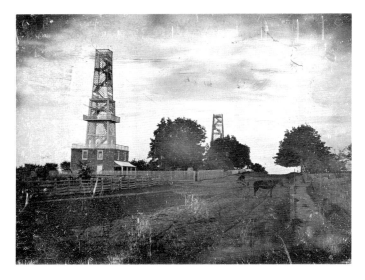

Fig. 4-19. *Pagoda on Lundy's Lane Battle-ground.* Half plate, 1853. MHS. Plate inscription: Pagoda on Lundy's Lane Battle-ground.

Exactly when Easterly made the Goat Island scenes or his more conventional view of the Falls is not known. During his early career, he had ample opportunity to visit and photograph Niagara. However, it is likely that the views were taken when he returned to the East in the summer of 1853 and spent several days working in the area of the Falls with John Werge, a Scottish daguerrean who was touring America.

In a later published account of his travels, Werge described his experiences at Niagara where he had the "good fortune to encounter two very different specimens of American character in the persons of Mr. Easterly and Mr. Babbitt, the former a visitor and the latter a resident Daguerrean, who held a monopoly … to Daguerreotype the Falls and visitors."[21] His lively narrative details the concerted effort that he and his "Yankee friend Easterly" made "to take" the Falls from "out-of-the-way" prospects by axing their way through the trees and tangled underbrush.[22] Werge reportedly lost the souvenirs of this memorable adventure—his own Niagara views and "others by Easterly"—when they were destroyed by fire some years later while on display in a Glasgow exhibit.[23] It is possible that some of the Niagara scenes made during Easterly's collaboration with Werge met a similar fate when his own St. Louis gallery burned. By Werge's account, the partners secured views of the Cave of the Winds, Grand Rapids,

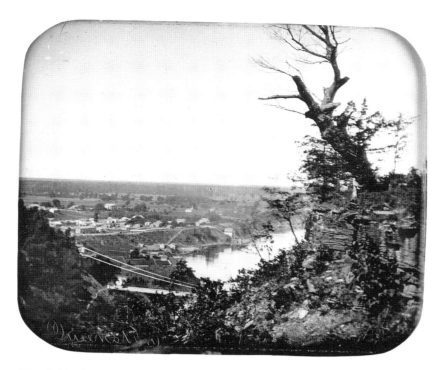

Fig. 4-21. *Queenston, Ontario.* Oversized quarter plate, 1853. MHS. Plate inscription: Queenston

and the Falls from Table Rock, the Niagara suspension bridge under construction, the Long Rapids, the Whirlpool, Devil's Hole, and other "impressions" of scenes "closely associated with the topographical history and legendary interest of the Falls."[24]

Other views made in the vicinity of the Falls can be assigned with greater certainty to Easterly's 1853 visit to that area. It was on this trip, probably still in the company of Werge, that Easterly made the one-and-a-quarter-mile carriage ride west of the Falls to daguerreotype the site known as the second most popular tourist attraction in the area. He recorded at least two views at Lundy's Lane in the village of Drummondville (now Niagara Falls), Ontario, where British and American soldiers fought one of the bloodiest battles of the War of 1812.[25] His plate engraved "Pagoda on Lundy's Lane Battle-ground" (fig. 4-19) shows two observation towers constructed in the early 1850s to provide tourists with a bird's-eye perspective of the battle site and its scenic environs.[26]

In a second, more extensive view captioned "Lundy's Lane Battle Field" (fig. 4-20), Easterly documented the spectacular panorama that greeted visitors from the top of the tower pictured nearest the camera in his "Pagoda" view. Adding visual drama to this sweep of historic landscape are the "perfect clouds" that he proudly advertised as a

measure of his talents as a viewmaker. The bleached and "overdone" sky, a hallmark of nineteenth-century views, was a byproduct of early photography's oversensitivity to blue and violet rays. As a consequence of this feature, both the landscape and the sky could not be accurately rendered in the same exposure because the time needed to record the landscape portion of the picture almost invariably produced an overexposed, featureless sky.[27]

It was undoubtedly on the same tour of the Niagara region that Easterly happened upon the impressive vista identified in his inscription as "Queenston" (fig. 4-21). The small village of Queenston, Ontario, seen in the far distance across the Niagara River, was located eight miles below the Falls. Cutting across the landscape at the lower left of the picture is the suspension bridge linking Queenston to Lewiston, New York. Completed in 1851 through the joint efforts of American and Canadian investors, the new bridge, like similar structures being erected at this time, was considered an engineering marvel.[28] In Easterly's deft orchestration of this remarkably sophisticated view, art and nature clearly take precedence over technology. While the bridge is shown dwarfed by the grandeur of the scene, the dramatic silhouette of a storm-blasted tree—the well-worn symbol of time and mortality in romantic landscape painting—frames and dominates the picture.

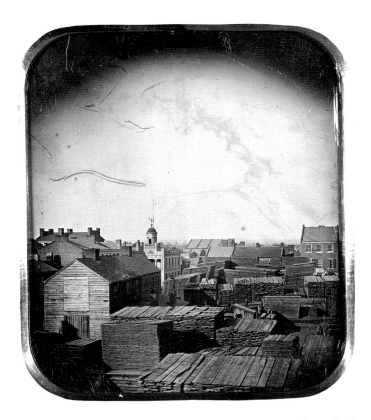

Fig. 4-22. *Locust Street East from Fourth Street.* Oversized quarter plate (laterally reversed), 1848. MHS.

Fig. 4-23. *Keelboat.* Quarter plate, c. 1850. MHS.

Easterly's trip to the East, which presumably included a visit to his family home in Vermont, surely intensified his awareness of the striking differences between his adopted frontier environment and his native New England locale. Indeed, the sights that engaged his interests as an urban viewmaker were a world apart from the sparsely populated vistas that had provided the settings for his first efforts in on-site photography. During the 1850s, when Easterly produced the majority of his urban views, that contrast became even more dramatic.

In his early years as a St. Louis resident, the transplanted New Englander had witnessed his country's most rapid period of expansion, as a burgeoning population pushed the boundaries of civilized society beyond the Mississippi Valley. St. Louis, which played a central role in this massive migration, flourished as America's "Gateway to the West." By midcentury, when Appleton's handbook for travelers described St. Louis as "the starting point from civilization for savagedom," more than a thousand immigrants were passing through the city each week as they made their way westward to populate the farms and "instant cities" that sprang up on the Great Plains and amid the gold fields of California.[29]

During the same period, thousands of newcomers ended their journeys in St. Louis, adding to its swelling population of permanent residents. In 1840, the river city was home to 16,469 citizens. By 1850, when Easterly had become a familiar face in the local business community, nearly seventy-eight thousand residents made up his potential clientele. That figure more than doubled by 1860, when foreign-born citizens constituted more than 60 percent of the city's population. This perpetual stream of newcomers brought rapid changes that dramatically and permanently altered the appearance and once predominantly French character of St. Louis.

Through the lens of his camera, Easterly became an astute observer and an insightful interpreter of that transformation. As early as 1852, the *Missouri Republican* noted that his "collection of illustrative views about the city are a treasure."[30] For nearly two decades, he was the only photographer who took a serious interest in documenting the St. Louis scene. In a city that offered hundreds of potential new clients weekly, the financial needs of his daguerrean colleagues could be met more quickly and conveniently in the studio setting. Even Fitzgibbon, whose early outdoor work appears to have been produced primarily for eastern exhibitions, made no concerted effort to promote daguerreotype views to St. Louis patrons.[31] It was not until 1852 that he routinely began to append footnotes to his gallery advertisements indicating his willingness to make "copies of buildings."[32] Although other daguerreotypists undoubtedly recorded an

occasional scene for local patrons, Fitzgibbon was the only practitioner among Easterly's competitors whose advertisements made mention of outdoor work.

In contrast, Easterly's announcements placed special emphasis on the expertise demonstrated in his display of "Beautiful Landscapes, Perfect Clouds, and a Bona Fide Streak of Lightning."[33] He began to promote this aspect of his practice only weeks after taking over John Ostrander's St. Louis gallery in 1848. When the city's daguerreans competed at the Mechanics Fair in early spring of that year, his gallery was distinguished for its display of "likenesses and landscapes."[34] Judges for the event, who deemed Easterly's work worthy of the "first premium" award, were apparently impressed with the unusual breadth of the newcomer's abilities. A view overlooking the city from the roof of the new Odd Fellows Hall (fig. 4-22), one of his earliest daguerreotypes of St. Louis, was probably shown in that exhibit.

Easterly's work as a "landscape" artist would continue to enhance his professional profile in the region. In 1850 the St. Louis *Reveille* suggested that the uncommon diversity of his talents played a key role in the "enviable reputation" that he had quickly earned in the community. The *Reveille*'s report concluded that Easterly's "landscape views, for number, beauty of scenes, and correctness of representation are the best collection ever exhibited in the city."[35] By 1852, the more widely distributed *Western Journal and Civilian* had furthered his reputation outside his immediate locale by publishing an engraving based on his daguerreotyped "impression" of the Missouri State Capitol (fig. 1-20). The accompanying text, which extolled the original author of the image as a "highly accomplished Daguerreotypist who stands in the front ranks of his profession," focused on his talents and experience in outdoor photography: "Mr. Easterly has traveled extensively in the United States, and has taken daguerreotype impressions of a large number of beautiful scenes, all of which as well as the points from which they were viewed, appear to have been selected with taste and judgement."[36] As late as 1869, his advertisements were still emphasizing that his practice gave "particular attention to outdoor pictures."[37]

During the active years of his career, Easterly's exceptional talents in this line were mentioned only once in a professional journal. In the spring of 1858, the *Photographic and Fine Art Journal* published a letter to the editor written by an eastern photographer who had recently visited galleries in Cincinnati and St. Louis. In his report on "Photography in the West," "C. H. E." (probably Charles H. Evans of Philadelphia) offered a brief but enthusiastic appraisal of Easterly's accomplishments when he assessed the "leading galleries" of St. Louis:

"There is one gallery in that city which has passed by all the boasted improvements in the arts, and has pursued 'the even tenor of its ways' with success. Mr. T. M. Easterly (to whom I refer) has continued to make the daguerreotype in a style which will equal anything in the country; while his views of Niagara, and other scenery, are unsurpassed."[38]

If Easterly was content to capitalize on his skills as viewmaker to enhance his local reputation, the work itself implies other, more far-reaching intentions that had little to do with the promise of immediate external rewards. His dedication to recording the St. Louis scene years before there was a commercial market for such images suggests a personal artistic enterprise aimed at weaving the rich and complex subjects of his city into a coherent historical narrative. The themes of change, growth, and progress, which appear with permeating frequency in his work, were central to his well-defined documentary mission.

As Easterly witnessed his city's transition into a thriving urban center, he showed an acute awareness of St. Louis' dynamic development and his own sense of participation in the city's history. His many views that document the old crumbling before the new reflect an uncommon sensitivity to the conditions of rapid urban growth, which buried the past under the exigencies of progress. As self-appointed visual historian of St. Louis, he made a concerted effort to secure lasting records of what remained from a time when the city had been an isolated wilderness settlement.

In the late 1840s, for example, he captured the sleek profile of a keelboat traveling down the Mississippi (fig. 4-23). The long, slender vessel, named for the heavy, square timber that extended from bow to stern along the bottom of the boat, had for decades been the principal mode of freight transportation on western rivers. Use of this man-powered watercraft had declined rapidly after the steamboat usurped its function in the 1830s. By 1847, only fifty-five keelboats were in operation along the entire stretch of the upper Mississippi.[39] This remarkable image is the first of many views that represent Easterly's conscious effort to catalogue transportation developments as a correlative of progress. His rich survey of work exploring this motif includes numerous later views picturing steamboats, steam ferries (fig. 4-24), omnibuses, horse-drawn railways, and railroad locomotives.

Although Easterly may have valued his keelboat view for its association with a passing era, he was also undoubtedly aware of its potential to spark the interest of viewers who understood the technology of his process. During the daguerreotype era and well into the glass-plate period, views that implied "instantaneous" exposures were considered noteworthy curiosities.

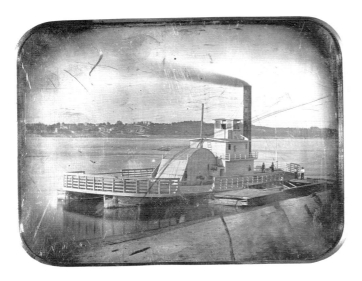

Fig. 4-24. *Ferryboat* Carondelet. Half plate, 1858. MHS.

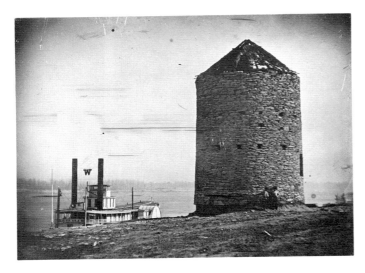

Fig. 4-25. *Roy's Mill at the Foot of Biddle Street, Steamer Wyoming at Bank.* Half plate, c. 1852. MHS.

Easterly had benefited from this sentiment as early as 1847, when the *Iowa Sentinel* publicized his impression of a streak of lightning as an "astonishing achievement."[40] Later views that showed awnings and laundry billowing in the breeze or laborers' gestures frozen in action suggest that he continued to take pleasure in demonstrating the expertise required to achieve such images.

While the term "instantaneous" was used during the daguerrean era in rare reports of scenes showing arrested motion, the process of securing such effects was primitive by modern standards. Working without a shutter, pioneer photographers simply removed the cap covering the lens and replaced it as quickly as possible. An exposure of possibly a fifth of a second would have been sufficient to arrest slow action, with the daguerreotype camera positioned at an appropriate distance from the moving object.[41] Smaller plates, such as the quarter-plate size that Easterly used for his view of the keelboat, were also more effective when exposure time was a critical factor. Larger-size plates, which required long focal-length lenses, typically required more extended exposures.

Like most accomplished daguerreans, Easterly undoubtedly perfected his own tricks for increasing the sensitivity of his plates. What little we know about the chemistry of his technique comes from George Rockwood, the New York photographer who praised Easterly's accomplishments at the meeting of the Society of Amateur Photographers of New York in 1885. What initially prompted those accolades was the group's discussion of "instantaneous" photography. Rockwood reported that by using "a combination of bromine and iodine," "Eastman" had produced "thousands" of "instantaneous" scenes.[42]

If Rockwood's information was accurate, the basics of Easterly's sensitizing technique were not unusual. One of the first widely adopted improvements on Daguerre's original one-step sensitizing process resulted from the discovery that exposure times could be reduced from minutes to seconds by fuming a previously iodized plate with the vapors of bromine. By midcentury, a wide variety of commercially prepared bromine and chlorine compounds known as "Quickstuff" or "sensitives" were sold as accelerators guaranteed to effect more rapid exposures.

Easterly's meticulously prepared plates and his ability to judge the strength and quality of light as they affected exposures served him well on his many "viewing" excursions to the original settlement area of the city. In the late 1840s, when he began to seek out the remnants of St. Louis' history, there were few visual cues left to remind residents or visitors of the city's rich and diverse colonial heritage.

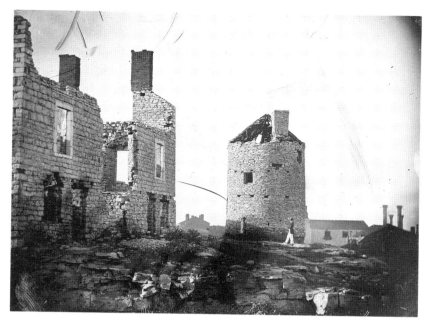

Fig. 4-26. *Roy's Mill at the Foot of Biddle Street.* Half plate, c. 1852. MHS.
Plate inscription: Roy's Tower

Before its Americanization with the Louisiana Purchase in 1803, St. Louis was one of the few settlements to fall under the governance of two European empires. The city was established by the French as a fur-trading settlement in 1764. France then ceded the land west of the Mississippi to Spain, although it was not until the end of the decade that the Spanish actually arrived to assume control of St. Louis. This transfer of power had little effect on the firmly established Creole culture or the physical character of the colonial outpost. Joseph N. Nicollet, a French scientist-explorer who visited St. Louis in the early 1840s, found it curious that after nearly three-and-a-half decades of Spanish rule, the community showed no visible signs of this authority: "the Spaniards have left no remembrances of themselves, saving their land register; no institutions, no works, not a single monument of public utility."[43]

At the time of Easterly's arrival on the frontier, a circular stone structure known as Roy's Tower or Roy's Mill was the only structure that locals could point to as a vestige of their city's colonial Spanish past. During the daguerrean era and for many years later, popular history promoted the belief that the tower was originally part of a series of fortifications, constructed by the Spanish to protect St. Louis from Indian and British attacks. When Easterly recorded the remains of the tower, it was widely regarded as "one of the most interesting relics in the city."[44]

Colonial records indicate that the structure, built in 1797 by Antoine Roy, was originally constructed as a wind-powered gristmill.[45] Stripped of its powerful blades, the basic form of the mill was similar to the Spanish fortification towers built during the same period. Roy's Tower operated as a flour mill until 1810. Easterly made several daguerreotypes of the deteriorating structure before it was razed to allow industrial development along the waterfront in 1853. By a strange coincidence, the steamer *Wyoming*, which forms a dramatic backdrop for the tower in one of these views (fig. 4-25), met its demise in the same year, when it was destroyed by fire in Pekin, Illinois. Other scenes show the tower flanked by the ruined shell of one of the first sawmills in colonial St. Louis (fig. 4-26).[46] The *Wyoming* and the mill appear again as lateral accents at the outer boundaries of a broader visual survey of this early industrial corridor along the river (fig. 4-27). From this more distant perspective Easterly could contrast the activity and enterprise of Peter Lindell's stone quarrying operation with outmoded industries of an earlier generation.

If Spain's colonial authority left no marks on the city landscape, signs of the once-dominant French presence were also quickly disappearing when Easterly settled in St. Louis. Only a few years earlier, during a visit to the

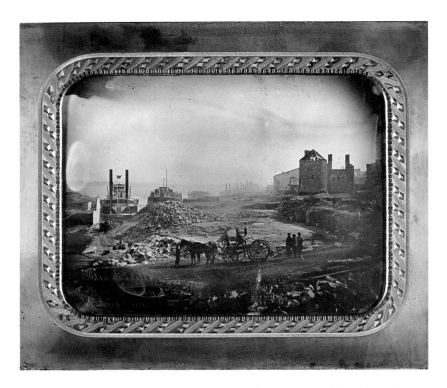

Fig. 4-27. *View South on Riverfront at Biddle Street, Lindell's Stone Quarry and Roy's Mill.* Half plate, c. 1852. MHS. Plate inscription: Peter Lindell's Stone Quarry St. Louis Mo.

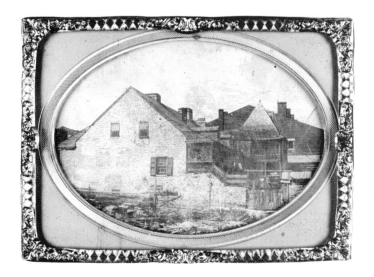

Fig. 4-28. *Robidoux House, Built 1790.* Quarter plate. MHS.

city in 1842, Charles Dickens had been charmed by the distinctive character of the old Creole section of town near the waterfront, where "the thoroughfares are narrow and crooked and some of the houses are very quaint and picturesque." He alluded to the inevitable fate of this colonial enclave when he observed that "these ancient habitations" in their "lop-sided" condition "hold their heads askew … as if they were grimacing in astonishment at the American Improvements."[47]

Easterly daguerreotyped numerous residences that reflected the original architectural character of the Creole settlement. His view of the immense stone dwelling built for Joseph Robidoux II (fig. 4-28) shows both the building style typical of more commodious homes in early St. Louis and the high standard of living enjoyed by its prosperous, fur-trading families.[48] He also made several views of a more modest structure occupied in the 1780s by the Jacques Noise family (fig. 4-29). As an engraved inscription on one plate in this group suggests, by midcentury the Noise house was better remembered as "The Former Residence of the First Governor of Missouri." Alexander McNair, who was elected to that post in 1820, had occupied the house from 1811 to 1819.

On other occasions Easterly's antiquarian pursuits took him out of the city to more isolated sites along the river.

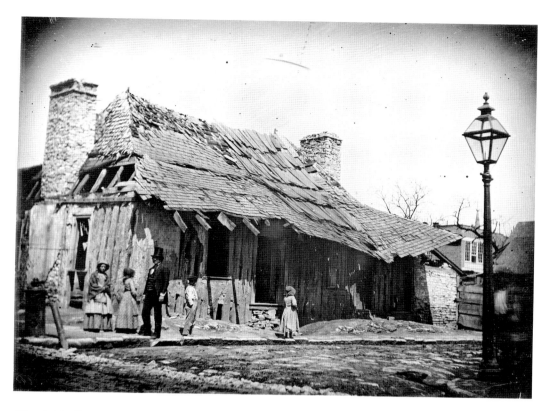

Fig. 4-29. *Governor Alexander McNair House.* Half plate. MHS.

Two strangely haunting images produced on these documentary excursions picture the remains of an abandoned cabin that was once the home of a Creole boatman or *habitant* (figs. 4-30, 4-31). Evoking a similar feeling of age and desolation, a crisply textural view preserves the remote ruins of a larger stone house (fig. 4-32). Easterly adroitly underscored these qualities by silhouetting the building's crumbling walls and listing roof against the flat, bleak plane of the sky.

Later in his career, Easterly added a better-known homestead to his catalogue of historic landmarks by traveling three miles south of the city to daguerreotype what had been known to two generations of St. Louisans as the "Bent place." The stone house, built by an early Creole settler, looked out across the river from a remote limestone outcropping called Rock Point. Judge Silas Bent, a well-known local lawyer, surveyor, and judge, owned the property early in the century when it was regarded as one of the most beautiful country estates on the river. The house and its once well-tended grounds showed years of neglect when Easterly daguerreotyped the site in the mid-1860s (figs. 4-33, 4-34, 4-35). By that time, the grounds had become a distribution point for firewood and the Bent residence a hostelry for quarrymen.[49] In nearly a dozen different views made on different occasions, he captured the scene from every accessible perspective. Views looking north contrast this picturesque relic with the rising city on the distant levee.[50]

Although most vestiges of the city's Creole heritage had vanished by the early 1850s, Easterly pursued his historical interests well into the 1860s when he made views of the Bienvenue house (fig. 4-36), widely believed to have been one of only two Creole buildings still standing in the inner city. Commonly known as the "old stockade house," the Bienvenue house was finally destroyed in 1875, when washerwomen carried away its last remaining boards for firewood.[51] Although it was still occupied when Easterly daguerreotyped its deteriorating facade, the dwelling had long since been stripped of the galleried porches that had once marked its Creole origins. Its remaining walls revealed the *poteaux en terre* architectural style common to early French settlements in the region. In this distinctive building technique, hewn posts were set vertically in a trench, and spaces between the posts were filled in with rubble stone and clay.

When Easterly was working to record these romantic artifacts, few individuals in the city shared his antiquarian interests. To a citizenry focused on making St. Louis the "star of the West," the promise of the future was far more compelling than the crumbling remnants of earlier eras.

Fig. 4-30. *Creole House.* Quarter plate. MHS.

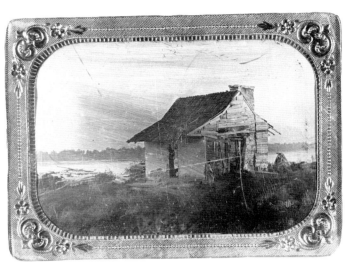

Fig. 4-31. *Ruins of Creole House on the River.* Quarter plate. MHS.

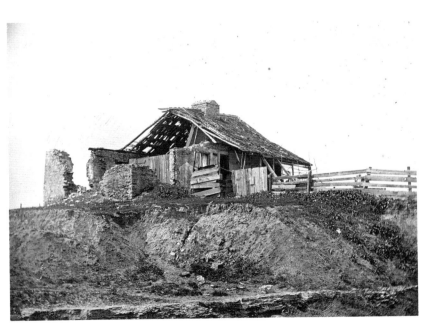

Fig. 4-32. *Ruins of Large Stone Creole House.* Half plate. MHS.

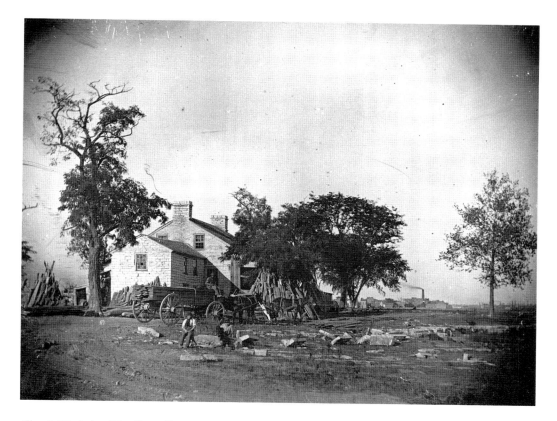

Fig. 4-33. *Judge Silas Bent House, St. Louis Levee Visible in the Distance.* Half plate, 1865. MHS.

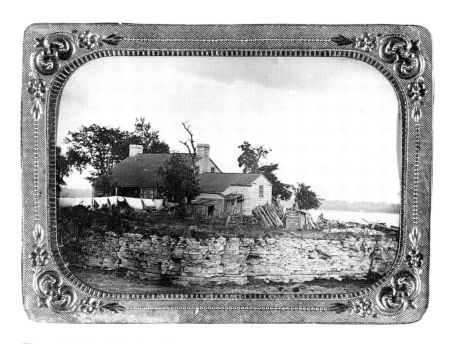

Fig. 4-34. *Judge Silas Bent House.* Quarter plate, 1865. MHS.

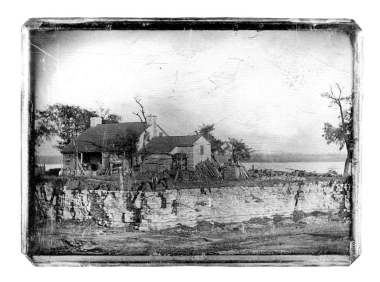

Fig. 4-35. *Judge Silas Bent House from across Ravine.* Quarter plate, 1865. MHS.

Indeed, like their counterparts elsewhere, the city fathers of St. Louis viewed the eradication of these physical remains as a tangible measure of civic advancement. The exuberant rhetoric of westerners like Missouri politician B. Gratz Brown affirmed the prevailing belief that America's unprecedented achievements severed connections with the past. Addressing his Missouri constituents in 1850, Brown declared: "With the Past we have literally nothing to do…. Its lessons are lost and its tongue is silent."[52] In 1854, the editor of the *Missouri Republican* commented on the impact of this attitude in St. Louis: "We are a practical people and when we have a mind to go ahead, there's nothing, however sacred or venerable it may be, that can stop our career…. We leave nothing, and seem intent upon leaving nothing to connect the past with the future."[53] The rapid transformation of the old townscape was material evidence of the accuracy of those observations.

The construction of large, new buildings in the heart of the city had been hastened by an 1849 blaze that destroyed twenty-three steamboats and nearly fifteen blocks of property on and near the waterfront in the original settlement area. If Easterly's record of the fire (fig. 4-37) lacked the imaginative impact of popular lithographs commemorating that event, his haunting image made the devastating aftermath of the great conflagration a startling, hand-held reality. For city boosters fascinated with the progress of growth, the disaster had a positive outcome in that it hastened the advance of welcomed "American Improvements," such as wider streets, fireproof masonry buildings, and the newly introduced cast-iron facades for commercial structures.

In the fiercely competitive race for economic preeminence among the emerging cities of the West, aggressive civic leaders promoted changing skylines and expanding boundaries as evidence of the unlimited potential of their respective communities. Eastern observers, stirred by the spirit of nationalism that swept the country in the 1840s, applauded the prospect of a westerly network of metropolises as affirmation of the destined greatness of America.

As one of the great boomtowns in American history, St. Louis was a key contender in the intense inter-city rivalries that abetted national aspirations for a more densely populated Middle America. Even before the fire made room for modernization in the central commercial sector, visitors to St. Louis had been struck by the ubiquitous construction, a sign of the city's phenomenal growth. Like Cincinnati and Louisville, its principal competitors in the trans-Appalachian frontier, Easterly's adopted city was thoroughly enamored of its own rise to prominence and supremely confident that no frontier community could outrank the busiest inland port in the nation. Easterly, whose decision to make St. Louis his permanent home had coincided with this wave of optimism, did not remain immune to the forward-looking spirit of his new environment. His documentary work in the 1850s is as much a celebration of future promise as it is a wistful acknowledgment of the vanishing pre-industrial past.

Few other daguerreans made significant contributions to the archive of images that map the growth of cities in antebellum America; rather, it was initially the mass-produced views of lithographers and engravers that gave pictorial expression to the impulses that fostered this period's phenomenal urban advancement.[54] Through these popular productions, the all-encompassing panoramic view became the norm for graphic re-creations of the city in antebellum America.[55] In this traditional order of picture-making, the city is defined and celebrated from afar as a static, orderly skyline of smokestacks and steeples. For St. Louis artists, such images—especially the city "seen from the Illinois shore"—served their intended symbolic function to focus attention on the thoroughly urban character of St. Louis and its advantageous location on the busy Mississippi.[56]

By contrast, Easterly's views place us in the city, rather than on its distant perimeters. Using the camera to extrapolate more explicit and closely observed fragments from the urban environment, he moved beyond the topographical tradition of distant and detached representations to make more complex statements about the urban experience. From his more immediate perspectives, we experience sights that escaped the selective, preconceived visions of his artist-contemporaries.

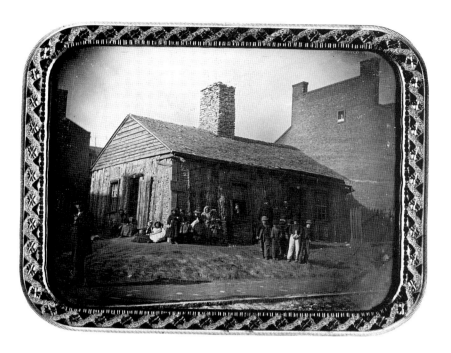

Fig. 4-36. *Bienvenue House.* Half plate, c. 1865. MHS.

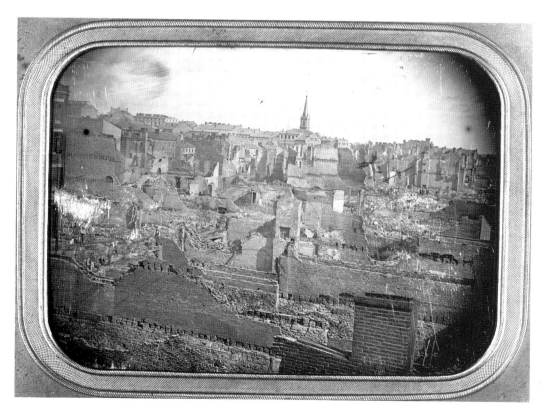

Fig. 4-37. *Ruins of St. Louis Fire of 1849.* Half plate, 1849. MHS.

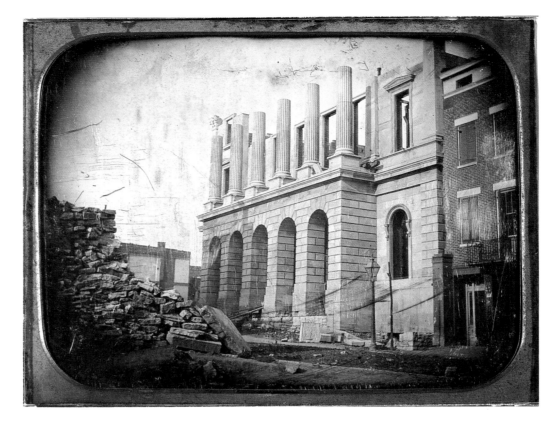

Fig. 4-38. *Construction of Custom House and Post Office, Third and Olive Streets.* Half plate, c. 1854. MHS.

Fig. 4-39. *Ninth Street North from Chestnut.* Quarter plate, 1852. MHS. Plate inscription: Ninth Street, St. Louis, Mo.

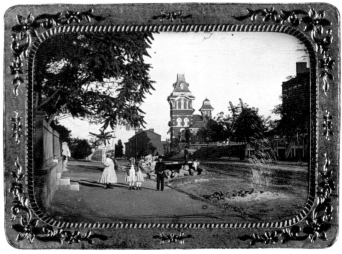

Fig. 4-40. *Jonathon O. Pierce Residence.* Quarter plate, c. 1866. MHS.

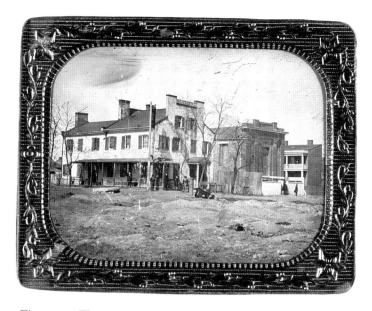

Fig. 4-41. *Eleventh Street and Locust, Northwest Corner.* Sixth plate (laterally reversed), c. 1858. MHS.

Fig. 4-42. *St. Louis Court House, Showing Unfinished Portion of New Building and Old Court House.* Half plate, 1851. MHS.

Because Easterly pictured the inhabited city, we are also privy to sights that tell us as much about the customs and lifestyle of urban dwellers as they do about the physical character of their environment.

On many occasions, Easterly's decisions about what was worthy subject matter for the urban photographer were firmly in line with prevailing values that brought St. Louis to the forefront of frontier society. Most prominent among the features that bolstered local pride were the new public buildings whose self-consciously ostentatious facades reflected the aspirations of local entrepreneurs. Easterly recorded many of the structures that brought the desired impression of eastern elegance to the urban landscape. His record of the Custom House and Post Office under construction is one of his most visually dramatic architectural views (fig. 4-38). He framed this carefully considered scene in 1854, when construction had progressed sufficiently to provide an adequate sampling of the architect's widely admired "Roman Corinthian" style.[57] This building had been a long-time dream of community leaders, who spent more than a decade rallying federal support for the project.

Like many of his architectural views of the 1850s, Easterly's record of the Custom House and Post Office provides a striking contrast between the orderly, geometric precision of the new structure and its disorderly setting. In 1854, when citizens dodged the mountain of stones and debris at this site, more than thirteen thousand buildings were under construction in St. Louis.[58] Easterly's views

translate such statistics into human experience. Sites recorded throughout the city show gaping trenches, piles of rubble and lumber, and building stones spilling onto streets and sidewalks. In numerous views, participants sit on slabs of limestone as casually as if they were posing in their parlors (figs. 4-39, 4-40). The rugged terrain that characterized miles of poorly paved streets dominates the foreground in a view of Locust Street, where a cow rests peacefully among the potholes (fig. 4-41). It is this rich ancillary detail that conveys the larger meanings to be gleaned from Easterly's photographic odyssey.

Plans for the imposing new Post Office may have intensified interest in making the St. Louis Court House a more stately structure. The inadequacies of the original brick Court House, which was completed in 1833, were already widely acknowledged by the end of that decade, when planning began for a larger and more impressive domed building. The original structure, with its semi-circular portico facing Fourth Street, remained intact as the east wing of the expanded building when Easterly made his earliest views of the site (fig. 4-42). That portion of the building was torn down in 1851 to make way for the new east wing, which was completed five years later.[59] After 1862, when his community could at last point proudly to the dramatically transformed Court House as "one of the most imposing and magnificent structures west of the Mississippi," Easterly documented the completion of the massive new Renaissance dome that crowned the impressive Greek Revival structure (fig. 4-43).

Fig. 4-43. *St. Louis Court House Showing Completed Dome.* Half plate, 1865. MHS.

Fig. 4-44. *Construction of Marble Building, Northeast Corner of Fourth and Olive Streets.* Half plate, c. 1853. MHS.

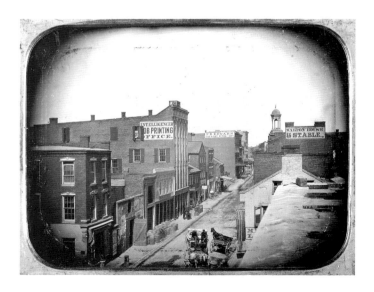

Fig. 4-45. *Third Street North from Olive Street, Showing* St. Louis Intelligencer *Office.* Half plate, c. 1854. MHS.

Through private enterprise or local group efforts, other building projects that contributed to St. Louis' increasingly cosmopolitan appearance advanced more rapidly. Easterly had ample opportunity to observe progress on the new Marble Building going up on the corner adjacent to his gallery. At its completion, the four-story structure was hailed as a model of tasteful design in commercial architecture. The building's most distinctive and innovative feature was its gracefully rounded corner at Fourth and Olive streets. Framed between the vertical components of a massive hoist, Easterly's view focuses on the structure's pilastered doorway and curved lintel (fig. 4-44). This remarkable image, taken at close range from his gallery window, also captures an exceptionally rare instance of workers engaged in their labors. The ghost figure of the worker below, who moved outside the frame of the picture during the several-second exposure, suggests the difficulty of securing action shots in this early photographic process.

In compiling his commercial portrait of St. Louis, Easterly selected a cross-section of the various new enterprises that symbolized the unlimited potential of the river city. At the time of his arrival on the frontier, which coincided with the phenomenal increase in the scale of river transport, trade and commerce were the backbone of the city's economic life. Multiplying warehouses and a growing roster of successful commission and wholesale houses attested to St. Louis' position as a major distribution center. The increasing diversity of locally produced and imported goods available in the city can be seen in the business signs that appear in Easterly's many street scenes, made from rooftops and upper-story windows in the heart of the commercial district (figs. 4-45, 4-46).

The conditions that bolstered community aspirations to reign as the "Commercial Emporium of the West" become even more vivid in the remarkable views that convey the volume of commercial activity on the levee (figs. 4-47, 4-48, 4-49). The importance of river trade in the life of the city becomes especially clear when we consider that Easterly's levee scenes were framed segments from a panorama of bustling activity that stretched for several miles along the riverbank. With views that take us from the drydocks to the heart of the levee, he composed a unique pictorial analogue to contemporary reports that repeatedly expressed amazement at the spectacle of St. Louis' waterfront pageant. A description of the levee recorded by a visitor to the city in 1851 typifies the responses of many observers:

This collection of steamers brings together an immense concourse of drays, carts, wagons, and every variety of pedestrians and freight. There is probably no busier scene in America in the same space. For two miles, a forest of smoke stacks is seen towering above the "arks" from which they seem to grow. The area between this and the lines of warehouses is filled with a dense mass of apparently inextricable confusion and bustle, noise and animation, more steamboats are probably seen here than at any port in the world....[60]

Easterly's success in capturing the character of this scene did not go unappreciated. In 1852, in an article entitled "Easterly's Daguerreotype," the *Republican* published a lengthy tribute to his "view of the levee of St. Louis, downstream" (fig. 4-49). Recommending the sweeping panorama as "quite the most beautiful specimen of the art we have seen lately," the writer also applauded the authenticity of the image: "The lively scene on the broad thoroughfare, the buildings and boats at the wharf, the piles of merchandise of various kinds, and the long line of steampipes, are pictured with a minute and delicate accuracy no artist's pencil could rival."[61]

The *Republican's* praise of Easterly's levee view may have inspired the curious union of art and photography in a St. Louis view drawn by George Hofmann, a local portrait painter (fig. 4-50). Reproduced as a steel engraving, Hofmann's imaginatively conceived bird's-eye panorama was published in 1854. The imprint on the engraving notes that the image was "taken partly from Daguerreotype by Aesterly [sic]." Since Easterly could never have positioned his camera to achieve this lofty perspective, it is likely that Hofmann used a daguerreotype of the levee or the harbor as a guide in sketching a segment of his view. As suggested by the existence of other artwork copied more faithfully from Easterly daguerreotypes, "pocket editions of nature"—the term one writer of the time used to describe the miniature views on silver—were enthusiastically welcomed as a visual aid to artists.[62]

While St. Louis leaders continued to place their faith in river trade and the mighty Mississippi as keys to the city's economic future, they also eagerly threw their support behind various railroad building ventures in the 1840s and 1850s. On July 1, 1851, Easterly may have joined the elated crowds that turned out to celebrate the beginning of construction on the new Pacific Railroad. To a country obsessed with speed and mechanization, nothing more vividly symbolized the miraculous and unlimited promise of new technology than the plume of smoke and the awesome power of the steam locomotive.

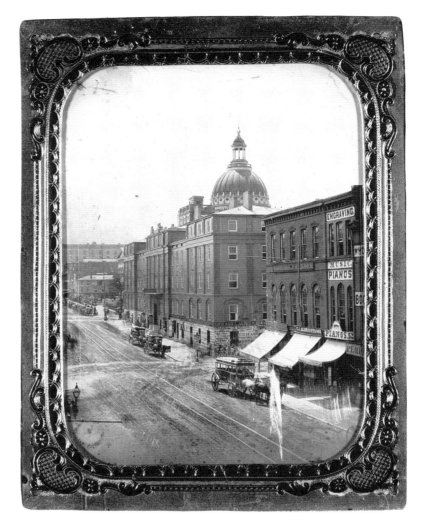

Fig. 4-46. *Fourth Street South from Olive Street.* Half plate, c. 1866. MHS.

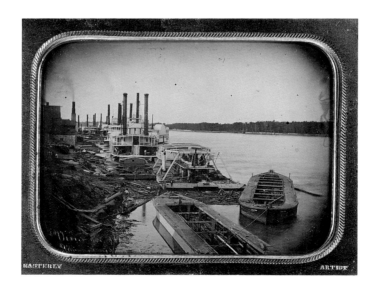

Fig. 4-47. *Dry Docks on the Levee.* Quarter plate (laterally reversed). MHS. Plate inscription: View on the Mississippi River.

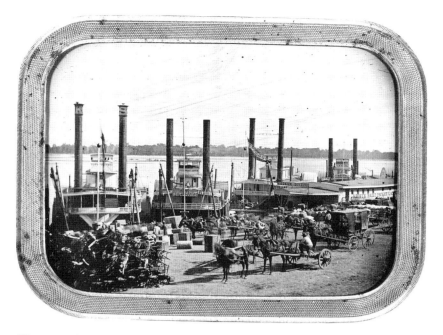

Fig. 4-48. *St. Louis Levee.* Half plate, 1853. MHS.

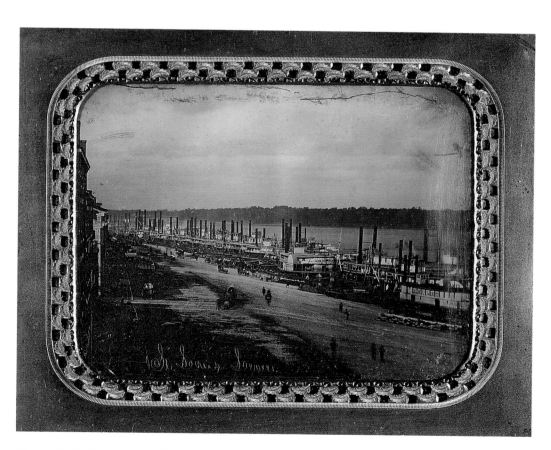

Fig. 4-49. *St. Louis Levee.* Half plate, 1852. MHS. Plate inscription: St. Louis Levee.

Fig. 4-50. *View of St. Louis, Missouri.* Steel engraving by E. B. Krausse after G. Hofmann, 1854. MHS.

Fig. 4-51. *Pacific Railroad Locomotive* Gasconade. Half plate, c. 1855. MHS.

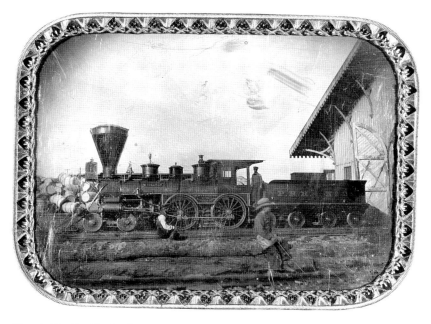

Fig. 4-52. *Pacific Railroad Freight Locomotive* O'Sullivan. Half plate, 1855. MHS.

Like many artists and even a few daguerreans who made visual records celebrating this vaunted icon of progress, Easterly reflected contemporary enthusiasm with views picturing two of the first locomotives to operate on the new Pacific line in the mid-1850s (figs. 4-51, 4-52). For local viewers, his record of the O'Sullivan, one of the first locomotives manufactured in a St. Louis foundry, had additional meaning as a tangible reminder of their city's industrial advancement.

In contrast to his celebratory images of locomotives, Easterly's scenes of a new railroad trestle (figs. 4-53, 4-54), cutting across the Cahokia Creek, suggest a more complex response to the artifacts of technology. Located on the Illinois side of the Mississippi, the creek and its wooded banks had long been recommended as one of the most scenic sites in the region. Showing an interest in similar themes, American artists of this period produced scores of paintings depicting the railroad in a pastoral landscape setting. Scholars explain the collective presence of such images as a shared pictorial response to the prevailing belief that, despite their potentially damaging forces, technology and industrial progress could co-exist with nature in a mutually beneficial, harmonious relationship.[63] Easterly's trestle views, which fall firmly within this genre, may have been a subconscious—if not a calculated—expression of these feelings.

As access to expanded transportation encouraged

greater diversity in the investments of St. Louis entrepreneurs by midcentury, Easterly's camera chronicled the vitality of those efforts. Following similar patterns of expansion in Cincinnati and Louisville, St. Louis made notable strides toward developing its potential as an industrial center during the 1850s. In earlier decades, local manufacturing businesses were small-scale operations largely dependent on the skills of a small workforce of artisans. Easterly's views of new operations like the St. Louis Glass Works (fig. 4-55) and Empire Mills (fig. 4-56) cast the enterprising spirit of his city's pioneering industrialists into compelling visual form.

The proprietors of these establishments exemplified numerous investors and entrepreneurs who recognized the enormous potential for profit in industries that utilized the region's rich reserve of raw materials. While the glass factory earned repeated accolades for expanding the economic base of the city, the Empire Mills represented the kind of production that lay more directly at the heart of St. Louis' rapidly expanding industrial economy during the final antebellum decade. The abundant farm products from the agricultural hinterland had once been shipped in and out of the city; now they provided the resources for a profusion of new flour mills, meat-packing factories, breweries, spinning mills, and soap and candle-making factories that soon established St. Louis' prominence as a major processing center.

Fig. 4-53. *Railroad Trestle across Cahokia Creek.* Half plate, c. 1855. MHS.

Fig. 4-54. *Railroad Trestle across Cahokia Creek, St. Louis Visible across the Mississippi.* Half plate, c. 1855. MHS.

Fig. 4-55. *St. Louis Glass Works, Northwest Corner of Broadway and Monroe Street.* Half plate, c. 1856. MHS.

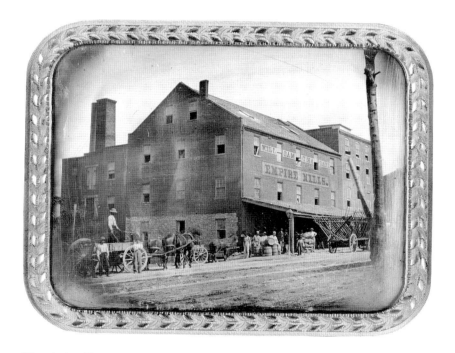

Fig. 4-56. *Empire Mills, North Broadway and Tyler.* Half plate, c. 1855. MHS.

Fig. 4-57. *Adolphus Meier's Cotton Factory.* Half plate, 1855. MHS.

Adolph Meier's St. Louis Cotton Factory, consistently singled out by city boosters as a model of what could be achieved "with energy and enlightened judgement," was one of the largest of the new farm-product manufactories.[64] Easterly's striking view of the massive, fortress-like facility (fig. 4-57) effectively conveyed the immense scale and solid success of Meier's business.

Easterly acknowledged another celebrated symbol of the city's industrial promise when he made several views of a manufacturing enterprise that had long been associated with the region. Among the most arresting images in his unique photographic inventory of early industrial architectural forms is a plate picturing the enormous shot tower erected by Luther Kennett in 1847 (fig. 4-58).[65] By 1852 Kennett's factory was turning out twenty-five thousand pounds of shot daily, anticipating the preeminent role that the city would play later in the century when it supplied nearly half of the shot manufactured in the United States. In 1856, when the popular *Ballou's Pictorial* brought national attention to the impressive achievements and "noble buildings" of St. Louis, a half-page engraving of Kennett's Shot Tower was the featured illustration.[66] With its close proximity to rich and abundant sources of lead, St. Louis had established its leadership in the shot industry early in its

history. Kennett's soaring 176-foot-high structure was the ambitious successor of earlier wood shot towers that had been distinguishing landmarks along the river for decades. Documenting that history, Easterly's plate inscribed "Shot Tower on the Mississippi" (fig. 4-59) pictures the skeletal remains of the last of the primitive structures that had established this industry in the region.

What is implied if not directly seen in Easterly's catalogue of developing industry is the workforce needed to operate the new large-scale establishments that doubled the annual value of St. Louis' manufactured products between 1850 and 1860. The expansion of locally based factories was a critical factor in the growth of all major Western cities during this period. Factory employment offered job opportunities that attracted both rural and immigrant populations. As the *Western Journal* pointed out as early as 1848, the consistent influx of foreign immigrants played a particularly important role in St. Louis' expanding industrial dimension:

> Most of the foreigners who come to the west land at St. Louis. Very many of them are mechanics and laborers who rely upon daily employment for subsistence, and as there is but little demand for farm labor, many remain in the city, and are

compelled by necessity to labor for such prices as they can obtain. These are the principal causes of the abundance and cheapness of labor in St. Louis.[67]

If the massive influx of foreigners favored the growth of an industrial economy, this burgeoning segment of the city's population also fostered less desirable conditions often associated with rapid urbanization. Thousands of immigrant newcomers crowded into multi-family tenements near the commercial and industrial districts along the waterfront, where jobs for unskilled laborers were most available. The squalid, congested living conditions in these developing slums gave rise to wide-spread disease and other evils of city life such as crime, intemperance, and prostitution.

Conforming to period expectations for tastefully informative or entertaining pictorial work, America's first urban photographers ignored these unpleasant conditions to focus on images that celebrated the heroic virtues of the public city. Indeed, historians often point to early photography's falsely conceived, idealized impressions of nineteenth-century urban society. It was not until late in the century, when Jacob Riis photographed the slums and immigrant ghettos of New York, that the camera was recognized as a uniquely powerful device for exposing the darker realities of urban existence.

Although Easterly may have had no intention of violating the conventions of etiquette that governed the early practice of his medium, his trips to the city's industrial sectors took him into territory where the less admirable aspects of urban life were unavoidable. His meticulously itemized images rendered all that they saw in these settings, including clues to the living conditions of St. Louis' poorest inhabitants. For example, we may wonder how many of the shabbily dressed youngsters who routinely inhabit these scenes were among the ever-increasing population of orphaned and abandoned children who lived by their wits in the back alleys of the city.

In a more explicit depiction, Easterly's view of Kennett's Shot Tower (fig. 4-60), taken from the nearby stoneyard, reveals the cramped, substandard dwellings squeezed along the alleys that separated the industrial structures between Main Street and the levee. Clothes hanging on a line from the upper story of a tenement building behind Nicholson's grocery signal the presence of life in this compound of poverty. When St. Louis engravers drafted their versions of this well-known landmark to illustrate the prosperity of local industry, they took care to eliminate such distracting and unappealing details.

Another view of Kennett's enterprise offers an even closer perspective on the dismal reality of life for the urban masses (fig. 4-61). While the shot tower remains an imposing form in this picture, Easterly gave center stage to a black man and two small black boys who occupy the immediate foreground. To the right of the figures is a row of squatters' shanties typical of the crude hovels that existed throughout the poorer sections of the city. In these enclaves of poverty, free blacks and slaves "hired out" by their owners lived side by side with the city's poorest Irish immigrants, despite the tension that existed between the two groups. With the flood of refugees from the Potato Famine providing an ever-expanding pool of unskilled laborers, blacks in St. Louis faced increasing competition for the carrying trade and other menial jobs that had long been the mainstay of their existence.

Although we will never know for certain what prompted Easterly to give such studied attention to a row of shacks and their impoverished attendants, it was more likely the artist rather than the socially conscious reporter at work in the conception of this scene. His engraved caption, which indicates that the "Shot Tower" was still the ostensible focus of the picture, suggests that he may have composed this view with an eye to the rustic character of these foreground components. Paintings and popular prints of the period provided ample precedent for seeing the "picturesque" virtues of shabby blacks, barefoot beggars, and others associated with urban street life. Regardless of his motives, what is presented in this scene offers a window on a world that is almost nonexistent in the photographic record of this period.

Easterly was surely struck by the contrast between the shanties that he daguerreotyped in the stone yard above Main Street and the lavish mansions going up in other parts of the city. By midcentury, such striking extremes of splendor and squalor were routinely classified as sights that distinguished the urban center from the rural community. Easterly's early daguerreotype of Hart Row (fig. 4-62) recalls the period when well-to-do citizens resided in economically diverse neighborhoods near the heart of the city in elegant attached houses like those in eastern cities. When Easterly arrived in St. Louis, wealthy pioneer industrialists and bankers such as Peter Lindell and Louis Benoist still occupied homes close to the site of their businesses (figs. 4-63, 4-64). Other views that Easterly made in the newer elite neighborhoods of his city offer an even more graphic index to the steadily increasing gap between the upper and lower economic classes in St. Louis and the resulting patterns of residential development.

With the rapid westward growth of the business district during the decade of the fifties, wealthy citizens built new detached houses in more exclusive areas such as Lucas Place, the first of the city's planned and restricted "private places" that guaranteed residents both social prestige and protection from the encroaching urban blight.

Fig. 4-58. *Kennett's Shot Tower, Man in Top Hat in Foreground.* Half plate, c. 1850. MHS.

Fig. 4-59. *Ruins of Jacob R. Stine's Wooden Shot Tower.* Quarter plate, c. 1850. MHS. Plate inscription: Shot Tower on the Mississippi.

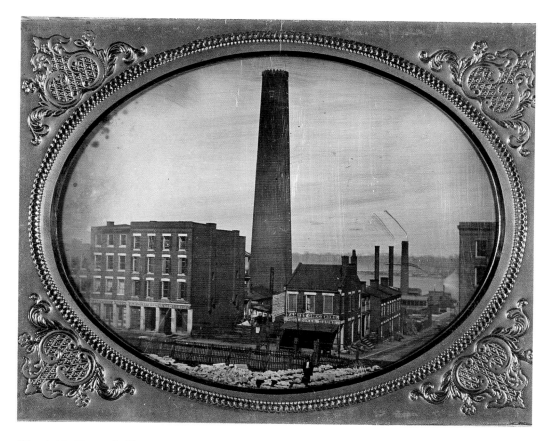

Fig. 4-60. *Kennett's Shot Tower.* Half plate, c. 1850. MHS.

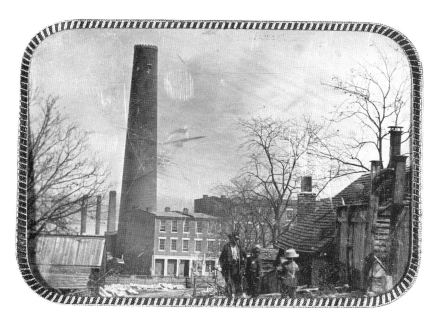

Fig. 4-61. *Kennett's Shot Tower.* Quarter plate, c. 1850. MHS. Plate inscription: Shot Tower

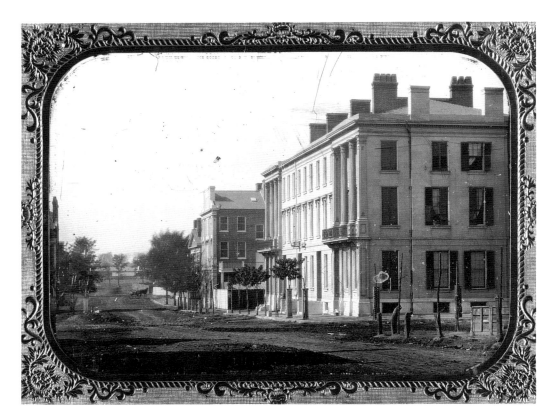

Fig. 4-62. *Seventh and Pine Streets, Hart Row.* Half plate, 1852. MHS.

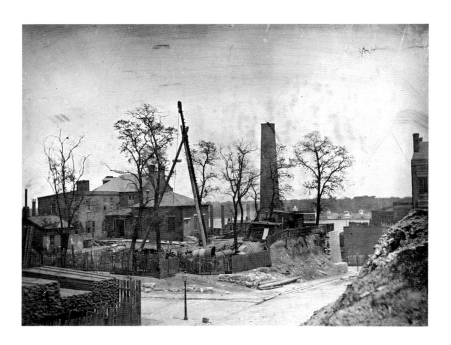

Fig. 4-63. *Peter Lindell Residence.* Half plate, c. 1850. MHS.

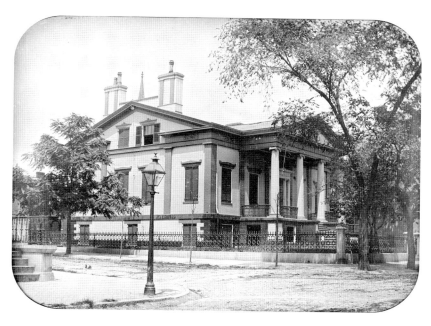

Fig. 4-64. *Louis A. Benoist Residence.* Half plate, 1852. MHS.

Lucas Place, which ran west from Fourteenth Street to Eighteenth Street, was still undergoing development when Easterly daguerreotyped the exclusive new subdivision, probably in 1858. The first of these views shows the Collier mansion, at the left of the picture, under construction (fig. 4-65). The stately home, with its fashionable classical facade, is almost complete in a second view made from the same vantage point a few weeks later (fig. 4-66).[68]

Easterly traveled still further from his gallery to record the luxurious new homes that established more remote areas of the city's north and northwesterly regions as fashionable residential districts for wealthy merchants and industrialists. Aaron Fagin's impressive Italianate mansion, built far from the commercial district on a quiet stretch of the Bellefontaine Road, symbolized the affluent lifestyle available to those who reaped the economic benefits of urbanization. The exodus of wealthy St. Louisans such as Fagin to the distant, more pastoral outskirts of the city initiated a pattern that continued for decades. By the early 1870s, these outlying suburbs, where "all is bright and beautiful," were viewed as idyllic preserves free from the unsightly congestion and blanket of factory smoke that gave the inner city its "Londonesque" appearance.[69]

Possibly at Fagin's request, Easterly made several daguerreotypes of the industrialist's lavish new home on at least two trips to the site: once in the spring or summer to capture the full effect of the mansion's park-like setting (fig. 4-67); and again in the fall or early spring, when the elaborate architectural details of the house would not be obscured by foliage. Lending a ceremonial air to the latter occasion, Fagin's wife and four daughters can be seen strategically posted on the terraces and balconies (fig. 4-68). Another image in this series, which presents the mansion reflected in the pond below, is a stunning testament both to Easterly's gift for pre-visualizing effects and to the strength of his impulse to go beyond the mere recording of fact (fig. 4-69). A number of Easterly's finest works utilize the striking visual effects of forms echoed in the reflective surface of water. While this motif appears frequently in nineteenth-century landscape painting, Easterly may have been the first American photographer to recognize and consciously explore its aesthetic potential in the creation of camera-made pictures. The strolling bull near the pond, who left his ghostly twin behind, denotes the seconds that elapsed during the plate's exposure.

In compiling his pictorial compendium of life in an ambitious frontier community, Easterly was attentive to the expanding social and cultural dimensions of his urban milieu.

Fig. 4-65. *Lucas Place East from 16th to 14th Street.* Half plate, c. 1858. MHS.

Fig. 4-66. *Lucas Place East from 16th to 14th Street.* Half plate, c. 1858. MHS.

Fig. 4-67. *Aaron W. Fagin Residence, 4003 Bellefontaine Road.* Half plate, c. 1856. MHS.

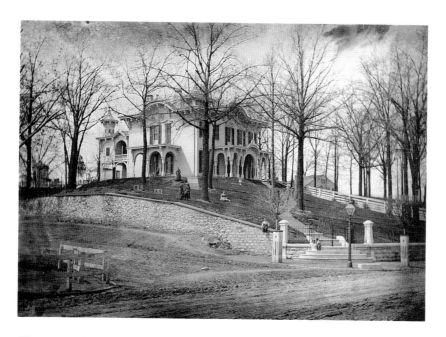

Fig. 4-68. *Aaron W. Fagin Residence, 4003 Bellefontaine Road.* Half plate, c. 1856. MHS.

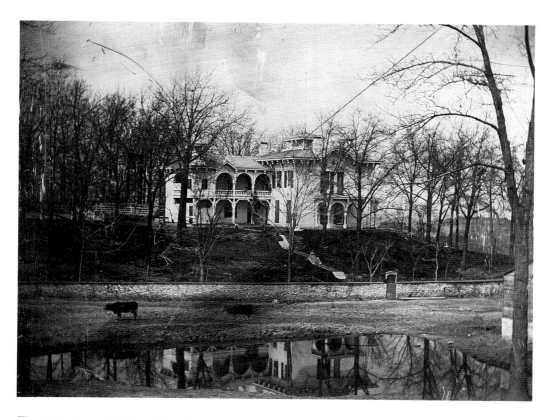

Fig. 4-69. *Aaron W. Fagin Residence, 4003 Bellefontaine Road.* Half plate, c. 1856. MHS.

Urban centers were expected to provide ample provisions for educating and entertaining their citizenry. Eager to establish St. Louis' prominence as the most sophisticated community in the West, civic leaders could point to a catalogue of cultural amenities available to residents and visitors alike. Easterly's plates recording such new landmarks as the People's Theatre (fig. 4-70), the new public high school (fig. 4-71), and Smith Academy (fig. 4-72), which was affiliated with Washington University, preserve important sights among those that fostered confidence in the growing cultural sophistication of St. Louisans. His inventory of old and new church buildings reflects the considerable wealth of various congregations and the growing diversity of religious faiths in the city (figs. 4-73, 4-74).

In his spirited street scenes, Easterly offers candid glimpses into the social life of midcentury St. Louisans. His view of a fireman's parade (fig. 4-75) is a charming reminder of the prominence of these volunteer citizens' groups in the social and political life of the city. When members of Union Fire Co. No. 2 paused to be daguerreotyped with their new engine, Easterly created a quaint memento of the pride and spirit of competition that were the hallmarks of these civic organizations (fig. 4-76). Looking down from his gallery window in the spring of 1848, he recorded a crowd of eager onlookers gathered to see Tom Thumb during his first visit to St. Louis (fig. 4-77). While his remarkable daguerreotype of a local youth band recalls the importance of music in the social life of the city (fig. 4-78), a street scene with a banner advertising an exhibit of Albert Bierstadt's well-known Rocky Mountain paintings suggests the ever-changing menu of fine arts events available to St. Louisans during this period (fig. 4-79).

During the 1850s, Easterly also documented an institution that did not enhance the reputation of his city. His view of Bernard Lynch's slave trading establishment was taken from inside the adjoining walled compound (fig. 4-80). Perhaps because of the controversial nature of Lynch's business in a city known for its tense relations between slaveholders and abolitionists, Easterly chose to record the trader's establishment without visual references to what actually occurred there. While local religious leaders and abolitionists deplored Lynch and his profession, as many as thirty "Negro dealers" operating in the city in 1850 made St. Louis a major center for the domestic slave trade throughout that decade.[70] Lynch, who probably appears in Easterly's line-up of unidentified men apparently gathered for an auction, was one of only two permanent dealers still operating in the city by 1859.

Fig. 4-70. *People's Theatre.* Half plate, 1853. MHS.



Fig. 4-71. *Public High School.* Half plate, 1856. MHS. Plate inscription: Public High School, St. Louis

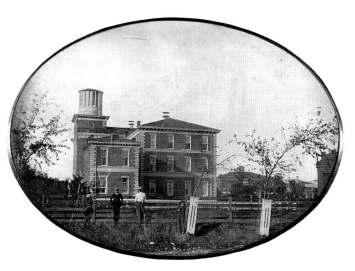

Fig. 4-72. *Washington University and Smith Academy.* Half plate, c. 1857. MHS.

Fig. 4-73. *Second Presbyterian Church.* Half plate, 1868. MHS.

Fig. 4-74. *Walnut Street East from Third, with St. Louis Cathedral.* Half plate, c. 1848. MHS.

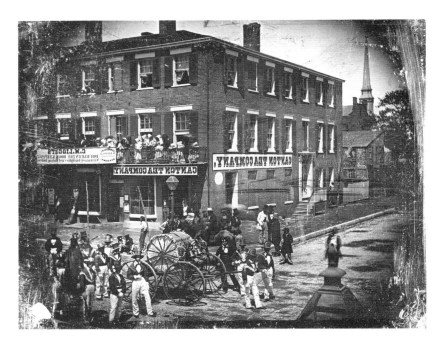

Fig. 4-75. *Union Fire Company on Parade, Northwest Corner of 4th and Olive Streets.* Quarter plate (laterally reversed), 1848. MHS.

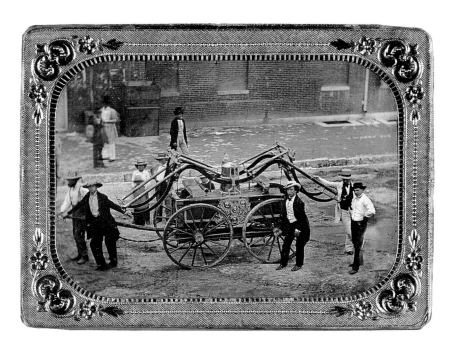

Fig. 4-76. *Union Fire Company with Fire Engine "Dinkey."* Hand-colored quarter plate, 1852. MHS.

Fig. 4-77. *Tom Thumb's First Visit to St. Louis, Northwest Corner of 4th and Olive Streets.* Quarter plate (laterally reversed), 1848. MHS. Plate inscription: Gen. Tom Thumb in St. Louis

Fig. 4-78. *German Youth Band.* Quarter plate, c. 1850. MHS.

Fig. 4-79. *Fourth Street North to Locust Street.* Quarter plate, 1867. MHS.

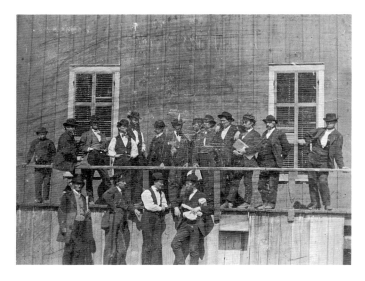

Fig. 4-80. *Lynch's Slave Pen, 104 Locust Street.* Half plate, c. 1852. MHS.

Easterly could anticipate a more appreciative audience for his views recording local disasters. Along with the benefits of urbanization and technological progress came the hazards and calamities associated with large concentrations of people, hastily constructed buildings, and inferior workmanship or materials. From the 1840s, when Nathaniel Currier enjoyed immense success with prints of urban and transportation catastrophes, America's appetite for such images seemed almost insatiable. By midcentury, engravings of natural disasters, train wrecks, steamboat explosions, collapsed buildings, or fires had become obligatory visuals in the pages of the popular illustrated press.

Although photographs of catastrophic events would later become commercially successful staples, especially in the stereograph format, daguerreotyped images of such incidents are rare. Easterly may well have introduced this function for the camera to frontier audiences with his view of the aftermath of the Great Fire of 1849. When he documented another local disaster nearly two decades later, he was more thorough in recording the extent of the destruction. On December 16, 1865, and again on January 12 and 13, 1866, the St. Louis harbor—long considered one of the safest winter havens on the river—became the site of the two most devastating ice gorges ever recorded on western waters.[71] We become firsthand witnesses of the damage wrought by the breakup of the ice-choked channel in Easterly's vivid visual account of the crushed and splintered vessels (figs. 4-81, 4-82). By mid-January, the damages resulting from the loss of more than a score of sunken or irretrievably damaged steamboats, wharf-boats, and barges totaled nearly a million dollars.[72]

The most visually compelling work in this series (fig. 4-83) maximizes the striking formal bluntness of an uplifted barge's jutting silhouette. The overexposed blue sky—a feature peculiar to the chemistry of the daguerreotype—adds to the stark pictorial drama of this scene. As in many of Easterly's most memorable views, his cast of mute, staring figures and their measured placements remind us of the daguerrean's unseen presence.

In the spring of 1867, Easterly added to his repertory of local disaster scenes by setting up his camera near crowds gathered to inspect the burned-out remains of the Lindell Hotel. With a price tag of more than a million dollars at its completion four years earlier, the immense luxury hotel was hailed as irrefutable proof of St. Louis' thoroughly urbane character. This largest hotel of its time in America was destroyed by what one enthusiastic reporter described as the "most splendid conflagration on record."[73] The latest in fire-protection devices, such as rooftop water tanks, failed to protect the building from total ruin.[74]

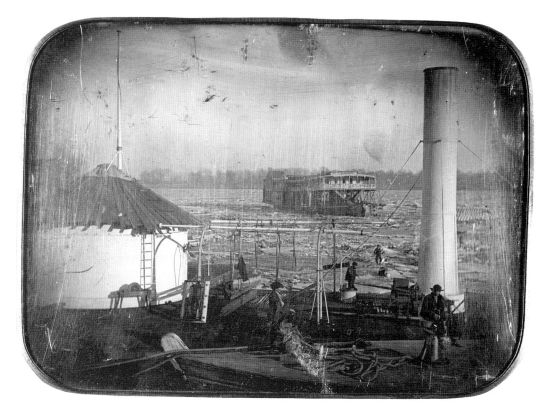

Fig. 4-81. *Steamboat* Metropole *Trapped in Ice.* Half plate, 1865. MHS.

As eye-witnesses recalled, the fire had spread downward "with wild magnificence" from the top floor of the six-story building, a height beyond the reach of firemen's hoses or ladders.

Easterly made at least two exposures documenting the fire's destruction. For one of these views, a vertically aligned plate effectively served his intention to convey the scale of the structure and the stark visual drama of its towering remains (fig. 4-84). Evoking the haunting mood of some ruined, ancient city, a second, more comprehensive view framed the immense hollow shell of the block-long building (fig. 4-85). In the vacant foreground of this scene, workers are gathering useable materials from the rubble.

To Easterly, one of the uses found for materials salvaged from the ruins of the fire may have seemed a curious contradiction in values for a city that had long shown a collective indifference to the past. In 1868, several wagonloads of ornamental stone recovered from the remains were used to fabricate a semblance of a partially fallen facade on the grounds of Tower Park, a 285-acre tract recently donated to the city by Henry Shaw, founder of St. Louis' famous Botanical Garden. The fabricated "ruin," built at the edge of an artificial pond, was in keeping with Shaw's plan to landscape and ornament the site in the spirit of a picturesque "English walking park."[75] If St. Louisans visiting the park

appreciated the romantic sentiments underlying Shaw's intentions, it would be years before they showed a similarly nostalgic regard for the remnants of local history.

In more enduring engagements with two of St. Louis' oldest and best-known landmarks, Easterly pioneered a more overtly interpretive approach to using the camera to preserve the past. Over a period of years during the 1850s, he several times revisited the site of Chouteau's Pond to chronicle its destruction, although it had once been regarded as St. Louis' most beautiful suburban "ornament." With the same dedication, he documented the leveling of a large Indian burial mound as it succumbed to urban advancement. The images that survive to recall his repeated excursions to daguerreotype these local landmarks may represent American photography's first sustained effort to record and interpret an event over time.

There are no hints of the preacher or reformer in the gentle tenor of these unfolding dialogues on the price paid for progress. Rather, they are silent, evocative tributes to the past, filtered through the sensibility of a man who had faced and accepted his own displacement in a rapidly changing world. Indeed, the poetic timelessness of his Chouteau's Pond series can be seen as a pictorial parallel to his retreat from the realities of progress and technology as they were affecting his profession.

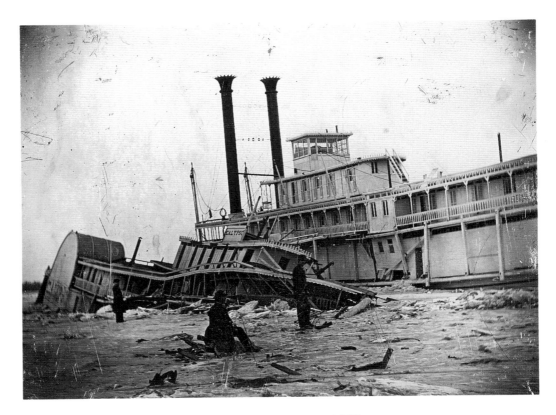

Fig. 4-82. *Wreck of the Steamer* Calypso. Half plate, 1865. MHS.

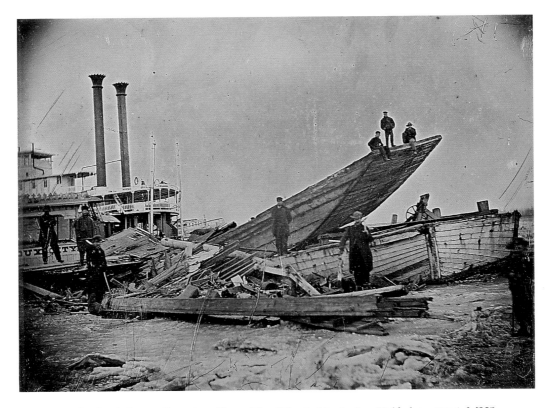

Fig. 4-83. *St. Louis Levee, Steamboat* Sioux City *Wrecked in the Ice.* Half plate, 1865. MHS.

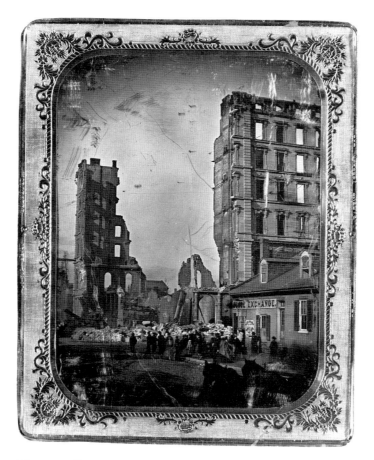

Fig. 4-84. *Ruins of the Lindell Hotel.* Half plate, 1867. MHS.

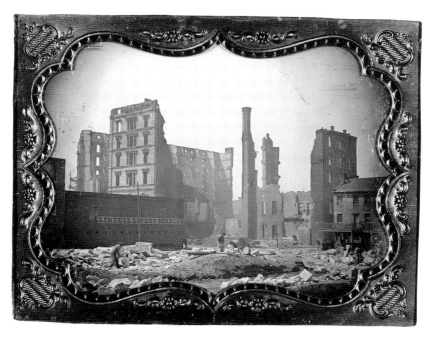

Fig. 4-85. *Ruins of the Lindell Hotel.* Half plate, 1867. MHS.

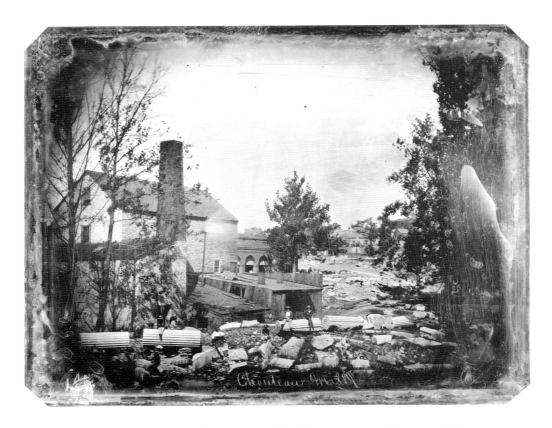

Fig. 4-86. *Chouteau's Mill.* Half plate, 1853. MHS. Plate inscription: Chouteau Mill

Among the Missouri Historical Society's thirteen scenes showing stages in the draining of Chouteau's Pond, one inscribed, dated image indicates that Easterly had initiated this series by 1850, when the fate of the lake-sized body of water was one of the most controversial issues facing city officials. The man-made pond had been created in early St. Louis by damming the Petite Riviére to provide power for the first water-powered flour mill in the area. In 1779 Auguste Chouteau, a founder of the city and one of its most prominent early citizens, purchased the mill tract and additional adjoining property. When he rebuilt and enlarged the mill to increase its capacity, he elevated the dam to create the hundred-acre lake that came to be known as Chouteau's Pond. The stream that ran from the dam to the river was called Mill Creek. Sometime after 1851, when Chouteau's mill was being used as a stone mill, Easterly added the site to his inventory of historic landmarks (fig. 4-86).

For decades Chouteau's Pond was St. Louis' most popular rural retreat. The Chouteau family, which profited from the pond as a source of industrial power for more than half a century, generously shared its benefits. The lake's expansive "glittery sheet" served as a recreational outlet for boaters, bathers, skaters, and fisherman, while it also answered the needs of preachers baptizing their flocks. Described as a "trysting place for lovers," its verdant shores were inviting havens for social gatherings and holiday picnics.

As St. Louis' population and industrial ambitions rapidly expanded, Chouteau's "beautiful fairy lake" lost its appeal. By the time of Easterly's arrival in the city, there were growing complaints that the pond had become a blight on the landscape and a threat to the health of the city. The condition of the lake in 1849 was vividly described in a letter to the local press: "Around this natural 'slop-bowl' are interspersed at short intervals, breweries, distilleries, oil and white lead factories, flour mills, and … residences. Into this pond goes everything foul. No cauldron ever filled by the worst of witches or the vilest of 'hags' can boast of such a stew."[76] Local citizens who routinely used the site as a garbage dump shared responsibility for the pond's debris-clogged shores and "miasmatic exhalations."

Public concern over the health threat posed by the pond's noxious condition intensified following the cholera epidemic that devastated the city in the summer of 1849. During the spring and early summer of 1850, town meetings and local newspapers provided a forum for heated debates over its future. The St. Louis *Reveille* led the move to eliminate the pond: "We heartily denounce the present system of making Chouteau's Pond the receptacle of carcasses, and every other description of filth. The most efficient mode, however, of abating this nuisance, would be to provide means for filling up the pond.... There can be no reason why the Pond should be preserved. It is neither useful nor ornamental."[77]

After months of such discussion, arguments in favor of eliminating the pond prevailed over compromise proposals to restore and preserve at least a part of the lake as a public "pleasure ground." The Board of Health declared the pond a public nuisance in the fall of 1850 and ordered the Chouteau family to drain the site.[78] The decision came as a shock and disappointment to older citizens with fond memories of the lake.

Made in the summers of 1850 and 1851, Easterly's earliest views of the site were carefully calculated to preserve these nostalgic recollections. These placid vistas masterfully recaptured the pristine beauty that had once recommended the same familiar prospects as visions suited "to the fancy of the poet, or the pencil of the painter."[79] As he intended, they are separate, idyllic worlds remote from the realities of urban encroachment.

In one of his first records of the pond, Easterly achieved a level of visual sophistication and a sense of the striking, happened-upon sight rarely encountered in photography of this era (fig. 4-87). Taken in the spring or summer of 1850 from a distant, elevated vantage point, this extensive view looks out across the "glittering sheet" where a small fishing boat is frozen in the gleaming expanse of water. Easterly's "perfect clouds" hover above this panoramic vista that so masterfully conveys the luminous glow and crystalline clarity that are the magic of this medium.

The daguerrean's decisions on where to set up his camera along the pond's extensive, meandering shoreline were as carefully considered as the compositions that comprise this series. In 1850, as on subsequent trips to the site, Easterly worked at the southern terminus of the lake, not far from the mill, where the pond covered its broadest expanse (fig. 4-88). When he returned to the site in 1851, he again made exposures from opposite shores of the pond, framing his scenes from the same vantage points that he had selected the previous summer (figs. 4-89, 4-90). On this second excursion, however, he exercised greater control in his quest for a picturesque image.

His self-conscious role as artist-director of the scene is especially evident in the signed plate inscribed "Chouteau's Pond taken July 18, 1851" (fig. 4-89). As in his earlier, laterally reversed record of the same prospect (fig. 4-87), the octagonal roof of the Missouri Medical College and the tower of Kemper College serve as prominent accents on the distant horizon. For his later view of this sight, Easterly moved closer to the bank to direct a poignant narrative alluding to the pond's long-time role as the city's favored recreational retreat. Placed at precisely measured intervals, the profile forms of a horse and buggy, a boy with a fishing pole, and two smaller children form a silent, disciplined parade across the foreground of the picture. The visual charm of this scene and its striking abstract rhythms hark back to the naive simplicity of his early view of the asylum at Brattleboro, Vermont.

At some point early in the series, Easterly moved to another section of the south bank of the pond to produce his only image that offers visible clues to the conditions contributing to the lake's demise (fig. 4-91). Here, his juxtaposition of two separate, disparate worlds renders the symbolic content of this image clear and seemingly deliberate. In the lower half of the picture, a man pushes the bow of a boat, his solitary presence on the deserted shoreline becoming a visual metaphor for the timeless, pastoral world of the city's pre-industrial past. The crowded panorama of houses and developing industry seen on the distant horizon suggests the inevitable triumph of a new world of enterprise and exploitation.

If Easterly's subjective records of the pond fail to corroborate contemporary reports on its polluted condition, they do confirm complaints that the Chouteaus did not move quickly to comply with the city's order. His earliest views show no discernible change in the level of the lake between 1850 and 1851. Although the owners of the tract were initially ordered to accomplish the task within sixty days of the city council's action, they did not take measures to drain the pond until the late spring of 1852. As the *Missouri Republican* observed in early June of that year, their initial effort only exacerbated the problem: "Last month they complied with the order, opening the dam gates and allowing almost all the water to escape. Since the warm weather has arrived, the surface thus exposed to the sun has, it is said, emitted the foulest and most alarming effluvia. For this reason, the proprietors have closed the gates and the pond is again filling."[80] The first optimistic report that the draining might eventually be accomplished came early in 1853 with the announcement that the newly completed section of the Poplar Street sewer would carry some drainage from the pond to the river.[81]

Fig. 4-87. *Chouteau's Pond, View South from Clark and Eighth Streets.*
Quarter plate (laterally reversed), 1850. MHS. Plate inscription: T.M.
Easterly Daguerrean Chouteau's Pond

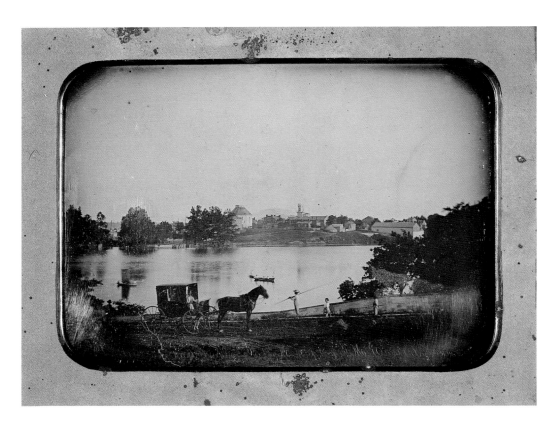

Fig. 4-89. *Chouteau's Pond, South to Eighth and Gratiot, 18 July 1851.* Half plate, 1851. MHS.
Plate inscription: Chouteau's Pond taken July 18, 1851, by T. M. Easterly Dgn

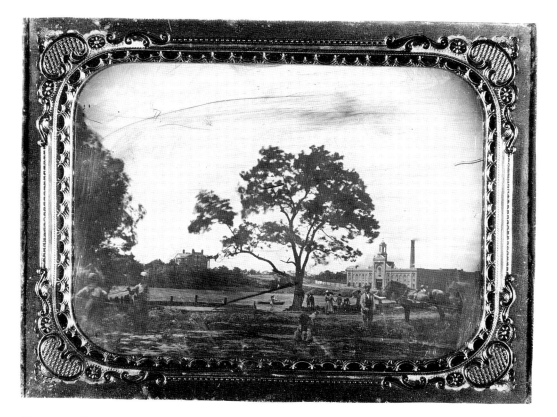

Fig. 4-88. *Chouteau's Pond, View Northwest from Eighth and Clark Streets.* Half plate, 1850. MHS.

Fig. 4-90. *Chouteau's Pond, View from Eighth and Clark Streets.* Modern print from glass copy negative by Emil Boehl, c. 1880, of half-plate daguerreotype by T. M. Easterly, 1851. MHS. The original plate held by MHS is in poor condition. Plate inscription: Chouteau's Pond, taken July 18, 1851 By T.M. Easterly, Dgn.

Fig. 4-91. *Chouteau's Pond, Man Putting Boat in Water.* Quarter plate, c. 1852. MHS. Plate inscription: Chouteau's Pond

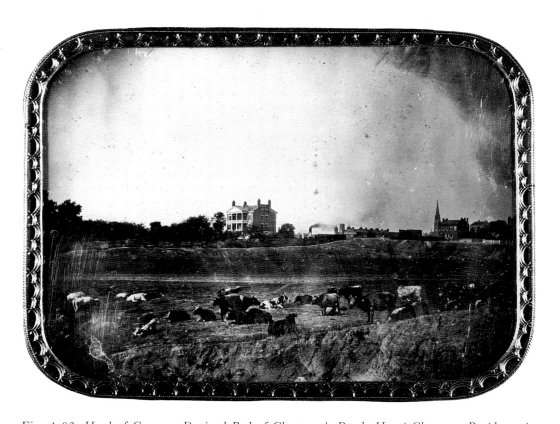

Fig. 4-92. *Herd of Cows on Drained Bed of Chouteau's Pond, Henri Chouteau Residence in Background.* Half plate, c. 1854. MHS.

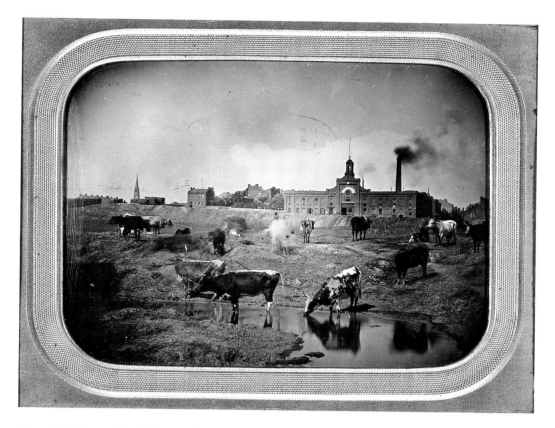

Fig. 4-93. *View of Drained Area of Chouteau's Pond with Cows.* Half plate, c. 1854. MHS.

Although it was years before the last remnants of the pond disappeared from the city landscape, its main body, where Easterly worked throughout the series, was almost completely drained in 1854 or 1855 when he daguerreotyped the empty basin from the embankment opposite the Chouteau mansion (fig. 4-92). Once the crowning focus of an idyllic sanctuary isolated by the pond's encompassing waters, the mansion now projected a stark presence on its summit above the quarter-mile sweep of barren landscape.

For a more immediate view of the newly exposed terrain, Easterly moved his camera to the surface of the lake bed (fig. 4-93). The image recorded from this perspective, like his earlier view of the man and his boat on the pond's deserted shoreline, conveys the muted message of his series through a symbolic juxtaposition of the real and the ideal. The bucolic foreground scene presents a vision of some peaceful, rural arcadia where grazing cows and a placid pool of water carry the burden of meaning. As a counterpoint to this serene partnership with nature and its nostalgic associations with a vanishing past, Collier's newly expanded lead works—black smoke mushrooming from its towering smokestack—looms conspicuously on the horizon.

Easterly concluded his visual narrative on the pond's demise from the high plateau near Chouteau's mansion. Taken in the mid-1850s, his panoramic vista encompassed the drained flatbed, known by that time as Mill Creek Valley, and the crowded city rising on its borders (fig. 4-94). Within a decade, this peaceful oasis would be transformed into a sea of industry when it became the major railroad yard in St. Louis.

In the late 1860s, when the massive Mill Creek sewer was draining the lingering, swampy sections of the original pond bed, Easterly made a last working excursion to the perimeter of the old lake site to document the inevitable triumph of human enterprise over nature. The image produced on this occasion is among his most memorable and visually arresting works (fig. 4-95). With the arched form of the sewer relegated to the middle distance of the picture, the viewer's attention is captured by the striking configuration of a boy perched precariously on a pipe above the creek's gleaming, metallic surface.

LIKENESS AND LANDSCAPE

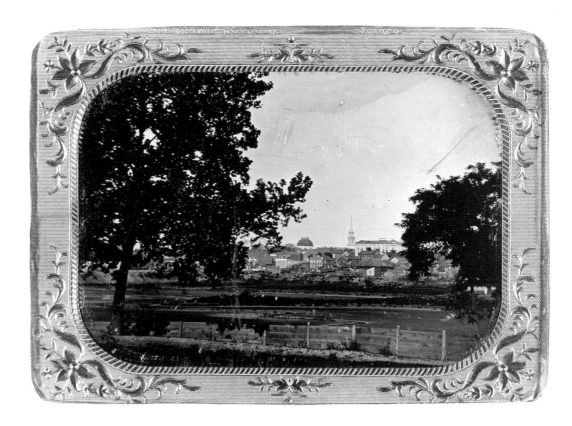

Fig. 4-94. *St. Louis from across the Mill Creek Valley.* Quarter plate, c. 1855. MHS. Plate inscription: St. Louis

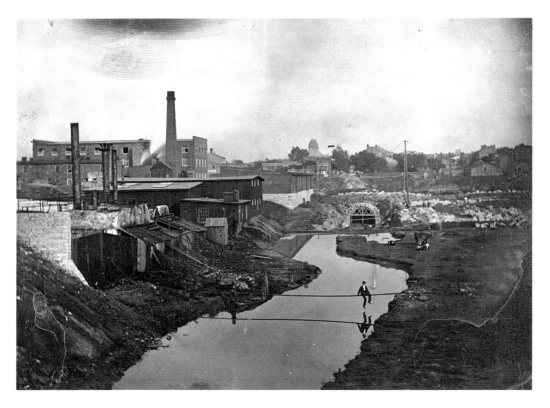

Fig. 4-95. *Construction of Mill Creek Sewer.* Half plate, 1868. MHS.

When the draining of the main portion of Chouteau's Pond was nearing completion, Easterly made the first of many documentary expeditions to the site of a massive Indian burial mound, situated amidst the mills and factories on the north side of town near the river. The "Big Mound," as it was known to St. Louisans, was located near the northeast corner of present-day Broadway and Mound streets. During the colonial era, at least twenty-seven mounds had dotted the landscape that later fell within the city limits. Succeeding generations leveled all but portions of two of the prehistoric structures that had given St. Louis its nineteenth-century nickname, "the Mound City." The Big Mound, known to Creole settlers as *La Grange de Terre* or Barn of Earth, was the largest of the area's ancient earthworks. They were created by the Mississippian culture, which reached its peak about 1100 A.D.

The imposing scale of the Big Mound and its once well-defined form can be seen in J. C. Wild's 1840 lithograph of St. Louis, seen from the Illinois shore (fig. 4-96). In 1844, two local lumber merchants, hoping to profit from the "extensive and beautiful view" from the mound's summit, erected a "pleasure resort" on top of the structure. Their "Mound Pavilion," with its restaurant and rooftop observation level, burned in 1848.[82] Through the first half of the century, the great heap of earth also served as a standard property marker for surveyors, a familiar landmark for boatmen traveling the Mississippi, and, on a few reported occasions, as a burial ground for local Indian tribes.

Measurements taken early in the century by Titian Ramsey Peale are generally regarded as the most accurate record of the original scale of the structure. Peale, the artist son of the prominent Philadelphia painter Charles Willson Peale, was the "assistant naturalist" traveling west with an expeditionary party led by Major Stephen H. Long. The group stopped in St. Louis in 1819 before embarking on an exploratory journey to the Upper Missouri region. Peale's notations on "the ancient tumulus" indicate that the slightly rounded-top form originally rose at least thirty-four feet high and covered an area 319 feet long and 158 feet wide at the base. A lower "step" or terrace some seventy-nine feet wide ran along the structure's eastern side toward the river.[83] As can be seen in an image thought to be Easterly's earliest extant view of the site (fig. 4-97), grading operations on the mound's bordering streets in subsequent years cut through its north and south ends and lowered the surrounding ground elevation to expose a significant portion of the natural clay base on which the mound was constructed. By the early 1850s, when Easterly recorded the steeply shaved western face of the mound from across Broadway, it was estimated that its highest summit rose approximately fifty-three feet above street level.[84]

Fig. 4-96. *View of St. Louis from the Northeast.* Lithograph by J. C. Wild, 1840. MHS.

Fig. 4-97. *Big Mound, Fifth and Mound Streets.* Half plate, c. 1852-54. MHS.

Fig. 4-98. *Big Mound, Fifth and Mound Streets.* Half Plate, c. 1854. MHS.

Compared to the chorus of voices engaged in the emotional debate over the future of Chouteau's Pond, relatively little public response greeted the news of a plan to dismantle the city's oldest antiquity. In 1854, A. B. Chambers, editor of the *Missouri Republican*, headed a short-lived committee formed to negotiate the transfer of the site from its owners to the city. Chambers' group proposed to preserve the mound as the focus of a public garden that would be built around its base. Acknowledging that neither the "proprietors" of the site nor the city had shown support for the plan, Chambers expressed regret at this lack of interest to *Republican* readers in February of 1854:

> It is with pain that we learn that one of the oldest monuments in the city—that, indeed, from which it derives its name of "Mound City," is about to be leveled with ordinary earth. The workmen, we understand, are already engaged in the work of destruction, and in a short time this mysterious and magnificent work of other times and an unknown people, will have faded from sight, a victim to the giant arms of the god Utility.

Chambers concluded that "there seems little hope of its standing fast under the great temptation to convert the ground it occupies into convenient building lots, or for horses auction stands and the hackstering trade."[85]

Easterly's earliest views showing the mass of the mound still essentially intact may have been made during the first reported efforts to level the site in 1854. In addition to the exposure which pictured the steep western face of the mound as seen from across Broadway, he made a second view from Brooklin Street which looked across the length of the sprawling slopes of its eastern terrace (fig. 4-98). A ridge of cleanly incised walls in the lower right of the picture signals the progress of workmen.

If work to level the mound continued over the next decade, there are no reports on that activity. It was not until 1868, when "the god Utility" acted with more determination through the agency of the North Missouri Railroad, that the excavation process began in earnest. By early November of that year, the *Missouri Democrat* reported: "To all intents and purposes, the Mound is gone. Men are digging on every side."[86] Through arrangements with owners of the site, railroad officials had purchased the earth from the mound to use as landfill for an extension of its roadbed. Over a period of weeks, while crews worked to pare away the ancient landmark, Easterly revisited the site to document its dwindling bulk. More than a dozen half-plate views show various stages in the destruction of the great "barn of earth" (figs. 4-99 to 4-105).

Fig. 4-99. *Big Mound, Looking East from 5th and Mound Streets.* Half plate, 1868-69. MHS.

Although Easterly's industrious dedication to this project was consistent with his long-time interest in local history, he was also one of the few St. Louisans who recognized the potential "scientific" significance of the ancient earthwork. In 1925, Dr. Henry M. Whelpley, a prominent St. Louis physician and authority on Indian archaeology of the region, delivered a paper on the excavation of the Big Mound to the American Association for the Advancement of Science. His presentation was illustrated with hand-colored lantern slides made from Easterly's daguerreotypes. On the topic of community involvement in the event, Whelpley concluded that "A local artist, A. J. Conant, a photographer, Thomas M. Easterly, and the editor of the *Missouri Democrat* seem to have been the only ones who followed the destruction of the mound with scientific interest."[87]

Conant, a respected portrait painter and long-time student of the mound-builders' culture, apparently served as the project's principal self-appointed archaeologist-in-residence. He later published a detailed description of what had been unearthed from the mound "based upon personal and careful examination of the work during the process of its removal...." By his account, the first discovery of interest occurred when two skeletons of "modern Indians" were uncovered three feet below the surface.[88]

When workers later dug a vertical shaft to a depth about twenty-five feet below the summit, they reached a large burial chamber containing the badly fragmented remains of twenty to thirty skeletons.[89] Conant reported that with the exception of two small copper masks believed to be "ear jewels," grave goods uncovered in the lower burial chamber consisted primarily of "an innumerable lot of beads and discs, formed out of shells."[90] The most curious newspaper account on "A Relic from the Mound" described a "two-wheeled vehicle, supposed to be an ancient Velocipide, and said to have been found at the Big Mound." Interested "antiquarians" were invited to view the "Indian Velocipide" in the show window of Rosenfield and Company's store.[91]

While Conant saw the sepulchral chamber and its contents as definitive links to acknowledged mound-builder monuments elsewhere, a long-standing local controversy persisted with respect to the "modern" versus the "ancient" origins of the city's Indian mounds. Findings in the mound also made no impact on ardent supporters of the popular "river deposit" or "sand-bar" theory, which contended that the mound was a natural formation and not a man-made structure. This was the prevailing opinion among members of both the St. Louis Academy of Science and the Missouri Historical Society.[92]

Fig. 4-100. *Big Mound During Destruction.* Half plate, 1869. MHS.

Fig. 4-101. *Big Mound During Destruction.* Half plate, 1869. MHS.

Fig. 4-102. *Destruction of the Big Mound.* Half plate, 1869. Easterly-Dodge Collection, MHS. Gift of Mrs. Alice Dodge Wallace.

Fig. 4-103. *Big Mound During Destruction.* Half plate, 1869. MHS.

Shortly after the mound's excavation, Elihu Shepard, an organizer and founding member of the Society, wrote: "The Missouri Historical Society have [sic] preserved photographs of it, and observed its removal, to ascertain whether it was the work of nature or art, and have ascertained, beyond a doubt, that it was the work of nature only." As for "the remains" uncovered in the mound, Shepard concluded that among the "many small, rude and trifling ornaments" there was "nothing that would enrich a cabinet or add anything to science."[93]

Easterly's daguerreotypes offer no direct visual information on the artifacts uncovered during the mound's excavation. His views made in the spring of 1869 do indicate, however, that the historic associations of the old landmark had at last captured the imagination of local citizens. As newspaper reports of "graves, skeletons, and relics" brought increasing numbers of spectators to investigate the site, he rose to the challenge of recording these sometimes massive congregations of visitors.[94] In one distant view, which probably commemorates the discovery of the lower burial chamber, a miniature army stretches across the entire horizontal expanse of the structure (fig. 4-100). A later image in the series shows the mound pared to its central core, attended by a retinue of more than a hundred patient participants in the scene (fig. 4-102).

These densely populated views confirm A. J. Conant's report that "The demolition of this ancient landmark was an event which awakened much interest among the citizens, who gathered in crowds, from day to day during the many weeks occupied by its removal."[95] His account details an experience which suggests that Easterly's orderly group portraits of curious visitors fail to tell all of the story:

> Being very desirous of securing, if possible, a perfect skull, or at least the fragments from which one might be constructed, and as all which were thrown out by the excavators were in small pieces which crumbled at the touch, I began a careful excavation with a common kitchen knife near the feet of a skeleton. . . . My work was soon interrupted however by the crowd of eager boys from the neighboring schools, who scrambled for the beads which were thrown out with every handful of earth, with such energy that I was lifted from my feet and borne away. By the aid of a burly policeman, however, I was able to finish my excavation, but without being able to secure what was so much desired.[96]

This incident may have been commonplace since there was no official agency or supervisor to oversee the collection of artifacts uncovered or to ensure their proper disposition. Like Elihu Shepherd, most civic leaders appear to have dismissed the possibility that the familiar landmark was a man-made structure and thus placed little value on

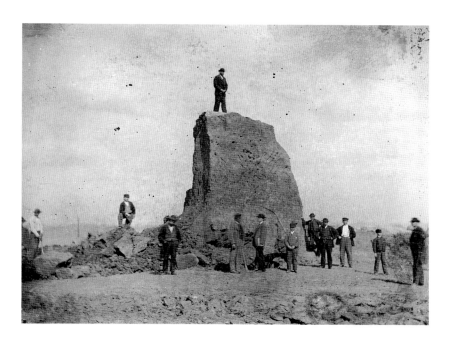

Fig. 4-104. *Big Mound During Destruction.* Half plate, 1869. MHS.

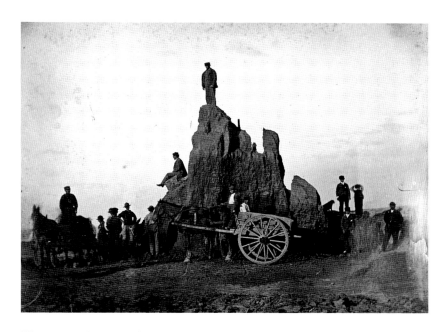

Fig. 4-105. *Big Mound During Destruction.* Half plate, 1869. MHS.

its contents. Although the Historical Society minutes record the acquisition of objects taken from the mound, many of the artifacts that did not disappear into the pockets of eager schoolboys and local curio collectors went to institutions outside St. Louis through private, poorly documented transactions.[97]

The public had lost interest in progress on the mound when Easterly documented its last remains. His two final views, with their small casts of boys, dogs, and workmen, have lost the carnival atmosphere of the earlier crowded compositions. In the first, the mound's dense clay substructure has been hewn to a stout vertical column jutting above the river's horizon (fig. 4-104). Like a silent sentinel, a single figure with folded hands and eyes gazing into the distance stands ceremoniously on top of the towering pedestal. As in every image in the series, Easterly's incisive composition makes the most of the dramatic silhouettes formed by the stark contours of the mound and its company of strategically dispersed attendants.

There is even more visual drama in the wonderful scene that marks the end of Easterly's dedicated effort to chronicle the mound's removal (fig. 4-105). In his last exposure, the once-monolithic structure has been chiseled into a strange, Gothic-like sculpture of cusps and pinnacles. Adding to the eccentricity of this curious formation are its human appendages. Like his colleague frozen on the ledge below, the man who forms the human apex of the composition seems as permanent and inanimate as his towering support. This arresting—if somewhat zany—image beautifully demonstrates the propensity for the constructed visual event that gives much early documentary photography its uniquely compelling character.

Although most St. Louisans accepted the leveling of the Big Mound as an inevitable consequence of the "great march of advancement," in some circles its removal intensified a new veneration for the city's remaining historic "relics." The impulse to preserve and pay homage to the past, first seen locally when civic leaders founded the Missouri Historical Society in 1866, was consonant with a wave of nostalgia that began to permeate American culture during the decade following the Civil War. With the nation's earlier mood of optimism checked by the tragedies of the war, gains earned by technology and "progress" began to be weighed more wistfully against the seemingly permanent loss of simpler past times. Artists and writers met this craving for an emotional escape from an uncertain, chaotic present with immensely popular artwork and literature that idealized rural arcadias, historic homesteads, and landmarks of local history.

Late in his career, Easterly reaped a small benefit from this changing cultural climate. In 1866, presumably in the hope of preserving his works as historical documents and supplementing his dwindling income, he approached the newly formed Missouri Historical Society to propose that the new institution include a body of his views among their first acquisitions. Despite a limited budget, the Society allocated funds in May 1867 for the purchase of twelve Easterly plates at twelve dollars each.[98] Unfortunately, the record of this transaction does not include an inventory of the specific images acquired.

This current of nostalgia for the past came too late to adequately benefit the man who had been faithfully preserving the city's past when his community had not yet recognized the value of its antiquities. During the 1870s, when Easterly's pioneering work as an antiquarian photographer found a more appreciative audience, it was in the form of copy work bearing the signatures or logos of other galleries. In the decade before the daguerrean's death, several St. Louis galleries were distributing his views of old St. Louis landmarks as cartes-de-visite, cabinet cards, or albumen prints in larger formats. Many of the original daguerreotype plates were apparently lost or destroyed. We will never know how many Easterly views were used for this purpose or whether he willingly relinquished his claim to authorship. Of the several photographers who appropriated Easterly's views, Emil Boehl's name appears most often as surrogate creator of his scenes. It was Boehl, the first local photographer to recognize the developing commercial potential for an establishment specializing in St. Louis views, who succeeded Easterly during the 1870s as the acknowledged pictorial historian of the city.

Although city directories continue to list Easterly's "Daguerrean" gallery until 1880, he produced very little work after completing the mound series in 1869. Among the handful of views that can be definitively assigned to the decade of the seventies is an image that serves as a particularly fitting conclusion to his career as an urban photographer. It pictures the Anne Lucas Hunt building sometime after its completion in 1872 (fig. 4-106). The commanding new structure, located at the northwest corner of Fourth and Olive streets on the site of the old Canton Tea Company, was a symbol of sophistication that rivaled the finest commercial buildings in Boston or New York.

The creation of this image surely triggered a flood of memories for the aging daguerrean. With the modest Canton Tea Company building as backdrop, his first views of St. Louis—memorable, spirited scenes of citizens gathered to see Tom Thumb and a firemen's parade—had been made looking across the same intersection, when his gallery was among the most prosperous establishments located at this busy commercial crossroad. In his early views of this corner, apartment residents living above the

Fig. 4-106. *Ann Lucas Hunt Building, Northwest Corner of Fourth and Olive Streets.* Half plate, c. 1872. MHS.

businesses hung from the windows as lively participants in the scene, eager to take part in what was then the novelty of being recorded by the camera. During the intervening quarter of a century, Easterly had preserved a unique pictorial record of a young frontier community's transformation into a thriving metropolis. With its high-rising, marble facade, the Ann Lucas Hunt building was material evidence of that transformation. It represented the kind of cosmopolitan elegance that one would expect to find in one of America's largest cities.

For nearly three decades, Easterly had quietly and independently pursued "the even tenor of his ways" to produce his "beautiful landscapes, perfect clouds" and his "collection of illustrious views about the city." As an urban viewmaker he not only discovered the city as a visually challenging resource but also pictured and defined it in ways that reflected some of the most profound cultural currents of the age. His sustained devotion to recording the changing face of a city was not surpassed until later in the century when Eugene Atget demonstrated the same preoccupation with the sights and scenes of Paris.

Believing that Daguerre's process alone could achieve his aim to leave a permanent visual record of his era, Easterly "stuck to the Daguerreotype until the last." The remarkable images that survive to recall his deep and enduring respect for this medium represent a moment of broad-based achievement unmatched in the early history of photography.

Selected Bibliography

Barger, M. Susan, and William B. White. *The Daguerreotype: Nineteenth-Century Technology and Modern Science.* Washington, D.C.: Smithsonian Institution Press, 1991.

Barry, Louise. *The Beginning of the West, Annals of the Kansas Gateway to the American West, 1540-1854.* Topeka: Kansas State Historical Society, 1972.

Berkhofer, Robert F., Jr. "White Conceptions of Indians." In vol. 4 of *Handbook of North American Indians,* edited by William C. Sturtevant. Washington, D.C.: Smithsonian Institution Press, 1988: 522-47.

_____. *The White Man's Indian: Images of the American Indian from Columbus to the Present.* New York: Vintage Books, 1979.

Blaine, Martha Royce. *The Ioway Indians.* Norman: University of Oklahoma Press, 1979.

Bogardus, Abraham. "Thirty-Seven Years Behind a Camera." *Photographic Times and American Photographer* 14 (May 1881): 73-78.

Bowen, Elbert R. *Theatrical Entertainment in Rural Missouri Before the Civil War.* Columbia: University of Missouri Press, 1959.

Brown, Slater. *The Heyday of Spiritualism.* New York: Hawthorne Books, 1970.

Brown, Thomas A. *History of the New York Stage.* New York: B. Blom, 1964.

Buerger, Janet E. *French Daguerreotypes.* Chicago: University of Chicago Press, 1989.

Carvalho, Solomon N. *Incidents of Travel and Adventures in the Far West.* New York: Derby and Jackson, 1857.

Clamorgan, Cyprian. "The Colored Aristocracy of St. Louis," ed. Lawrence O. Christianson, *Bulletin of the Missouri Historical Society* 31 (October 1974).

Conant, Alban Jasper. *Foot-Prints of Vanished Races in the Mississippi Valley.* St. Louis: Chancy R. Barns, 1879.

Conklin, Will. *St. Louis Illustrated.* St. Louis: Will Conklin, 1876.

Cosentino, Andrew F. *The Paintings of Charles Bird King (1785-1862).* Washington, D.C.: Smithsonian Institution Press, 1977.

Danley, Susan, and Leo Marx, eds. *The Railroad in American Art: Representations of Technological Change.* Cambridge, Mass.: MIT Press, 1988.

Davidson, Carla. "The View from Fourth and Olive." *American Heritage* 13 (December 1971): 76-91.

Dow, Charles Mason. *Anthology and Bibliography of Niagara Falls.* Albany: State of New York, 1921.

Drimmer, Frederick. *Very Special People.* New York: Amjon Publishers, 1973.

Dunn, J. P. *Massacres of the Mountains: A History of the Indian Wars of the Far West.* New York: Harper and Bros., 1886.

Ewers, John C. "An Anthropologist Looks at Early Pictures of North American Indians." *New York Historical Society Quarterly* 33 (October 1949): 223-34.

_____. *The Emergence of the Plains Indians as the Symbol of the North American Indian.* Annual Report of the Smithsonian Institution for 1964. Washington, D.C.: Government Printing Office, 1965.

_____. "Thomas M. Easterly's Pioneer Daguerreotypes of Plains Indians." *Bulletin of the Missouri Historical Society* 25 (July 1968): 329-39.

Field, Richard, and Robin Jaffee Frank. *American Daguerreotypes for the Matthew R. Isenburg Collection.* New Haven, Conn.: Yale University Art Gallery, 1989.

Fleming, Paula Richardson, and Judith Luskey. *Grand Endeavors of American Indian Photography.* Washington, D.C.: Smithsonian Institution Press, 1993.

_____. *The North American Indians.* New York: Harper and Row, 1986.

Gies, Joseph. *Bridges and Men.* Garden City, N. Y.: Doubleday and Co., 1963.

Gould, E. W. *Fifty Years on the Mississippi.* St. Louis: Nixon-Jones, 1889.

Green, Charles R. *Early Days in Kansas, In Keokuk's Time on the Kansas Reservation.* Olathe, Kans.: C. R. Green, 1913.

Green's St. Louis Directory. St. Louis: James Green and Cathcart & Prescott, 1851.

Guidry, Gail R. "Long, Fitzgibbon, Easterly, and Outley: St. Louis Daguerreans." *St. Louis Literary Supplement* 1 (November-December 1977): 6-8.

Hafen, Leroy R., ed. *The Mountain Men and the Fur Trade of the Far West.* Glendale, Calif.: A. H. Clark Co., 1965.

Hagan, William T. *The Sac and Fox Indians.* Norman: University of Oklahoma Press, 1958.

Hales, Peter, B. *Silver Cities: The Photography of American Urbanization, 1839-1915.* Philadelphia: Temple University Press, 1984.

Hill, Edward E. *The Office of Indian Affairs, 1824-1880: Historical Sketches.* New York: Clearwater Publishing, 1974.

Honour, Hugh. *The New Golden Land: European Images of America From the Discoveries to the Present Time.* New York: Pantheon Books, 1975.

Horan, James D. *The McKenney-Hall Portrait Gallery of American Indians.* New York: Crown Publishing Group, 1972.

Humphrey, S. D. *American Hand Book of the Daguerreotype.* 1858. Reprint. New York: Arno Press, 1973.

Humphrey, S. D., and M. Finley. *The Daguerreotype Process: Three Treatises.* Edited by Robert Sobieszek. New York: Arno Press, 1973.

Hunter, Louis C. *Steamboats on the Western Rivers.* Cambridge, Mass.: Harvard University Press, 1949.

Hyde, William, and Howard L. Conard. *Encyclopedia of the History of St. Louis.* 4 vols. Louisville, Ky.: Southern History Company, 1899.

Isaac, Stevens. *U.S. War Department Reports of Explorations and Surveys ...* 36th Cong. 1st sess., Senate Executive Document. Washington, D.C. : Thomas H. For, Printer, 1860.

Jackson, William Henry. *Descriptive Catalogue of Photographs of North American Indians.* U.S. Department of Interior, Miscellaneous Publications, no. 9. Washington, D.C.: U.S. Department of Interior, 1877.

Jameson, Anna B. M. *Winter Studies and Summer Rambles in Canada.* London: 1838.

Keeler, Ralph, and Alfred R. Waud. "St. Louis: Rambling About the City." *Every Saturday* 3 (28 October 1871): 414.

Kennedy's St. Louis City Directory. St. Louis: R. V. Kennedy & Co., Publishers, 1860.

Kennerly, William Clark. *Persimmon Hill.* Norman: University of Oklahoma Press, 1948.

Marberry, M. M. *Vicky: A Biography of Victoria C. Woodhull.* New York: Funk & Wagnalls, 1967.

Marzio, Peter. *Perfect Likenesses: Portraits for "History of the Indian Tribes of North America" (1837-1844).* Washington, D.C.: National Museum of History and Technology, 1977.

McCracken, Harold. *George Catlin and the Old Frontier.* New York: Dial Press, 1959.

McCue, George. *The Building Art in St. Louis: Two Centuries.* St. Louis: American Institute of Architects, 1967.

McDermott, John F. "Another Coriolanus: Portraits of Keokuk, Chief of the Sac and Fox." In *Portrait Painting in America: the Nineteenth Century,* edited by Ellen Miles. New York: Main St. Press, 1977.

_____, ed. *The Early Histories of St. Louis.* St. Louis: St. Louis Historical Documents Foundation, 1952.

_____, ed. *The Frontier Re-examined.* Urbana: University of Illinois Press, 1967.

_____, ed. *Travels in Search of the Elephant: The Wanderings of Alfred S. Waugh, Artist, in Louisiana, Missouri, and Sante Fe, in 1845-1846.* St. Louis: Missouri Historical Society, 1951.

McKenney, Thomas, and James Hall. *History of the Indian Tribes of North America, with Biographical Sketches and Anecdotes of the Principal Chiefs.* 3 vols. Philadelphia: Fred Greenough, 1838.

McKinsey, Elizabeth. *Niagara Falls: Icon of the American Sublime.* Cambridge: Cambridge University Press, 1985.

Moore, Charles LeRoy. "Two Partners in Boston: The Careers and Daguerreian Artistry of Albert Southworth and Josiah Hawes." Ph.D. diss., University of Michigan, 1974.

Morden, James C. *Historic Monuments and Observatories of Lundy's Lane and Queenston Heights.* Niagara Falls, Ont., Canada: The Lundy's Lane Historical Society, 1929.

Morrison's St. Louis City Directory. St. Louis: *Missouri Republican,* 1852.

Musick, James B. *St. Louis as a Fortified Town.* St. Louis: R. F. Miller, 1941.

Parry, Elwood. *The Image of the Indian and the Black Man in American Art, 1590-1900.* New York: George Braziller, 1974.

Peale, Titian Ramsey. *Ancient Mounds of St. Louis, Missouri, in 1819.* Annual Report of the Board of Regents of the Smithsonian Institution. Washington, D.C.: 1862.

Peters, Frank, and George McCue. *A Guide to the Architecture of St. Louis.* Columbia: University of Missouri Press, 1989.

Peterson, Charles E. *Colonial St. Louis: Building a Creole Capital.* St. Louis: Missouri Historical Society, 1949.

Pfister, Harold. *Facing the Light: Historic American Portrait Daguerreotypes.* Washington, D.C.: Smithsonian Institution Press, 1978.

Primm, James Neal. *Lion of the Valley: St. Louis, Missouri.* Boulder, Co.: Pruett Publishing Co., 1981.

Reavis, Logan Uriah. *Saint Louis: The Future Great City of the World.* 4th ed. St. Louis: E. F. Hobart, 1873.

Reps, John W. *St. Louis Illustrated: Nineteenth-Century Engravings and Lithographs of a Mississippi River Metropolis.* Columbia: University of Missouri Press, 1989.

Richter, Stefan. *The Art of the Daguerreotype.* New York: Viking Penguin, 1989.

Rinhart, Floyd, and Marion Rinhart. *The American Daguerreotype.* Athens: University of Georgia Press, 1981.

Rogers, Patrick. *Father Theobald Matthew: Apostle of Temperance.* New York: Longmans, Green and Co., 1945.

Romer, Grant. "The Daguerreotype in America and England after 1860." *History of Photography* 1 (July 1977): 201-12.

Root, Marcus Aurelius. *The Camera and the Pencil.* 1864. Reprint. Pawlet, Vt.: Helios, 1971.

Rudisill, Richard. *Mirror Image: The Influence of the Daguerreotype on American Society.* Albuquerque: University of New Mexico Press, 1971.

Ryder, James F. *Voightlander and I: In Pursuit of Shadow Catching.* Cleveland: Cleveland Printing and Publishing, 1902.

Savage, Charles C. *Architecture of the Private Streets of St. Louis.* Columbia: University of Missouri Press, 1987.

Scharf, John Thomas, ed. *History of St. Louis City and County, from the Earliest Periods to the Present Day.* 2 vols. Philadelphia: Louis H. Everts & Co., 1883.

Scherer, Joanna Cohan. "You Can't Believe Your Eyes: Inaccuracies in Photographs of North American Indians." *Studies in the Anthropology of Visual Communication* 2 (Fall 1975): 67-79.

Schoolcraft, Henry R. *Historical and Statistical Information Respecting the History, Condition and Prospects of the Indian Tribes of the United States.* 6 vols. Philadelphia: J. P. Lippincott & Co., 1851-57.

Shepard, Elihu H. *The Early History of St. Louis and Missouri.* St. Louis: Southwestern Book and Publishing Co., 1870.

[Shindler, Antonio Zeno.] "Photographic Portraits of North American Indians in the Gallery of the Smithsonian Institution," 1867 [1869.] *Smithsonian Miscellaneous Collections*, vol. 14, no. 216. Washington, D.C.: Smithsonian Institution, 1876.

Stevens, Walter B. *St. Louis, The Fourth City.* St. Louis: S. J. Clarke Publishing Co., 1909.

Taft, Robert. *Photography and the American Scene.* 1938. Reprint. New York: Dover Publications, 1964.

Taylor, Colin. "William Blackmore: A 19th Century Englishman's Contribution to American Ethnology." In *Indians and Europe,* edited by Christian Feest. Aachen, Germany: Heerodot, 1987.

Trachtenberg, Alan. *Reading Photographs.* New York: Hill and Wang, 1989.

Troen, Selwyn K., and Glen E. Holt. *St. Louis.* New York: New Viewpoints, 1977.

Truettner, William H. *The Natural Man Observed: A Study of Catlin's Indian Gallery.* Washington, D.C.: Amon Carter Museum and National Collection of Fine Arts, Smithsonian Institution, 1979.

Van Ravenswaay, Charles. "The Pioneer Photographers of St. Louis." *Bulletin of the Missouri Historical Society* 10 (October 1953): 48-71.

_____. *Saint Louis, An Informal History of the City and its People, 1764-1865.* St. Louis: Missouri Historical Society Press, 1991.

_____. "Years of Turmoil, Years of Growth: St. Louis in the 1850's," *Bulletin of the Missouri Historical Society* 23 (July 1967): 303-24.

Weinstein, Robert. "Das Bild der Indianer in der Photographie, 1840-1880," *Du,* #444 (February 1978): 58-72.

Weitenkampf, Frank. "Early Pictures of North American Indians: A Question of Ethnology." *Bulletin of the New York Public Library* 52 (November 1949): 591-614.

_____. "How Indians Were Pictured in Earlier Days." *The New York Historical Society Quarterly* 33 (October 1949): 213-21.

Welling, William. *Photography in America: The Formative Years, 1839-1900.* New York: Crowell, 1978.

Welter, Rush. *The Mind of America, 1820-1860.* New York: Columbia University Press, 1975.

Werge, John. *The Evolution of Photography.* 1890. Reprint. New York: Arno Press, 1973.

Wood, John, ed. *America and the Daguerreotype.* Iowa City: University of Iowa Press, 1991.

_____. *The Daguerreotype: A Sesquicentennial Celebration.* Iowa City: University of Iowa Press, 1989.

Notes

Introduction

1. Broadside 1 January 1865. Easterly-Dodge Collection, Missouri Historical Society Department of Photographs and Prints.

2. Cole quoted in Louis Legrand Noble, *The Life and Works of Thomas Cole,* ed. Elliot S. Vesell (Cambridge, Mass.: Harvard University Press, 1964), 210.

3. *Missouri Republican*, 10 April 1882.

4. Minutes, Meeting of the Missouri Historical Society, 27 February 1896.

5. According to Ruth K. Field, a previous Curator of Pictorial History at the Missouri Historical Society, several hundred Easterly plates "were received by the Society in an unknown manner about 1890, and were in slotted boxes, unmounted. The cases and mats now on the photos are not necessarily the originals, but were blanks received with the collection." Ruth K. Field, conversation with William C. Sturtevant, Curator of North American Ethnology, Smithsonian Institution, 12 March 1969. Sturtevant research notes on Easterly Indian portraits.

6. Robert Taft, *Photography and the American Scene* (1938. Reprint. New York: Dover Publications, 1964), 249.

7. Charles van Ravenswaay, "The Missouri Historical Society's Photographic Collection," *Eye to Eye* 2 (September 1953): 11.

8. Minutes, Meeting of the Missouri Historical Society, 1 December 1866.

Chapter I

1. Guilford, Vermont, land records, vol. 7, 191.

2. Guilford, Vermont, birth records register a Martin Easterly born to Philomela and Tunis Easterly on 3 October 1809.

3. 1830 census records for St. Lawrence County, New York, show a Martin Easterly, age 20-30 years, residing in Gouverneur township near the New York-Ontario border.

4. Along with other Easterly memorabilia, these mementos of the daguerrean's first career were given to the Missouri Historical Society by Margaret Wing Dodge, a descendant of Miriam Bailey Easterly.

5. *Burlington Free Press* (Vt.), 22 June 1838.

6. *Weekly Tribune* (Liberty, Mo.), 11 July 1846.

7. *Daily Albany Argus* (N.Y.), 1 February 1841; *Daily Albany Argus*, 2 December 1843.

8. Advertisements for Thomas H. Cushman, operating at No. 1, Fourth Floor Exchange Building, began appearing in the *Daily Albany Argus* in January 1841 and ran through late June of that year. His April 3 advertisement, which

notes that instructions in "Portrait and Landscape taking" were available, indicates that Cushman had taken E. N. Horseford as a partner.

9. The *Daily Albany Argus'* first mention of Henry Meade appears in a January 28, 1843, advertisement for the daguerrean gallery of Charles E. Johnson. A footnote to Johnson's advertisment states: "The only tolerable specimens of the art, now exhibiting at the Exchange as the work of Henry W. Meade, are rejected pictures taken by me at my room, no. 18, Douw's Buildings." Meade may have been operating in the space earlier occupied by Cushman and Horseford.

10. Easterly quoted in Logan Uriah Reavis, *St. Louis: The Future Great City of the World*, 4th ed. (St. Louis: E. F. Hobart, 1873), 192.

11. *Weekly Tribune*, 11 July 1846.

12. *Northwestern Gazette* (Galena, Ill.), 8 September 1845.

13. *Davenport Gazette* (Iowa), 30 October 1845.

14. Ibid.

15. *Weekly Tribune*, 11 July 1846.

16. Ibid.

17. Ibid.

18. In their *Tribune* announcement, Easterly and Webb credited the invention

of the gilding technique to the American artist-inventor Samuel Morse. Although Morse made substantial contributions to the practice of daguerreotypy in America and may have introduced gilding to the New York daguerrean community, it was the French physicist Hippolyte Fizeau who first discovered and publicized the advantages of the gold chloride bath.

19. *Weekly Tribune*, 11 July 1846.

20. *Mississippian and Republican* (Rock Island, Ill.), 30 October 1845.

21. *Burlington Hawkeye* (Iowa), 6 November 1845.

22. Ibid.

23. *Weekly Tribune*, 11 July 1846.

24. Ibid.

25. Gail R. Guidry, "Long, Fitzgibbon, Easterly, and Outley: St. Louis Daguerreans," *St. Louis Literary Supplement* 1 (November-December 1977): 7.

26. *Iowa Sentinel* (Fairfax, Iowa), 21 August 1847.

27. *Reveille* (St. Louis), 19 August 1847. Irwing sometimes appears spelled as Irving.

28. *Missouri Republican* (St. Louis), 1 October 1847.

29. *Reveille*, 27 February 1848.

30. *Missouri Republican*, 25 March 1848.

31. Charles van Ravenswaay, "The Pioneer Photographers of St. Louis," *Bulletin of the Missouri Historical Society* 10 (Oct. 1953): 48. The first reported daguerreans in St. Louis were Moore & Moore, who set up a gallery at Dennis' Boarding House at the corner of Main and Market streets on June 2, 1841.

32. James F. Ryder, *Voightlander and I: In Pursuit of Shadow Catching* (Cleveland: Cleveland Printing and Publishing, 1902), 20.

33. *Missouri Republican*, 10 September 1850. After declaring Miss Dinsmore's likenesses as "truthful, distinct, and effective as life itself," the writer added, "There is also something very agreeable in having an intelligent and interesting lady presiding over the monotony of sitting for one's picture." Despite favorable response from the local press, Dinsmore apparently found the new profession inadequate as a livelihood. Like so many of her contemporaries who made the modest investment required for equipment and instruction in Daguerre's process, she soon moved on to try other of the many new enterprises of the day that required few, if any, professional credentials. After several years away from St. Louis, she was back in town in the 1860s, advertising her skills as an "electro-magnetic physician."

34. *Reveille*, 2 June 1850.

35. *Reveille*, 8 July 1850.

36. Van Ravenswaay, "The Pioneer Photographers of St. Louis," 63.

37. *Missouri Republican*, 6 March 1852.

38. *Daguerreian Journal* 1 (1 November 1850): 23.

39. *Missouri Republican*, 22 May 1850.

40. *Photographic Art Journal* 2 (October 1851): 254.

41. *Reveille*, 12 September 1850.

42. *Missouri Republican*, 8 January 1852.

43. *Missouri Republican*, 8 January 1854. Fitzgibbon's purchase of the Vance, California, views was earlier noted in *Humphrey's Journal* 5 (September 1853): 105.

44. *Missouri Republican*, 8 April 1854.

45. *Missouri Republican*, 1 May 1854.

46. *St. Louis Daily Evening News*, 22 September 1856. "Vance's great collection of panoramic views of towns, cities, and places of note in California—about 200 in number" were listed along with fossils, reptiles, stuffed animals, and "many other interesting curiosities" at the St. Louis Museum. A search for information on this establishment and the fate of its contents proved unsuccessful. Fitzgibbon apparently sold or loaned the Vance views to the museum's proprietors.

47. *Humphrey's Journal* 4 (January 1853): 287.

48. The original letter from Easterly to Miriam Bailey is in the Easterly-Dodge Collection in the Photographs and Prints Department at the Missouri Historical Society in St. Louis.

49. Anna Miriam Bailey graduated from Monticello Female Seminary in Godfrey, Illinois. Her shy nature, noted in letters written in 1864-1865 by her brother-in-law, Norton S. Townshend, to his wife, may have been influenced by her difficult childhood (A. D. Wallace Family Papers). Her parents, John and Sara Lang Bailey, moved from Virginia in 1831, settling on a large farm in the Missouri Meramec River Valley. John Bailey was a minister and a farmer. When both parents died in 1835, their five young children were separated and placed in the care of foster parents. Through the manipulation of an administrator of Bailey's estate, the children were retained in Missouri, despite efforts of the Lang family to take them back to Virginia. A family history written by Margaret Bailey Townshend (A. D. Wallace Family Papers) details the hardships the children experienced during these years. Margaret eventually worked her way through Monticello Female Seminary and later, as a teacher at a

female seminary in Ohio, provided her younger sisters with their educations.

50. Norton S. Townshend to Margaret Bailey Townshend, 15 December 1864, A. D. Wallace Family Papers.

51. Ibid.

52. Ibid.

53. Easterly quoted in *St. Louis: The Future Great City of the World*, 193.

54. Linden F. Edwards, "Norton Strange Townshend—Physician, Legislator, 'Father of American Agriculture,'" unpublished ms., n.d., 2, A. D. Wallace Family Papers.

55. *Reveille*, 5 July 1847.

56. *Reveille*, 11 August 1850.

57. *Western Journal and Civilian* (March 1852): 435.

58. *Morrison's St. Louis City Directory* (St. Louis: Missouri Republican, 1852), XVII.

59. *Reveille*, 12 November 1848.

60. *Photographic and Fine Art Journal* 9 (April 1856): 148.

61. *Daily Missouri Democrat* (St. Louis), 8 May 1854.

62. *Missouri Republican*, 12 March 1858.

63. "Gallery Biographic," *Anthony's Photographic Bulletin* 4 (1872): 81-82.

64. *Daguerreian Journal* 12 (November 1851): 371-72.

65. *Kennedy's St. Louis City Directory for 1857* (St. Louis, Mo.: R. V. Kennedy), 67.

66. For a thorough and insightful study on renewed interest in the practice of

daguerreotypy in both the nineteenth and twentieth centuries, see Grant Romer, "The Daguerreotype in America and England after 1860," *History of Photography* 1 (July 1977): 201-12.

67. Abraham Bogardus, "Thirty-Seven Years Behind a Camera," *Photographic Times and American Photographer* 14 (May 1881): 74.

68. The *Alton Weekly Courier* (Ill.), 3 June 1858. The misspelling of Easterly's name, which is spelled correctly at the bottom of the ad, may have been a printing error. Although it may be coincidental, research on Easterly's family in New York suggests that his father's family probably descended from early Dutch settlers named Esterly.

69. *Kennedy's St. Louis City Directory for 1860* (St. Louis, Mo.: R. V. Kennedy), 149.

70. Townshend to Margaret Bailey Townshend, 1 December 1864, A. D. Wallace Family Papers.

71. Ibid., 14 December 1864.

72. The original broadside, dated 1 January 1865, is in the Easterly-Dodge Collection in the Photographs and Prints Department at the Missouri Historical Society in St. Louis.

73. The *Missouri Republican* carried news of the fire on January 20, 1865: "At about 9 o'clock last evening a fire broke out in the daguerrean gallery on the second floor of the building on the southeast corner of Fourth and Olive, and upon the alarm being given, some 15 or 20 minutes elapsed before the arrival of the engines, owing to the fact that they were ... at a distant quarter of the city.... The fire on Fourth and Olive created great excitement, drawing an immense crowd...." On January 21, the *Republican* gave additional details on the damages suffered by the occupants of

the building, indicating that "the heaviest individual loss is that of Mr. T. L. Rivers, who lost daguerreian goods, furniture, etc. to the amount of $500, and was without any insurance." Based on city directory information, Thomas L. Rivers established his gallery in rooms adjoining Easterly's in 1863. Perhaps because Easterly's losses were partially covered by insurance, the *Republican* viewed his damages as less severe than those suffered by his neighbor.

74. Townshend to Margaret Bailey Townshend, 20 January 1865, A. D. Wallace Family Papers.

75. Another person, whose exact relationship to the photographer remains unknown, also appeared in the city directory of 1867 as a resident of the Easterly household. Martin Easterly, listed as a professional artist, was undoubtedly a relative from the East, possibly a nephew or cousin of the daguerrean, who left the city after spending a number of months in St. Louis. In 1873, Martin Easterly was again residing with the Easterlys and carrying out his work as an artist at the daguerrean's Fourth Street gallery. By 1874 he had moved on to practice his business elsewhere.

76. *Missouri Weekly Herald* (Rolla, Mo.), 1 April 1869.

77. Townshend to Margaret Bailey Townshend, 6 May 1865, A. D. Wallace Family Papers.

78. *Practical Photographer* 6 (1882): 144.

79. Broadside, 1 January 1865.

80. *Missouri Republican*, 6 October 1866.

81. Ibid.

82. *Tenth Annual Report of the St. Louis Agricultural and Mechanical Association* (St. Louis, 1871), 84.

83. *Philadelphia Photographer* 7 (November 1870): 385.

84. Ibid.

85. *Practical Photographer* 6 (April 1882): 144.

86. *St. Louis Globe-Democrat*, 12 March 1882.

87. Jean D. Wilson, M. D. et al., *Harrison's Principles of Internal Medicine*, 12th ed. (New York: McGraw-Hill, Inc., 1991), 2185.

88. Stefan Richter, *The Art of the Daguerreotype* (New York: Viking Penguin, 1989), 10.

CHAPTER II

1. *Godey's Lady's Book* 38 (May 1849): 352.

2. Morse quoted in Van Deren Coke, "Camera and Canvas," *Art in America* 49 (May 1961): 68.

3. "Photography," *The Crayon* 1 (March 1855): 107.

4. "Daguerreotypes," *Ballou's Pictorial Drawing Room Companion* 8 (June 1855): 387.

5. *Photographic Art Journal* 1 (1851): 163.

6. Marcus Aurelius Root, *The Camera and the Pencil, or, The Heliographic Art* (1864. Reprint. Pawlet, Vt.: Helios, 1971), 122.

7. Abraham Bogardus, "Thirty-Seven Years Behind a Camera," *Photographic Times* 14 (May 1881): 73.

8. The most complete study on the work of Albert Southworth and Josiah Hawes is Charles LeRoy Moore, "Two Partners in Boston: The Careers and Daguerreian Art of Albert Southworth and Josiah Hawes." Ph.D. diss., University of Michigan, 1974. Also see Robert Sobieszek and Odette Appell, *The Daguerreotypes of Southworth and Hawes* (New York: Dover Publications, 1980).

9. Because of the discrepancy between the character of the block-style printing and Easterly's more familiar cursive style, it is conceivable that the names etched on the verso of the plates were added at a later time by another party who had access to the portraits. John Scholten or staff members of the Missouri Historical Society, the most likely candidates to have assumed the task of identifying Easterly's subjects, might certainly have recognized the faces of the early leaders of their community and subsequently incised their names on the back of the images. However, many of the individuals identified in this manner were average citizens who played no significant role in St. Louis history. It seems highly unlikely that observers examining the plates in the 1890s would have recognized the barbers or bootmakers of the 1850s, or subjects such as Easterly's sister-in-law, Malinda Bailey Cahill, who moved away from St. Louis before 1853. Thus, it seems safe to conclude that in most instances the author of the portraits provided the original documentation.

10. In an 1891 interview, Mathew Brady recalled his sitting with Father Theobald Mathew: "At Fulton Street, ... I took many a great man and fine lady—Father Mathew, Kossuth, Paez, Cass, Webster, Benton, and Edgar Allen Poe." In George Alfred Townsend, "Brady, the Grand Old Man of American Photography: An Interview," *New York World* (12 April 1891): 26. I am grateful to Laurie Baty for bringing my attention to a portrait of Father Mathew engraved by Thomas Doney after a daguerreotype by Marcus Root.

11. *Davenport Gazette* (Iowa), 3 October 1845.

12. From an article on James Kirker's visit to St. Louis credited to Charles Keemle, editor of the St. Louis *Reveille*, that appeared in the *St. Louis Saturday Evening Post*, 10 July 1847. Quoted in William Cochran McGaw, *Savage Scene; The Life and Times of James Kirker, Frontier King* (New York: Hastings House, 1972), 190. An engraving after Easterly's daguerreotype portrait of Kirker accompanied the article. No copy of this issue of the *Post* exists, but it was reprinted in the Santa Fe *Republican*, 20 November 1847.

13. Norton S. Townshend, diary entry, 11 June 1865, A. D. Wallace Family Papers.

14. Root, *The Camera and the Pencil*, 102.

15. *Missouri Republican*, 12 March 1858.

16. Cyprian Clamorgan, *The Colored Aristocracy of St. Louis* (St. Louis, 1858). Clamorgan, a mulatto grandson of colonial fur trader Jacques Clamorgan, published this small pamphlet, which identified forty-three free blacks who were successful leaders in business and the black community in St. Louis.

17. S. D. Humphrey, *American Hand Book of the Daguerreotype* (1858; reprint, New York: Arno Press, 1973), 33.

18. Root, *The Camera and the Pencil*, 106.

19. Ibid., 118.

20. S. D. Humphrey and M. Finley, *A System of Photography, Containing an Explicit Detail of the Whole Process of Daguerreotype* (Canandaigua, N. Y., 1849), in S. D. Humphrey and M. Finley, *The Daguerreotype Process: Three Treatises*, ed. Robert Sobieszek (New York: Arno Press, 1973), 33.

21. Letter, L. C. Champney, Bennington, Vt., to Albert Southworth, Boston, 9 March 1843, Southworth and Hawes MSS, George Eastman House, Rochester,

N. Y. Another letter to Southworth and Hawes voiced a similar complaint about the outcome of their dramatic lighting. The partners had apparently pictured a gentleman patron, G. H. Thayer, with his features partially obscured in shadow. If Thayer appreciated the results, he wrote to report that his friends and associates were less than impressed: "I am sorry to say that the Daguerreotype does not receive the approbation that I had anticipated for it. One lady thought *I was a white man*—wondered why Mssrs. S. & H. 'represented me as colored!'" Letter, G. H. Thayer, Boston, to Southworth and Hawes, 22 December 1857, Southworth and Hawes MSS, George Eastman House.

22. Floyd and Marion Rinhart, *The American Daguerreotype* (Athens: University of Georgia Press, 1981), 208.

23. Humphrey and Finley, *A System of Photography*, 7.

24. For detailed accounts of the various methods used to color daguerreotypes, see Susan M. Barger and William B. White, *The Daguerreotype: Nineteenth-Century Technology and Modern Science* (Washington, D.C.: Smithsonian Institution Press, 1991), 38-42, and Janet Buerger, *French Daguerreotypes* (Chicago: University of Chicago Press, 1989), 115-21.

25. *Photographic Art Journal* 7 (March 1854): 103.

26. Humphrey, *American Hand Book of the Daguerreotype*, 49.

27. Ibid.

28. *Weekly Tribune* (Liberty, Mo.), 11 July 1846.

29. Humphrey and Finley, *A System of Photography*, 23.

PORTRAIT PORTFOLIO

1. *Missouri Republican*, 15 July 1849.

2. William Hyde and Howard L. Conard, *Encyclopedia of the History of St. Louis* (Louisville, Ky.: Southern History Company, 1899), vol. 1, 100.

3. M. M. Marberry, *Vicky: A Biography of Victoria C. Woodhull* (New York: Funk & Wagnalls, 1967), 12.

4. Ibid.

5. Emanie Sachs, *The Terrible Siren* (New York: Harper & Brothers Publishers, 1928), 284.

6. Marberry, *Vicky*, 130-31.

7. Sachs, *Terrible Siren*, 307.

8. *Daily Missouri Republican*, 16 October 1851.

9. Hyde and Conard, vol. 1, 270.

10. John Francis McDermott, "Alfred S. Waugh's 'Desultory Wanderings in the Years 1845-46,'" *Bulletin of the Missouri Historical Society* 7 (October 1950): 119.

11. William Clark Kennerly, *Persimmon Hill* (Norman: University of Oklahoma Press, 1948), 57.

12. Ibid.

13. Frederick Drimmer, *Very Special People* (New York: Amjon Publishers, 1973), 133.

14. John Thomas Scharf, ed., *History of St. Louis City and County, from the Earliest Periods to the Present Day* (Philadelphia: Louis H. Everts & Co., 1883), vol. 2, 1294.

15. Slater Brown, *The Heyday of Spiritualism* (New York: Hawthorne Books, 1970), 99.

16. *Missouri Republican*, 11 January 1852.

17. Thomas A. Brown, *History of the New York Stage* (New York: B. Blom, 1964), vol. 1, 41.

18. *Daily Missouri Republican*, 13 May 1853.

19. Constance Rourke, *American Humor: A Study of the National Character* (New York: Harcourt, Brace & Co., 1931), 19.

20. Charles van Ravenswaay, "Years of Turmoil, Years of Growth: St. Louis in the 1850's," *Bulletin of the Missouri Historical Society* 23 (July 1967): 324.

21. N. E. Robinson, "Ethan Allen Hitchcock," *Missouri Historical Review* 2 (April 1908): 79.

22. "Kirker Offered $100,000," *The Southwesterner* (Columbus, N. Mex.), March 1963. This newspaper article is the last in a series of four on the life of James Kirker.

23. *Reveille*, 5 July 1847.

24. *Daily Missouri Republican*, 3 January 1849. The *Missouri Republican* article inaccurately refers to Lehmanowsky as Martin rather than John.

25. Quoted in William Porter Ware and Thaddeus Constantine Lockard, *P. T. Barnum Presents Jenny Lind: The American Tour of the Swedish Nightingale* (Baton Rouge: Louisiana State University Press, 1980), 157.

26. Quoted in Beaumont Newhall, *The Daguerreotype in America* (New York: Duell, Sloan & Pearce, 1961), 81.

27. *Daguerreian Journal* 4 (15 April 1852), 10.

28. *Humphrey's Journal* 5 (1 August 1853), 143.

29. Quoted in Rev. Patrick Rogers, *Father Theobald Matthew: Apostle of Temperance* (New York: Longmans, Green and Co., 1945), 69.

30. *Daily Missouri Republican*, 22 May 1852.

31. Mary Grace Swift, "St. Louis's Resident Ballet Company," *Missouri Historical Review* 72 (January 1978): 133.

32. *Daily Missouri Republican*, 24 September 1853.

33. Helen Holdredge, *The Woman In Black* (New York: G. P. Putnam's Sons, 1955), 156.

34. Elbert R. Bowen, *Theatrical Entertainment in Rural Missouri Before the Civil War* (Columbia: University of Missouri Press, 1959), 30.

35. Dumas Malone, ed., *Dictionary of American Biography* (New York: Scribner's Sons, 1935), vol. 15, 536.

36. U. S. Office of Indian Affairs, *Report of the Commissioner of Indian Affairs, 1850*, Department of the Interior Office Document 1 (Washington, D.C.: Department of the Interior Office), 42.

37. J. P. Dunn, *Massacres of the Mountains: A History of the Indian Wars of the Far West* (New York: Harper and Bros., 1886), 377.

38. Cyprian Clamorgan, "The Colored Aristocracy of St. Louis," ed. Lawrence O. Christensen, *Bulletin of the Missouri Historical Society* 31 (October 1974).

39. Lloyd A. Hunter, "Slaves in St. Louis: 1804-1860," *Bulletin of the Missouri Historical Society* 30 (July 1974): 225.

40. Clamorgan, "The Colored Aristocracy of St. Louis," 19.

CHAPTER III

1. Eighteen Indian portraits, the largest concentration of Easterly's work on this theme, are in the Easterly Collection at the Missouri Historical Society in St. Louis. Presumably these plates remained in Easterly's gallery throughout his career and became part of the MHS collections along with other plates acquired from John Scholten's estate in the 1890s. The lavishly engraved portrait of Nachininga (fig. 3-22), which Easterly's wife kept after his death, was part of the Dodge Collection of Easterly daguerreotypes received by MHS in 1970. Two unidentified Indian portraits (figs. 3-35, 3-36) thought to be Easterly's work are in the Society's general daguerreotype collection. For a thorough and informative discussion of Easterly's Indian portraits in the MHS collections, see ethnologist John C. Ewers' "Thomas M. Easterly's Pioneer Daguerreotypes of Plains Indians," *Bulletin of the Missouri Historical Society* 24 (July 1968): 329-39.

2. The earliest known photograph of an American Indian is a calotype portrait of the Rev. Peter Jones (Kahkewaquonaby), the son of a Welshman and a Mississauga Indian. This full-length, outdoor portrait was made by the Scottish photographers David O. Hill and Robert Adamson on 4 August 1845, during Rev. Jones' visit to Great Britain.

3. Many of King's Indian portraits burned in a fire at the Smithsonian in 1865. For a complete catalogue of his known works, see Andrew F. Cosentino, *The Paintings of Charles Bird King (1785-1862)* (Washington, D.C.: Smithsonian Institution Press, 1977) and Herman J. Viola, *The Indian Legacy of Charles Bird King* (Washington, D.C.: Smithsonian Institution Press, 1976).

4. On Catlin's career, see William H. Truettner, *The Natural Man Observed: A Study of Catlin's Indian Gallery* (Washington, D.C.: Amon Carter Museum and National Collection of Fine Arts, Smithsonian Institution, 1979).

5. George Catlin, *Letters and Notes on the Manners, Customs and Conditions of the North American Indians ...* (1844; reprint, New York: Dover Publications, Inc., 1973), vol. 1, 36.

6. For varying assessments of the ethnographic accuracy of artists' records of Indians and Indian culture, see Frank Weitenkampf, "Early Pictures of North American Indians: A Question of Ethnology," *Bulletin of the New York Public Library* 52 (November 1949): 591-614; John C. Ewers, "An Anthropologist Looks at Early Pictures of North American Indians," *New York Historical Society Quarterly* 33 (October 1949): 223-34; "Fact and Fiction in the Documentary Art of the American West," in John F. McDermott, ed., *The Frontier Re-examined* (Urbana: University of Illinois, 1967), 79-95.

7. For an extensive examination of this subject, see Peter Marzio, *Perfect Likenesses: Portraits for "History of the Indian Tribes of North America" (1837-1844)* (Washington, D.C.: National Museum of History and Technology, 1977).

8. Audubon quoted in John Francis McDermott, *Audubon in the West* (Norman: University of Oklahoma, 1965), 116, n. 6.

9. Frank Weitenkampf, "How Indians Were Pictured in Earlier Days," *The New York Historical Society Quarterly* 33 (October 1949): 219.

10. Henry quoted in Paula Richardson Fleming and Judity Lynn Luskey, *Grand Endeavors of American Indian Photography* (Washington, D.C.: Smithsonian Institution Press, 1993), 21.

11. The artist describes the difficulties of daguerreotyping in the field in Solomon N. Carvalho, *Incidents of Travel and*

Adventures in the Far West (New York: Derby and Jackson, 1857).

12. [Isaac I. Stevens, U.S. War Department], *Reports of Explorations and Surveys ...*, U. S. 36th Cong., 1st sess., Senate Executive Document (Washington, D.C.: Thomas H. For, Printer, 1860), vol. 12, 87, 103-4.

13. It is speculated that a half-plate view of a Plains Indian village in Kansas Territory in the collections of the Library of Congress may be the work of Carvalho. See Paula Richardson Fleming and Judith Luskey, *The North American Indians* (New York: Harper and Row, 1986), 111, plate 5.2.

14. For a comprehensive work on these daguerreans as photographers of Indians and their culture, see Peter E. Palmquist, "Mirror of Our Conscience: Surviving Photographic Images of California Indians Produced Before 1860," *The Journal of California Anthropology* 5 (Winter 1978): 163-78.

15. The eight daguerreotype Indian portraits in the Smithsonian's Division of Photographic History were matched to images made from A. Zeno Shindler's glass-plate negatives in the National Anthropological Archives. There is sufficient evidence to indicate that these daguerreotypes were made in Fitzgibbon's gallery, purchased by William Blackmore, an English collector, and later copied by Shindler in Washington, D.C. The Smithsonian's images are all full-length, hand-colored, whole-plate portraits. Brass mats, which appear on three of the portraits (nos. 3974.23, 3974.24, 3974.25), are identical. The sitter shown full-length in no. 3974.23 (identified in the *Shindler Catalogue* as "Little Bear, a Chief of the Kansas Tribe") is the same subject pictured in a daguerreotype bust portrait in the Gilman Paper Collection. The Gilman plate displays Fitzgibbon's engraved signature and the inscription "Kno-Shr, Kansa Chief." The Indian's costume is identical in both portraits. Fitzgibbon also daguerreotyped a second Kansas tribesman (no. 3974.25) who is shown standing next to the same square table seen in his full-length portrait of Little Chief, or Kno-Shr. Six other portraits among the Smithsonian plates picture members of a delegation party of Arapaho, Cheyenne, Sioux, Oto, and Iowa Indians who traveled through St. Louis during their journey to Washington. See *Missouri Republican* (St. Louis), 30 October 1851 and Peter J. Powell, *People of the Sacred Mountain* (New York: Harper and Row, 1981).

16. *Photographic Art Journal* 6 (September 1853): 193.

17. *New York Tribune* report on Crystal Palace exhibition in Floyd and Marion Rinhart, *The American Daguerreotype* (Athens, Georgia: University of Georgia Press), 127.

18. Gallery advertisement, *The Minnesotian* (St. Paul), 26 November 1853. I am indebted to Bonnie Wilson of the Minnesota Historical Society for bringing this information to my attention. Whitney's collection of "Indian pictures, in groups, and some single figures" is also mentioned in an excerpt from "a St. Paul paper" reprinted in the *Photographic and Fine Art Journal* 7 (October 1854): 320.

19. *Daily Union* (St. Louis), 24 March 1847.

20. Robert F. Berkhofer, Jr., "White Conceptions of Indians," in William C. Sturtevant, ed., *Handbook of North American Indians* (Washington, D.C.: 1988), vol. 4, 528. For an extensive study on this topic, see Robert F. Berkhofer, Jr., *The White Man's Indian: Images of the American Indian from Columbus to the Present* (New York: Vintage Books, 1979).

21. George Catlin, *Letters and Notes on the Manners, Customs and Conditions of North American Indians*, vol. 2, 210.

22. John Francis McDermott, "Another Coriolanus: Portraits of Keokuk, Chief of the Sac and Fox," in *Portrait Painting in America: The Nineteenth Century*, ed. Ellen Miles (New York: Main St. Press, 1977), 158-60.

23. Thomas McKenney and James Hall, *History of the Indian Tribes of North America, with Biographical Sketches and Anecdotes of the Principal Chiefs* (Philadelphia: Fred Greenough, 1838), vol. 2, 80.

24. William T. Hagan, *The Sac and Fox Indians* (Norman: University of Oklahoma Press, 1958), 209. Hagen's work is the only comprehensive study of the Sauk and Fox.

25. Joanna Cohan Scherer, "You Can't Believe Your Eyes: Inaccuracies in Photographs of North American Indians," *Studies in the Anthropology of Visual Communications* 2 (Fall 1975): 75.

26. James D. Horan, *The McKenney-Hall Portrait Gallery of American Indians* (New York: Crown Publishing Group, 1972), 184.

27. This annotation appears on the Appanoose portrait #AP3658 in the Newberry Library's Ayer Collection.

28. Minutes of a treaty held at the Sauk and Fox Agency, 15 October 1841, *Senate Documents*, 27 Cong., 2 Sess., 270-75. Quoted in Hagen, *The Sac and the Fox*, 213.

29. *Daily National Intelligencer* (Washington, D.C.), 27 August 1852.

30. Ibid.

31. William Henry Jackson, *Descriptive Catalogue of Photographs of North American Indians*, U.S. Department of Interior, Miscellaneous Publications, no. 9 (Washington, D.C.: U.S. Department of Interior, 1877), 47.

32. Edward E. Hill, *The Office of Indian Affairs, 1824-1880: Historical Sketches* (New York: Clearwater Publishing, 1974), 82.

33. This annotation appears on the Nacheninga portrait #AP3656 in the Newberry Library's Ayer Collection.

34. Ibid.

35. For a general history of this tribe, see Martha Royce Blaine, *The Ioway Indians* (Norman: University of Oklahoma Press, 1979).

36. Jackson, *Descriptive Catalogue*, 47.

37. Ibid.

38. For a discussion of style and interpretation in nineteenth-century portraits of Native Americans, see Victoria Wyatt, "Interpreting the Balance of Power: A Case Study of Photographer and Subject in Images of Native Americans," *Exposure* 28 (Winter 1991-92): 21-30.

39. Henry R. Schoolcraft, *Historical and Statistical Information Respecting the History, Condition and Prospects of the Indian Tribes of the United States* (Philadelphia: J. P. Lippincott & Co., 1853), vol. 3, 265.

40. Scherer, "You Can't Believe Your Eyes," 73.

41. John C. Ewers, "Thomas M. Easterly's Pioneer Daguerreotypes of Plains Indians," 339.

42. Major J. A. Burbank, U.S. Indian Commissioner for the Great Nebraska Agency, quoted in "The Indian Delegation from Nebraska," *Harper's Weekly*, 27 January 1866. Scherer, "You Can't Believe Your Eyes," 68, notes a portrait (fig. 68) illustrating the use of European feather dusters as replacements for traditional feather fans. In a personal communication with Paula Fleming, she points out that Crow Indians and possibly other tribes used traditional feather fans that could be mistaken for European feather dusters.

43. William Blackmore Collection, box 8, item 0070, Blackmore diary no. 17, History Library, Museum of New Mexico, Santa Fe. An entry dated "St. Louis Oct. 30, 1868" lists amounts paid for "Pictures of Indian warriors from photographs." Blackmore paid $58 in cash and $300 in a draft drawn on a Brown Brothers and Company, Liverpool, England.

44. Blackmore diary no. 17, History Library, Museum of New Mexico, Santa Fe. The "Fitzgibbon Gallery," the only photography establishment noted in Blackmore's St. Louis records, is written at the top of an October 30 entry listing expenditures for photographs in St. Louis. Since Blackmore paid $300 of the $358 total with a single bank draft, it is likely that Fitzgibbon acted as a broker for the Englishman. He may have selected photographs on October 22, the second day of his stay in St. Louis, when he recorded a sketchy "Memorandum" on "Photographs of N. A. Indians" suggesting that their transaction may have involved more than 150 photographs.

45. For the most detailed account of Blackmore's contributions to American ethnology, see Colin Taylor, "'Ho, For the Great West!' Indians and Buffalo, Exploration and George Catlin: the West of William Blackmore," ed. Barry C. Johnson (London: Eatome Ltd. for the English Westerner's Society, 1980), 9-49. An abbreviated form of that article appears in Colin Taylor, "William Blackmore: A 19th Century Englishman's Contribution to American Ethnology," in *Indians and Europe*, ed. Christian Feest (Aachen, Germany: Heerodot, 1987), 321-35. For Blackmore's contributions to the photography of the American Indian, see Paula Fleming and Judith Luskey, *Grand Endeavors of American Indian Photography* (Washington, D.C.: Smithsonian Institution Press, 1993).

46. Taylor, "'Ho, for the Great West!'," 14.

47. Ibid., 15.

48. Blackmore diary no. 17, History Library, Museum of New Mexico, Santa Fe. An entry on October 18 reads "Photographs of North American Indians, 6 to 10 vols., 300 copies... Intention to print 6 to 8 photos of each tribe, Abt 50 photographs in each vol., Carbon Prints so as not to fade."

49. Paula Fleming, Photo Archivist at the National Anthropological Archives at the Smithsonian Institution, has been most instrumental in bringing attention to Blackmore's contributions. Her assistance in the complicated process of tracking later copies of Easterly and Fitzgibbon Indian portraits in the Shindler and Jackson catalogues and in the British Museum collection has been invaluable.

50. [Antonio Zeno Shindler], "Photographic Portraits of North American Indians in the Gallery of the Smithsonian Institution," *Smithsonian Miscellaneous Collections* (Washington, D.C., 1869), vol. 14, no. 216. The catalogue was erroneously dated 1867.

51. A detailed description of Eastman's depiction of a "Sioux funeral," deemed "a more animated picture of real Indian life, than any we have seen before," appeared in the *Missouri Republican*, 29 November 1847.

52. The most comprehensive and appreciative discussion on Deas' work in the West appears in John Francis McDermott, "Charles Deas: Painter of the Frontier," *Art Quarterly* 13 (Autumn 1950): 293-311. In 1846, the *Weekly Reveille* reported that Deas was displaying his work in a new frame establishment on Glasgow Row.

CHAPTER IV

53. *Reveille*, 26 October, 1847.

54. Much like William Blackmore, Edward E. Ayer made an invaluable contribution to the study of ethnology in his remarkable commitment to preserving materials related to North American Indian cultures. Thousands of photographs were among the extensive assortment of books and other archival materials that the Chicago businessman amassed over several decades. Collected from 1911 until his death in 1922, Ayer's archives were given to the Newberry Library. Through this benefactor's endowment, the Newberry has continued to build this important repository of materials related to the history of the American West.

55. The "memorandum" added to Blackmore's diary of 22 October 1868 records the acquisition of one portrait of a "Trapper," a designation that describes Kirker's principal livelihood during his years as a Mountaineer. The "memorandum" also records the purchase of one picture of a "Seminole," possibly a reference to the Newberry's portrait of Muxta, the Indian that Easterly identified as a Seminole.

56. Catalogue card, AP3649 Don Santiago Kirker, Ayer Collection, Newberry Library. Provenance: "Purchased from rare book dealer, 1951; dealer acquired from the Blackmore Museum." The Kirker portrait is the only Easterly work in the Ayer Easterly series for which provenance information is recorded. An extensive search through Ayer Collection accession records turned up no references to daguerreotype acquisitions.

1. *Davenport Gazette* (Iowa), 30 October 1845.

2. "American Photography," *The Liverpool Photographic Journal* 3 (12 January 1856): 1.

3. Ibid., 2.

4. *American Journal of Photography and the Allied Arts and Sciences* 1 (15 September 1858): 130.

5. Janet E. Buerger, *French Daguerreotypes* (Chicago: University of Chicago Press, 1989), 27.

6. For a major survey of the development of the calotype process, see Richard R. Brettell et al., *Paper and Light: The Calotype in France and Great Britain, 1839-1870* (Boston: David R. Godine, 1984).

7. Although some sporadic use of daguerreotyped sites can be noted in the American printmaking industry by the early 1850s, this later application of Daguerre's process appears to have been confined largely to the production of single-sheet city views.

8. Hesler began taking views in 1851, when he made his well-documented trip to daguerreotype the Falls of St. Anthony. Although his original plates from that excursion were lost in his Chicago gallery fire in 1871, the Minnesota Historical Society owns copy prints of several Hesler views of the falls. Unlike Easterly, Hesler actively promoted his talents as a viewmaker to enhance his national reputation and as a commercial enterprise. In 1854, he was exhibiting and selling stereoscopic daguerreotype views of western scenery.

9. Rockwood's comments appeared in a report on the meeting of the Society of Amateur Photographers of New York in *Anthony's Photographic Bulletin* 16 (14 February 1885): 92. George Gardner Rockwood (1832-1911), who began his professional career in St. Louis in 1853, became a prominent photographer in New York, where he established a gallery in the late 1850s.

10. Ibid.

11. *Missouri Republican*, 2 November 1873.

12. Ibid.

13. Bryant F. Tolles, Jr., "The 'Old Mill' (1825-29) at the University of Vermont," *Vermont History* 57 (Winter 1989): 27.

14. John N. Houpis, Jr., *Brattleboro: Selected Historical Vignettes* (Brattleboro, Vt.: Brattleboro Publishing Co., 1973), 32. Also see Esther Munroe Swift and Mona Beach, *Brattleboro Retreat: 150 Years of Caring, 1834-1984* (Brattleboro, Vt.: The Book Press, 1984).

15. David Potter, "A History of the Mineral Industry of Clarendon Springs, Vermont," *Vermont History* 29 (July 1961): 148.

16. Some of the most closely related American antecedents for these pastoral rural views are several landscape scenes made by Dr. Samuel Bemis during his brief tenure as one of America's first amateur practitioners of Daguerre's process. In 1840, the Boston dentist and jeweler traveled to New Hampshire, where he recorded distant views of the Mt. Crawford House Inn and its mountainous setting. Bemis apparently gave up his work with the camera not long after this New Hampshire excursion. By the early 1840s, when daguerreotypy had become the exclusive domain of profit-minded professionals, amateur practitioners such as Bemis had essentially disappeared from the American photographic scene.

17. Marcus Aurelius Root, *The Camera and the Pencil* (1864; reprint, Pawlet, Vt.: Helios, 1971), xvi.

18. James Silk Buckingham, "Hymn to Niagara," in Charles Mason Dow, *Anthology and Bibliography of Niagara Falls* (Albany: State of New York, 1921), vol. 2, 723-25.

19. Caroline Gilman, *The Poetry of Traveling* (New York, 1838), quoted in Elizabeth McKinsey, *Niagara Falls: Icon of the American Sublime* (Cambridge: Cambridge University Press, 1985), 154.

20. Anna B. M. Jameson, *Winter Studies and Summer Rambles in Canada* (London, 1838), in Dow, *Anthology and Bibliography of Niagara Falls,* vol. 1, 218.

21. John Werge, *The Evolution of Photography* (1890; reprint, New York: Arno Press, 1973), 50-51.

22. Ibid., 141.

23. Ibid., 51.

24. Ibid., 152.

25. In the Battle of Lundy's Lane, which occurred on 25 July 1814, twenty-six hundred Americans under General Jacob Brown fought a British force of three thousand men. Both sides claimed victory in this encounter, which is recorded as the most evenly fought and bloodiest land battle of the war.

26. James C. Morden, *Historic Monuments and Observatories of Lundy's Lane and Queenston Heights* (Niagara Falls, Ont., Canada: The Lundy's Lane Historical Society, 1929), 7-31. Five different observatory towers were constructed on Lundy's Lane, the first in the 1840s and the last steel tower in 1893. No more than two existed simultaneously. In the distance of Easterly's view (fig. 4-19) stands the third tower or the Fralich Observatory, which was constructed on the summit of the hill about 1850. The Durham Observatory seen in the middle ground of the picture is the fourth tower built at the site in the early 1850s.

27. With the introduction of collodion glass negatives, which continued to produce cloudless skies, some photographers adopted the practice of combination printing (a technique that used two or more negatives to create a single positive print) to address this problem. In this process, the sky was blocked out with an opaque material and clouds were printed in using a second negative.

28. Joseph Gies, *Bridges and Men* (Garden City, N. Y.: Doubleday and Co., 1963), 187.

29. T. A. Richards, ed., *Appleton's Illustrated Handbook of American Travel* (New York, 1857), n.p.

30. *Missouri Republican*, 5 October 1852.

31. The earliest report on Fitzgibbon working outside the gallery notes his interest in making "something new in the way of mountainous views" that "cannot be made about St. Louis." He may have secured such scenes on a trip East in 1851. See *Daguerreian Journal* 2 (August 1851): 211.

32. Advertisement, *Morrison's St. Louis Directory* (St. Louis: Missouri Republican Office, 1852).

33. Advertisement, *Green's St. Louis Directory* (St. Louis: James Green and Cathcart & Prescott, 1851), 405.

34. *Daily Missouri Republican*, 25 March 1848.

35. *Reveille*, 11 August 1850.

36. "The Capitol of Missouri at Jefferson City," *Western Journal and Civilian* 7 (March 1852): 435. David Boutros, in "The West Illustrated: Meyer's Views of Missouri River Towns," *Missouri Historical Review* 80 (April 1986): 315, suggests that Easterly's view of the Missouri state capitol was also the basis for the engraving titled *Jefferson City* that appeared in *The United States Illustrated: The West* (New York: Hermann J. Meyer, 1853).

37. *Missouri Weekly Herald* (Rolla), 2 April 1869.

38. "Photography in the West," *The Photographic and Fine Art Journal* 11 (April 1858): 108.

39. Louis C. Hunter, *Steamboats on the Western Rivers* (Cambridge, Mass.: Harvard University Press, 1949), 54.

40. *Iowa Sentinel* (Fairfax), 21 August 1847. The writer described the daguerrean's accomplishments: "Mr. T. M. Easterly, of St. Louis, after repeated experiments, has actually succeeded in Daguerreotyping a streak of lightning; a genuine antic-playing streak of the real snake order. So perfect and instantaneous was the operation, that myriads of intervening drops of rain were transferred, with wonderful distinctness, to the plate, every drop retaining its globular form, showing that no appreciable space of time was consumed."

41. Robert Taft, *Photography and the American Scene*, 98.

42. *Anthony's Photographic Bulletin* 16 (14 February 1885): 92.

43. Joseph N. Nicollet, "Sketch of the Early History of St. Louis," in John Francis McDermott, ed., *The Early Histories of St. Louis* (St. Louis: St. Louis Historical Documents Foundation, 1952), 162.

44. Walter B. Stevens, *St. Louis, The Fourth City* (St. Louis: S. J. Clarke Publishing Co., 1909), 440.

45. James B. Musick, *St. Louis as a Fortified Town* (St. Louis: R. F. Miller, 1941), 102. Antoine Roy was also recorded as Roi. James Neal Primm, *Lion of the Valley: St. Louis, Missouri* (Boulder, Colo.: Pruett Publishing Co., 1981), 100, notes that the mill was a half-block north of the original north boundary of Dr. Martin Luther King, Jr., Drive in St. Louis.

46. An engraving based on this view appears as an illustration in Will Conklin, *St. Louis Illustrated* (St. Louis: Will Conklin, 1876), 15. The caption identifies the ruins in the scene as Roy's Tower and Labbadie's Mill. According to Walter B. Stevens, Sylvester Labbadie operated the first oxen-powered gristmill in the region. See Stevens, *St. Louis, The Fourth City*, 613.

47. Charles Dickens, *American Notes for General Circulation* (1842; reprint, New York: Westavco Corp., 1970), 204.

48. Charles E. Peterson, *Colonial St. Louis: Building a Creole Capital* (St. Louis: Missouri Historical Society, 1949), 32. According to Peterson, the Robidoux house, located on the northeast corner of Main and Elm, was built after 1787. Merrill J. Mattes, "Joseph Robidoux," in *The Mountain Men and Fur Trade of the Far West*, ed. Leroy R. Hafen (Glendale, Calif.: A. H. Clark, 1965), 294, states that the home "achieved a certain fame" in its day as the meeting place of the first General Assembly of the Missouri Territory in 1812.

49. Conklin, *St. Louis Illustrated*, 9. The article "Retrospect" includes an engraving of "Judge Silas Bent's residence" based on an Easterly daguerreotype of the Bent home. He states that this "picture is after a photograph taken in 1865" and that the east wall of the house shows a fissure caused by the New Madrid earthquake of 1811. The Bent home, located near the U.S. Arsenal, was built c.

1790. In the 1870s it served as the office for the Tudor Iron Works.

50. The amount of time devoted to this extensive survey, not to mention the considerable outlay of expensive materials, suggests that Easterly had some hope of being remunerated for his efforts. It could be that the work was made at the request of Silas Bent, Jr., whose childhood home was pictured in the scenes, or perhaps as a speculative venture with Bent in mind as a potential customer. From the minutes of one of the first meetings of the Missouri Historical Society in 1866, we know that Easterly had contact with Bent close to the time that the daguerrean worked at Rock Point. It was Bent who informed other founding members of that group that "Mr. Easterly, a daguerrean artist on Fourth Street" possessed a collection of "old landmarks which he would be glad to present to the society if he was pecuniarily able to do so." Bent assured members that "these pictures could be obtained for a reasonable price." Minutes of a meeting of the Missouri Historical Society, 1 December 1866.

51. Peterson, *Colonial St. Louis*, 31.

52. B. Gratz Brown quoted in Rush Welter, *The Mind of America, 1820-1860* (New York: Columbia University Press, 1975), 6.

53. *Missouri Republican*, 13 February 1854.

54. For the most comprehensive study of nineteenth-century urban photography, see Peter B. Hales, *Silver Cities: The Photography of American Urbanization, 1839-1915*. Although this work provides an excellent overview of daguerrean contributions to this genre, it does not include Easterly's work.

55. John W. Reps, *St. Louis Illustrated: Nineteenth-Century Engravings and Lithographs of a Mississippi River Metropolis* (Columbia: University of Missouri Press, 1989), ix. Before the

mid-1850s, it was St. Louis "seen from the opposite shore" that routinely engaged the attention of its artist-recorders. In these narrowly contained panoramas of the harbor, the city itself is often little more than a skyline backdrop for a picturesque assemblage of river-craft. By the third quarter of the century, artists and printmakers adopted the more dramatic bird's-eye perspective to better convey the city's expanding boundaries. These sweeping vistas placed the spectator at an imaginary, elevated vantage point far above the expanse of the city.

56. Only a few ambitious daguerreans attempted to bring camera-made views in line with these pictorial conventions. The multi-plate panorama was the most conspicuous extension of this inherited tradition.

57. Begun in 1852 and completed in 1859, the Custom House and Post Office was designed by well-known St. Louis architect George I. Barnett. Reports such as one that appeared in the *Daily Missouri Republican*, 15 May 1854, suggest the chaotic physical environment that citizens faced during this period of ubiquitous construction. Under the heading "Dangerous," the article called for immediate action from the safety inspector at the construction site of the Custom House. The writer predicted that without additional measures for pedestrian safety, "the Coroner will very likely be called soon to hold an inquest" for a victim of the debris.

58. Glen Holt, unpublished manuscript, Department of Photographs and Prints, Missouri Historical Society, St. Louis.

59. For an account of the history of the construction of the Court House, see Lawrence Lowic, *The Architectural Heritage of St. Louis, 1803-1891* (St. Louis: Washington University Gallery of Art, 1982), 51-52. This exhibition catalogue has been a valuable reference for background information on

the major public and commercial buildings that Easterly recorded.

60. Frank Blackwell Mayer quoted in Bertha L. Heilbron, *With Pen and Pencil on the Frontier in 1851: The Diary and Sketches of Frank Blackwell Mayer* (1932; reprint, New York: Arno Press, 1975), 74.

61. *Missouri Republican*, 5 October 1852.

62. *Northwestern Gazette* (Galena, Ill.), 16 April 1851.

63. See Susan Danley and Leo Marx, eds., *The Railroad in American Art: Representations of Technological Change* (Cambridge, Mass.: MIT Press, 1988).

64. John Hogan, *Thoughts About the City of St. Louis, Her Commerce and Manufacturers, Railroads, Etc.* (St. Louis: Republican Steam Press Print., 1854), 54.

65. "Shot Towers As a Major Missouri Industry," *Missouri Historical Review* 48 (January 1954): 162-63. Also see William Hyde and Howard L. Conard, *Encyclopedia of the History of St. Louis* (Louisville, Ky.: Southern History Company), 2062-63.

66. "Shot Tower, St. Louis," *Ballou's Pictorial* 10 (12 July 1856): 1.

67. *Western Journal* 1 (April 1848): 230.

68. Charles C. Savage, *Architecture of the Private Streets of St. Louis* (Columbia: University of Missouri Press, 1987), 15-16.

69. Ralph Keeler and Alfred R. Waud, "St. Louis: Rambling About the City," *Every Saturday* (28 October 1871): 414. Waud, who also practiced photography, was the illustrator for the article.

70. Lloyd A. Hunter, "Slaves in St. Louis 1804-1860," *Missouri Historical Society Bulletin* 30 (July 1974): 258.

71. E. W. Gould, *Fifty Years on the Mississippi* (1889; reprint, Columbus, Ohio: Long's College Book Co., 1951), 434.

72. William J. Peterson, *Steamboating on the Upper Mississippi* (Iowa City: State Historical Society of Iowa, 1968), 477. Valued at more than thirty thousand dollars, the *Calypso*, shown in Easterly's daguerreotype fig. 4-82, was one of the most expensive vessels lost in the ice breakup.

73. *Missouri Republican*, 31 March 1867.

74. *St. Louis Globe-Democrat*, 12 April 1877.

75. Frank Peters and George McCue, *A Guide to the Architecture of St. Louis* (Columbia: University of Missouri Press, 1989), 109.

76. *Daily Missouri Republican*, 16 August 1849.

77. *Reveille*, 2 May 1850.

78. *Missouri Republican*, 11 October 1850.

79. Henry Brackenridge quoted in John Thomas Scharf, ed., *History of St. Louis City and County, from the Earliest Periods to the Present Day* (Philadelphia: Louis H. Everts & Co., 1883), vol. 1, 127.

80. *Daily Missouri Republican*, 4 June 1852.

81. *Daily Missouri Republican*, 2 February 1853.

82. William M. Smit, "Old Broadway, a Forgotten Street, and Its Park of Mounds," *Bulletin of the Missouri Historical Society* 4 (April 1948), 155.

83. Titian Ramsey Peale, *Ancient Mounds of St. Louis, Missouri, in 1819*, in Annual Report of the Board of Regents of the Smithsonian Institution (Washington,

D.C.: 1862), 391.

84. Spencer Smith, "Origin of the Big Mound of St. Louis, A Paper Read Before the St. Louis Academy of Science, 1869," quoted in Stephen Williams and John M. Goggin, "The Long Nosed Mask in Eastern United States," *The Missouri Archaeologist* 18 (October 1956), 16.

85. *Missouri Republican*, 13 February 1854. Rev. S. A. Hodgeman also noted "work of demolition" being carried out on the Big Mound in the spring of 1854. He observed that "from present appearances [the Mound] will soon be 'hauled away' and 'numbered with the things that were.'" Lamenting that it "ought to have been preserved as a memorial of the past," he indicated that it was instead being demolished "at public expense, with a few thousand or million cart loads of earth [to] fill up some sinks and hallows, quagmires and stinking ponds...." Hodgman's comments appear in "The Mound," *The Western Casket* 4 (May 1854), 144.

86. *Daily Missouri Democrat*, 8 November 1868. The article reported: "About two years ago the mound was sold by Bishop Kenrick, to Duncan, Sherman & Co. of New York, and Caspar Bestring, for some $30,000.... Messrs. Dowling & Donnely, contractors for the extension of the North Missouri Railroad, are taking the dirt from the Mound."

87. Synopsis of "The Group of Mounds That Gave St. Louis the Name of Mound City," a paper delivered by Henry M. Whelpley, M.D., President of the St. Louis Anthropological Society, at the 1925 meeting of the American Association for the Advancement of Science, scheduled for release to press on 2 January 1926, Whelpley Papers, box 1, Missouri Historical Society, St. Louis. Although no documentation has been found on when or how the Big Mound daguerreotypes came to the Missouri Historical Society's

Easterly Collection, Dr. Whelpley is recorded as donor of the plates. Based on Society minutes reporting the acquisition of "photographs" of the mound during its excavation, it seems likely that some of the views were obtained directly from Easterly in the spring of 1869. One of the mound views (fig. 4-102), donated to the Society by Alice Dodge Wallace (MHS Easterly-Dodge Collection), remained in the possession of Easterly's wife after the daguerrean's death.

88. Alban Jasper Conant, *Foot-Prints of Vanished Races in the Mississippi Valley* (St. Louis: Chancy R. Barns, 1879), 41.

89. *St. Louis Daily Times*, 16 April 1869.

90. Conant, *Foot-Prints of Vanished Races*, 42-43.

91. *Daily Missouri Democrat*, 19 April 1869.

92. Scharf, ed., *History of St. Louis City and County*, 96.

93. Elihu H. Shepard, *The Early History of St. Louis and Missouri* (St. Louis:

Southwestern Book and Publishing Co., 1870), 21-22. Since Easterly's daguerreotypes are the only known photographic records of the excavation of the Big Mound, it is likely that the "photographs" obtained by the Society were Easterly daguerreotypes. Minutes from the Historical Society's meeting of 4 March 1869 note: "Mr. Richard Dowling reported that he had procured two photographs of the ancient grand mound as its now appears in process of being removed from its resting place for unnumbered ages...." In various references to the 1867 purchase of Easterly's twelve plates picturing "old landmarks" of the city, Society minutes refer to those works both as "daguerreotypes" and as "photographs."

94. The most detailed account found on artifacts uncovered appears in *Missouri Republican*, 17 April 1868. The 16 April 1869 issue of the *St. Louis Daily Times* gives little specific information on grave goods uncovered, stating only that "workmen for several weeks have been turning up portions of human bones, Indian coin, beads, and other gewgaws." Williams and Goggin, in "The Long Nosed Mask," 16, state that a detailed

description of the grave goods "supposedly" appeared in the *Missouri Democrat* on 18 April 1869. However, they were unable to locate that issue. An extensive search by this author also failed to locate an extant copy of this issue.

95. Conant, *Foot-Prints of Vanished Races*, 41.

96. Ibid., 44.

97. A decade after the leveling of the mound, some Missouri Historical Society members looked back with regret on "the disjointed efforts made to collect relics" from the Big Mound. It is "most discreditable," observed the chairman of the Society's newly formed Committee on Archaeology, that one has "to resort to the Smithsonian Institute, the Peabody Museum, and to the Blackmore Museum in Salisbury, England to find proper collections of our prehistoric remains." Minutes of a meeting of the Missouri Historical Society, 17 January 1880.

98. Minutes of a meeting of the Missouri Historical Society, 13 May 1867.

INDEX

Paper: UK Paper North America
100 lb. text Consort Royal Silk Tint
120 lb. cover Gleneagle Osprey Geo Dull Tint
Paper meets the requirements set forth by the
ANSI Standard (Z39.48-1984),
Permanence of Paper for Printed Library Materials.

Typefaces: Horley, Trajan, Kuenstler Script.